Painting Indiana

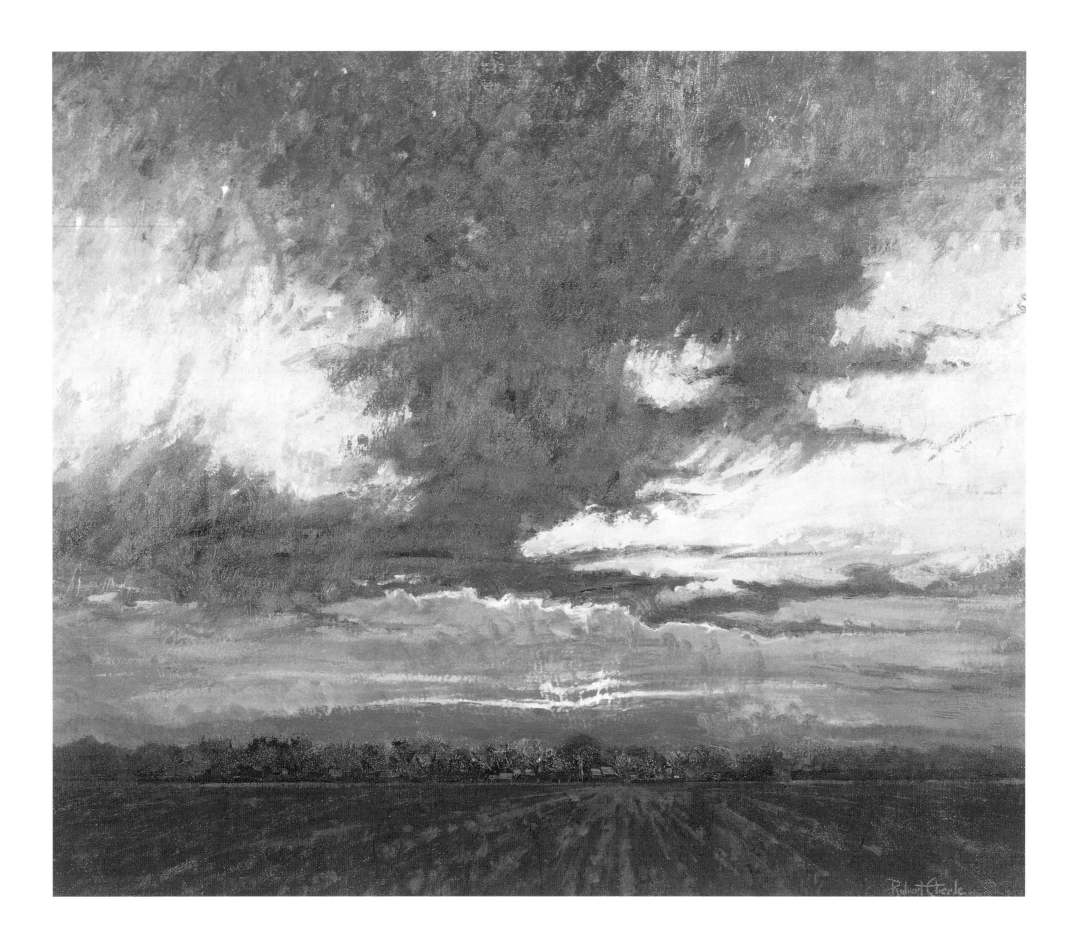

Portraits of Indiana's 92 Counties

Painting Indiana

Indiana Plein Air Painters Association, Inc.

Anne Bryan Carter
Editor and Project Coordinator

Paintings by Lyle Denney, Robert Eberle, Ronald Mack, Don Russell, and Dan Woodson

County Essays by Earl L. Conn Foreword by James Edward May

INDIANA UNIVERSITY PRESS BLOOMINGTON AND INDIANAPOLIS

This book is a publication of

Indiana University Press

601 North Morton Street

Bloomington, IN 47404-3797 USA

http://www.indiana.edu/~iupress

Telephone orders 800-842-6796

Fax orders 812-855-7931

Orders by e-mail iuporder@indiana.edu

Printed in China

Library of Congress Cataloging-in-Publication Data

Painting Indiana : portraits of Indiana's 92 counties / Indiana Plein
Air Painters Association, Inc. ; Anne Bryan Carter, editor and project
coordinator ; paintings by Lyle Denney . . . [et al.] ; county essays by
Earl L. Conn ; foreword by James Edward May.
 p. cm.
 ISBN 0-253-33692-9 (cloth : alk. paper)
 1. Indiana—In art. 2. Landscape painting, American—Indiana.
 3. Landscape painting—20th century—Indiana. I. Carter,
Anne Bryan. II. Indiana Plein Air Painters Association.

ND1351.6 P355 2000
758'.1772—dc21
 99-048558

1 2 3 4 5 05 04 03 02 01 00

To my sons, Charles and Stephen, and to art lovers everywhere.

To my inspiring wife, Carol, who brings balance, harmony, and value to my most important "work in progress"—my life. Her loving support keeps me mindful of the words of Robert Henri: "Living a full life is the goal, art is the result."

To my dad, who was always there to help, and my brother, Jim, a talented artist who inspired me when I was young. Also to my wife, Dottie, I owe my development and direction. Her support, patience, insight, and love have made it all possible.

In memory of my son, Mark A. Russell, who passed away in spring 1999, and to my sons Don II, John, Edward, Kevin, Kurt, and Kraig.

To my children: Sherri, David, and Kristin. You are the loves of my life. And to Anne Carter, whose perseverance has made your wonderful idea for the project and this book a reality. Maybe now you can go home in the daylight.

CONTENTS

Indiana County Paintings and County Essays

Foreword: A Hundred Years of Painting Outdoors

Speaking of his generation of painters, William Forsyth wrote: "Before their time those who painted, only guessed and dreamed in their studios, but these men went out into the open and joyously sought to measure themselves with nature."[1] Indiana's tradition of painting outdoors traces to the 1870s and the state's first art schools. This style defines Indiana's most acclaimed group of artists, The Hoosier Group, and it is a tradition that remains strong today, a hundred or so years later, even though the land itself has changed dramatically. The Arcadian Indiana "scene" is harder to find today, but it exists and can still be the source of profound inspiration. It may be nestled a hundred yards from a busy interstate highway or a mile back from the last row of sprawling suburban homes, but the scene can be found, and it still beckons the artist.

Today, it may seem odd that little more than two hundred years ago, painting *en plein air,* or in the open, was a rarity. Artists might sketch in the wilds of the field, but they completed their important work in the refined air and light of the studio. To paint a tree one did not need to see the tree; one only needed to know the formula for *Tree.* These formulas, for *Tree, Mountain, Apple,* et cetera, could be combined with different color choices and lighting gimmicks *ad infinitum.*

Drawn and modeled "reality" can be thoroughly believable. In fact, many artists received their training exclusively through the study of other prints and paintings. Yet, beginning in the mid-eighteenth century in Europe, some artists began to look more closely at nature. They realized that visual reality was far more complex than artistic reality. Light does funny things in nature. Colors affect each other. Light reflects through shadows that on first glance appear dark as pitch. Artists came to discover that light and vision are both transitory and that maybe neither could, nor should, be fixed so rigidly with paint.

The rise of the cult of nature in the eighteenth and nineteenth centuries is in part responsible for elevating the genre of landscape painting. Historically considered, at best, a secondary form of art, more and more pure landscapes began to be produced. Beginning with the Romantic painters and writers, nature went from setting to subject. Artists started to study nature while being immersed in it. Landscape painters freed themselves from academic, formula-based painting and went out into the clear light of day to observe how things really were.

Early pioneers such as John Constable, painting in England in the late eighteenth and early nineteenth centuries, sought to strip the genre of its metaphor and historical allusions in hope of creating a new art form based on faithful observation. It was his intention to bring human significance to the landscape without relying on artifice. Other Romantic painters in England and Germany increasingly focused on "sublime imagery" in an attempt to place mankind in the natural world.

As "manifest destiny" pushed the United States westward, a number of American painters satisfied a growing demand for nostalgia. Americans sensed a loss as civilization pushed the sublime natural world further and further away. In the best works by American masters such as Thomas Cole, Asher B. Durand, or Albert Bierstadt, the pristine American landscape becomes a metaphor unto itself—an allegory for morality, spirituality, or just simply the great American potential.

Indiana in the first half of the nineteenth century would have been considered indistinct from the vast Eden extending west. By 1850, that had changed. Civilization had reached the frontier and the demand for art in the state began to rapidly increase. George Winter, British by birth, came to Indiana in 1837. Though he certainly sketched and painted watercolors outdoors, it is doubtful that his formal oils were done anywhere other than the studio. Other early Indiana painters such as Lewis Peckham, Horace Rockwell, and Jacob Cox found more work as portrait painters than as landscape painters. Robert Hughes, in his book, *American Visions,* points out that the notion of a landscape was unknown to farmers in the early nineteenth century. What artists call a "landscape," settlers, farmers, and in general Hoosiers of the time, would have considered territory, property, or raw materials.[2] It is only after mid-century that the genre of landscape painting took hold in the state and only after 1875 did we see real *plein air* painting.

John Love is considered to be Indiana's first professional painter who worked en plein air. Born in Ripley County in 1850, Love settled in Indianapolis as a boy. He studied at the National Academy in New York and at the Ecole des Beaux Arts in Paris under Gérôme, but perhaps more importantly he studied with the art colonies at Barbizon and Pont-Aven. When he returned to Indiana in the late

1870s, he brought with him the Barbizon School's passion—a passion derived from extended immersion in nature.

At mid-century, European painting was dramatically changing. In France, in particular, the roots of Modernism were forming. The Barbizon painters, J. B. Camille Corot, Théodore Rousseau, Jean François Millet, and others broke with academic tradition and created a program of direct study from nature. Realists Edouard Manet and Gustave Courbet assaulted conventional tastes with their gritty reality and following them the first real Modernists, the Impressionists, redefined what a painting was to be.

It was in this period of artistic transformation that Indiana produced its first group of mature indigenous artists. Theodore Clement Steele arrived in Indianapolis in 1873. The city and state at that time were blossoming. The population of Indianapolis increased nearly tenfold between 1850 and 1880. Steele joined Jacob Cox and Barton S. Hays and was able to make a decent living as a professional artist, a feat that just ten years earlier would have been almost impossible. By 1880 Steele and several other young artists had decided that in order to compete in an ever more sophisticated art market, they needed to study abroad. Much has been written about Steele, J. Ottis Adams, William Forsyth, and the others who took off for Munich to study at the Royal Academy of Arts. For our purposes here, it is really only important to note why they decided to come back.

"People often wonder why so many of the artists who had had the advantage of the best study and training abroad should come home to Indiana to settle down to the long, hard struggle for patronage and position in an environment that had been proved only indifferent at best. . . . The explanation is quite simple: They have attempted to realize an ideal."[3] Forsyth was referring to a notion common to the Hoosier Group—Steele, Adams, Forsyth, Otto Stark, and Richard B. Gruelle— who decided that they could find their personal expression best amidst the places with which they were most familiar. If the Barbizon painters could make a career and a lasting art in the fields of Fountainebleau and Monet could immortalize Giverny, then they could make Indiana's land, Indiana's seasons, the subject of great art.

Most of the Hoosier Group members were trained in Munich as purely Academic-style artists. They were heavily instructed in figure drawing and portrait painting. Only during vacations or free time did they work with the landscape. Most important in the formation of Indiana's plein air tradition is the time spent by Steele in the village of Schleissheim, north of Munich. There he, and many other American painters, learned to paint outdoors from J. Frank Currier. An American painter, Currier came to Munich in 1870 and stayed until 1898. Most of that time he worked as a landscape painter and an informal teacher in and around Schleissheim. From him, several artists studying in Munich learned to observe the earth, including its seemingly invisible constituents: wind, humidity, and temperature.

Forsyth wrote of Currier: "[he] paints with a savage dash and an utter contempt for all refinement of form. . . . He never pretends to work on a picture for more than a few hours and never touches it afterward . . . his execution is usually very bold. But terribly careless and unusually ragged and slovenly. But sometimes he gets brilliant color."[4] What Currier gave to Steele, Adams, and Forsyth was the permission to paint outdoors as well as a notably dark palette that would take them all some time to shake.

When the Hoosier Group artists returned to Indiana, they did what they had set out to do. Based out of his Indianapolis home, Steele made painting excursions to Jennings and Montgomery counties. These paintings are inspired studies of atmospheric light though quite dark because of his remaining allegiance to a somber Munich palette of browns and blacks. By the late 1890s Steele and Adams were painting together at Metamora and Brookville. It was in Brookville that the two artists bought a joint home and studio called The Hermitage. It was also during this period that a true Impressionist palette was used consistently by both artists. Pastels and white-based color constructions replaced the heavier palette of the 1880s and early 1890s.

It is important to point out that while The Hoosier Group is often called the Hoosier Impressionists, the artists were more *influenced* by Impressionism than they were strict practitioners of the style. American Impressionism in general is not a very cohesive school of painting. Many American artists adopted the poetic tonal qualities of light and color found in the work of Claude Monet, but unlike Monet few American artists found those qualities to be sufficient as a subject. On that note, Forsyth wrote that "though on their arrival [home] the old browns and blacks of the studio still persisted, the influence, first of the plein air artists, as outdoor painters were called, and afterwards that of the Impressionists prevailed, and the pure colors and light in all its phases are the dominant traits in all these Hoosier artists' works. Impressionism has influenced them to a greater or lesser extent and has taught them more than any other single factor."[5]

Perhaps the Hoosier Group artists most resemble Impressionists in their desire to be physically immersed in their subject, as Forsyth wrote: "To live out of doors in intimate touch with nature, to feel the sun, to watch the ever-changing face of the landscape, where waters run and winds blow and trees wave and clouds move."[6]

The changeability of nature was a characteristic to be embraced by the artist. While on a painting excursion in Owen County, near Spencer, Indiana, Steele wrote to his first wife, Libbie: "Of course everything seems beautiful now. Gold and purple, blue sky and water. The sycamores seem to be the prevailing trees along the river and are now in their best. Some fine oaks not yet crimson but beginning to turn. I wonder if the crimson oaks will ever look so fine, burn with such inward fire . . . as those we used to see at Vernon."[7]

Steele concisely summed up what the Hoosier Group and other "real" artists of the period were supposed to do: "Landscape painting is a modern art. There are comparatively no old masters in landscape, certainly none that exert any influence on the great modern school. . . . The artist does not sit in his studio and conjure up a weak suggestion of out-of-door life. He goes at once to nature herself, not as a mere copyist, for while he holds himself rigidly to truth or effect in atmosphere and light, his trained eye broadly generalizes, his imagination works his hand, and the result, though it may be ideal, embodies the truth of reality. In fact it is the interpretation of Nature into the more impressive language of Art."[8]

In 1907, Steele ushered in a new phase of Indiana plein air painting when he moved to his new home in Belmont, Indiana—The House of the Singing Winds. He had started painting in the area the year before, but upon settling his hilltop in Brown County he automatically became the local sage, maestro for the blossoming Brown County Art Colony. To be fair, artists had admired the rustic nature of the region for years and Adolph Shulz probably visited the area as early as 1900.

Centered in the town of Nashville, the Brown County Art Colony was a loose affiliation of painters and print makers, most of whom were from outside Indiana,

predominantly from Chicago. These artists were drawn to the denuded hills of the area for their panoramic vistas. Those vistas have an immediately recognizable purple haze in the distant atmosphere that in part defines the school of Brown County painting. At its peak there were as many as fifty to sixty professional artists making treks to the remote hills and valleys around Nashville.

The stylistic connections between Brown County's best-known artists are tentative. Adolph Shulz, Will Vawter, L. O. Griffith, Carl Graf, Edward K. Williams, and C. Curry Bohm resemble each other mostly because of their common subject matter. Close inspection of many Brown County paintings reveals a wide range of skill levels between artists. As the reputation of the colony spread, a more commercial side of painting developed.

The Brown County artists shared a common ideal with many American artists of the 1920s and 1930s. These artists wanted to promote American painting. European Modernism was taking hold in the United States and many American painters, in order to postpone the inevitable, retreated from the cities for more "American" places to paint. These artists identified more with the modernism of the Impressionists than the modernism of the Cubists, and they sought to continue the traditions of plein air landscape painting.

Working en plein air was not always as poetic as some artists would have you believe. Although not a painter, the Brown County photographer Frank M. Hohenberger had this to share about his working method: "Any time your conscience hurts you as to the price you are charging for your summer landscapes, just recall: Starting out in the hottest weather, working in the very hot sun under a focusing cloth, every minute expecting the heat to ruin your bellows. Using rubber boots, and how nice to change to shoes when your feet are sweating. Stopping in the creek to cool the boots . . . chiggers galore . . . how many times you pulled the big camera out of the rig and returned it, disgusted with the composition."[9]

A solitary artist, unaffiliated with any school in the state but nevertheless making a significant contribution to Indiana's art history, was the plein air painter Frank V. Dudley who worked almost exclusively in northern Indiana along Lake Michigan. A contemporary of the Brown County painters and, like many of them, a Chicago resident, Dudley is commonly called the Painter of the Dunes. For nearly 40 years, from 1921 until 1957, Dudley spent nine months of each year painting in the unique ecological environment of the Indiana Dunes. His work covers the gamut of scenes to be found in the region, from purely sky and water imagery of Lake Michigan to beachgoers at play to portrait-like specimen pictures of native flora.

Dudley wrote in 1936 that he believed "the artist through his study and close contact with the landscape is enabled to see more closely and feel more the joyous message of nature."[10] His sentiments are common to many landscape painters. With plein air painting, artists are forced to pay attention to the truth of nature. Indiana-born William Merritt Chase, who taught scores of American artists at the beginning of the twentieth century, instructed his students this way during summer classes at his school at Shinnecock: "Open your sky more and paint a tree that a bird could fly through. . . . How much light there is in everything out-of-doors! Just look out that window and note that even the darkest spot of that clump of trees is many shades lighter than the sash of the window."[11]

By the 1950s, plein air painting was out of vogue. What the Impressionists had begun with their studies of light had evolved into non-objective painting. Color freely applied to a board or canvas was as valid as any color that referenced a real object. Mainstream art followed this course of Modernism through the expressive color studies of the Abstract Expressionists and the Color Field Painters to the flatly applied paint of the Minimalists. Traditional tree-and-field paintings fell into decline mostly because of a lack of market but partly because of an overreliance on photography.

Artists have used photographs for as long as photography has existed. Some use them as references, some quote freely from them, and some transcribe them literally. There is as much danger for the artist in thinking that a photograph equals reality, as there is in thinking that a painting equals reality. Both are abstractions. Just as the old academic artist who studied prints to learn visual truths, a landscape painter who does not go outdoors does not really know his subject. The Indiana painter Frederik Grue was able to strike a balance between a thorough understanding of plein air technique and a reliance on photographic documentation. He often used a camera to "sketch" or record subjects, but his own eye recorded much detail as well.

Referring to his 1987 painting *Moonrise, Farmland, Indiana,* Grue said, "I saw this location during the late fall on a drive out to Farmland with one of my students. Next to the green space off the highway was a field that was covered with light grass, dried weeds, and wild thistle. The whole thing had turned shades of golden brown. What was wonderful about this spot to me was the light . . . standing by the roadside with the sun to my back as I took photographs, I thought, 'Okay, the sunset is going to give me the color. What's behind me is what's going to determine the values and the atmosphere of what's in front of me.' While I was shooting, the moon was coming up in a sky that was still blue but turning a pale grayish pink toward the bottom of the horizon line."[12]

Painting en plein air is more than just a stylistic decision. It is a development in the scheme of art history that has changed our perceptions. Just as we today are more comfortable with abstraction than, say, T. C. Steele would have been in 1900, we are also more sophisticated in our expectations of realism. We can easily distinguish the studio painting from the field painting. Judging which of the two is better is best left to the individual critic, but we can at least accept the motives of each as valid.

The Hoosier Group would be proud to know that what they started in Indiana has survived and is flourishing again. For plein air painting to survive next to various other art movements is very healthy. Its evolution over the new century will define art in this state for the next generations. Forsyth began his essay on art in Indiana: "A hundred years ago—indeed for many years afterward—there was no art in Indiana. . . . Brave they were and hardy, epoch making, these forefathers. . . . To those who should come in after time, whose lives should be laid on easier lines, was left the task of celebrating . . . the deeds of the pioneers."[13]

JAMES EDWARD MAY
Curator of Fine Arts
Indiana State Museum & Historic Sites

NOTES

1. William Forsyth, *Art in Indiana* (Indianapolis: H. Lieber Company, 1916), p. 12; a reprint of a series of articles beginning Saturday, August 12, 1916, in the *Indianapolis News.*

2. Robert Hughes, *American Visions: The Epic History of Art in America* (New York: Alfred A. Knopf, 1997), p. 142.

3. Forsyth, *Art in Indiana,* p. 15.

4. William Forsyth to Thomas E. Hibben, May 13, 1882; quoted in Judith Vale Newton, *The Hoosier Group: Five American Painters* (Indianapolis: Eckert Publications, 1985), p. 121.

5. Forsyth, *Art in Indiana,* p. 17.

6. Ibid.

7. Theodore Clement Steele to Elizabeth Lakin Steele, October 18, 1895; quoted in Selma N. Steele, *The House of the Singing Winds: The Life and Work of T. C. Steele* (Indianapolis: Indiana Historical Society, 1966), p. 42.

8. Ibid., p. 36.

9. M. Joanne Nesbit, *Those Brown County Artists: The Ones Who Came, the Ones Who Stayed, the Ones Who Moved On, 1900–1950* (Nashville, Ind.: Nana's Books, 1993), p. 118.

10. C. J. Bulliet, "Artists of Chicago Past and Present—Frank V. Dudley," *Chicago Daily News,* March 28, 1936.

11. Reynolds Beal Papers, Archives of American Art, Smithsonian Institution, Roll 286.

12. Frederik Grue to Judith Vale Newton, 1994; quoted in Carol Ann Weiss and Judith Vale Newton, *Beyond Realism: The Art and Life of Frederik Ebbesen Grue* (Indianapolis: BCL Press, 1995), p. 118.

13. Forsyth, *Art in Indiana,* p. 5.

The seed for the Painting Indiana project, strangely enough, began to grow in the dreariest part of winter 1998. On January 18, one of those cold gray days with icy wind and freezing drizzle, Dan Woodson and I were driving along, engaged in one of our seamless discussions about painting. Even on this day, a day most would find uninspiring, Dan dreamed aloud: "I just wish I could paint in every county in Indiana."

As enthusiasts of outdoor landscape painting, known as plein air painting from its rise to popularity through the French Impressionist movement, painting Indiana county by county sounded like great fun, but the time and expense of travel seemed formidable obstacles. Our way would certainly be easier than that of the Hoosier Group, early Indiana artists who would travel for days by wagon to reach new territory to paint. Modern means of travel could take us to any corner of the state in a few hours.

Today's Indiana painters use books such as *The Hoosier Group* and *The Artists of Brown County* as textbooks and bibles in their studies to capture the Hoosier essence on canvas. The works of important Indiana artists show us the depth of their talent, and they also document the natural beauty they found in the yet-to-be-developed Hoosier landscape. Scenes from Franklin County, where T. C. Steele and J. Ottis Adams lived and worked at The Hermitage in Brookville, and Brown County, the modern day mecca for Hoosier artists, were preserved as artistic documents of Indiana's past. The rugged wooded hills, meandering streams, bridges, barns, homes, and quiet scenes from daily life of folks who worked the land and built the early communities were studied, appreciated, and sealed in time with paint and brush. Scenes from a hundred years ago still live in the works of these artists.

As we continued our drive, we talked about an idea we had considered for a long time for an association of plein air painters. An alliance of the many small groups of Indiana landscape painters would allow us to learn from each other, exchange information, and paint all over the state. Once started, such an association could sponsor a project to paint Indiana's counties.

The drizzle continued and so did our conversation. Perhaps the paintings of today's artists could document our own view of Indiana . . . the seed started to grow. How many painters would we need to go to all ninety-two counties to paint a landscape? Twelve? No, five could do it. Could it be completed in time to be exhibited in 2000, the threshold of a century and a millennium? Maybe . . . maybe too, we could feature the paintings in a book as a modern day portrait of the beauty and diversity that today's Hoosier painters study, appreciate, and seal with paint and brush.

That was it. Painting Indiana had begun.

In the weeks that followed, we formalized the plans for the painting group that we had dreamed of—a statewide alliance of Hoosier plein air artists. It would be open to all artists at any level of skill or experience. Members only needed to be interested in painting outdoors. With our artist friends, we developed a plan to offer paint-outs, workshops, and seminars to teach and encourage artists who wanted to learn more. Exhibits would bring our art to the public to promote painting as well as Indiana's beautiful landscapes. A newsletter would provide an open forum for artists around the state to share ideas, opportunities, and support for our members. The Indiana Plein Air Painters Association, Inc., or IPAPA, was a reality.

The development of the Painting Indiana project ran simultaneously with the start-up of the association. From a random list of twenty Hoosier plein air artists, we began to offer participation in the project. We sought artists who understood the premise of the project and could make a commitment to complete eighteen or nineteen paintings in a little more than a year's time. Participation would require traveling and time spent searching for scenes in counties that the artists likely had never visited before. Above all, we needed artists who could capture the diversity of Indiana as it appears now with its fertile fields of corn, rivers, and hills; and its undisturbed places, small towns, and great cities. After seven offers, five participants were confirmed by April 1, 1998.

Fortunately, the randomly chosen painters showed a brilliant diversity in style. Robert Eberle, from the northeast side of Indianapolis, painted with environmental awareness, a beautiful palette, and lively brushwork. Muncie's Lyle Denney's brushwork and color, mixed with a limited palette, were free, expressive, and alive with passion. Don Russell, from Zionsville, captured light in quiet scenes after years of experience, training, and skill. Ronald Mack, from the south side of Indianapolis, incorporated his skill as a still life artist into his landscapes with

familiar and evocative detail. Hagerstown's Dan Woodson offered his ability to capture the feel of the air in the scenes he painted, with an unexpected command of color for one who is color-blind.

The ninety-two Indiana counties were divided into four quadrants: northwest, northeast, southwest, and southeast. Each of the five artists agreed to travel to each quadrant to ensure a variety of styles and to equalize travel burdens. Then the counties were assigned to the artists by a very scientific lottery system—drawing numbers out of a hat. Two artists needed to paint an additional painting. Brown and Marion counties, the two counties most highly coveted, were drawn separately with three blank pieces of paper to ensure a fair drawing. Ron Mack won Brown County and Don Russell would paint Marion County.

The five participants were seasoned artists, each having painted abundantly, and it was never necessary to question their ability or commitment. The goals of the project were balanced with the working styles of the individual artists to keep the project itself from adversely affecting their freedom to choose subjects and paint them their own way. They were each asked to go to their designated counties, study its landscape and character, find a scene that represented the county, and paint it well. And that's exactly what they did.

They say in Indiana that if you don't like the weather, just wait a little while. That waiting took much of the wet, late spring of 1998. The artists were eager to get started, but the weather just wasn't cooperative. They did what they could do under these circumstances—they started driving. Their "scouting missions" were the first trek into undiscovered country. Many wonderful, familiar destinations are sprinkled across Indiana, and most of them had visited many of them, having lived in the state their entire lives. But this was different. They looked at all those places in between, places they'd never been or even heard of except on severe weather bulletins. They traveled the highways and looked, turned onto the county roads and looked, then headed down the gravel back roads that sometimes didn't lead to anywhere and looked some more. Some of the artists traveled with wives or friends and some went solo, taking notes and photos for reference. They started to get to know Indiana and what it looked like.

A mishap in late March 1998 put one artist's participation in jeopardy. Falling from a ladder during a household chore, Dan Woodson broke his painting wrist. Surgery was required to reposition the bone with pins and rods, which he endured for six weeks. Unwilling to give up his participation in the project, he was painting again three weeks later, his elbow resting on pillows and the metal pins holding his wrist in an awkward position. His first two paintings, of Union and Owen counties, were painted before the pins were removed. His wrist was a constant difficulty throughout the year, but it did not stop him from producing his paintings.

With the paintings under way, we began to gather information about each county for the artists to use as they researched their destinations. The same county facts would then be used in the book we wanted to have published about the project. Over the next year we sent our plans for Painting Indiana to chambers of commerce, historical societies, and visitors bureaus, asking for information about their counties. We asked them to tell us what they would want readers to know about their part of Indiana and to offer suggestions for places our artists might find interesting for painting. We also requested the name of a contact person who could answer our questions, advise us on travel and accommodations, and keep others in their county informed about our progress.

Throughout the sixteen months of working on the project, we interacted with hundreds of helpful and enthusiastic people. The information we received assured us of what we already knew—each county has its own treasures. The lay of the land, whether hilly, rugged, or flat; historic places, whether monuments or quiet remembrances; hometowns of politicians, inventors, or scoundrels; little nuggets of local fact that only locals know; and the people themselves—these are the jewels of Indiana, and we collected a fortune.

We had the good luck of finding Earl L. Conn, retired journalism professor and former dean of the College of Communication, Information, and Media at Ball State University, who agreed to take the folders full of information and write essays for every county. Finding capable hands to do the work of the project was the key to our success, and Earl's ability to take a mountain of paperwork and write the essays in his conversational style was a perfect fit. We quickly loaded him up and let him do the job.

By July we began to see completed paintings at our artist meetings. The artists, still a little unsure of their chosen views and grasp of the project, each brought two or three pieces. We talked, studied, questioned, and made suggestions, slowly growing into the project as a group. Some of the painters had never met and only knew each other by their work. We found as time went by that they weren't just great artists, they were good people. Somehow we had brought together a random group of strangers who shared gentleness in temperament, an understanding of each other's motivations and concerns, and a generous amount of support and encouragement for each other's creative efforts. The pleasant and unexpected melding brought new possibilities for the project into focus.

Summer flew by as the artists crisscrossed the state, painting in parks, backyards, city streets, and side ditches, finding the essence of each scene and committing it to canvas. We marveled at the range of texture that Indiana's environment offered. The beauty of the southern hills and valleys is well-known, but the depth of that beauty, the way it rose and fell, twisted and turned as it rolled toward the Ohio River was a constant revelation. The decision to paint a particular scene was not in the finding, but in the elimination of a hundred other wonderful possibilities and selection of just one.

The northern flatlands, we were warned, would be a much more difficult area in which to locate subjects to paint. We found the opposite to be true. The seemingly endless acres of rich farmland, acre after acre of corn, beans, wheat, and pasture did take a bit more time, but only because of the sameness of the land at first sight. More miles, closer looks, suggestions from folks in small towns and filling stations, and just plain perseverance eventually uncovered the heart of each county. Along rivers, creeks, and lakes, down quiet streets of neighborhoods, up hillsides overlooking the farms that stretch for miles, on the hallowed ground of places where Hoosier legends made their mark in our history, the artists found the scenes that revealed the character and the essence of each county's land and life.

The paintings came together like a patchwork quilt. The artists, fully engaged in their adventure, completed painting after painting, documenting each site and experience as they progressed through their lists of counties. The stories behind the paintings brought them to life. Tales of curious cows, ankles twisted while navigating pastures, unfortunate run-ins with rain, mud, and mosquitoes, and deep, satisfying conversations with locals added dimension to the paintings. A deeper understanding and appreciation of Indiana emerged. We were creating a living, breathing portrait of our home, a legacy we could be proud to share with our fellow Hoosiers.

Amidst the frantic pace of the Painting Indiana project, the Indiana Plein Air

Painters Association began to take shape. Word spread of our new organization, now familiar enough to be known as IPAPA. Its commitment to Hoosier artists was clear, and membership grew. Our first paint-out in Madison, with its Ohio River views, Clifty Falls State Park, and old river town architecture, was a fulfilling day for all who shared the vision of IPAPA. Board members from the area—Bill Borden and Chuck Stookey—arranged the event and half of our members joined us for a wonderful day of painting. Membership has steadily increased, with more and more artists coming into the fold. Our paint-out schedule for 1999 expanded to areas throughout the state—New Harmony, Lafayette, Rome City, Brookville—increasing our connection with artists across Indiana and our ability to share the diversity of Indiana's landscapes with its painters. The association, once the vessel that carried the Painting Indiana project, was reaping benefits from the project's wealth of information and connections to new places. The possibilities for both endeavors began to emerge. The IPAPA and its jewel of a project would celebrate the landscape of Indiana and present it for public view to encourage its protection. It would also support the Hoosier artists who have the ability, desire, and drive to go outside, see, feel the essence of a place, and paint.

Keeping up with the progress of the Painting Indiana project was something like hanging on to the back of a freight train. The artists sent documentation of their paintings—where, when, and why they selected a site—and the information was logged regularly. The county on an Indiana road map on the office wall was highlighted in yellow when we established a county contact person and received its information. Board secretary Pat Templin took on the added responsibility of consultant, penning grants and making connections with the people whose services and support we desperately needed. LouRae Downs spent hours making phone calls to locate additional information, and Dora Bryan typed, sorted, stuffed envelopes, and kept the coffee fresh. Board member Tom Farris provided advertising expertise to develop strategies for fundraising and marketing. Sandy Clamme from Marsh Supermarkets' corporate advertising offered sound advice on photography and presentation. Artists and friends across the state joined in to help locate the funding we needed to meet our goals. These special people volunteered their time, wisdom, and enthusiasm in abundance. We all knew we were working to create an artistic milestone for Indiana, the likes of which had never before been attempted.

Efforts to make the project fly began to reap rewards. We dreamed of bringing the Painting Indiana artworks to the public in a prestigious and well-known venue like the Indiana State Museum. We presented our project to Jim May, art curator for the museum, and his response led to an invitation to present the works at the museum. The thought of entering this beautiful building, climbing the stairway where artworks of our Hoosier heroes reside, and finding a room filled with the ninety-two Indiana portraits our artists had created had once seemed an impossibility. The merit of our project was thus confirmed, and we were thrilled to know that Painting Indiana would be presented in style beyond our wildest imaginings.

Even more incredible news came from John Gallman, director of Indiana University Press. He liked the concept for the book and invited us to Bloomington. We met with Mr. Gallman, explained our plans and progress, showed him some of the finished paintings, and came away with a commitment from Indiana University Press to publish the book. Again, to our amazement, a wild idea had become reality.

The magnificent colors of autumn in Indiana wove themselves into the paintings as the project pushed on. The change of season was captured as the five

adventurers moved across the state. The feeling of summer fog burning away in mid-morning, warm light draping a rail fence, cool shadows on a quiet small town square, orange and gold reflections dancing across the still waters of a creek—the sensations and emotions of Indiana's land—were being recorded on canvas. Winter came, offering scenes draped with quiet blankets of snow, conveying the crispness of the air and quality of its light. The air itself from where the artists painted incorporated itself into the canvas.

Plein air painting involves all of an artist's senses. It is a unique experience to stand before a canvas and interpret a landscape scene you are part of, influenced by warm sun or cool shade, gentle breezes, sounds of chirping birds, rustling leaves, and the occasional squirrel or woolly worm. Urban scenes offer different stimuli—children's laughter, cars rumbling by, chimes of church bells at noon, the feel of heat radiating from pavement, the smell of flowers and bakeries—all these elements come together in an artist and flow out of the brush. It is a spiritual experience for an artist. It is more than painting. It is learning to see.

By February 1999, many of the paintings were complete. Subject choice had been left to the artists, allowing them to freely respond to their scenes. The time arrived to view all the work together to check the variety and quality. The paintings were fantastic. The review helped identify the familiar elements of Indiana that had not yet been represented. Some paintings were pulled and replaced with scenes from different seasons or of more metropolitan views. Spring scenes replaced some summer images since the early part of 1998 had been difficult to work in. Counties were revisited to check again on a historical site or city that would achieve a more complete sampling of Indiana's past and present. Without hesitation, some counties were painted and repainted, as many as six times. The artists had grown with the project, responding to the evolution of ideas and intentions, and understanding the importance of their own contribution to the project as a whole. We could not have anticipated a better or deeper commitment from the five artists; their insight and response as a team, working toward a common goal, proved them all to be consummate professionals.

Whether the paintings could be worked on in the studio after they had been started on location was a question we had to address. The question had been considered early in the project. Many plein air artists believe that paintings must be created completely outdoors, while others have no qualms about finishing the work in the studio. Through our studies of great artists like Monet and T. C. Steele, we knew that many would continue their refinements when they returned to their studios, or even use their on-site work as a color sketch for a larger painting. From experience, we know painting en plein air creates an ability in the artist to bring the essence of the painting experience home, allowing continued work that is still true to the scene. Because of the validity of both viewpoints, each artist decided for himself if he would continue work on his paintings after returning from a county. The very personal and carefully considered decisions resulted in works that the artists knew were the best they could produce, whether finished in the field or studio, all true representations of the environment they sought to capture.

The spring of 1999 was brilliant with light and color, easily making up for the year before. The weather fully cooperated with our project and allowed plenty of time for outdoor painting. With their contributions to Painting Indiana well in hand, the artists enjoyed a collective sigh of relief when all the pieces were finished.

The month of May 1999 was a flurry of paper flying by mail, fax, and courier as the essays were assembled, checked for accuracy with county contacts, and edited. The names of contributors and the artists' biographies were given one last

read. McGuire Photography finished shooting the flawless transparencies of the paintings and Richard Fields, from the Department of Natural Resources, sent us excellent photos he had taken of each artist at work. Our work was nearly done.

In writing the story of the Painting Indiana project, we were finally able to evaluate what we had accomplished and what we had gained. We had traveled the state like never before—collectively, more than 100,000 miles—visiting places we may never have passed through otherwise. We found treasures on every trip—many were easy to find, laid out before us like a grassy green welcome mat; some required closer study and a good road map; a rare few required real work to turn up the gem that we eventually found.

We gained an understanding of what we saw in Indiana's landscapes, getting a statewide view of how the land undulates in hills and flatlands from edge to edge. We saw how the many rivers and highways divide and unite places along their way. The impact of 100 years of progress has changed the look of Indiana. Cities have emerged and grown where cows once grazed, while some areas of forest and wetland have been bypassed completely, leaving them as they always have been. Everywhere in Indiana—in small towns like Williamsport and Metamora, with their distinctive flavor, in farm counties like Tipton and Wells, with their seemingly endless acres of lush crops emerging from rich black soil, and in cities brimming with history such as Vincennes and Corydon—there is a wealth of inspired scenes for Hoosier artists. All one needs to do is look.

We rediscovered that the gift of Indiana's richness is a precious thing, and it is woven into the paintings that the artists have produced. Throughout the project our concern for these wonderful places has grown. The changes of the last 100 years have not all been positive—the price of progress can be too high if scenic and unspoiled areas are adversely and irreversibly affected. Much of Indiana's land has changed since the turn of the last century, and the pristine view that was painted by Indiana artists of the past has become more difficult to find. But somewhere in every area we passed through, there are wetlands, wildlife refuges, state parks, and preserves. These places, left to themselves to grow unencumbered, offer homes to countless varieties of native wildlife and vegetation. The importance of preserving them became abundantly clear to us as we experienced the undisturbed Indiana lands. Will they be there for artists in another hundred years? Only with careful planning, protection, and involvement of all of us who understand the gifts that they provide and will continue to provide for our descendants can we be sure of their longevity.

Indiana's unique and exciting history came to life through Painting Indiana. Historic places—the Tippecanoe and Mississinewa battlefields; the homes of James Whitcomb Riley, T. C. Steele, and Gene Stratton-Porter; cabins and homes that played a part in the important work of the Underground Railroad—are maintained by State Historic Sites through the Indiana State Museum. Places of national importance—the Indiana Dunes, Lincoln's boyhood home, and Vincennes's George Rogers Clark memorial—are cared for by the National Park Service. Local history is preserved by county and community groups that are dedicated to saving the stories and artifacts of Indiana's past. The benefits of having these sites available were abundantly clear as we looked, for the first time, at our state as a whole.

Above all, we have confirmed that Indiana is fertile ground for artists. The five participants have visibly grown from their experience of Painting Indiana. Each has reached a new excellence in his creative pursuit. Despite the constraints of time

and subject choice that were so critical to the project, the artists have produced a view of Indiana that is unique, personal, and evocative.

For those who see the paintings or peruse this book, we offer this portrait of the Hoosier State to you; to see what we have seen and to appreciate more deeply, understand more fully, protect more carefully, and *enjoy* what God has given Indiana. As the new millennium begins, make the choice to enrich your life—visit a museum, put a paint brush in your child's hand, travel to a place in Indiana you've never been, and look around and *really* see what's around you . . . Indiana itself is a gift.

The Painting Indiana project has been a heart-and-soul operation from the very beginning, and it is only because of the quality and perseverance of the people involved that this endeavor was possible. It is with deep gratitude that I salute these contributors and acknowledge the special part they each have played.

For the artists—Bob Eberle, Lyle Denney, Ron Mack, Don Russell, and Dan Woodson—Painting Indiana has been the adventure of a lifetime; it has exceeded every expectation we had of what the project could be. The artists' contributions are immeasurable, and their future possibilities are endless. For their time, commitment, and friendship, I thank them. It has been an honor and privilege to witness their growth on their personal paths to excellence.

The support and enthusiasm of Carol Eberle and Dottie Mack were a constant from start to finish. IPAPA Board Members Bill Borden, Chuck Stookey, Tom Farris, and Ron Elkins provided sound guidance and good ideas all the way through, and Board Secretary Pat Templin's grant writing opened many doors to our success.

The ball started rolling with a contribution from Marsh Supermarkets, Inc., and Sandy Clamme from Marsh Advertising offered support and much needed guidance. Bob East, Gloria Wright, and Jan Vance helped with our computer dilemmas. John Gallman, director of Indiana University Press, made our dreams for a book a reality, and his wonderful staff helped us through the process. Earl Conn's county essays brought the text to life and Jim May's foreword added historic depth that makes us proud to be Hoosier artists.

Contacts in all ninety-two counties provided a wealth of information over a sixteen-month period, and we found many sources through suggestions from the Indiana Tourism Bureau. LouRae Downs, Dora Bryan, Allyson LoPilato, Chris Woods, Kate Carter, and Deirdre Carter proofread, filed, shuffled, and sorted more paper than they ever want to see again.

The completed paintings were beautifully photographed by McGuire Photography. Richard Fields from the Department of Natural Resources captured our artists in the wild with his camera. The contribution of brochures from RPS Printing and an anonymous paper donor helped us visually communicate the quality of our project. Fundraising proved to be our greatest obstacle and we deeply appreciate the hard work, good strategies, and tenacity of Pat Templin, Tom Farris, Chuck Stookey, LouRae Downs, and Woodburn, Kyle & Company. The financial support of the artist sponsors, community foundations, businesses, and individuals all over the state helped us fund this formidable task. Special thanks to the warm and wonderful Hoosiers we have met throughout our travels: your enthusiasm, interest—and directions—have made Painting Indiana an absolute joy. And Dan Woodson—thanks for dreaming.

ANNE BRYAN CARTER
President, Indiana Plein Air Painters Association, Inc.
June 15, 1999

Sponsors

The success of this project is greatly due to the support of many individuals and organizations. Each of the county artist sponsors contributed $100, and these funds were the lifeblood of the project in the early stages. Marsh Supermarkets provided our initial momentum, and the Indiana State Museum offered to exhibit the ninety-two paintings, the perfect venue to bring this historic collection to public attention. While financial assistance came from many sources, great and small, our ultimate success—including the affordable price of this lavish book—is attributable to a major grant from the Lilly Endowment. To each of our donors of money, time, and assistance, the Indiana Plein Air Painters Association extends our most sincere gratitude.

Financial Sponsors

Lilly Endowment, Inc.

Marsh Supermarkets, Inc.

Ball Brothers Foundation

Indiana Arts Commission

Central Indiana Community Foundation

Indiana Farm Bureau and Farm Bureau Insurance

Indiana Humanities Council, Indianapolis

Noble County Community Foundation, Albion

Community Foundation of Bloomington and Monroe County, Bloomington

Whitley County Community Foundation, Inc., Columbia City

Grand Victoria Casino & Resort, Rising Sun

Kevan and Jennifer Fight, Brecksville, Ohio

Charles and Alice Stookey, Madison

Leigh and Marcia Morris, LaPorte

Thomas M. Lee, M.D. and Susie Nottingham, F.N.P.

Dr. Jack B. Nicholson of Madison County Historical Society

Anderson Fine Arts Center, Anderson

Citizens Exchange Bank, Fairmount

Family and Friendship memorial for John R. Light, Indiana Farmer

In-Kind Donors

Indiana State Museum

Indiana University Press, Bloomington

RPS Printing, Indianapolis

Richard Fields, photographer for Indiana Department of Natural Resources

McGuire Photography, Indianapolis

Sigman's Gallery, Broad Ripple

Jackson & Wickliff Auctioneers, Carmel

Honeysuckle Gallery, Nashville

Carriage House Bed & Breakfast, Madison

Woodburn, Kyle & Company, Madison

The Hermitage, Brookville

Robert East, Indianapolis

County Artist Sponsors

ADAMS	Bob, Karen, Johnny, Robby, and Rachel East of Indianapolis
BARTHOLOMEW	In memory of Jane Allison of Bartholomew County
BLACKFORD	Perry and Sandy Clamme of Lick Creek Valley Farms, Hartford City
BOONE	IPAPA in memory of Mark A. Russell of Zionsville
BROWN	John and Gaye Rardon of Indianapolis
CLARK	William Grote III of Madison
CRAWFORD	Mr. and Mrs. Stanley Pinnick of Fishers
DELAWARE	Michael Thielen of Pendleton
FLOYD	Tom Woodson and Allyson LoPilato of Muncie
FRANKLIN	Kate and Deirdre Carter of Muncie
GRANT	Margie Prim of Muncie

HENDRICKS	Matt Buis of RPS Printing Services, Indianapolis
HENRY	Bill and Brenda Buck of Knightstown
HUNTINGTON	Rose Meldrum of Huntington County Convention and Visitors Bureau
JACKSON	Dr. Allen Dale Olson of Southern Indiana Center for the Arts, Seymour
JEFFERSON	Charles and Alice Stookey of Madison
KOSCIUSKO	Lila O'Connell of Lakeland Art Association, Inc., Warsaw; Douglas Mayer of Kosciusko County Historical Society, Book Fund
LAKE	Bruce L. Woods of Lake County Historical Society, Crown Point
LAPORTE	Leigh and Marcia Morris for LaPorte Regional Health Systems, Inc.
LAWRENCE	Brian and Julie Waldo of Honeysuckle Gallery in Nashville, Bedford
MADISON	James J. and Connie Biddle of Markleville
MARION	Anthony, Danielle, and Kara Longoria of Indianapolis
MARTIN	Judy Woodson of Muncie
MIAMI	Catherine Powell of Miami County Historical Society, Inc., Peru
MONROE	In memory of Dorothy Allison East
MONTGOMERY	Sharon Kenny of Montgomery County Visitors and Convention Bureau, Crawfordsville
NOBLE	Barb Mulholland of Kendallville Area Chamber of Commerce
OHIO	Mayor Mark Guard and the City of Rising Sun
PERRY	Perry County Convention and Visitors Bureau of Tell City
PORTER	Kathleen Talenco of Porter County Convention, Recreation and Visitor Commission, Chesterton

POSEY	Nancy L. Burns of Mt. Vernon Chamber of Commerce, Inc.
PULASKI	Charlene Kruzick of Pulaski County Chamber of Commerce, Winamac
RIPLEY	Melinda Thompson of Ripley County Chamber of Commerce, Versailles
ST. JOSEPH	Tom and Linda Farris of Muncie
SCOTT	Kevin and Laura Bridgewater of Indianapolis
STARKE	Zeta Eta Chapter (Knox) Tri Kappa; James and Melba Shilling of Knox, Book Fund
SWITZERLAND	Ann Mulligan of Switzerland County Welcome Center, Vevay
TIPPECANOE	Chris Jones of Tire Barn Warehouse, Anderson
VANDERBURGH	Carol Carithers of Pigeon Creek Greenway Passage, Evansville
VERMILLION	Diann McIntosh of Vermillion County Indiana Historical Society, Inc., Newport
WABASH	Wabash County Arts Council, Inc., Wabash Art Guild, and Ron Woodward of Wabash County Historical Society
WASHINGTON	Washington County Historical Society, Inc., Washington County Art Guild, and Steve and Lucille Hand of Salem
WAYNE	Hattie Stanton of Muncie
WELLS	Rodney and Brenda Clamme of Bluffton
WHITE	In memory of Florence Gwaltney of Gaston
WHITLEY	September McConnell of Whitley County Community Foundation, Columbia City

BALL BROTHERS FOUNDATION

The County Essays: An Introduction

These county essays have been written with three specific goals in mind.

First, each was to be about the same length, around 600 words. This was to provide an evenness of content for the design of the book. Also, the essays are to accompany the paintings, not the other way around. The paintings come first and, appropriately, are the special feature of the book. That meant, with some counties, much had to be left out. Marion County, with Indianapolis as the county seat and state capital, is one example.

Second, the intent was to make the essays an interesting read, not merely a recitation of information. County histories already exist and many publications highlight community strengths. My purpose was to find something special about each county that, hopefully, will gain the casual reader's attention and lead into an overview of the county.

Third, every effort was made to make the essays accurate. Given the hundreds of sources used and, because there's never enough research or writing time, this goal was daunting. For instance, I found three different lengths for the railroad bridge in Greene County, built during 1905–1906 and believed to be the third longest in the world. (Unable to resolve its measurement, I used no figure.) Also, things change and a statement factually accurate yesterday may not be today—a museum closes, a county seat is changed (even as recently as the 1990s—Tell City for Cannelton in Perry County). Ultimately, in making editing decisions, I used the most authoritative information available. In most cases, this verification came from the persons in the counties. I cannot express enough appreciation for all the helpful people in Indiana's ninety-two counties who provided information and who carefully and critically evaluated the county essay drafts for accuracy. Still, errors may remain and I must accept the responsibility for them.

Not everyone will agree, of course, with the topic used to introduce each county. "Balance" could be another criticism. Community pride could be offended. A sentence describing a place or event could, somehow, be interpreted differently by different readers.

Nevertheless, given what the writing tried to accomplish—consistency, an interesting read, and accuracy—I hope to have at least come close.

Earl L. Conn
June 10, 1999
Muncie, Indiana

Painting Indiana

ADAMS COUNTY

In Hoosier pioneer days, a road and water made all the difference. Fortunately for what was to become Adams County, it had both.

The so-called Wayne Trace—built by General Anthony Wayne to move his army in 1794 during the frontier Indian wars—stretched from present-day Fort Wayne to Greenville, Ohio, passing through Adams County. It again served a military purpose when General William Henry Harrison used it in the War of 1812. A second north–south road, the Fort Wayne to Winchester road, also went through the county. (Remember, these "roads" were really little more than clearings in those days.) In 1853, a plank road built from Willshire, Ohio, to Fort Wayne passed through the county at Decatur.

Waterways were important for development, too. Adams County lies in the watershed between the Mississippi River and St. Lawrence River basins. The St. Mary's River, flowing to the north, was used to deliver necessary food staples from Fort Wayne on a weekly rowboat. The Wabash River, in the southern part of the county, flows west and ultimately south into the Mississippi. These rivers and others were the major transportation system in this part of the Old Northwest Territory well into the 1800s.

Before the pioneers, Indians inhabited present-day Adams County. The Mound Builders of the Hopewell Culture were here around 1000 A.D. but the best known were the Miami. Their headquarters were at Kekionga (Fort Wayne).

Adams County in the early 1800s was part of one huge county, Randolph, which occupied all the land from Winchester, today's Randolph County seat, north to the Michigan border. Allen County, which once included today's nine northeastern Indiana counties, was split off from Randolph in 1823 and, finally, the southernmost part was organized as Adams County through an act of the Indiana General Assembly on January 23, 1836.

The county is relatively flat with some gently rolling hills and is mostly known for its farming. Many visitors come to see the extensive Amish settlements around Berne. More than 3,600 Amish farm in the area and their horses and buggies are regularly seen on roads and at hitching posts. Swiss Mennonites settled in the region in the mid-1800s and their heritage is celebrated annually with the Swiss Days Festival the last weekend of July. The twenty-two acre, thirteen-building Swiss Heritage Village on the north edge of Berne depicts the lives of these early settlers. Berne also has the largest and oldest Mennonite church in Indiana.

Another frequented site is the Limberlost home of author Gene Stratton-Porter, just south of downtown Geneva. The author's books include *Girl of the Limberlost* and *Freckles*. Her home, where she lived for eighteen years while exploring and photographing the Limberlost swamp environment, is now a state historical site. The two-story log house contains some of her furnishings, personal belongings, and photographic works. Little evidence of the Limberlost swamp remains today as it was drained in 1913.

A search for a county seat settled on present-day Decatur, named after Stephen Decatur, a naval hero of the War of 1812 who also battled with the Mediterranean corsairs (pirates). His toast became famous: "Our country! In her intercourse with foreign nations may she always be right; but our country, right or wrong."

The county is named for John Quincy Adams, sixth president of the United States.

"I've been drawn to the area near Geneva for many years since reading several books by Indiana author Gene Stratton-Porter. On July 4, 1998, [on] one of three trips to this spot, the sun backlit the scene after a rain. The puddles and swamp gave up a mist that softened the freshness of the light. I remembered the descriptions Stratton-Porter gave of the swamp in her novel **Freckles** *as the waist-high grass in the distance began to sway with the breeze —for a while I was in another world."*

LYLE DENNEY
"Remnants of the Limberlost"
Oil on canvas 24 x 36 inches

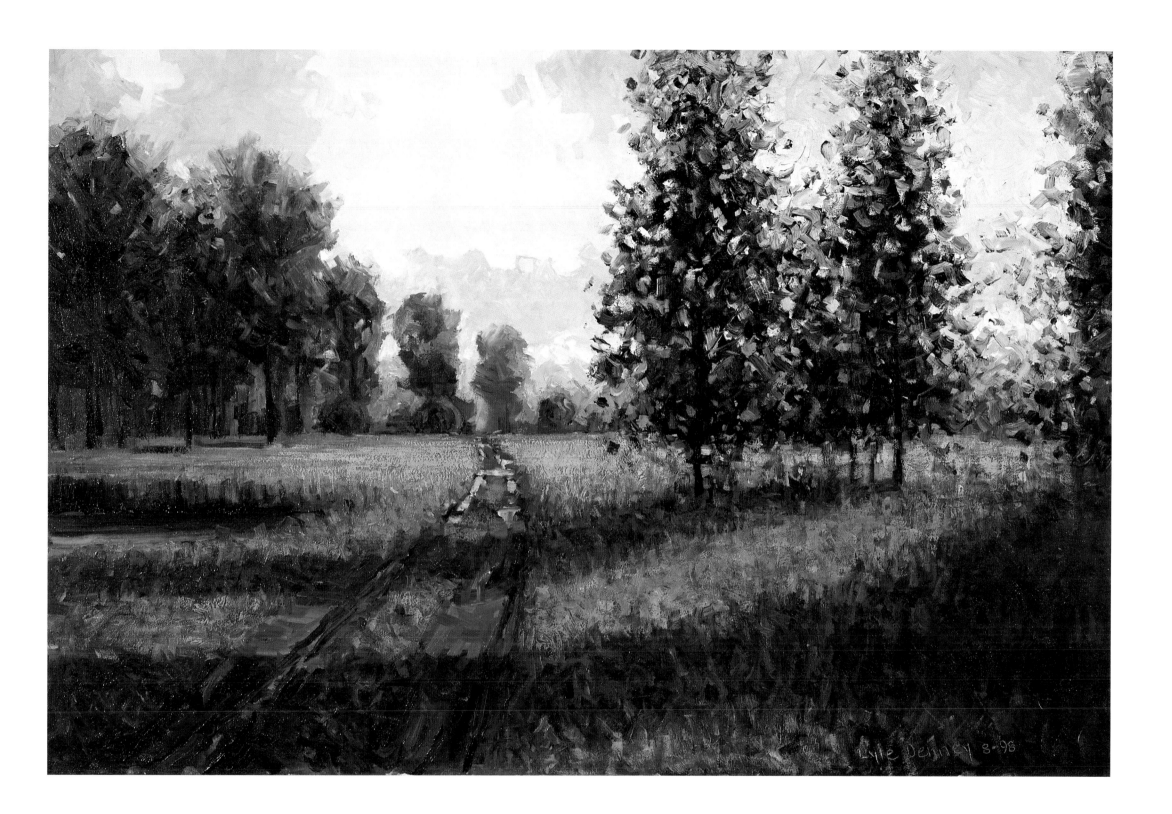

Lyle Denney 8-98

ALLEN COUNTY

Fort Wayne either gets all the credit or all the blame! It depends on what you think of television: either it is the greatest communications device in history or it is the tool that will ultimately lead to mass illiteracy and the downfall of civilization. What does Fort Wayne have to do with this debate? Television production started here. Philo Farnsworth, who had successfully demonstrated television in San Francisco in 1927, moved his company to Fort Wayne in 1938 and began the first mass production of TV sets.

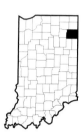 Television is not the only Allen County first nor its only claim to fame. John Chapman, known as Johnny Appleseed, walked these county roads and is buried at Johnny Appleseed Park in Fort Wayne. It's here that three rivers converge—the St. Joseph's, St. Mary's, and Maumee—celebrated by the Three Rivers Festival, the most well-attended event in Indiana other than the Indianapolis 500 race. The longest canal in America, the Wabash and Erie, went through Fort Wayne, making the city an important trade center. The world's first self-measuring pump—later becoming today's gas pump—was developed here. The Fort Wayne Kekiongas played what is believed to be the first professional baseball game in 1871. In professional basketball, the team that is now the Detroit Pistons was once known as the Fort Wayne Zollner Pistons. *A League of Their Own,* the TV documentary, was co-written by Kelly Candaele, whose mother, Helen, played for the Fort Wayne Daisies in the mid-1940s. While Wabash, Indiana (of Wabash County) was the first electrically lighted city in the world, lights were manufactured in Fort Wayne by the Jenney Electric Light Company. Jenney also lighted the New Orleans World's Fair in 1884–85.

The list goes on. One of the first pilots to shoot down a German plane in aerial combat in World War I was Paul Baer, a native son. Baer Field, named for him, is today's Fort Wayne International Airport and is a major airfield for northeastern Indiana. Top fashion designer Bill Blass was born here. Hollywood actresses Carole Lombard and Marilyn Maxwell both got their start in Fort Wayne. Resident Joseph Muhler, in 1950, discovered the usefulness of fluoride and developed Crest toothpaste. Fluoride is now used in many of the world's water systems.

What the county may be as well known for as anything else is two devastating floods, one in 1913 and the second in 1982. Both floods forced residents to regroup and rebuild a badly battered Fort Wayne. Coverage of the 1982 flood brought the staff of the Fort Wayne *News-Sentinel* the Pulitzer Prize for local reporting.

It hasn't all been awards and accolades, however. Allen County has had a large German population since the 1880s when advertisements for skilled laborers in Germany brought thousands of workers to Fort Wayne. They were severely tested in the days before World War I when the anti-German sentiment in the country became more pronounced. When the United States entered the war, the teaching of the German language was restricted and the German American Bank displayed its patriotism by changing its name to the Lincoln National Bank.

Today, Fort Wayne is the second largest city in Indiana with 202,904 (based on population estimates in the late 1990s) while the total for Allen County is 300,000. The county is home to eight colleges and universities and is the manufacturing center of northeast Indiana.

Fort Wayne is named for General "Mad Anthony" Wayne, who established the fort in 1794 along the Maumee in the American effort to wrest control of the lower Great Lakes territory from the British and the Indians. The county is named for Colonel John Allen, a Kentucky frontiersman who helped lift Tecumseh's siege of Fort Wayne in 1812.

"It was mid-morning on one of many trips through the county. The broken fence on Carroll Road first caught my eye—the dark, backlit, evergreen tree coupled with the bush and barn in the foreground just seemed to work. The city of Fort Wayne, with its history and its metropolitan feel, is dominant in Allen County, but to me this rural setting on the outskirts of the city was very interesting. The barn is over 200 years old but there was a beautiful surprise—the wood inside the barn still looked brand new."

RONALD MACK
"Mending Required"
Oil on linen 16 x 20 inches

BARTHOLOMEW COUNTY

Although it was founded in 1821, the modern history of the county and especially of its county seat, Columbus, could be said to have started in 1942. That's when the First Christian Church, originally the Tabernacle Church of Christ, designed by world-famous architect Eliel Saarinen, was dedicated. Or perhaps it started in 1957 when the Cummins Engine Foundation offered to pay the architectural fees for the design of new school buildings in the city so long as the architect was chosen from an approved list of international experts. Or perhaps it began a few years later when the foundation expanded its offer to include all public buildings.

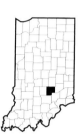

Whichever date is selected, Columbus today stands first among all cities in Indiana—actually, it's ranked sixth in the nation—in architectural quality, innovation, and design. Only the mega-cities of New York, Chicago, Boston, Washington, D.C., and San Francisco are above it.

It's no surprise, then, that Columbus has attracted visitors from literally all over the world to marvel at the city's buildings, designed by the leading architects of the day, including the city hall, county jail, post office, mall, bank, fire stations, and schools. In 1994, these architects gathered in the city for the Pritzker Architecture Prize award ceremony—architecture's equivalent of the Nobel Prize—and to see the latest project, a 5,400-square-foot addition to the visitors center in downtown Columbus. Designed by 1982 Pritzker winner Kevin Roche, this addition doubled the visitors center, a Victorian home known as Storey House.

The work of internationally renowned architects extends into the county. Only recently, in the small Moravian town of Hope, a branch library designed by Deborah Berke—who has designed homes and buildings in Seaside, Florida—joined the Irwin Union Bank and Trust office designed back in the 1950s by Harry Weese.

If architecture alone epitomized Columbus, it would be enough to mark the city as being in a class by itself. However, one observer of the American scene has named Columbus one of the 100 best small arts towns in the country, and no wonder. It has the only satellite gallery of the Indianapolis Museum of Art, called the Columbus Gallery. Located on the mezzanine level of The Commons, it is a 4,600-square-foot art exhibition center. Students take part in the Art Smart program, sponsored by the Columbus Gallery, and receive hands-on experience at Kidscommons, a museum for children within The Commons. Dance Workshop sponsors cultural activities and the city has its own dance troupe, Dancers, Inc. There's also the Columbus Symphony Orchestra, the Columbus Philharmonic, and theatrical productions. All in a city of 35,000.

Bartholomew County's historical museum is housed in a partially restored Victorian home in Columbus. The Irwin Gardens are part of a private residence but are open to the public during summer weekends. The Henry Breeding Farm off U.S. 31 North informs visitors about farming in the past. The Atterbury-Bakalar Aviation Museum is dedicated to aviation between 1942 and 1970. The Yellow Trail Museum in Hope recounts the history of the Moravian community founded in 1830. The Wheatfields Natural Arts Learning Center demonstrates the creative and spiritual relationships between human-kind and nature.

The county's economic base is anchored in Cummins Engine Company, a Fortune 500 company and manufacturer of heavy-duty diesel highway engines, and Arvin Industries, Inc., builders of exhaust systems and ride control products for automobiles. Between these two firms, 8,000 are employed locally and 40,600 worldwide.

The county is named for General Joseph Bartholomew, who fought in the Battle of Tippecanoe.

"After driving through a dark woods, I emerged to see the old farm near Sand Creek in Azalia. I loved the sight—it seemed the typical Indiana farm. I was captivated by the huge vine-covered walnut tree in the yard in front of the house. In the background, the south sun struck the giant red barn, the bent trees, and the winding driveway leading up the hill to the farmhouse. I had to paint it. I returned early the next day to catch the morning light."

ROBERT EBERLE
"Summer Memories"
Oil on canvas 16 x 20 inches

BENTON COUNTY

Like other states in America's Heartland, Indiana is a changing mixture of growing cities and small, frequently declining, farming communities. While the state increasingly becomes known for its major metropolitan areas and their media-savvy activities—Indianapolis, Evansville, Fort Wayne, and South Bend, for example—the older stereotype of flat countryside, barns and fences, sparsely settled small towns, and a more slowly paced life still remains a basic pattern of the Hoosier landscape.

For now, at least, counties such as Benton are an integral part of the Indiana fabric. Yes, Benton County has lost population—from 13,000 in 1900 to 9,400 in 1990. Yes, its farms have dwindled from 1,400 to 600. And, yes, horses, which once numbered more than 10,000, aren't even counted today.

What remains? For starters, there are miles and miles of farmland where corn and soybeans are planted, grown, and harvested season after season, decade after decade. Benton County resident Thelma Glaspie describes it thus: "In the summer, the county is carpeted with long green rows of corn and soybeans . . . it appears that county roads are lined with green 'fences' and you can't see the neighboring farmhouses until fall. Then the fields turn gold and tan until the combines start rolling to harvest the crop. The winter landscape is white, dotted with homes, barns, and silos. Spring brings out the tractors with tillage equipment and the earth looks black and brown until the corn and soybean seeds come to life with little green shoots reaching up for the sun."

There's also the Otterbein Street Festival, the Fowler Fourth of July Festival, the Boswell Street Fair, the Benton County 4-H Fair, the Earl Park Fall Festival, Dan Patch Days at Oxford, the Oak Grove Heritage House community center, the historic town square in Oxford with many of its original brick buildings, the St. Patrick Catholic Church in use for more than 130 years—in other words, small town America, romanticized as if it has disappeared but actually very much alive here.

Residents of Benton County take pride in their historic record: This is the county where a small barn on the edge of Oxford was the home of the most famous pacer in history, Dan Patch. His first race was in Boswell in 1900 and by 1904 he had lowered the record for a mile to 1:56 in a race in Memphis, Tennessee. In 1906 at the Minnesota State Fair, he set a record of 1:55 that stood for 32 years until it was tied in 1938. The record was lowered to 1:47.3 in 1996. A historical marker was dedicated at century's end at the Oxford barn site.

Although Indiana became a state in 1816, most of the state's present ninety-two counties did not yet exist. Benton, created in 1840, was one of the last. In its earliest days, it was considered fit only for livestock. Settlers later found the rich soil beneath the tall prairie grass and today, it is considered prime agricultural property.

Fowler, the county seat, is named after Moses Fowler, who owned immense acreage in the 1800s. Fowler is said to have owned 20,000 acres in what is now Benton County plus another 35,000 acres in White and Warren counties. He probably owned the largest private farm ever operated in Indiana. He wanted the county seat near the center of the county in order to more easily get his crops to market and thus donated land for it.

The county is named for Senator Thomas Benton of North Carolina, a champion of Western expansion.

"Because of its old country charm, its red brick street, and interesting architecture, I chose this small town scene of Oxford's town square. While painting this scene, a group of young people gathered in the gazebo to watch and listen to the Beethoven music I was playing. We spent time sharing [stories] about Dan Patch, the famous trotter from this area. I learned that three of the kids watching me paint were related to me through our families in Kentucky. Some even had the last name Denney—what a small world it really is!"

LYLE DENNEY
"View from Oxford's Town Square"
Oil on canvas 20 x 30 inches

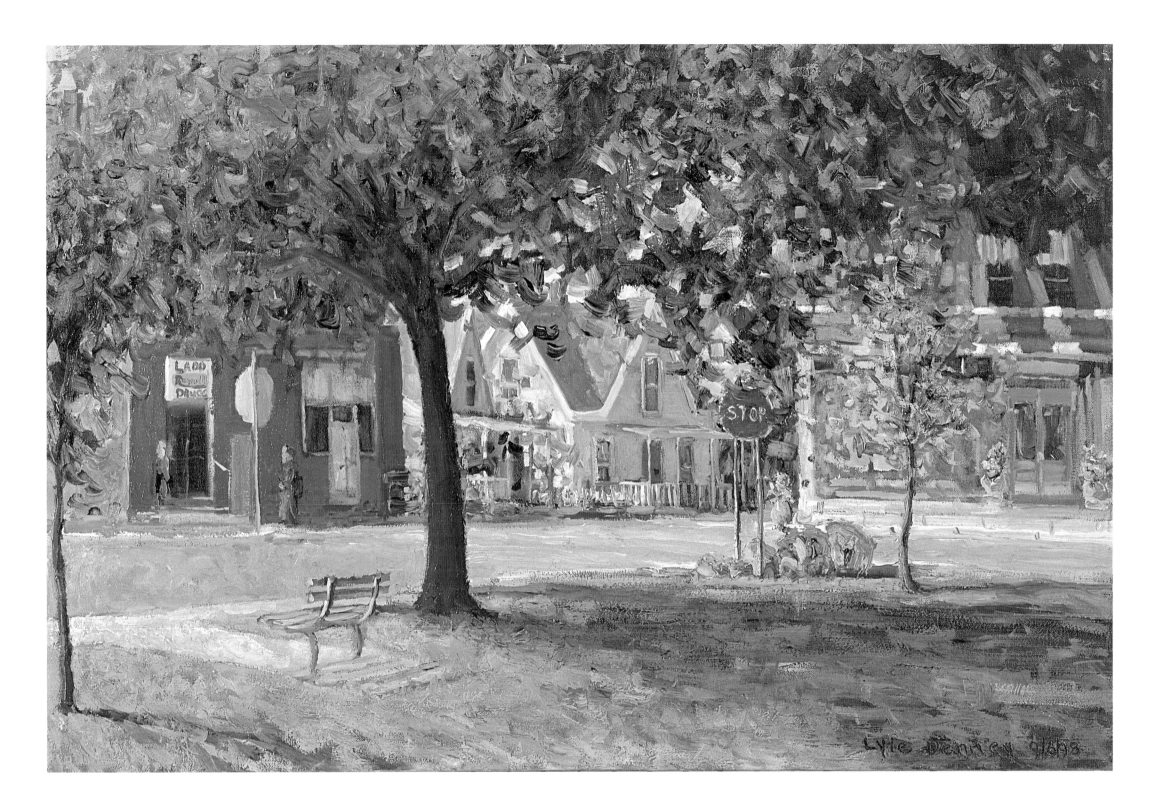

BLACKFORD COUNTY

They thought the gas would last forever. When Indiana gas well No. 1 was sunk in Blackford County in 1887 and sent up a sheet of flame that was visible for miles, it was the beginning of the gas boom in east-central Indiana. Over the years, thousands of wells were drilled here and in neighboring counties. Usually, no attempt was made to stop the natural gas from burning day and night—the supply was considered limitless. Now we know there was indeed a limit as, over time, the wells began to play out. By the early years of the twentieth century, the boom was over.

But the legacy of the gas boom in Blackford County and elsewhere lasted much longer—for well over a century. The industrial base, founded in the late 1800s, while lessening decade after decade, still remains the core for Hartford City and other neighboring gas boom towns.

The towns of Blackford County were transformed during the boom. New commercial and public buildings replaced older structures around the downtown areas and began to spread into adjacent streets. The Blackford County Courthouse was built 1893–95 in Hartford City and is one of the state's finest examples of Richardsonian Romanesque architecture. Directly north of the town square is the Presbyterian Church, built in 1892, and both it and the courthouse are now on the National Register of Historic Places.

Transportation inevitably increased. Interurban lines, all long since gone, were electrically propelled motor cars which ran on tracks that crisscrossed the state. One line ran through Hartford City, connecting it with Fort Wayne to the north and Muncie, New Castle, and Indianapolis to the south. Just as the gas began to fail early in the twentieth century, so did the interurban lines, which were increasingly replaced by the automobile. At the time of the gas boom, in the early 1880s, Hartford City also had another important transportation link—the railroad, with the Union and Logansport line in 1867 its first rail connection.

Glass factories in the area drew a sizable group of skilled craftsmen from Belgium. They and others are perhaps the boom's greatest legacy to the county. Hartford City's population went from about 1,000 to more than 6,000 shortly after the discovery of gas. (It's 7,500 about 100 years later with 14,067 in the entire county.) Hurrying to such Blackford County towns as Hartford City, Montpelier, and Roll were businessmen, parsons, school teachers, merchants, and hotel and bar proprietors—in short, the people who serve a growing community.

Political life has also been important to the county. Indiana's governor from 1936 to 1940 was M. Clifford Townsend from Blackford County, a former county school superintendent. He later went on to serve in the federal administration of President Franklin D. Roosevelt.

Today, Blackford County residents—like citizens everywhere—put less emphasis on county lines and have a broader geographic perspective. Maybe this tendency is even more pronounced here since the county is a small one, one of the smallest in the state. While the residents take justifiable pride in their schools, parks, new homes, and growing business community on the north side of Hartford City, they call attention equally to nearby reservoirs and state recreational areas to the north, universities to the west and south, and urban opportunities to the north and south.

Blackford County is named for Isaac Blackford, who was speaker of the first Indiana General Assembly and a justice of the State Supreme Court.

"As I drove through the county looking for a site to paint, I found Fireman's Park, north of Montpelier. I was drawn to this scene because of the heavy, twisting hickory limb that snaked across the river. I liked the visual interest created by the sun hitting the twisting limb against the serene water. I had to stop painting at one point and get into my van because the quarry down the road was preparing to blast. Later in the morning a squirrel scurried down the tree next to me to raise a ruckus in protest of my invasion of his territory. It was a great day."

ROBERT EBERLE
"Shadows on the Salamonie"

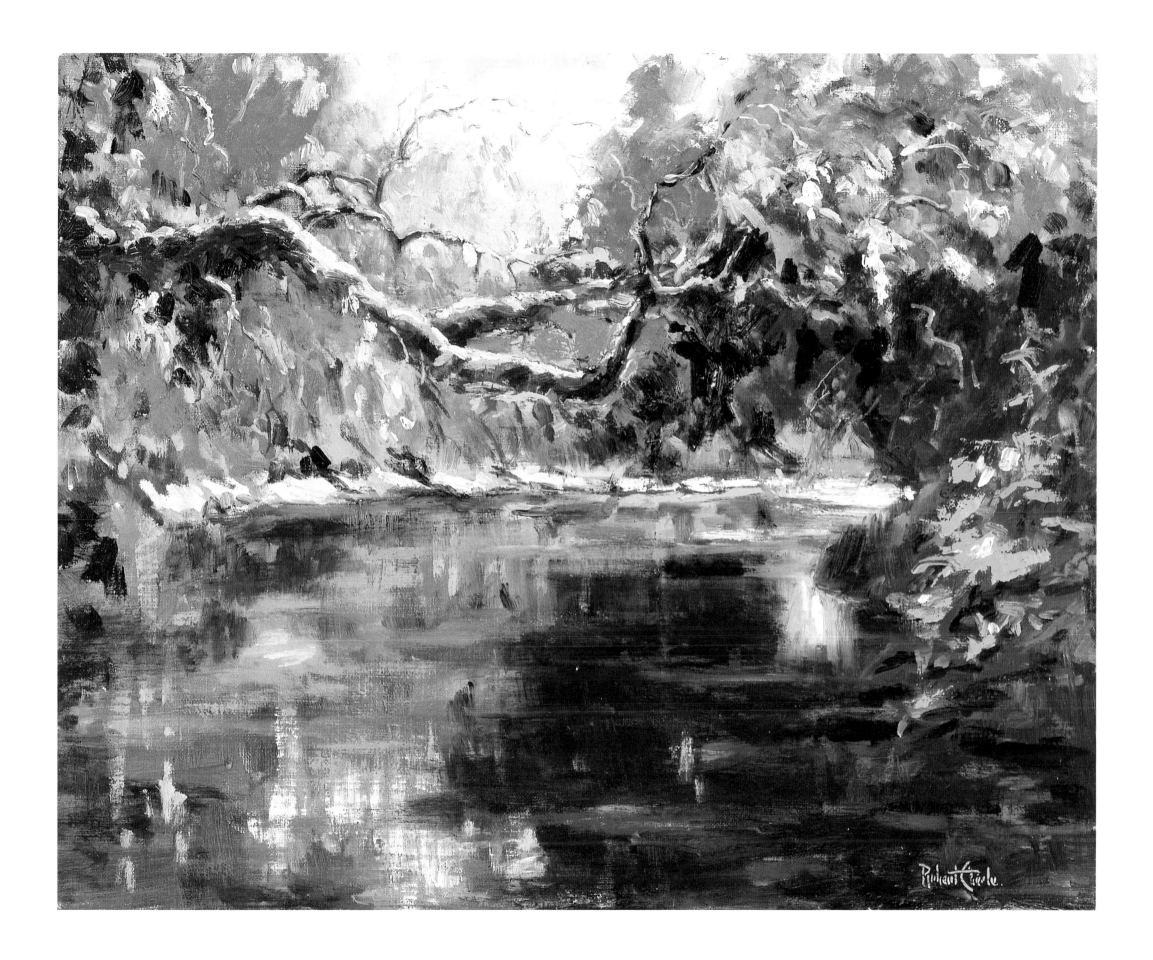

BOONE COUNTY

The western expansion of the United States is replete with the stories of men who were simultaneously community builders and land speculators, civic officials and wanderers. They would appear out of the wilderness, build cabins, start businesses, become government officials, and, before you knew it, pull up their stakes and move on. In the course of a lifetime, they would switch careers time and time again or just add another one—tradesman, builder, banker, entrepreneur, with maybe a little teaching and pastoring thrown in for good measure.

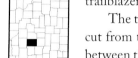

Perhaps here it had something to do with the county name. Boone County is named for famous frontiersman Daniel Boone, who in his lifetime was a teamster, hunter, trapper, trailblazer, militia officer, Indian fighter, land speculator, and surveyor.

The two acknowledged founders of Lebanon, county seat of Boone County, were cut from that mold. General James P. Drake and Colonel George L. Kinnard were, between the two of them, involved as lawyer, real estate speculator, in the state militia, as county clerk, recorder, county agent, postmaster, receiver of public monies, treasurer, representative in state government, assessor, teacher, editor, and U.S. representative—and Kinnard died at 33! Drake later left Indiana to live in Tennessee.

Their land speculation opportunity came when Boone County, lying northwest of the new state capital, was organized in 1831. With the question open as to where the county seat would be established, they bought land in present-day Lebanon, figuring the site would be near the new county's geographic center. Their plan had a setback when Jamestown in southwestern Boone County was selected. An uproar convinced the state legislature to make a change and what is now Lebanon eventually won out. That name, incidentally, is supposed to have been suggested by a state commissioner who helped select the site. As the story goes, he noted a cluster of trees nearby that reminded him of the biblical cedars of Lebanon, so "Lebanon" it was.

Lebanon is literally and figuratively at the center of the county. Its diversified industrial base includes agricultural products, machine tools, filtration equipment, business forms, medical technology, suspension systems, publishing, meat processing, and electronics.

Today Boone County seems to have the best of both the big city and the country. It is increasingly pulled into the Indianapolis/Marion County metropolitan area with the state capital's expansion into neighboring counties. It has the advantage of being only half an hour away from a major city. Boone County can look north up Interstate 65 to Tippecanoe County with Lafayette and Purdue University just thirty-five miles from Lebanon. At the same time, Boone County takes pride in being a modern pastoral community.

Zionsville, located in the southeastern corner of the county, has become a tourist destination for central Indiana. Its Main Street area of tree-lined brick streets is home to specialty and antique shops and restaurants, set in a village of Victorian-period architecture. This city also takes pride in having been one of the stops of the presidential train in 1861 when Abraham Lincoln left Illinois to assume the presidency. A stone monument in Lincoln Park marks where the Great Emancipator addressed citizens from the platform of his railroad car.

Another Washington D.C. connection was Lebanon attorney Samuel M. Ralston. He was Indiana's governor from 1909 to 1913 and died in the nation's capital in 1925 while serving in the U.S. Senate.

What would Drake and Kinnard think of Boone County today? They would probably be running some of its businesses and scheming how to take over Marion County.

"I have explored the entire county and many good sites were noted. As a resident of Boone County, I chose a subject about a mile from my home, near 131st Street. I pass this spot every day and I feel an emotional connection to it. I love to paint water because of the mood and variety of colors and reflections."

DON RUSSELL
"Eagle Creek"
Oil on linen 16 x 20 inches

BROWN COUNTY

Mention Brown County to a tourist and the first thought is of autumn foliage, when the colors are at their peak in the tens of thousands of trees found throughout the county. Traffic is at its peak, too, but that doesn't seem to stop anyone.

Mention Brown County to an art lover and you will hear about the Brown County Art Colony and the successors who have continued the tradition of those early artists. T. C. Steele was the first artist to move to the county in 1907, building his House of the Singing Winds near Nashville. As the years passed, the Impressionist landscape and portrait artist was followed by others, including Adolph Shulz;

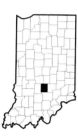 Marie Goth and her sister, Genevieve Goth Graf; V. J. Cariani; Will Vawter, illustrator of Hoosier poet James Whitcomb Riley's works; L. O. Griffith, etcher; and E. K. Williams, oil painter. Many took up residence while others came during the summer months to paint.

These artists were enticed by the rolling hills, the bucolic landscape, and the quiet pace of life. With Steele's growing prominence, Brown County evolved into a regional art center, drawing patrons from Indianapolis, Chicago, and surrounding areas. Following his death in 1926, his wife, Selma, gave Singing Winds and 300 of his paintings to the state. Today, the Steele home, along with the original studio and grounds, is open to the public.

The rich artistic tradition that has distinguished the county for more than a century continues to this day. More than eighty artists reside here. Others join them periodically to capture on canvas the hazy hills and sweeping vistas, the village of Nashville, and Brown County State Park.

Mention Brown County to a state park enthusiast and the subject will be Indiana's largest state park, the 15,696-acre Brown County State Park. Open all year, the park has the Abe Martin Inn, lodges and cabins, camping, fishing, swimming, picnic areas and shelters, playgrounds, auto and walking tours, seventy miles of bridle trails, twelve miles of hiking trails, and the Ogle Hollow Nature Preserve self-guiding nature trail—in other words, a *complete* state park.

Mention Brown County to an antiques and crafts shopper and the response will be Nashville, the county seat, where visitors can find weaving, pottery, leatherworking, jewelry, baskets, musical instruments, wreaths, bonnets, candles, silk flowers, stained glass, garden supplies, furniture, silver, photography, woodworking, glass, clothing, floral designs, and toys.

Mention Brown County to an entertainment buff and learn about the theater and music venues offering country, bluegrass, and other music from the 1950s on.

Mention Brown County to a historian or linguist and what's of interest will be how the county has managed to maintain much of its early twentieth-century flavor despite its location just west of a Big Ten university and its proximity to Indianapolis.

Mention Brown County to those who know it more intimately than the occasional vacationer or traveler and it means the kind and hospitable but careful people whose families have lived here most of the century, the quiet back roads that wind in and around the hills, and the changing scenery of the seasons. Brown County is home for people who gladly welcome the out-of-county guest but are quite content to rest at evening's end, happy to live in "the hills of Brown County."

Formed in 1836, the county is named for General Jacob Brown of the War of 1812 and commanding general of the United States Army in the 1820s.

"I was really excited when I heard that I would paint Brown County for this project. I've traveled around this county for many years in search of painting locations and have always found something new and inspiring to paint. In fact, I painted my first plein air painting 25 years ago in Brown County. I was drawn to the area west of Stone Head. There were many different shades of green fading to blue, then to purple in the distant hills. This and the trees in the foreground framing the distant bales of hay on the green pasture created a special view."

RONALD MACK
"Greens of Nature"
Oil on linen 16 x 20 inches

CARROLL COUNTY

It was a grand idea: The Wabash and Erie Canal, stretching 468 miles from Toledo to Evansville, would connect the Great Lakes with the Ohio River and thus on down the Mississippi River to New Orleans. With federal money, state money, imported Irish labor, and high expectations for riches to be gained, the project was approved in 1827 with construction beginning in 1832. Some twenty-one years later the longest U.S. canal was completed to Evansville and, for more than twenty-five years, the idea more or less worked.

Then came the railroads. Not that they were the only problem for the continued success of the canal in Carroll County. A spillway break on Deer Creek in 1874, the state's sale of canal lands to satisfy creditors in 1876, and vigilantes who blew up the Wabash Dam at Pittsburg in 1881 effectively ended canal days in this county.

The canal had never been very successful south of Terre Haute; it was often inoperative. The canal depended on a series of seventy-three locks to maintain proper water levels and the system was far more intricate than early planners had imagined. But where it worked, it worked well and that included Carroll County. Farms and industry had a relatively inexpensive way to ship north toward Fort Wayne and then east, if not always south and west.

Delphi profited as much as any city on the canal. Businesses developed, population increased. A lime production industry grew up with kilns burning locally quarried limestone to produce plaster and whitewash that was considered some of the best quality in the country. The canal carried it both east and west. Two large paper mills used a millrace between the canal and the Wabash River where excess canal water was sent to the river after passing over the mill wheels to provide power. This manufacturing came to an end when a dam that controlled waterflow downriver and for the canal was destroyed by vigilantes, angered by the dam's flooding of farmlands.

Today, Delphi has the longest remaining section of the canal still containing water, about a mile. Lying just northwest of downtown, the canal's towpath has become part of the Wabash Corridor Heritage Trail, which—hopefully—will link the nineteen Indiana counties that border the Wabash River. Canal Park near downtown has a refurbished Federal-style house, log cabins, and a blacksmith shop and is a popular tourist spot.

With both the Tippecanoe and Wabash rivers as well as Wildcat and Deer creeks and other smaller tributaries flowing through the county, Carroll has 111 bridges, nineteen of them already declared historically significant. The Carroll County Historic Bridge Coalition has organized three bridge tours, offering the visitor more than twenty bridges to see, including the Adam's Mill covered bridge, southeast of Delphi, built in 1872. Nearby is Adam's Mill itself, constructed in 1845, powered by Wildcat Creek. The mill is open on summer and fall weekends and also on weekdays by special arrangement. Commercial milling ended in the 1950s, although most of the original machinery is still operable.

Adam's Mill covered bridge isn't the oldest bridge in the county, however. That's Burnett's Creek Arch, built in 1840 so the canal could pass over the creek. Later the waterway was converted into a road. It is one of the oldest bridges in the state.

The county is named for Charles Carroll, who served in the Continental Congress and signed the Declaration of Independence. His later railroad business ventures made him the wealthiest citizen in the United States at the time of his death in 1832.

"Adam's Mill, fed by Wildcat Creek, is a huge old mill that has been preserved and is now open on weekends during the summer. The area is an amply shaded, almost park-like place to picnic, paint, or sightsee. Upstream is an old covered bridge, now being restored to handle traffic, and there is a beautiful spot on the river below the bridge. A sandstone bluff, partially overgrown with shrubs and trees, provides a lovely scene in the half-light of evening. I sat and painted at the water's edge."

LYLE DENNEY
"Along the Wildcat"
Oil on canvas 20 x 30 inches

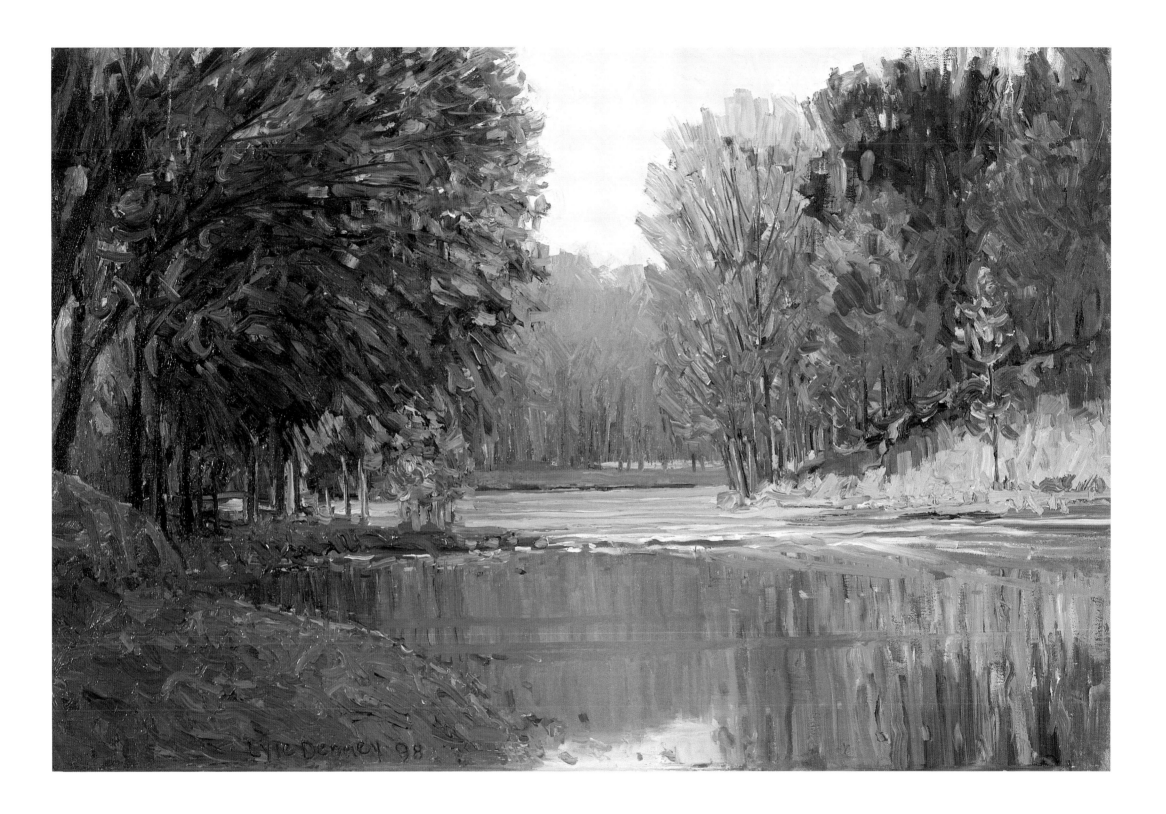

CASS COUNTY

It is perhaps understandable that we look back to the beginnings of the State of Indiana, especially to 1816 when statehood was enacted by Congress, and assume that it came into the Union with counties in place, cities established, and governments at work—a state not totally dissimilar to what we know at the close of the twentieth century.

Such was not the case. Cass County is but one example. The first permanent white settler, so far as historians have recorded, did not even come into Cass County until 1826—ten years after Indiana had become a state! He was Alexander Chamberlain, who set about building his log cabin, where he provided shelter and meals to others who were beginning to move to the newly opened lands between Fort Wayne and Lafayette. Then he built a second cabin, which he sold to another entrepreneur of the day, General John Tipton. General Tipton, a veteran of the War of 1812, was preparing to move his Indian Affairs office from Fort Wayne to the new town of Logansport—where, of course, he had land holdings.

Logansport was named in honor of a Shawnee chief, whose Anglicized name was James John Logan. The chief died while fighting with the Americans against the British in the War of 1812. Since the city was built where the Eel and Wabash rivers meet, the suggestion was to add "port," hence Logan's Port and later Logansport.

Events happened more quickly after that point. The Wabash and Erie Canal, connecting the Great Lakes with the Ohio River, reached the town in 1837, crossing the Eel River with a viaduct. The Michigan Road, built to join Lake Michigan with the Ohio River, came through Logansport in the mid-1800s.

As important as these transportation systems were, it was the railroad that largely created modern-day Logansport.

The first train arrived in 1855 and, while it took a number of years, Logansport ultimately became one of Indiana's primary railroad towns. More than 225 trains came through town daily by the 1920s.

That time has passed. It is remembered at the annual Iron Horse Festival in July and at the Iron Horse Museum, located in a restored railroad station in the downtown district. The county's heritage is also recalled at the Cass County Historical Society Museum, a twenty-room, Italianate-style house built in 1853, which includes artifacts of the last 200 years. Next to it stands a smaller two-story log cabin built in 1854. France Park, just west of town, also has a cabin, this one built in 1839. Another community point of pride is the Riverside Park carousel. The merry-go-round, still operative, has forty-four wooden animals carved by hand in the late 1800s.

Meanwhile, Logansport and Cass County have moved on; manufacturing, retail trade, government, and service industries are the largest employers today, accounting for more than 80 percent of the county's work force. Transportation, on the other hand, now uses less than 4 percent of the county's workers. Agriculture, once a dominant part of the labor market, employed only slightly more than 1 percent of all county workers by 1990.

Like many other counties, Cass took a hit to its population in the 1970s and early 1980s, dropping from 40,000-plus to 38,000-plus in the 1990 census. The population has now stabilized at just above 38,000.

The county is named for General Lewis Cass, governor of the Michigan Territory, President Jackson's secretary of war, U.S. senator, and minister to France.

"In the past, Logansport was an important railroad hub and I sought to incorporate this history into my painting. When I arrived in Logansport, I found no bustling railroads—only remnants of days gone by, now memorialized by parks and monuments. As I headed home, I passed by the point where the Eel and Wabash rivers converge. The low-setting sun cast a golden glow on the church steeple and rooftops across the river. I returned the following weekend to make color sketches and was very pleased with the subject."

DAN WOODSON
"Converging Rivers at Logansport"
Oil on canvas 20 x 24 inches

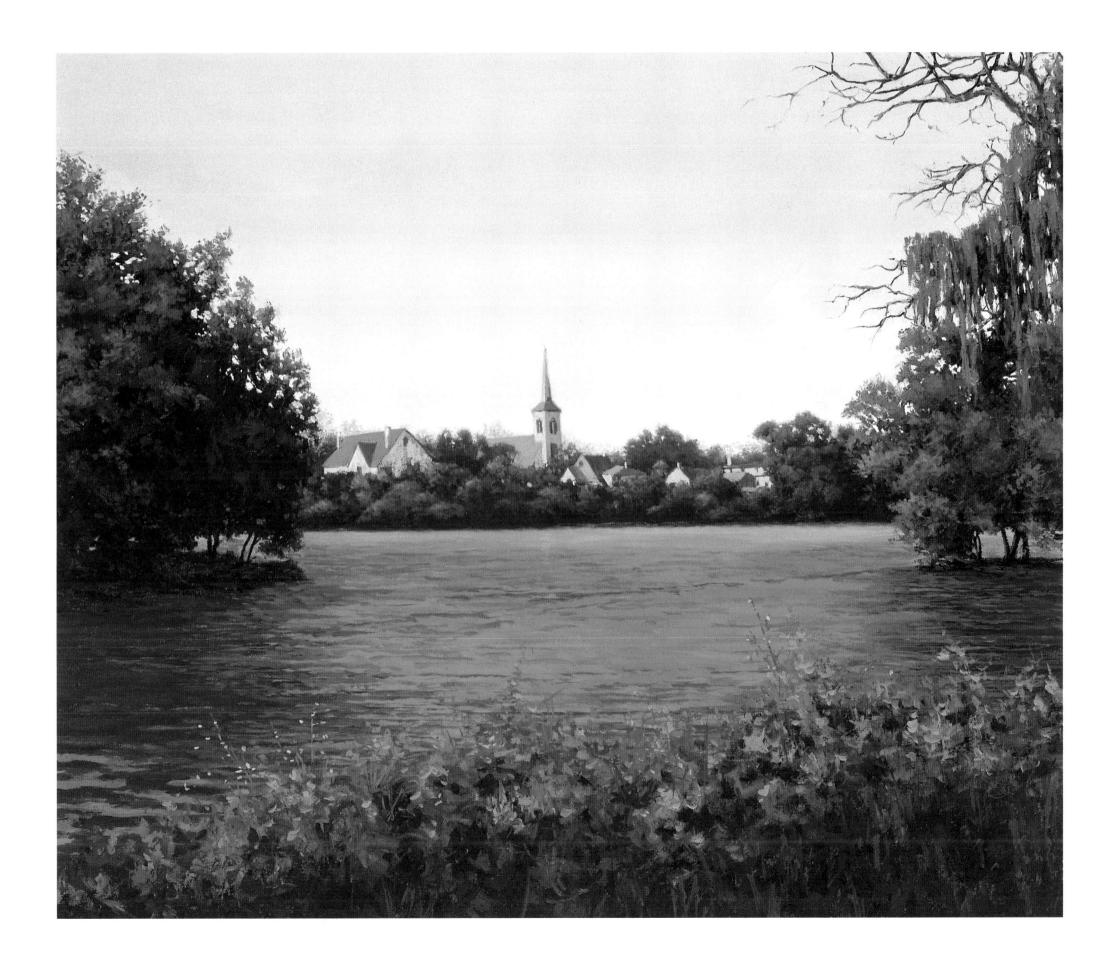

CLARK COUNTY

Historian Stephen Ambrose says that when Meriwether Lewis and William Clark shook hands in 1803 at brother George Rogers Clark's cabin near the Falls of the Ohio, there began one of the most legendary feats in American history—the Lewis and Clark Expedition to the Pacific Ocean that opened up the Louisiana Territory. William Clark, the younger brother of George Rogers Clark, had been selected by Lewis to become co-leader of this western trek that would take three years and which, 200 years later, continues to fascinate adventure lovers. It was at Clarksville that they met, joined together the volunteers they had chosen, and started west.

George Rogers Clark, a hero of the Revolutionary War, knew the Clark County region well. In 1778, he passed through the Falls of the Ohio—that spot in the Ohio River where the river drops twenty-six feet in three miles over a series of rapids—when he led a group of Virginia-sanctioned militia on a daring raid of British western forts. His best-known victory came at Vincennes in 1779 when he captured Fort Sackville.

In appreciation of Clark's achievements, the Virginia legislature gave him and his men 150,000 acres of land on the north side of the Falls and named the county, Indiana's second oldest, Clark in his honor. Over time, the huge area was divided into eighteen other counties.

In the early 1800s, the county seat was first at Springville, which no longer exists, then moved to Jeffersonville. Only a few years later it was moved to Charlestown, considered a more central location. Finally, nearly seventy years later, it was moved again to Jeffersonville. As the years passed, the land across the river from Louisville had the greatest growth, in part as an extension of the Louisville metropolitan area. Along with Floyd County, it markets itself today as "the sunny side of Louisville."

The boat industry has played a major role in Jeffersonville's economic and population growth. First, it was steamboats, barges, and towboats. Then, with World War II came landing craft and submarine chasers. Today, production continues of pleasure and commercial boats including showboats, car and passenger ferries, tankers, and barges. The mansion of the second-generation Howard shipbuilders houses a steamboat museum with original furnishings and models, tools, artifacts, documents, photos, and paintings of the steamboat era.

Another county connection to America's military efforts, in addition to shipbuilding during World War II, is the old Indiana Ordnance Works, which once stretched for six miles along the Ohio River from Jeffersonville to Charlestown. Three wars later and now deactivated by the federal government, it has become the Charlestown State Park and the home of private businesses.

Downriver, the Falls of the Ohio State Park contains George Rogers Clark's homesite and the Indiana part of the river's fossil beds formed 400 million years ago. A 16,000-square-foot Interpretive Center is open throughout the year. In the northern part of the county, to the west of Interstate 65, lies the 20,000-acre Clark County State Forest, a tourist draw for thousands who use its trails, picnic areas, and recreational facilities.

Many Hoosiers today know little about the floods that once devastated cities along the Ohio River. The river crested at its second highest recorded level in 1773 with other floods throughout the years, notably in the mid-1880s and in 1913. The granddaddy of them all, however, was the Flood of 1937 that crested at 58 feet. The damage and recovery were almost beyond calculation. After numerous attempts starting back in 1886, a system of floodwalls and levees was finally completed in 1953 that now protects Jeffersonville, Clarksville, and New Albany.

"It took five trips—two with a broken wrist—and a multitude of ideas to choose a representative view of Clark County. I painted a scene from the Falls of the Ohio fossil fields, but wasn't satisfied. A friend from Floyds Knobs offered to show me the spectacular view from the Knobs, overlooking Clarksville, Jeffersonville, and beyond the Ohio River to Louisville. My dilemma was solved. The contrast of the shadowed trees and shrubs against the muted, distant horizon made a very interesting subject. The painting turned out to be one of my best."

DAN WOODSON
"View from the Knobs"
Oil on canvas 17 x 36 inches

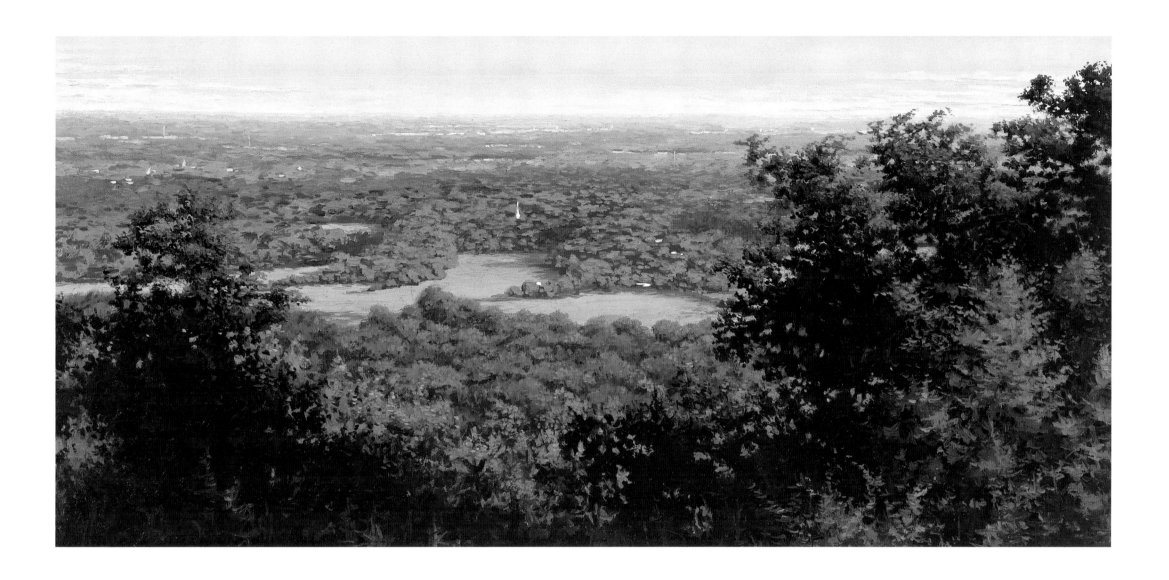

CLAY COUNTY

There's a story behind the name of everything and cities and counties are no exception. In the mid-1800s, when a few people had moved into what is now Clay County and settled in the northern part near present-day U.S. 40, it came time to name the community. As the story goes, four property owners got together, liked the attention being given to a nation in South America, and so decided to call their new town Brazil. In an appreciative gesture, Brazil, South America, gave Brazil, Indiana, a granite and brick fountain in 1956, called the Chafariz dos Contos or the "Fountain of Tales," a replica of the monument in that South American nation where, it might be noted, in Portuguese the name is spelled *Brasil.*

The naming of the county followed a pattern similar for most counties in Indiana—the name was selected to honor a statesman or warrior of the country's early history. In this case, it was Henry Clay from Kentucky, who served in both the Senate and the House of Representatives. Twenty-five years after the county was named for him, Clay authored the famous 1850 compromise as an attempt to avert civil war over the slavery issue.

Located as it is between Terre Haute to the west and Indianapolis to the east, Clay County is one of four counties in western Indiana crossed by, first, U.S. 40 which goes through Brazil and, later, by Interstate 70 which passes three miles south and is connected to the city by Indiana 59. The county's population has remained stable in recent decades—actually increasing by about 2,000 in a 1997 estimate, up to 26,500 from the 1990 census—while Brazil has also gained about 1,000 residents, to an estimated 8,500 in 1997.

Brazil's major industry today is connected to transportation: the manufacturing of tractor trailers to customers' specifications. More than one-half of the county's labor force is employed in this single industry. Other workers are engaged in the production of auto parts and window and door screens, while smaller numbers work in the production of corrugated plastic tubing, trucking, and strip mining, among other areas.

Clay County was the home of Indiana Governor George N. Craig, 1953–57, who also served as the national commander of the American Legion before his election and in whose honor a new park was dedicated in 1977; Orville Redenbacher, probably America's best-known popcorn king; and James R. (Jimmy) Hoffa, who was head of the International Brotherhood of Teamsters from 1957 to 1971. Hoffa was indicted by a federal grand jury for accepting illegal payments from a Detroit firm, but a mistrial was declared in 1963. He resigned his union post in 1971 and disappeared in 1975.

Along with the Brazilian monument gift in Brazil's Forest Park are two historic cabins that have been moved to the site. The cabins, both built in the mid-1800s, were dismantled log by log and reassembled at the park. One cabin is furnished to represent a home of the day, while the other has artifacts of the period. The park also has recreational facilities, including an eighteen-hole golf course.

While some counties have torn down their older courthouses to make way for modern structures, the Clay County Courthouse, built 1912–14, still stands. It has a stained glass dome (cleaned, repaired, and rededicated in 1987) which allows natural lighting into the building's rotunda of inlaid floors, marble wainscoting, gold leaf, and granite columns. It underwent major renovation in 1998–99 to its infrastructure, retaining its historical integrity while improving its heating, cooling, and lighting.

"I chose for my subject Norman Hunt's Pleasant Acres Farm, on U.S. 40 west of Putnamville. A beautiful Greek revival home, meticulously kept, it sits on rolling acres surrounded by a bright white, flat board fence. A lovely 1850s farm, with several large outbuildings and a wonderful three-story Craftsman-style barn, complete with cupola, are all painted green with white trim. The farm is on the Register of Indiana Historic Landmarks and will soon be entered in the National Registry. The buildings, nestled among huge maple and oak trees, presented a great setting. I liked the way the snow reflected the colors of the sky and the trees."

ROBERT EBERLE
"Hunt's Farm"
Oil on linen 14 x 18 inches

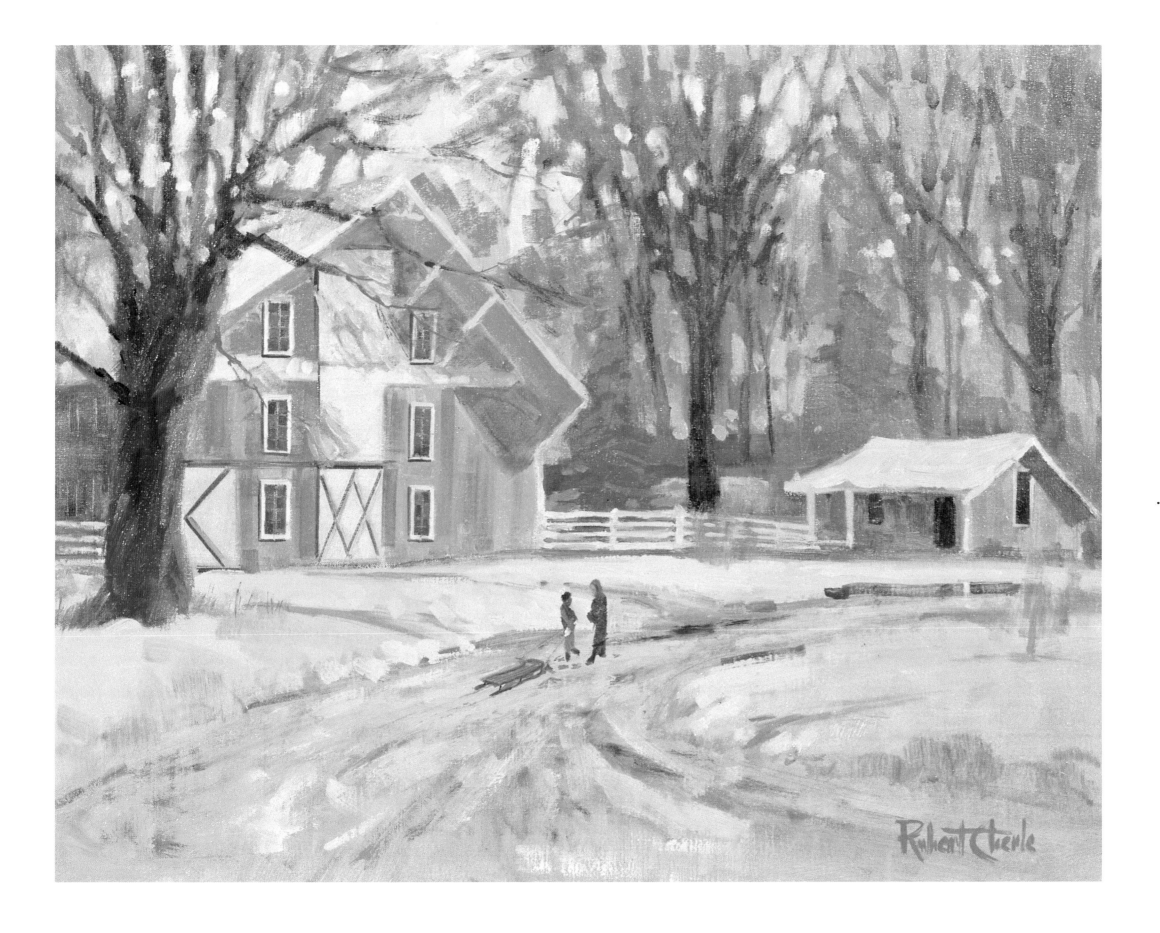

CLINTON COUNTY

In the mid-twentieth century, things didn't look too promising for Clinton County and its county seat, Frankfort. The railroads, a key part of Frankfort's economic life since the 1870s, were beginning to show definite signs of slowing down as more and more freight went by highway and passengers by air. Being a major railroad hub, that spelled bad news for Frankfort and led to a decline in population.

Fifty years later, Clinton County had turned a corner. Frankfort's population in 1990 was almost equal to the 1970 level and the 1994 count was even higher. The same was true for the county.

To no small degree, Frankfort's resurgence has been due to the successful Clinton County Industrial Park, a 2,240-acre home to more than fifteen of the forty industries located in the county. Nine of the industrial park businesses have more than 100 employees each. The largest of them, the world's biggest Frito-Lay, Inc. plant, employs 1,300. A second, Federal-Mogul Corporation, makers of oil seals, has 800 workers. Mallory Controls, which produces timers, is third in the park with 545 employees. Although Sun Chemical employs only 150, it is reported to be the world's largest printing ink producer.

A plus for the industrial park is the fact that it is the site of the 230-acre Frankfort Municipal Airport, with two lighted runways. The Norfolk Southern railroad also services the industrial park. And Interstate 65 lies five miles to the west.

While another major city to the southeast has been billed as the "Crossroads of America," Frankfort likes to think it isn't doing too badly on that score either. It refers to itself as being on the "Chicago-Indianapolis corridor" and "in the middle of things." That crossroads city, Indianapolis, is but forty-five miles away, making big city life quickly accessible to Frankfort and the rest of the county. Lafayette is even closer at twenty-two miles. Then there's Chicago, Louisville, and Detroit, all within 200 miles.

Even with the importance of industry to the town, downtown Frankfort still revolves around its courthouse with its curving staircase (it is listed in the National Register of Historic Places). The city gained "model city" honors as one of the top five in the state with its downtown revitalization efforts, including paved sidewalks, new trees, rehabilitated buildings, and the encouragement of specialty shops, restaurants, and professional offices. The TPA Park is a community favorite, with eighty-five acres of playgrounds, tennis courts, ball diamonds, a roller rink, swimming pool, petting zoo, and an aviary. Next door is the eighteen-hole golf course of the Frankfort Country Club. The park was opened in 1911 on land purchased by the Travelers Protective Association, an insurance group, and was donated to the city in 1928.

While the emphasis on farming has lessened, it certainly has not disappeared. The county still has close to 800 farms in its 409 square miles, with corn and soybeans being the big crops, along with hog production. The Clinton County Fair ranks as one of Indiana's largest.

Of the other five smaller towns in the county, perhaps Mulberry has the greatest claim to fame. Its Slipher brothers were Vesto Melvin, who was a co-discoverer of the planet Pluto, and Earl C., who was a pioneer in planetary photography.

The county, organized in 1830, is named for DeWitt Clinton, longtime mayor of New York City and governor of the state in the early 1800s.

"My patience was wearing thin as I drove through the farmland on an exceptionally hot summer day. I came upon a distinctive old tree, unusually shaped with large, sturdy limbs. This healthy old giant still gave good shade. After studying it for a long time, other elements in my view started to make good sense. I liked the white farmhouse in the distance with its rust-colored roof, and the white gravel road appeared even brighter in the sun. And to the cows, all seemed fine as they watched me move about."

RONALD MACK
"Oak Lane"
Oil on canvas 20 x 24 inches

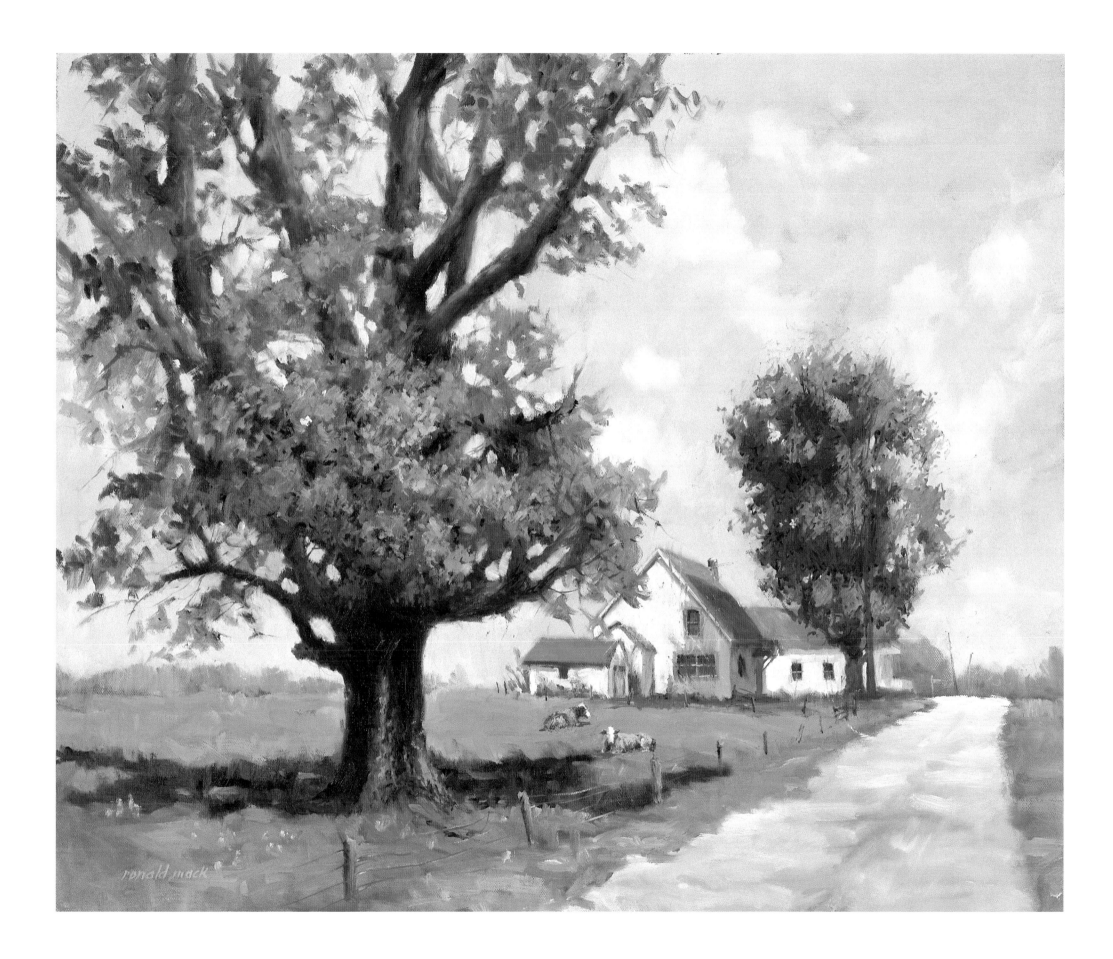

CRAWFORD COUNTY

They may not always know the name of the county, but they certainly know its caves, forests, and lakes. Especially well known is Wyandotte Cave with more than six miles of caverns. Its biggest chamber is named Monument Mountain and it has one of the largest stalagmite formations in the world, the Pillar. Experienced and novice spelunkers alike, as well as tour groups, can explore these caves. The Big Wyandotte was used by prehistoric Indians for shelter and the Little Wyandotte was discovered in 1851. A second major cave system in the county is the privately owned Marengo Cave, famous for its Crystal Palace flowstone formations and Dripstone Trail stalagmites. It's just east of English, the county seat.

Not as well known by spelunkers, but possibly even more popular, is the Hoosier National Forest. The 195,000 rugged and unspoiled acres of forest lie in parts of seven counties but include almost all of Crawford. The Hoosier National has 200 miles of trails open to mountain bikes, horses, and hikers, although hikers also have the option to go cross-country. Ten campgrounds range from open fields to electric hookups. The Hemlock Cliffs Geological Area, part of the forest, has archeological digs that show evidence of human dwelling as far back as 10,000 years ago.

In addition to Crawford County's caves and forests, Patoka Lake, lying in the western part of the county, is, at 8,800 acres, the third largest body of water in Indiana. The lake was created for flood control, but today supplies water for three counties as well as swimming, boating, fishing, and, on its shores, picnicking, camping, and hunting. There are more than 500 campground sites, one of the largest facilities in the state. Talk about visitors: The lake is visited annually by more than one million people.

The county's southern border is the Ohio River with its boating, fishing, and water skiing. On the eastern edge of the county is the Harrison-Crawford State Forest, which also has the Ohio as its southern border. Here one can find more picnicking, hiking, and swimming areas, plus camping and cave tours in part of the Wyandotte Cave complex. Separating Crawford and Harrison counties is the Blue River, whose meandering course is a favorite of canoeists. Water comes into this river through the hundreds of cave springs along the bluffs.

Just to prove that Mother Nature is still in charge, two floods—in 1979 and 1990—put the county seat of English under water, forcing the town to move to higher ground. Down on the Ohio River, Leavenworth learned the same lesson when the Ohio just about wiped out the town in the 1937 flood. Now there are two Leavenworths: Old Leavenworth on the river and the present town high above on Indiana 62. Old Leavenworth, located just before a big bend in the Ohio, still recalls its steamboat days when the town was a bustling river stop of 2,000.

Crawford County has remembered its frontier heritage with the Crawford County Indian Museum at unincorporated Alton on the Ohio River.

Some claim that the county, established in 1818, is named after Colonel William Crawford, a frontier surveyor and friend of George Washington. Crawford was captured by Indians and burned at the stake in Ohio about 1782. More likely the county is named after William H. Crawford, the U.S. secretary of the treasury when the county was formed. In 1816, despite his disavowal of candidacy, he received only eleven votes fewer than James Monroe for president and was said to have numerous friends in Indiana.

"As I drove north from Milltown along the river valley I spotted a long vista. I stopped to ask Mr. Melvin Jones if I might walk up the hillside behind his house to get a better view. It was awesome! I later asked Mr. Jones about William Branham, an outstanding minister who spoke at Milltown Baptist Church and baptized folks at Toten's Ford. A look of joy and surprise came over his face as he slapped his knee and exclaimed 'I was one of them!' The history I had learned of the area came alive as we talked. I later painted in the field up on the hillside on a perfect autumn evening, when the atmosphere was just charged with light and shadow, contrast and color. I'll never forget it—like T.C. Steele said of this time of year, it was 'the bloom of the grape.'"

LYLE DENNEY
"Blue River Valley near Toten's Ford"
Oil on canvas 24 x 30 inches

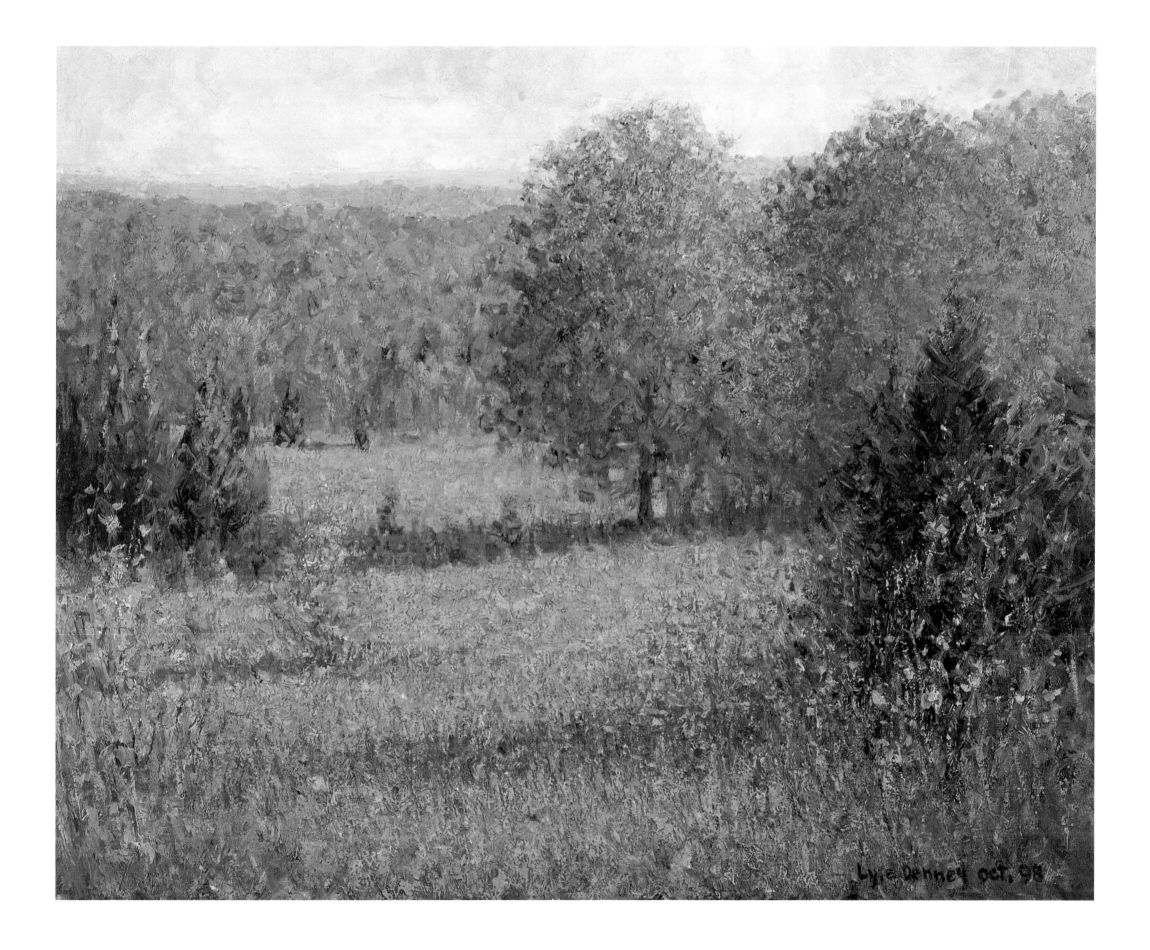

DAVIESS COUNTY

As Indiana was settled in the early 1800s and counties and towns were established, it is not surprising that the names selected for these locations are of heroes from the Revolutionary War, the frontier skirmishes, the statesmen of the time, and the War of 1812.

Daviess County, organized in 1816, was named for a Virginian, Joseph Daviess, who went to the frontier as a youth, became a lawyer, and married the sister of U.S. chief justice John Marshall. He later sought an indictment against Aaron Burr, who he believed was trying to lead a secessionist movement in the western part of the new nation. Failing in this attempt, he moved west himself, settling in Kentucky. With

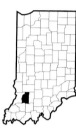

a new war against Great Britain imminent and frontier warfare increasing, he volunteered to serve with William Henry Harrison's military campaign against Tecumseh. In November 1811, he was part of the thousand-man force that fought Tecumseh near Prophetstown in the Battle of Tippecanoe. Daviess was wounded in the ferocious two-hour struggle and died the next day—a fate that enshrined him in frontier lore.

It is perhaps paradoxical, then, that an important settlement in the county only a few years later was built by the peaceable Amish. Migrating west from Pennsylvania, they were descendants of religiously persecuted European minorities who wanted no part of the world's desire for possessions or for its wars. These Old Order Amish settled in the eastern part of the county and ultimately numbered about 500 families.

Today, Amish businesses of woodworking, cabinet and furniture making, and quilt and craft stores are mostly clustered north of Montgomery and Cannelburg and north toward Raglesville and Odon. The community is divided into thirteen districts, where the children are taught both English and German in their schools, German being the first language spoken in church and home.

The county seat of Washington needs no elaboration, nor do some of the better-known townships in the county: Harrison, Van Buren, and Madison.

Daviess County is another of those southern Indiana counties defying the "rust belt" population depletion suffered by some of the more industry-based counties of central and northern Indiana. Its population stood at 27,602 in 1970, dipped slightly by a few hundred in the 1980 census, but climbed to 28,252 in 1994.

Slightly more than 9,000 of the county's inhabitants are engaged in some form of industrial work, the largest group in processing turkeys. Other large employers are in the fields of health care and manufacturing, specifically of steel ball bearings, industrial outerwear, extension cords, and concrete products. Farming continues to play a key part in the county's economy, along with farm-related businesses including grain elevators, fertilizer services, feed supplies, and milling. A 1993 estimate showed about 11 percent of the residents engaged in farm work out of the county's total work force of 14,025.

Like other counties in southern Indiana, outdoor activities play an important role in its recreational and tourist-based economy. In conjunction with Martin County to the east, Daviess County has constructed Boggs Creek Reservoir and Park, a two-square-mile facility north of Loogootee. Half of the park is now a lake with water sports and fishing. Southeast of county seat Washington is the Glendale State Fish and Wildlife Area, which includes a 1,400-acre lake.

The county is partially framed by the White River, its east branch forming the county's southern boundary and the west branch its western boundary. They join at the southwestern tip of the county.

"Amish buggies, pulled by a single bay horse. The friendly passengers indicate with a wave or nod that they're as interested in you as you are in them. I've always found something worthwhile to paint in Indiana's well-tended Amish communities. I chose a subject for Daviess County that was simple and typical of the area. What interested me most was the old gnarled tree that could no longer cast a cool shadow, but still has a lot to offer. Perhaps one day it will cast a warm glow in the fireplace on a cold winter day. I found many wonderful scenes, but when you come upon the right one, you know it."

DAN WOODSON
"Grazing"
Oil on canvas 20 x 24 inches

DEARBORN COUNTY

The most spectacular view of the Ohio River? While many vantage points would be nominated, what about standing on the front porch of Veraestau, overlooking the river town of Aurora? From Veraestau, there's a panoramic view of the river, both upstream as the river bends toward Aurora and downstream toward the west with Kentucky spread out to the south across the river.

It isn't difficult to understand why Jesse Holman chose this place in 1810 to build his two-story log house with a brick addition. The Indiana Supreme Court justice and federal judge who helped draft the Indiana Constitution named his home Veraestau, combining the Latin words for spring, summer, and 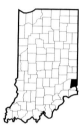 autumn, hoping winter would never come. It did in 1837 in the form of a house fire. Over the years, with salvaging and several additions culminating in a two-story Greek Revival house, Veraestau is still privately owned today but is open for tours and events by appointment.

Only a short distance away, majestically crowning a hill in Aurora, stands Hillforest, built in the mid-1800s by industrialist and financier Thomas Gaff. It, too, commands a view of Aurora and the river, especially from its pilothouse-like belvedere. The property has been largely restored by the Hillforest Historical Foundation and is open to the public.

Dearborn County is one of Indiana's oldest, founded in 1803. The Ohio River forms part of its eastern boundary with Ohio. It's in Dearborn that some other claims for outstanding scenic views could be made, especially from the hillsides of Laughery Valley.

The river towns of Aurora and Lawrenceburg—both with historic districts—along with Moores Hill, Dillsboro, Guilford, and St. Leon, are some of the picturesque communities of the county. Lawrenceburg is the site of another historic home, the Vance-Tousey house, an 1818 Federal-style residence now maintained as the county museum. Also located in Lawrenceburg is an Ivy Tech State College branch campus. Longtime county residents fondly recall an earlier effort at higher education, Moores Hill College, which opened in 1854 as a school for women. Closed in 1917 after a disastrous fire, its Carnegie Hall, a three-and-a-half story structure, still stands and is used as a community center.

The Ohio River is more than just a pretty view; it continues to have a significant impact on the county. The Argosy Riverboat Casino in Lawrenceburg, a levee walk around the perimeter of the city, and a riverfront park in Aurora are just some of the more recent examples. River traffic, largely barges, also remains a part of economic life and employment for these cities on the river. To the north, Interstate 74 goes across the county along the Cincinnati-Indianapolis route.

Dearborn County figured in one of the few northern excursions by Confederate forces in the Civil War when General John Hunt Morgan's raiders swept across the northern part of the county. No one was killed, so far as records show, but the Southerners terrified the populace. As quickly as he came, Morgan was gone. Historians believe Morgan counted on Confederate sympathizers coming to his assistance, but that didn't materialize.

An earlier Revolutionary War battle occurred at present-day Aurora when Colonel Archibald Lochry landed with part of George Rogers Clark's army. A war party commanded by Iroquois Chief Joseph Brant attacked, killing or capturing Lochry's forces in what came to be called the Lochry Massacre.

Two Indiana governors were from the county, Albert Gallatin Porter and Winfield T. Durbin. The county is named for Major General Henry Dearborn, President Thomas Jefferson's secretary of war.

"The scenic areas along the Ohio River are a joy to paint. I wanted to incorporate the river into Dearborn County's painting. I moved up high into a quiet residential area in Aurora and I was able to capture the river beyond the rooftops of this unique town. The afternoon sun and the autumn color certainly added to the scene. I visited Aurora six times in 1998 to paint or search for subjects. It has always been an enjoyable experience, except for one trip when a heavy fog set in until after noon, sending us packing home."

DAN WOODSON
"Aurora"
Oil on canvas 20 x 36 inches

DECATUR COUNTY

If there's one thing people know about Greensburg, it's that a tree grows out of the top of the courthouse.

That's more or less right. Actually, a number of trees have sprouted from the tower atop the courthouse since the first one was noticed in the early 1870s. Over time, residents realized several trees had somehow taken root in the crevices of the tower roof. In 1888, fearful of damage to the tower, a steeplejack was dispatched to clean out all the trees except two. Why two were left is a bit unclear. Only one seemed to grow much, reaching a height of about fifteen feet before it died and was removed. Then, amazingly, a tree began to grow in the southeast corner of the tower and another in the southwest corner. These *two* trees have grown to nearly twenty feet in recent years.

What causes the trees to grow? No one knows for certain, but the best guess is that it's a combination of dust from the courthouse interior and moisture from outside.

As might be imagined, the trees have been pictured in publications around the world and visitors arrive from throughout the United States to witness this strange growth 110 feet above the courthouse lawn. Incidentally, Smithsonian Institute experts have identified the trees as large-tooth aspens.

The trees are not the only Decatur County draw. The historic town square and buildings dotted throughout the county attract shoppers and visitors. The entire downtown shopping district is listed on the National Register of Historic Places and features architecture from five different design periods. Many of the buildings in the area just north of the courthouse date from the 1800s. Going north on Franklin Street, one can see the First Presbyterian Church (1878), the Decatur County Historical Museum (1835), a law office (1845), a business office building (1868), a funeral home (date uncertain but remodeled in 1907), a red brick residence (1870) where presidential candidate James Blaine was once entertained, and the Presbyterian manse (1869).

That's just one side of the street. On the other, again going north, is a private home (1862) at the corner of Franklin and North, a Victorian home (date uncertain but built in the late 1800s), a large brick home (1875), and another house with long front windows and a fan window over the front door (1868).

Out in the county, the visitor also finds homes from the same periods, identified in a tour guide published by the Greensburg/Decatur County Chamber of Commerce. Some of the homes sheltered slaves heading north as part of the Underground Railroad in the years before the Civil War. Also in the northwestern part of the county is an extensive Amish settlement. Herds of cattle and other livestock are in the pastures of these Old Order Amish farmers.

Decatur County shows evidence of glacier activity from millions of years ago. Small hills, called eskers, are believed to have been formed during the Devonian limestone glacier age. Drillings show three different forms of bedrock under the glacier soil, extending down 200 feet.

Decatur, named after American naval hero Stephen Decatur, is one of Indiana's southeastern counties crossed by Interstate 74 as it makes its way from Cincinnati to Indianapolis. It was Decatur who captured the British frigate *Macedonian* in the War of 1812. In 1804, he defeated the Barbary pirates off the coast of Africa.

"On my excursion through Decatur County, I drove through Westport and saw a sign for a covered bridge. After finding it, I walked around the area and was excited by the view of the hill on the west side of the creek. This trip brought back thoughts of an old friend, Dr. Dale Dixon from Greensburg. We painted in classes and in Vermont together years ago."

DON RUSSELL
"Sand Creek at Westport"
Oil on linen 16 x 20 inches

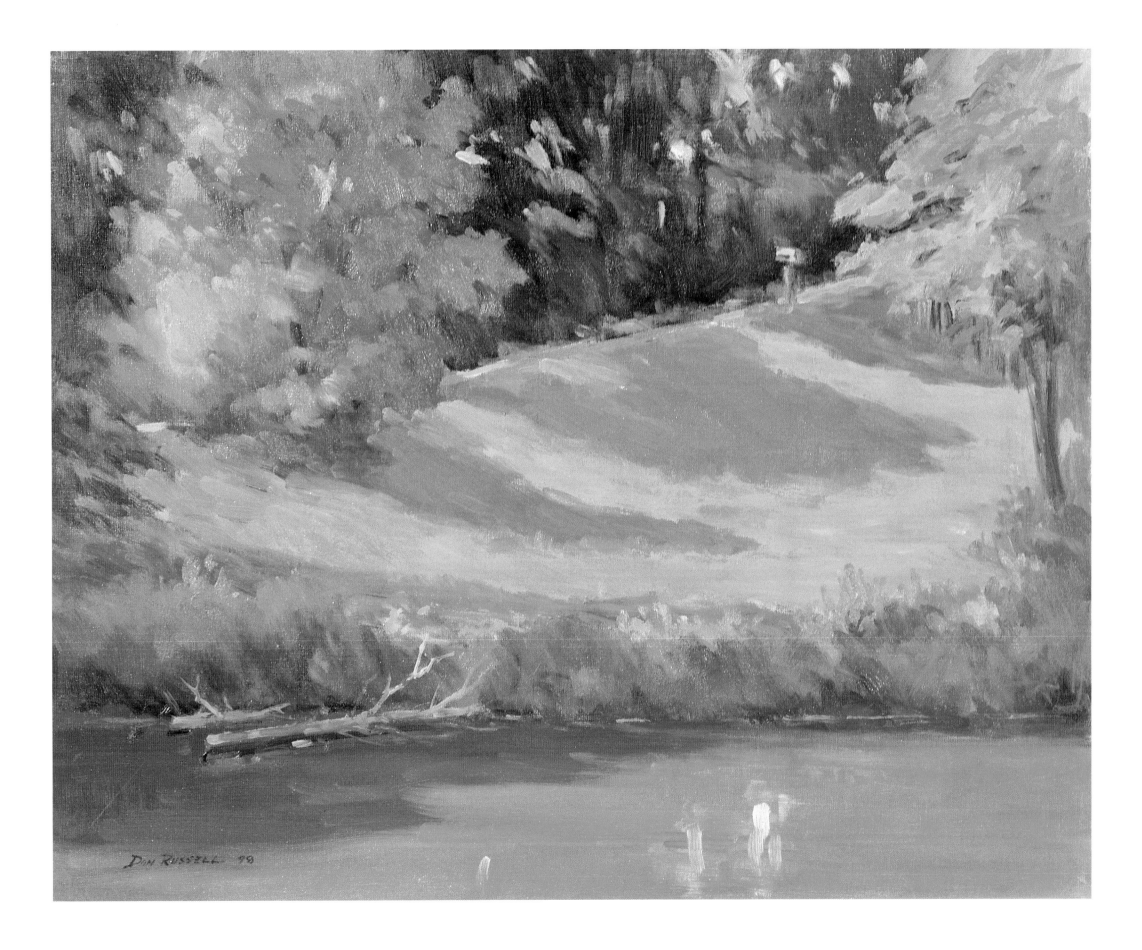

DEKALB COUNTY

If only two words could be used to describe DeKalb County, they would have to be automobiles and railroads. However, like the rest of Indiana, the story began on foot.

That would be how John Houlton came into what is DeKalb County around 1830 and how Wesley Park and John B. Howe arrived in what was to become the county seat of Auburn in 1836. Auburn's name either came from Auburn, New York, or from a Goldsmith poem which includes the line "Sweet Auburn, the loveliest village of the plains." DeKalb County, organized in 1837, was named for Baron DeKalb of Germany—actually Johann Kalb—who came to the colonies with the Marquis de Lafayette and fought in the Revolutionary War against the British. Wounded in the Battle of Camden, he died three days later.

It wasn't long after the first settlers arrived before railroads made their considerable impact on the county. That was how many families, chiefly of German and English ancestry, arrived in the last half of the nineteenth century. Butler, in the northeastern part of the county, became a division point for the Wabash Railroad and boomed when the Lake Shore and Michigan Southern Railroad was completed in 1856. At one time, the Wabash, the New York Central, and the Pennsylvania railroads all intersected in Butler, making it a busy transportation center.

Garrett was even platted as a railroad town by the Chicago Division of the B&O Railroad, when an agent of that company in 1874 bought 604 acres for a division point. In less than a year, Garrett had hotels, stores, and, of course, saloons, along with several hundred residents. In poured immigrants from Poland, Germany, Italy, and Hungary. The town remains an important rail-switching yard today.

Despite all this, it is the automobile for which the transportation world (and auto buffs) best know Auburn. It was here that the legendary Auburn, Cord, and Duesenberg automobiles were manufactured early in the twentieth century. Actually, fifteen different cars were produced in Auburn but the Auburn, Cord, and Duesenberg are the ones that have lived on even though no cars have been produced in Auburn since 1937.

What have continued, however, are the Auburn-Cord-Duesenberg Museum, located in the 1930 art deco, 80,000-square-foot factory showroom built for the Auburn Automobile Co.; the National Automobile and Truck Museum with its cars from the 1940s through the 1960s, trucks from all eras, and transportation toys; the Auburn-Cord-Duesenberg Festival, held over Labor Day weekend, with its parade of classic cars; and the Kruse International Collector Car Auction, held the same week, where as many as 5,000 collector cars are sold in a double auction ring with million dollar prices sometimes paid. On the grounds of the auction, visitors can ogle the classics at a huge car corral before they go to the auction rings.

At festival time, as many as 200,000 tourists crowd into Auburn, a city of less than 10,000.

Sparking the most attention over the years have been the expensive Duesenbergs, brought here from Indianapolis in 1926, with limited models built for movie stars and other notables, and the Cord, now called "the car before its time." Its rakish design, front wheel drive, low-slung and high-powered look, and other innovations—as beautiful and trend setting as they were—could not save the company with the Great Depression settling over the nation.

Even today, about 2,000 county workers are involved in some part of the automobile industry, from the manufacture of auto glass, metal stamping, clutches, and automotive rubber to bumpers.

"On a very foggy, early morning near Corunna, the bright morning light caught the edges of all the objects as the fog burned away. Cool, dark shadows against the warm, foggy morning backdrop created good contrast, and the light draping the house and the barn made a very pleasing scene."

RONALD MACK
"Burning of the Fog"
Oil on canvas 15 x 30 inches

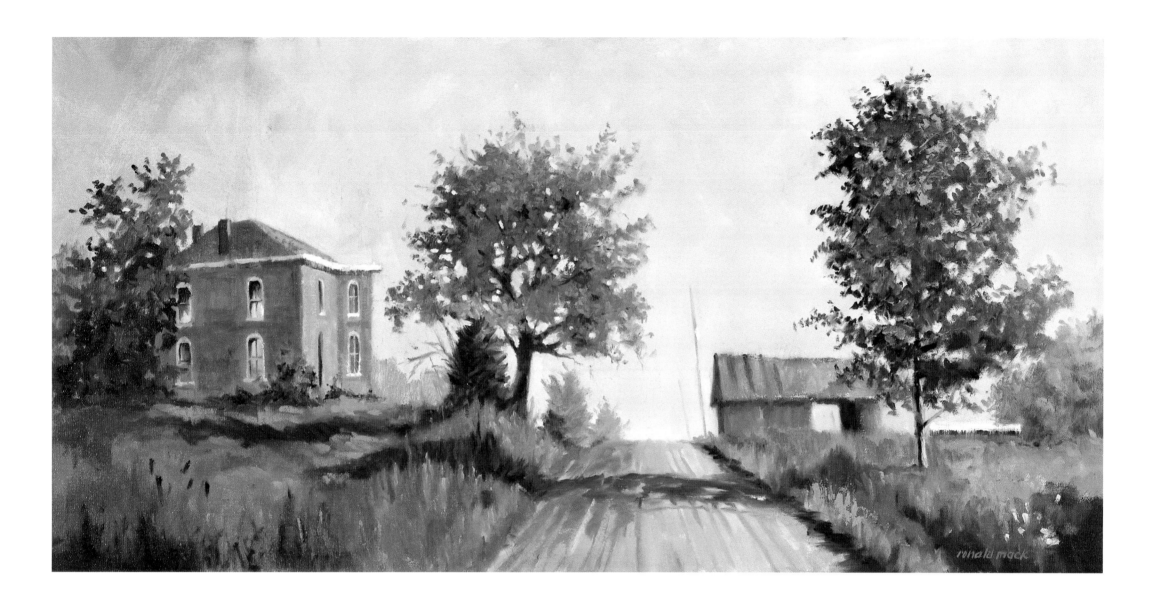

DELAWARE COUNTY

Muncie may be the most studied city in America. Not the most written about—that would probably be New York City—but the most studied. First, the sociological team of Robert and Helen Lynd came to town in the late 1920s and out of their research was published *Middletown: A Study in American Culture,* a pioneering look at day-to-day life in an American community. The Lynds followed up with their 1937 study, *Middletown in Transition: A Study in Cultural Conflicts.* Then a group of sociologists, headed by Theodore Caplow of Virginia, showed up fifty years after the first Lynd study and in 1982 produced *Middletown Families: Fifty Years of Change and Continuity.*

By now, television was a dominant communication medium, so in 1982 the Public Broadcasting System showed producer Peter Davis's series of programs examining life in Muncie. (A controversial film on the city schools was not shown to the public.) Caplow's 1983 book, *All Faithful People: Change and Continuity in Middletown's Religion,* followed.

And those are just the major reports. Sandwiched in between have been hundreds, if not thousands, of articles, radio and television shows, and academic studies examining almost every aspect of Muncie life—books read, movies seen, church attendance, impact of the Klan, television viewing habits, housing, divorce, etcetera.

With the millennium at hand, apparently it's time to do it again. PBS is scheduled to report on what's happened in the nation in the twentieth century in a weeklong special. Of course, Muncie is included. Sociologists from the 1970 study will return to the community for yet another look seventy-five years after the first Lynd studies.

Studied or not, Delaware County and its county seat have struggled in recent years to rebuild a solid economic foundation. The five Ball brothers who came to Muncie in the late 1800s during the gas boom days to build their glass jar business were inseparable from the story of Muncie for a century. The once dominant Ball canning jar factory is now long gone; even its corporate headquarters recently moved to Colorado. As part of the "rust belt," Muncie has seen other old-line industries slow down or, more frequently, close. In the late 1990s, Muncie, in the span of a few months, lost 1,700 jobs. Only recently has a possible industrial turnaround appeared: New Venture Gear announced a new contract to build a transmission that supplies on-demand, all-wheel drive for General Motors vehicles beginning with year 2002 models. This and other new job opportunities could add as many as 1,100 workers.

With its industrial base weakened, services and education have emerged as major community employers, including Cardinal Health System and its Ball Memorial Hospital, along with Ball State University. Tourism and leisure activities have also become important. The Minnetrista Cultural Center, the Academy of Model Aeronautics International Aeromodeling Center, Oakhurst Gardens, the Muncie Children's Museum, Prairie Creek Reservoir, Muncie Civic Theater, Horizon Convention Center, and the Delaware County Fairgrounds attract visitors in the tens of thousands.

Other attractions are the considerable activities and centers at Ball State—Christy Woods, the Wheeler Orchid Collection, the Museum of Art, Emens Auditorium, Planetarium and Observatory, University Theater, the Muncie Symphony Orchestra, and Mid-American Conference athletics.

Don't forget to add Garfield the Cat to the list. Cartoonist Jim Davis continues his operational base just north of Muncie for the world-famous cat and all its auxiliary enterprises including merchandising, books, and television specials. The cartoon strip appears in more than 2,500 newspapers worldwide.

The county, organized in 1827, is named for the Delaware tribe.

"I have always enjoyed water scenes by other artists. For Delaware County, I wished to paint a recognizable subject with an atmospheric sky. I have been to Prairie Creek Reservoir many times to paint and to study the boats, water, and atmosphere. This painting was a joy to do."

LYLE DENNEY
"The Reservoir"
Oil on canvas 21 x 28 inches

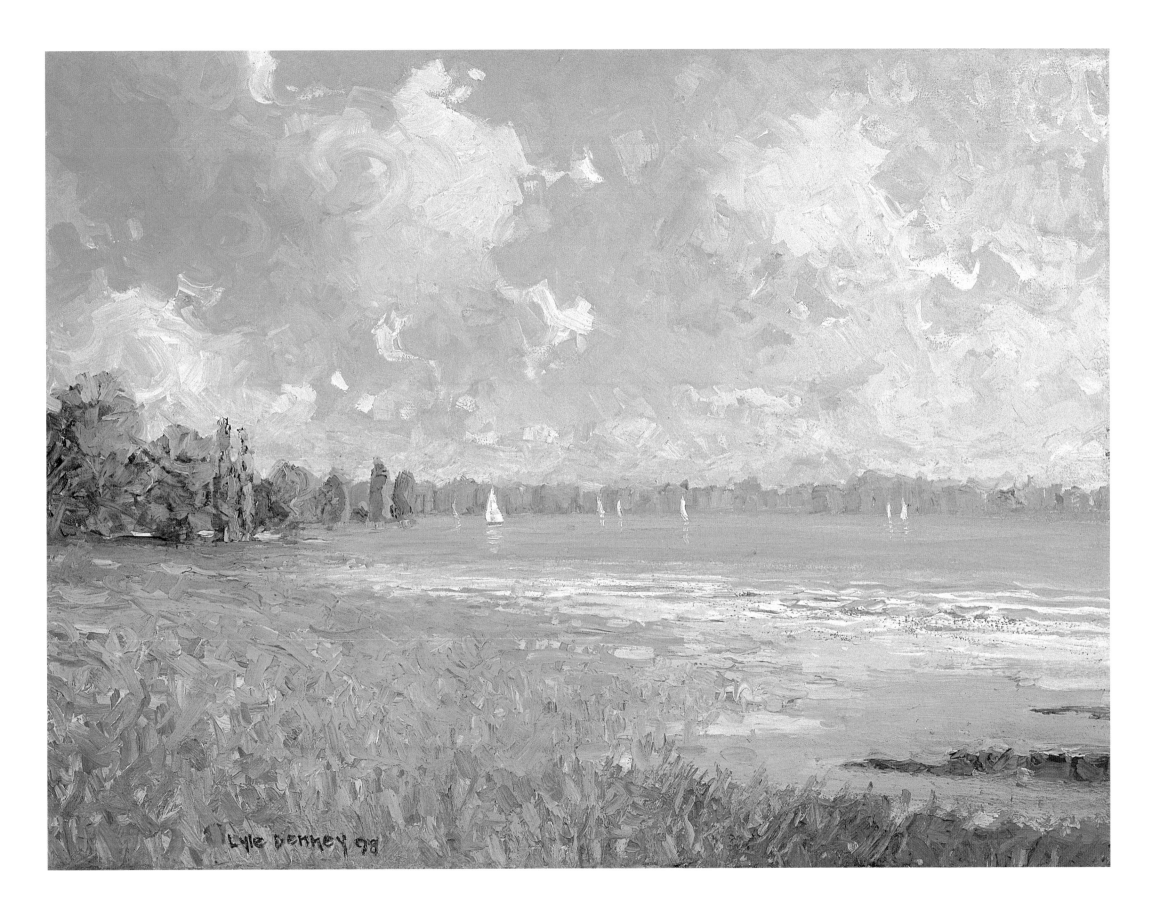
Lyle Denney 98

DUBOIS COUNTY

Nowhere is the pioneering story of the development of Indiana more clearly evident than in Dubois County. In its earliest days, white settlers lived in four counties over a period of twelve years, without moving! First, in 1805, they were part of Knox County when Indiana was declared a territory. In 1813, Knox was divided and they lived in Gibson County. When Indiana became a state in 1816, the county was further divided, so they were in Pike County. Then Dubois County was created out of Pike in 1817. Some families may have even lived in five counties as Martin to the north and Perry to the south were divided from Dubois in 1820.

Dubois County is named for the French frontiersman, Captain Toussaint Dubois, who came into the area while working for Canada's Hudson Bay Company. An adept tradesman, he later became a scout and spy for Governor William Henry Harrison's military forces around the War of 1812 and acquired vast lands in what is today both Indiana and Illinois. Lore has it he drowned in 1816 while swimming his horse across the flooded Little Wabash River; the story is enhanced by the tale that he was carrying large amounts of silver and gold in his saddlebags, which pulled him under the current.

The first settlers, William McDonald and family, built a fort near the White River in the northern part of today's Dubois County in 1801. With Dubois a county in late 1817, modern Portersville, near McDonald's fort, was made the county seat. The seat was moved to Jasper in 1830. By that time, flatboats were using Jasper as a stop on the Patoka River on their way to the Wabash, the Ohio, and the Mississippi. The county courthouse was built in 1910, the third to be constructed on the town square. On the east side of the courthouse is the Dubois Soldiers and Sailors Monument, honoring Civil War veterans.

Long before the settlers, the buffalo roamed this area. As the herds migrated from the Illinois prairies to the Kentucky salt licks, they created a trail, or trace—the so-called Buffalo Trace—which went across the county's northern border.

While most of the early settlers were Protestant, there were a few German Catholic families, too. Soon a Croatian priest, Father Joseph Kundek, arrived. Due to a combination of his endeavors, the natural forests of white oak and tulip poplar, and a large immigration from the Baden and Bavarian areas, more German families poured into the region—many of them, then and now, woodworking masters. Today, the furniture and cabinetry industries are still thriving, as is the poultry industry, which helps rank Dubois as the number one agricultural county in the state (based on farm receipts).

The German influence is highlighted the first weekend in August with the Jasper Strassenfest. It is also present in the St. Joseph Church, which, built in 1880, is the major nineteenth-century reminder of the German Catholic settlement in the county. The church has priceless German stained glass windows and mosaics designed with twenty-five million stones.

Dubois County also boasts the League Stadium at Huntingburg, site for the filming of three motion pictures including *A League of Their Own,* about professional women's baseball.

Northeastern Dubois County is part of the Hoosier National Forest, created during the Depression years of the 1930s. Much of the forest had to be replanted because it had been stripped of trees. It includes the 8,800-acre Patoka Lake Reservoir, which stretches across three counties. The Ferdinand State Forest, a 7,000-acre nature preserve, lies in the southern part of Dubois.

"Jasper has such a nice small town flavor, with all its neatly tended houses, and this cityscape was too appealing to pass up. It was early morning and the light on the small white house in the foreground made a wonderful contrast against the old stone St. Joseph Catholic Church. I have always been fascinated with this church and have often wanted to paint it."

RONALD MACK
"St. Joseph of Jasper"
Oil on linen 16 x 20 inches

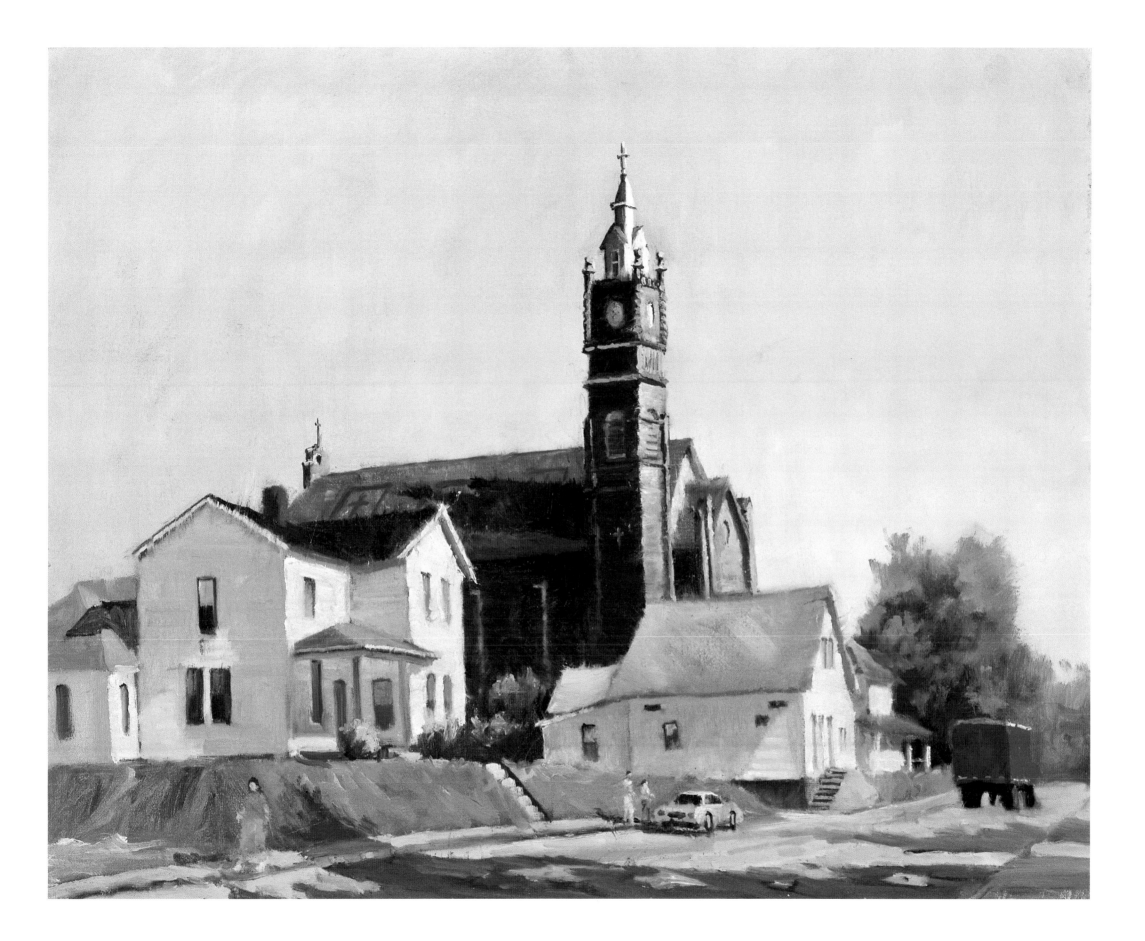

ELKHART COUNTY

When white settlers first came to what is Elkhart County in the early 1800s, they found Potawatomi, who described their sacred island of peace—now called Island Park, a small island at the confluence of two nearby rivers—as being shaped in the likeness of the heart of an elk. The city's founder, Dr. Havilah Beardsley, wanted to name the village after the legend and so it was officially designated in 1839.

The land near the merging of the rivers had been the crossing of several tribal trails; that's what attracted the earliest settlers to the area. The two rivers, later named the St. Joseph and Elkhart, gave the settlement the waterpower it needed to draw industry. Later, Elkhart became a major center for railroads and still has a railway classification yard.

Today, Elkhart is the largest city in the county with diversified manufacturing. Throughout much of the twentieth century, it was probably best known for making band instruments and has been called the "band capital of the world." Other major industries include pharmaceuticals and the manufacturing of recreational vehicles along with power presses, pumps, tools, machinery, office equipment, television parts, and power, aviation, and automotive equipment.

The Ruthmere Museum is a reminder of turn-of-the-century, luxurious living by the well-to-do. The mansion was built in 1908 by A. R. Beardsley, one of the founders of Miles Laboratories. The exterior is highlighted by a wraparound marble verandah. Inside are Tiffany lamps, period furnishings, and a 1915 choralcelo, which is heard as a piano in some rooms and in others, through use of a pipe room, as an organ. The home is open to the public.

Goshen, organized in 1830, is the county seat. Called the "maple city" because of the trees bordering Elkhart River as it runs through Goshen, it is host to the Elkhart County 4-H Fair. More than 250,000 people attend this nine-day event and the county considers it one of the largest county fairs in the nation. Goshen College is located here, and its Mennonite Historical Library contains the largest collection of books about this religious community.

South and east of Elkhart, extending over much of the rest of the county, are large Old Order Amish settlements, somewhat clustered around Middlebury, Wakarusa, Nappanee, and Goshen. The Amish settlements in Elkhart and LaGrange County to the east are the second largest in the nation and the largest in Indiana. Furniture and cabinet making are primary industries, along with farming. Working with wood has long been a tradition among the Amish, passed down from one generation to the next. As in other parts of Indiana, abundant forests encouraged settlement by these woodworkers.

Amish Acres, a restored living historical farm, includes an old-time farm—the only Old Order Amish farmstead listed on the National Register of Historic Places. It was homesteaded in 1850 by the fatherless Stahly family from Germany. The mother and her five sons made a home in this swampy soil and heavy timberland left unworked by others farming the Elkhart prairie lands. Drainage lowered the water table on the Stahly land, revealing fields of rich black soil.

Near Bristol, just east of Elkhart on the Little Elkhart River, is Bonneyville Mill Park, where a waterpowered turbine-type grist mill, one of the few horizontal mills in the world, is still operating. It was built in 1837 to grind corn, wheat, buckwheat, and rye and is the oldest continuously operating grist mill in the state.

"On my first trip to this county, the beautiful farms and farmland appealed to me. I liked the barn with cows grazing in the field in this particular scene. I took a good look at the St. Joseph and Elkhart rivers during my stay, but decided on this pleasant rural scene in the southern part of the county."

DON RUSSELL
"South of Goshen"
Oil on linen 16 x 20 inches

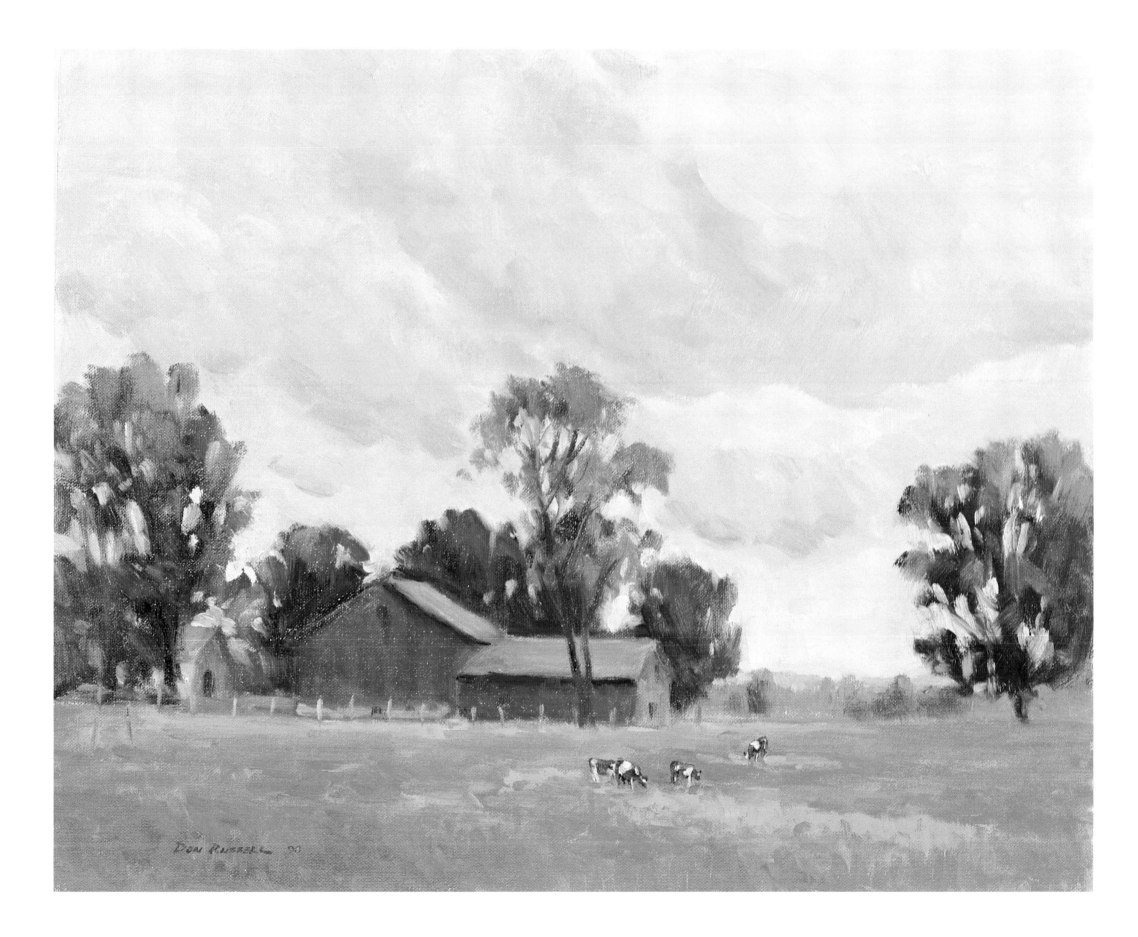

FAYETTE COUNTY

Furs, water, railroads, and automobiles—together with industrial innovation—have marked the history of Fayette County.

John Conner came into what is now Fayette County in the early 1800s and established a trading post, today's Connersville, along the west fork of the Whitewater River. His brother, William, was also a frontier trader and entrepreneur near Noblesville and, between them, they developed a highly profitable fur trade with the Indians. John Conner established the original plat for Connersville, which had only three houses when Indiana became a state in 1816.

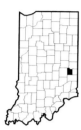 The first barge arrived in Connersville the same year the Whitewater Canal was completed (in 1845), connecting the Ohio River to Connersville, and the town, now the county seat, began to grow. The historic Canal House, built in 1842 to be the headquarters for the canal company, is one of the outstanding examples of Greek Revival architecture in Indiana and is listed on the National Register of Historic Places. At various times a residence and a bank, it is owned today by Historic Connersville, Inc. and is open to the public by arrangement.

Business grew when John B. McFarlan Sr. moved his buggy manufacturing operation to Connersville in 1886. Wanting buggy components to be easily available and wanting to cut costs, he converted a cornfield into what might be the nation's first industrial park.

When the Roots brothers were attempting to design a better waterwheel for their Roots Woolen Mill, they hit upon a system of moving air now referred to as the Roots principle. Fayette County's oldest industry, the now-named Roots Division of Dresser Industries, produces rotary blowers, vacuum pumps, and centrifugal compressors. Their Western Tornado blower in 1867 was used in the construction of the New York City subway under Broadway and could move 100,000 cubic feet of air per minute.

Railroads tied Connersville to the industrial and passenger world in the late nineteenth and early twentieth centuries. Even now, the Whitewater Valley Railroad continues to operate and, at sixteen miles, is the longest run for a steam engine in the Midwest. Passengers board at the station across the street from the Elmhurst estate, now a Masonic lodge and owned at one time by Caleb Blood Smith, secretary of the interior in Lincoln's cabinet. After following the towpath of the old Whitewater Canal, travelers step off for shopping at Metamora before the return trip to Connersville.

In the 1930s, Connersville became known as "Little Detroit" because of its manufacture of automobiles. The major firm was the Lexington Motor Car Company, owned by the brothers E. W. and William Ansted. Lexington cars dominated the popular Pike's Peak Hill Climb in the early 1920s until the firm failed in 1926 and was purchased by the Auburn Automobile Company, makers of the Cord and Auburn. The American Automobile Manufacturers Association identifies ten makes of autos as cars made in Connersville. Stant Manufacturing, Inc. had an early reputation as a designer of auto hood ornaments, their most famous being the "flying quail" on the 1928 Ford Model A. Today, Fayette County involvement in the auto industry continues through Stant, the world's largest producer of fuel, oil, and radiator caps, and Visteon Automotive Systems, makers of climate control systems and fuel injection components and the county's largest employer with more than 3,000 workers.

The county's Mary Gray Bird Sanctuary, south of Connersville, is the 650-acre home of the Indiana Audubon Society. The Shrader Weaver Nature Preserve is 107 acres of virgin forest, recognized by the Department of the Interior as a natural landmark.

The county, established in 1819, is named after the Marquis de Lafayette, who aided the colonists in the American Revolution.

"In the early spring, I made my second trip to Fayette County. The yellow-green color in this distant valley west of Connersville assured me that spring had arrived. The open valley floor with the winding creek and horses in the distance was a peaceful view. Some winter colors still remained in the far-off trees: gray-red with new, pale green leaves."

RONALD MACK
"Spring Valley"
Oil on canvas 16 x 20 inches

FLOYD COUNTY

Like many cities and counties in southern Indiana, the history of New Albany and Floyd County is inextricably tied to the Ohio River.

That's how the first white settlers reached the area. After braving the Falls of the Ohio, they arrived at this forested land with limestone knobs that rise to 1,000 feet above sea level. Not all of the land was knobby. A wide and more level path—the Buffalo Trace—cut northwest toward Vincennes. This was the route of buffalo herds migrating from the Illinois plains to the salt licks in Kentucky. Later, after Indiana was a state, a project was started to pave the path. Before it could be finished, the state was nearly bankrupt and had to sell the partially completed road, which then became a private toll road. The first stagecoach rumbled over it in 1820, going from New Albany to Paoli.

Railroads played their part, too. The Louisville, New Albany, and Chicago Railroad—today's Louisville and Nashville Railroad—dug a nearly 5,000-foot tunnel (completed in 1881) when it reached the knobs that ultimately cost about $1 million. The tunnel is still used today.

New Albany takes its name from Albany, New York. Three Scribner brothers—Abner, Joel, and Nathaniel—purchased the land for development and named their city after the capital of the state from which they had set out for the West. The Scribners, especially Nathaniel, played a key role in petitioning Indiana to separate what was to become Floyd County in 1819 from Clark and Harrison counties. It's the second smallest county in Indiana; Ohio County in southeastern Indiana is the smallest.

The Joel and Mary Scribner house, built in 1814, stands on Main Street. The most famous house, however, is the William S. Culbertson mansion, built between 1867 and 1869. Now a state historic site, the three-story brick structure encompasses 20,000 square feet and has twenty-five rooms—reflecting the affluence of one of the state's wealthiest men.

New Albany quickly became a busy river town. Until locks were built on the Louisville side of the river, New Albany was one of the largest of the frontier towns; in 1850 it was the largest city in Indiana. Shipbuilding was the major business. In a fifty-year period, some 350 steamboats were built, including the famous Robert E. Lee. Because New Albany was downriver from the Falls of the Ohio, many of the shipbuilders' customers were from the South. With the onset of the Civil War, this business came to an end.

During the war, New Albany became a supply center for the Union armies in the West and also a hospital center for wounded soldiers. President Lincoln established one of the first national cemeteries in New Albany.

After the war, New Albany businessmen developed hardwood, plywood, and veneer industries. One account has it that by 1920 New Albany was producing more plywood than any other place in the world. Other important industries today include electrical components, plastic, metal-working equipment, and the manufacture of shirts, plaques, and awards.

New Albany established Indiana's first public high school in 1853. The New Albany-Floyd County Consolidated School Corporation was the state's first countywide school system.

The naming of the county is disputed. The popular belief is that it is named for Davis Floyd, a territorial politician and the first judge in the county. Others claim it commemorates a Kentuckian, John Floyd, who was killed in a frontier skirmish.

"Rich in culture and with [an] interest in the arts, New Albany was my choice for a painting in Floyd County. This scene along Main Street displays the labor of love the people of this town have put into restoring this part of town and the beautiful results they have achieved."

LYLE DENNEY
"Main Street, New Albany"
Oil on canvas 18 x 27 inches

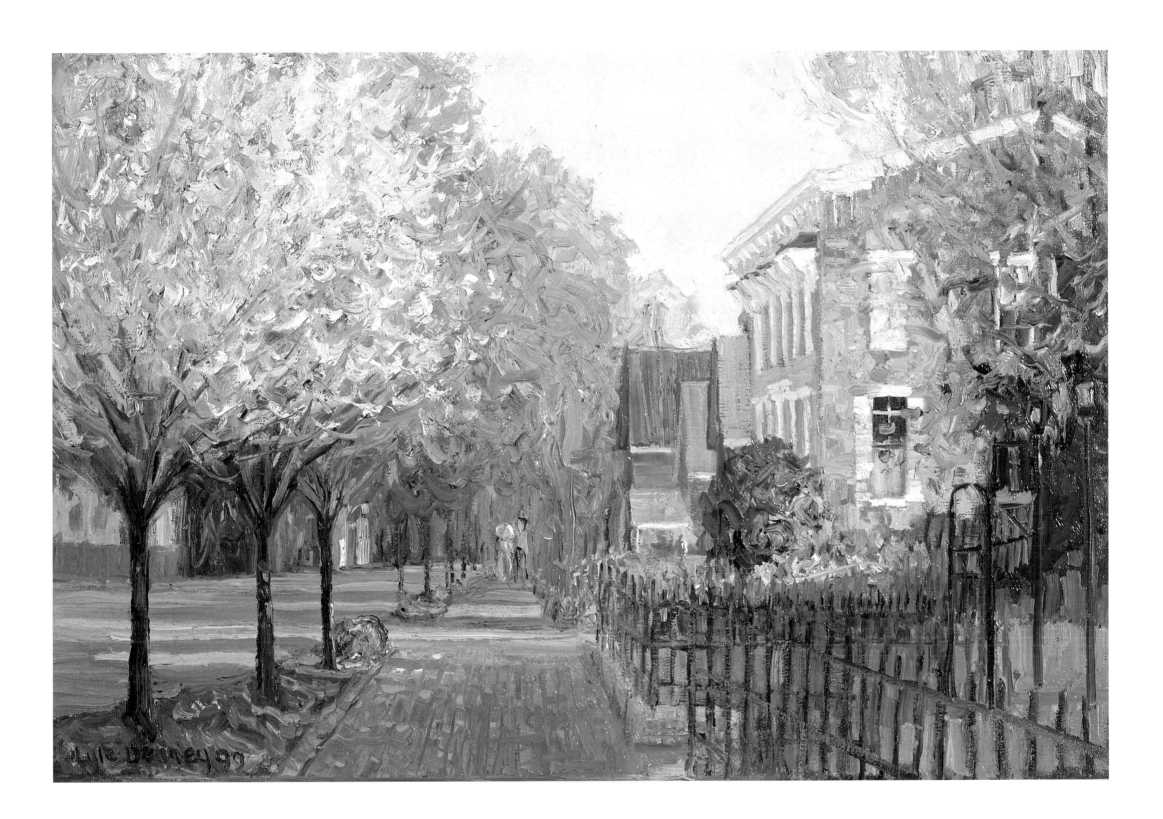

FOUNTAIN COUNTY

When towns were platted in the early 1820s, hotels, saloons, opera houses, and other businesses were soon operating in the growing communities. The Wabash River brought water traffic along the western border and the Wabash and Erie Canal, which reached Attica and Covington in 1846, brought more rewards and economic promise to Fountain County.

But when the canal closed in the mid-1870s, the economy shut down, too. Only the opening of several railroads saved the three largest towns from serious population decline. Today, Attica, Veedersburg, and Covington, the county seat, are towns with populations between 2,000 and 3,000 in a county with a total population of about 17,000. Some smaller communities, surrounded by farmland, dot the landscape in the county's eleven townships. Many residents have ancestors who were among the first white settlers to arrive in the county in the early 1800s.

Agriculture still provides the major work for the county although manufacturing exists in factories making bumpers, steel fabricating and castings, and radio components. Family businesses provide everything from car repair and carpentry to veterinary care.

Tourists are drawn to the county by hunting, which is one of the favorite pastimes for visitors and county residents alike, with deer, ducks, geese, rabbits, and occasionally a wild turkey, pheasant, or quail spotted in the fields. Other draws include several local festivals and events, such as the Potawatomi Festival, the Apple Fest, the Hillsboro Barbecue, and the Fourth of July celebrations. Other tourist attractions include remnants of the old Wabash and Erie Canal, a natural rock formation called Portland Arch, and the murals in the county courthouse in Covington. These murals were painted by county residents under the direction of Eugene Savage, an internationally known muralist, who was raised in the county. Savage painted the two large murals on either side of the east entrance in his New York studio before they were transported to their permanent installation. Residents have recently been working to preserve them. Other murals were repaired several years ago, some by the original artists.

Residents have also worked to preserve some of the oldest homes and buildings in the county. In 1993, the entire downtown and several homes in Attica were placed on the National Register of Historic Places. Among them is perhaps the oldest private home in Attica, located on Brady Street. It was built in 1839 and the wooden structure that comprises the front of the house was used as the first frame schoolhouse in Attica. A back addition was added in 1883. The oldest building in downtown Attica is the McDonald house, constructed in 1840.

Fountain County's three covered bridges are all Howe truss spans—X-beams along each side of the bridge. The 1871 Wallace covered bridge over Sugar Mill Creek, southeast of the town of Wallace in southeastern Fountain County, was originally built as an interurban bridge. The longest of the three at 150 feet, Cade's Mill over Coal Creek is also the oldest, built in 1854. The only one still in use, though, is the one that was built near Rob Roy in 1860.

Three Indiana Congressmen were born in Fountain County—Fred S. Purnell, Cecil Murray Harden, and John T. Myers. One political aspirant, Edward A. Hannegan, took up the slogan "54-40 or fight" in a campaign during one of the United States's border disputes with the British in the northwest. The slogan is sometimes remembered today; his candidacy is not. Another one-time resident was General Lew Wallace, best remembered for his work *Ben-Hur*.

The county, created by the Indiana legislature in 1825, is named for Major James Fountain, a Kentucky frontiersman who was killed at Fort Wayne in the Battle of Maumee in 1790.

"The landscape near Veedersburg says pastoral farm all over it, and that certainly typifies this part of Indiana. As I painted on this perfect evening, cows gathered behind me to see what I was doing. There they stood, studying my canvas as if to see if I'd represented them well. They'd look at each other, bawl, and then look back at my painting . . . it was so funny I laughed out loud! There they stayed until the farmer's wife brought them grain, coaxing them downstream, where you see them in the painting."

LYLE DENNEY
"Late Summer on the Helms' Farm"
Oil on canvas 24 x 36 inches

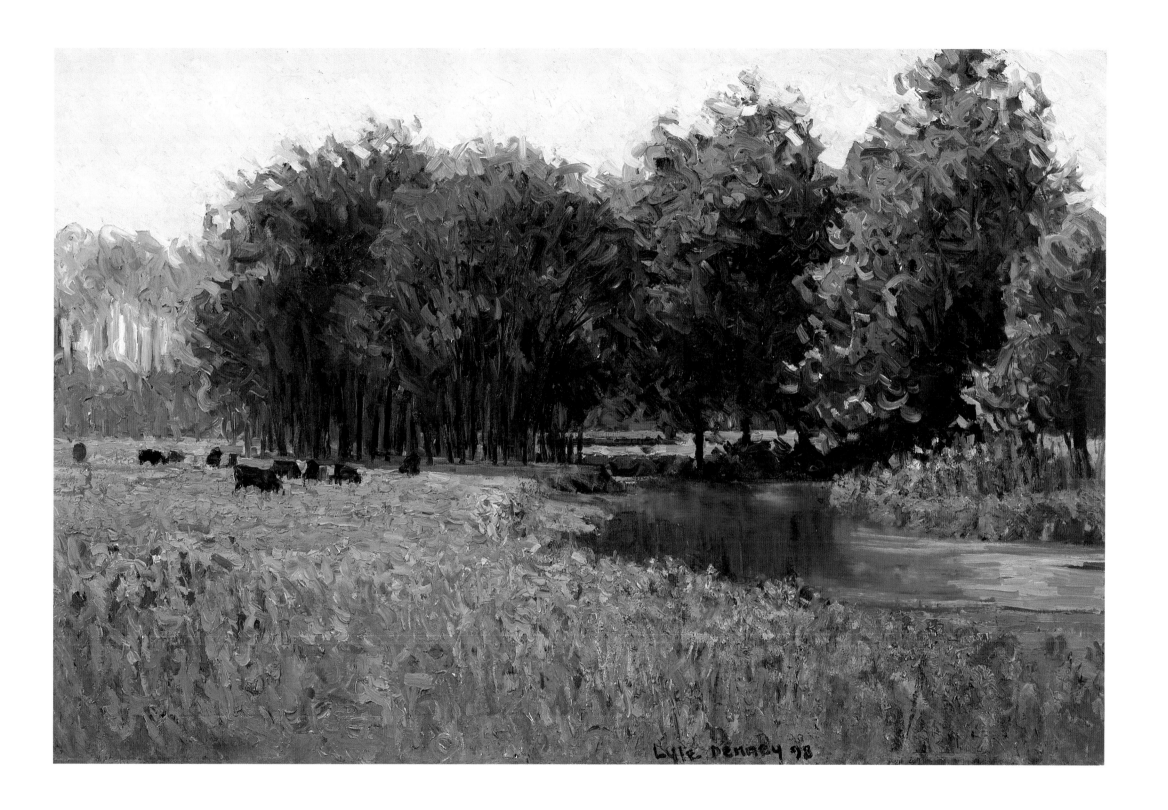

Lyle Denney 98

FRANKLIN COUNTY

Franklin County's appeal is a combination of the scenic landscape that artists love and the outdoor life at Brookville Lake State Park.

The scenery prompted two young artists in 1898 to set up their painting studio at Brookville. T. C. Steele and J. Ottis Adams had been painting at Metamora when they followed the east branch of the Whitewater River down to Brookville. There they found an isolated house, built in 1835 by James Speer, where they could paint in near isolation. They called it The Hermitage and, over the years as other painters joined them, they became known as The Hoosier Group. A short time after the death

of his first wife, T. C. Steele sold his half-interest in the house to Adams and moved to Brown County, where he built his famous House of the Singing Winds and continued his painting career. Adams, who helped found the Herron School of Art in Indianapolis, continued to paint at The Hermitage, where an artists' colony grew up around him. Exhibits at The Hermitage look to the future these days by including the works of young, aspiring artists from the local schools.

Brookville was settled in 1808, long before the artists arrived. Situated between the east and west forks of the Whitewater River, it was an important point of entry into the lands of the old Northwest Territory. It quickly became a political and cultural center of the new state with three governors, in office between 1825 and 1840, calling Brookville their home. When the land office was moved to Indianapolis in 1825, decline seemed inevitable until the canal came through in 1836. Prosperity lasted for another 35 years after that.

Up north, the Brookville Lake State Park attracts visitors by the thousands. Brookville Lake and adjacent Whitewater State Park in Union County cover more than 23,000 square acres—only the Monroe and Patoka reservoirs are larger. Work was started in 1938 in an effort to control flooding and the lake became operational in 1974. Making the lake, community water supplies, and recreation possible was the construction of the 2,800-foot earthen Brookville Dam with a drainage area of 379 square miles. Along the southern part of Brookville Lake are the Mounds, prehistoric sites of which there are but traces today because of excavation, erosion, and cultivation.

The region is also known for Metamora. Once a flourishing community with the Whitewater Canal doing good business, the area suffered in the 1870s, due to the railroads. Today, however, Metamora has rebounded and is a favorite tourist spot with about a hundred shops and restaurants located in historic buildings. There's also a canal boat trip, the Whitewater Valley Railroad excursion from Connorsville, and its numerous special celebrations.

A portion of the canal and locks was purchased in 1938 by the Whitewater Canal Association. It's the only working aqueduct remaining in the United States, repaired in 1998–99 when a leak was discovered. At the same time, the canal bed was restored to include the area within the town and around the nearby lock.

Another prominent tourist city is Oldenberg, just north of the Ripley County border and Interstate 74. Its architectural design has led to its being called an Old World German "Village of Spires."

The county, organized in 1811, is named after Benjamin Franklin, the Mr. Everything of the eighteenth century. One of his most important feats was negotiating peace terms with the British following the Revolutionary War.

"I saw some great painting areas from Oldenburg to Brookville. I would like to spend more time in the area to become familiar with the light of the various seasons and times of day. Unfortunately, the project does not allow for that kind of time now. I chose to paint this exciting view of the Little Cedar Creek east of Brookville for the colorful lighting of the fall trees."

DON RUSSELL
"Little Cedar Creek"
Oil on linen 18 x 24 inches

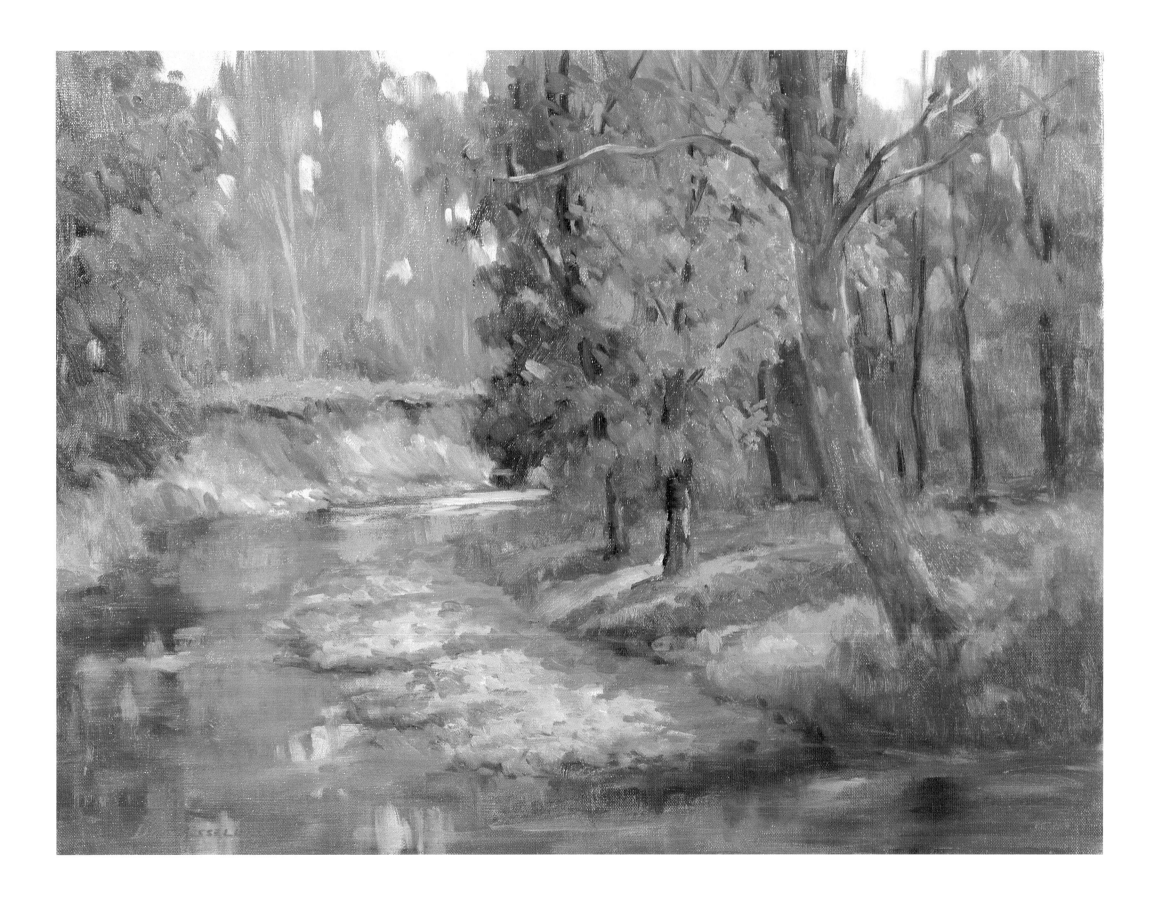

FULTON COUNTY

The date was September 4, 1838. Fulton County was three years old. As one piece of land after another was ceded to the ever-encroaching white settlers, the final step was the removal of the Potawatomi and the Miami, urged for years by politicians, agents, and settlers in the new state of Indiana. The Potawatomi were the first to go. When some of them resisted, armed militia arrived at Twin Lakes north of the county and, on that September date, marched nearly 900 Potawatomi down Main Street in Rochester on their way to Kansas. The Indians were told that they would be away from the whiskey of the whites and could re-establish their culture. At least forty persons died en route, mostly of typhoid fever. Their journey would later be called the "Trail of Death."

Today, the event is marked by the Trail of Courage Living History Festival held the third weekend in September on the Fulton County Historical Society grounds, four miles north of Rochester on the Tippecanoe River. Nearly 20,000 people, including descendants of the forced march, stay in tents and teepees and exhibit a pre-1840 way of life.

On the historical society's thirty-five-acre grounds is a living history village called Loyal. It's named after a nearby village which changed its name from Germany to Loyal during World War I. At present, the grounds include the Rochester train depot, a log cabin, an 1832 stagecoach inn which is the oldest building in the county, a print shop, blacksmith shop, Kewanna jail, doctor's office, 1920 general store, and railcar garage, plus a round brooder house, windmill, iron foot bridge, and a privy! To be added are a cider mill, a one-room schoolhouse, and a church.

Recollections of the Big Band era, from the 1920s to the 1940s, are centered around Lake Manitou, a resort with large hotels where famous bands entertained. Trains would come from as far as Indianapolis, with vacationers arriving to dance away the weekends. Manitou is also the site of the so-called Manitou Monster, seen by whites and Indians in the 1830s. No sightings have occurred in recent times—unless you include the Manitou Monster slide at the new playground in the Rochester city park.

Fulton County is known as the county of round barns. These structures were popular in the early twentieth century because they could supposedly be built faster, more easily, and more cheaply. At one time, seventeen round barns existed in the county, but time, fire, and tornadoes have reduced that number to eight. Three have been placed on the National Register of Historic Places and one, the Leedy-Partridge-Paxton barn, is now the Round Barn Museum. It was originally built in 1924, was later hit by a tornado, and then it was restored in 1990–91.

Rochester was the winter home of the Clyde Beatty Cole Brothers Circus from 1934 until 1940, when their quarters were destroyed by fire. During that six-year period, a number of famous circus performers were frequently seen around town, including probably the most famous circus clown of all time, Emmett Kelly, and the 1930s cowboy star Ken Maynard.

The first Tarzan of the movies—in a silent film in 1918—was Elmo Lincoln, né Otto Elmo Linkenhelt, who was born in Fulton County. Former Governor Otis E. Bowen (1971–80) was also born here. He later served in President Reagan's cabinet as secretary of health and human services.

The county, established in 1835, is named for Robert Fulton, inventor of the steamboat but also credited with invention of the submarine, torpedo, and a machine that twisted hemp into rope.

"After spending all morning driving the county, I was intrigued by this view of the water and trees by the Tippecanoe River in this area along 700 North near Rochester. After completing my painting, I discovered that I had painted behind the home of my kids' orthodontist!"

DON RUSSELL
"Tippecanoe River, North Bank"
Oil on linen 16 x 20 inches

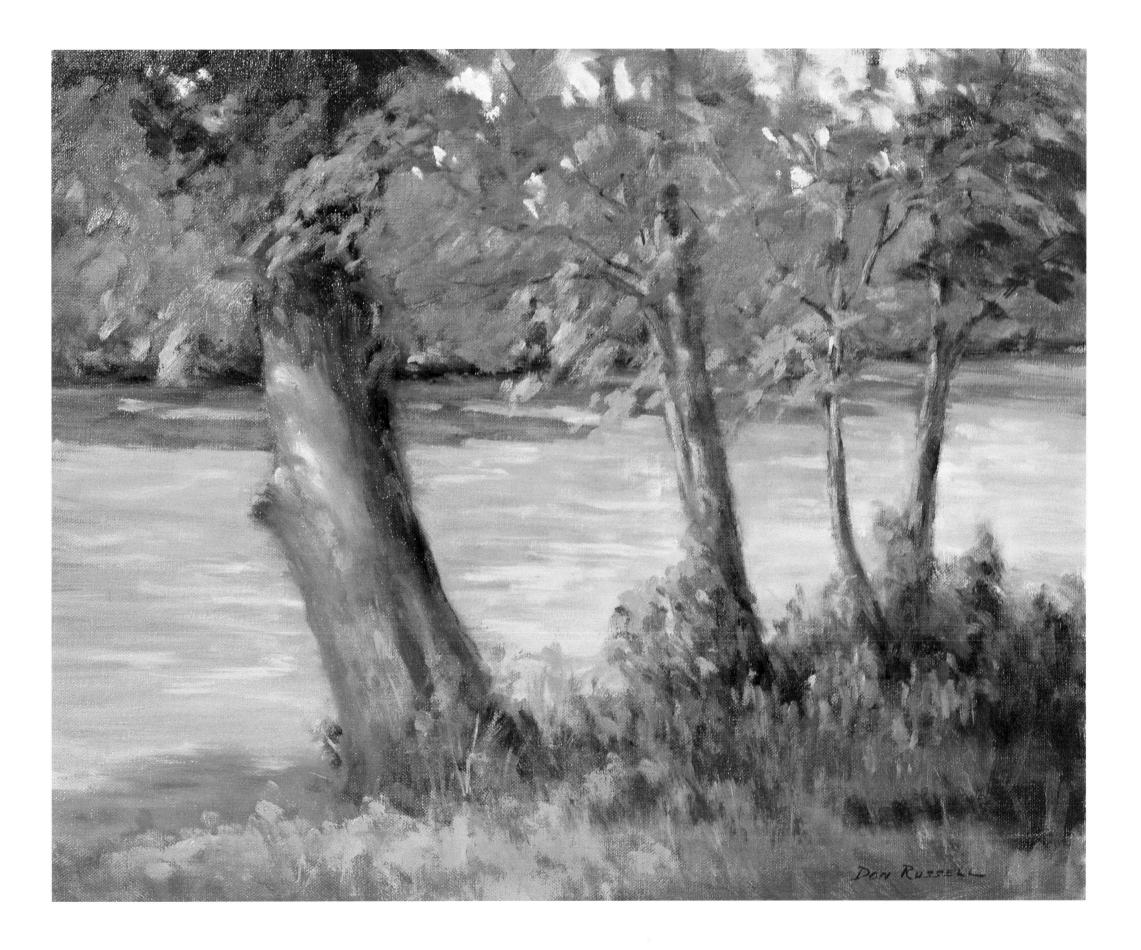

Don Russell

GIBSON COUNTY

Indiana's oldest restaurant where Lincoln once stopped. Indiana's newest major manufacturing plant. An 1884 courthouse considered one of the best examples of the Romanesque Revival style. The third largest coal-fired generating station in the world. Gently undulating river bottom lands and plateaus with deep valleys. Rivers, a nearby interstate, and a university. Famous former residents including Orville Redenbacher, the popcorn king, and Dave Thomas, founder of Wendy's restaurants.

This is a snapshot of Gibson County, but the biggest news in years occurred when Toyota Motor Manufacturing Indiana, Inc. decided to build its new $700 million automotive manufacturing facility between Princeton and Ft. Branch on U.S. 41. Immediately, it became the largest county employer by far with 1,300 workers. When Phase II is completed at a cost of another $500 million, an additional 1,000 workers are expected. Its impact is clear when one realizes that the major employer in the county prior to Toyota was the Cinergy/PSI Energy generating station with 525 employees. Nearly 20 percent of the county's work force had been employed in Vanderburgh County, most of them in Evansville, and that has changed.

But other aspects of the county haven't. The county courthouse in Princeton (the county seat) stands much as it was when built in 1884. Its four corner towers frame four central entryways. A clock tower rises above the center of the structure where the U.S. flag waves above a widow's walk (a railed, rooftop gallery). Mosaic tiles cover most of the hallways on the first and second floors with offices retaining their original oak floors.

Another landmark, an 1825 log cabin stagecoach station, the Log Inn, one mile off of U.S. 41, is recognized as the oldest restaurant of continuous business in Indiana. It was in 1844 that Abraham Lincoln, campaigning for Henry Clay on the Whig ticket, stopped on his way from Evansville, as he was heading home to Illinois. He visited his mother's gravesite in Spencer County on this trip, the only time he is known to have done so. The cabin has had several additions, including an upstairs dance hall. The story is that in the 1960s the owners discovered the log cabin under more recent exteriors.

The Historic Landmarks Foundation of Indiana has named Lyles Station, the last remaining of the original African-American settlements in Indiana, one of ten most endangered landmarks. Just west of Princeton, the station was founded in 1849 by freed slaves from Tennessee. It was part of the Underground Railroad and was a thriving educational and commercial center. A corporation was formed in 1997 to preserve the buildings and artifacts of the settlement.

Oakland City University is located in the eastern part of the county. Founded by the Baptists in 1885, it changed from a college to a university in 1995.

Gibson County was part of Knox County until 1813. It is named after General John Gibson, a frontiersman who, in a day of men of all-around expertise, outdid most of his contemporaries. A Revolutionary war soldier and second in command to George Rogers Clark on his expedition to fight the British, he had once been captured by Indians. He learned the languages and customs of his captors and later became a skilled negotiator. Jefferson appointed him territorial secretary for Indiana after Gibson served as a government administrator in western Pennsylvania.

To name the new county seat, four commissioners drew lots and Captain William Prince won. Naturally, it became Princeton. Although the first house was built in 1814, Princeton was not incorporated as a city until 1884.

"Saunders Woods and Coffee Bayou make up 1,000 acres of 'wet' forests—woods that need periodic flooding from rivers to thrive. Donated in 1998 to the Nature Conservancy, the tracts constitute the largest piece of bottomland forest in the lower Wabash River Valley. Hardwood trees, such as pin and overcup oak, shellbark hickory, and pecan, grow in this preserve, a critical stopover for migratory birds. Rare for the Midwest, the area has not been farmed for hundreds of years. I chose to paint the woods to show the natural wonder of our state and to capture the beauty of nature left untouched. When I set up, I heard a woodpecker in the background, black birds, tree frogs, and an oil pump. A young man checking the pump told me the well pumps crude oil and salt water and is checked daily. I also painted at Coffee Bayou. I took a picture of my painting van under a road sign—1375W 150 S—with a fish hanging from it."

ROBERT EBERLE
"Saunders Woods Legacy"
Oil on linen 20 x 16 inches

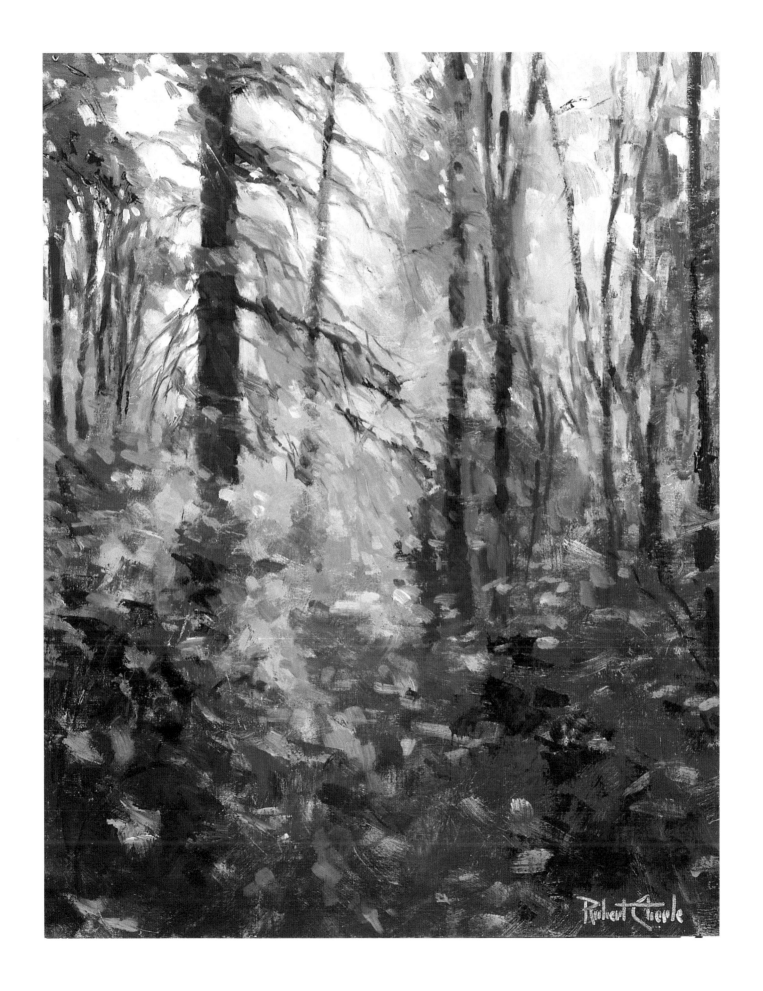

GRANT COUNTY

The assumption might easily be made that Grant County was named for General and later President Ulysses S. Grant. While understandable, a quick mathematical check makes that most unlikely. Grant County was founded in 1831 and General Grant was an unknown for 30 years more. The county was in fact named after two Kentucky frontier fighters, Captains Moses and Samuel Grant, who died in frontier Indian battles in southern Indiana.

For recent generations, however, the naming of the county is of little consequence. Nor is the naming of the county seat, Marion, so called after the Revolutionary War hero, General Francis Marion, the "swamp fox" who eluded the British with his highly successful hit-and-run tactics.

Grant County is now known as the birthplace of James Dean, who, although he made only three motion pictures, remains a cult hero for the 1950s generation. He was born in Marion, lived briefly in Fairmount, and then moved with his parents to California. His mother died when he was nine years old, and he was sent back to Fairmount to be raised by his aunt and uncle on a farm. When he was killed in a California automobile accident on September 30, 1955, his body was sent to Fairmount for the funeral and burial. Fans from all over the world visit his gravesite. These same visitors also go to the Fairmount Historical Museum with its Dean collection as well as to the James Dean Gallery, a memorabilia site. A September festival, Fairmount Museum Days: Remembering James Dean, draws thousands to town and to the James Dean Run car show.

Another Fairmount native and now a resident of nearby Muncie is Jim Davis, creator of the Garfield comic strip, which appears in more than 2,500 newspapers. Davis also grew up on a Fairmount farm.

Fairmount farms are known for more than their famous residents: Corn, soybeans, winter wheat, and tomatoes are major crops, as well as popcorn, especially around Van Buren, the self-styled "popcorn capital of the world."

The Mississinewa River enters southeast Grant County at Matthews, which has the county's only covered bridge. The Cumberland Covered Bridge Festival takes place around this 175-foot single-span truss. North of Marion, the Mississinewa becomes Lake Mississinewa, a state recreational area that crosses into Wabash and Miami counties before it empties into the Wabash River.

Just north of Marion along the banks of the Mississinewa River, the Miami were defeated in a December 17–18, 1812, battle that marked the end of fighting in Indiana during the War of 1812. The battle is commemorated annually with a battle reenactment, a Native American village, and other frontier life experiences. It attracts about 30,000 people during an October weekend.

A Union Army veteran, Colonel George W. Steele, was elected to the Congress and introduced legislation to establish a home for disabled soldiers. It was built on the southeast edge of Marion and continues today as the Veterans Administration Medical Center.

Marion and other county towns such as Gas City, Upland, Matthews, and Fairmount were part of the gas boom in the late 1800s. In one three-year period, the population of Marion tripled. As with other cities, the end of large amounts of natural gas prior to World War I also meant the end of rapid expansion.

Among Marion industries, including General Motors and Thomson Consumer Electronics today, was Crosley Motors, Inc. which, shortly after World War II, built the Crosley, a compact automobile.

Since the Depression days, Marion and area citizens have produced the sunrise service Easter Pageant, the story of Christ's last week on Earth.

"I met some hunters in Matthews while buying very necessary bug spray. They told me about the Miami Indian battleground along the Mississinewa, where an 1812 reenactment is held every year. It is a beautiful and peaceful place with high bluffs along the river. I was struck by the contrast of movement and stillness. The water flowing over the rocks, rushing down the river, played against the stillness of the trees and unmoving stones. It was here I chose to paint. We met many friendly, helpful people in Grant County. One couple even loaned us a book about Fairmount. They have made the project a joy to be part of."

ROBERT EBERLE
"On the Mississinewa"
Oil on linen 14.5 x 20 inches

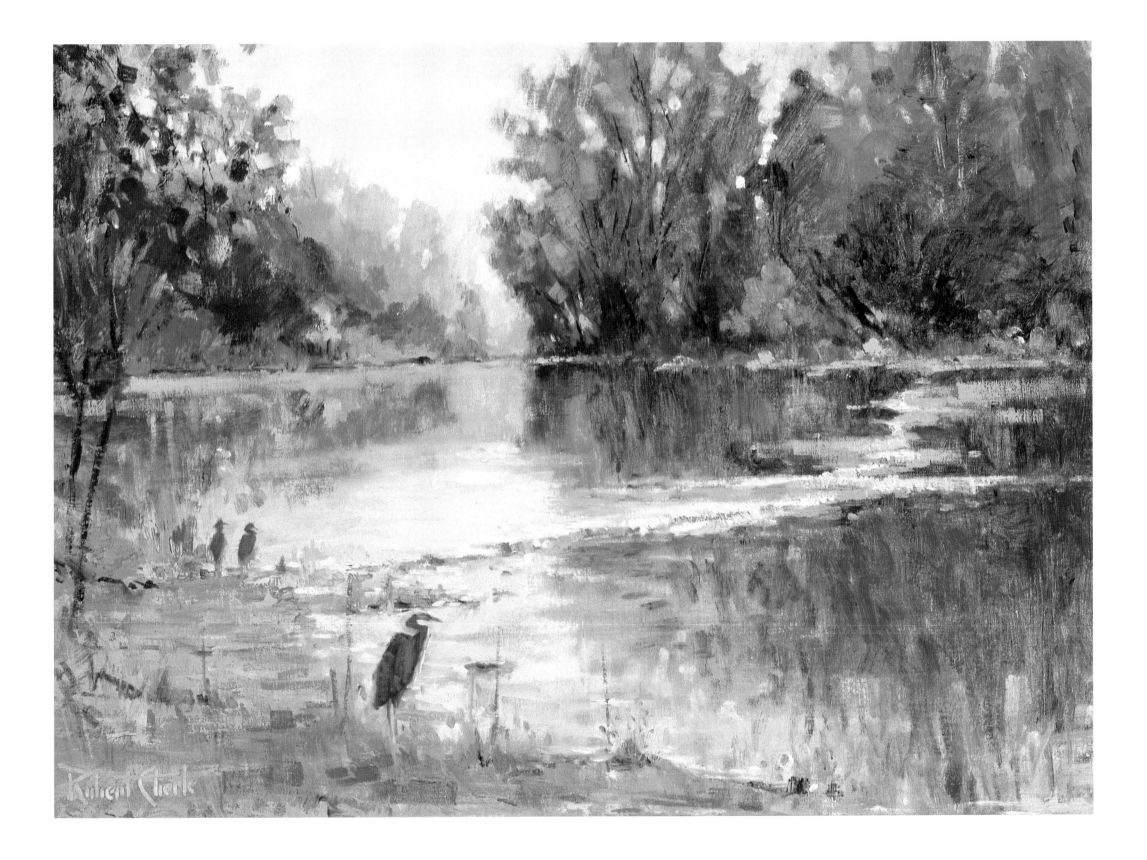

GREENE COUNTY

The Illinois Railroad calls it Bridge X75-6. Some call it the Tulip Trestle, since it is just southeast of the community of Tulip. But most people in Greene County refer to it as the Viaduct. "It" is believed to be the third-longest railroad bridge in the world, a skeletal-steel trestle built during 1905–1906, stretching a half-mile as it spans Richland Creek and a valley between Tulip and Solsberry in eastern Greene County. At its highest point, it is 157 feet and its cost at completion was $1 million at a time when a million dollars was a lot of money.

The story behind the viaduct is as fascinating as is the view of the railroad trestle. Its engineers conceived the viaduct as a way to shorten the distance between Indianapolis and Effingham, Illinois. The Indianapolis Southern Railroad went bankrupt trying to build a line to Illinois and sold out to the Illinois Central Railroad. Work continued, despite imported laborers, high absenteeism, contractors pulling out, poor communications due to the lack of a common language resulting in, for example, dynamite going off prematurely, daily fights, and not a few murders. Ultimately, out in this wilderness and chaos, concrete bases were formed, tower girders raised, and spans installed. When finished, it contained an estimated 3,000 tons of steel and cost four times the initial estimate. It is still used today to move coal.

Another Greene County giant was the sycamore tree that grew near Worthington until it was blown down by a windstorm in the 1920s. Arguments abounded in several communities about the largest broad leaf tree in the eastern United States—or perhaps in North America? In the world? The Worthington claim was based on the tree's 150-foot height, 100-foot spread, and circumference of forty-five feet, three inches—measured at one foot above the ground. The tree was estimated to be about 500 years old but was decaying badly when it finally crashed to the ground. One piece of a limb is now in the Worthington City Park, planted in concrete and protected by a roof.

While it may not be the biggest, the Greene County Drive-In theater near Linton does claim to be the oldest in Indiana, starting business in 1948. The theater's only changes have been the replacement of the screen, due to tornado damage, and individual car speakers instead of the original two big speakers mounted on the screen.

One top form of recreation is fishing in the county's many lakes, rivers, and strip-mined pits. Tourists are drawn to Shakamak State Park—1,766 acres of three lakes, an Olympic-size swimming pool, cabins, campgrounds, and hiking trails in northwestern Greene and Sullivan counties. Much of the work on the park was done in the early 1930s by the Civilian Conservation Corps with reclaimed coal-mined land.

Greene County was one of several southern Indiana counties traversed by the ill-fated Wabash and Erie Canal. It entered the county at the northern border and went down the middle, following the Eel River to the west fork of the White River and then to the county's southern border. The canal wasn't completed until 1853 and, by then, the railroads were already sounding its death knell.

Coal mining and agriculture remain the county's major industries. Corn and soybeans are the biggest cash crops, along with livestock.

The county was organized in 1821 and is named after General Nathaniel Greene, a Revolutionary War hero.

"I find the eastern side of Greene County one of the most rugged and beautiful areas of Indiana. As my navigator, Anne Carter, and I meandered down many a gravel road, we found this gentle pasture with an awesome view of the rolling hills to the east. When our work was done we traveled on, detecting the unsavory odor of dead animal traveling with us. Anne had noticed the remains of an unlucky deer near where we were parked and had apparently waltzed right through it. With the truck windows down, we headed for the nearest spot to wash off her boots, then continued our meandering."

DAN WOODSON
"Autumn Light"
Oil on canvas 16 x 24 inches

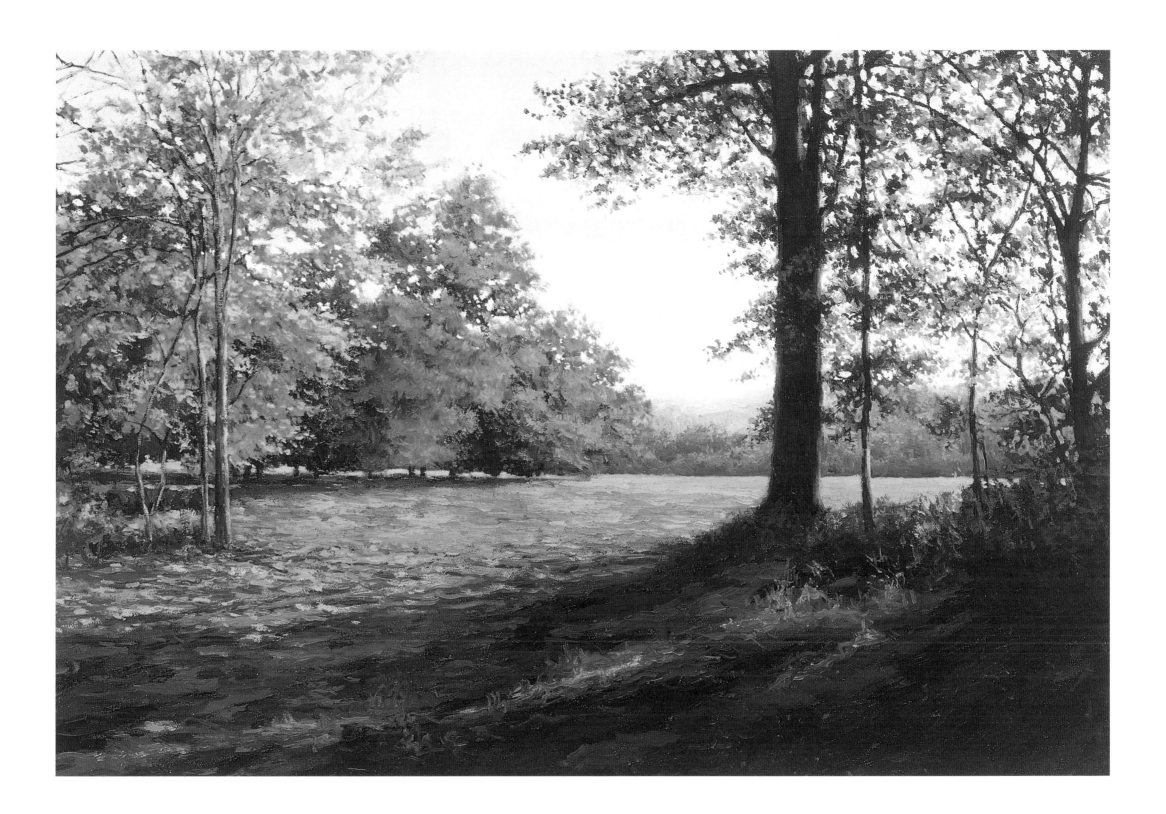

HAMILTON COUNTY

First, Americans moved west. Next, they moved into the cities. Then, they moved from the South to the North. Soon after came the flight to the suburbs. Now, the movement is back into the rural areas of the nation. Hamilton County, which has long been farmland and small towns, became the most rapidly growing county in Indiana during the last decade of the twentieth century, when it experienced a nearly 50 percent increase in population. The forty-first most rapidly growing county in the nation, its growth came as Indianapolis continued to sprawl in all directions, particularly north into Hamilton.

When will it end? It could stop when the commute to Indianapolis simply becomes too far, or some years from now when the farmland is gone. But, for now, Hamilton County has what many Americans seem to want: quiet, rural countryside next to upscale housing developments and the conveniences of the big city a short distance away.

Considerable growth has occurred at Geist Reservoir in southeastern Hamilton County, a popular building area shared with Marion County to the south. The Morse Reservoir in the center of the county, north of Noblesville, is another building spot sought by home owners who want to be near water. Fishing, of course, is popular, as is golf with fifteen public courses available in the county.

One of the county's major visitors' attractions is built on its past. Conner Prairie, a living history museum in Fishers, is rated one of the top seven such museums in the nation, getting the highest ranking for authenticity and entertainment. More than 300,000 persons annually visit the Federal-style home and lands pioneered by William Conner nearly 200 years ago. With Conner's home, the 1836 Prairietown Village, and a pioneer adventure area already in place, the museum at the end of the twentieth century was renovating its visitors center and adding a riverfront with trading post, flatboat, and a former encampment site of the Delaware. Coming next will be a Quaker meetinghouse and an 1886 working farm. Symphonies on the Prairie are an audience favorite, performed by the Indianapolis Symphony Orchestra during the summer months.

A second major music site is the 220-acre outdoor amphitheater, Deer Creek Music Center, just off Interstate 69 in southeastern Hamilton County, where popular entertainers of the day perform before audiences of up to 21,000.

Another attraction is the Indiana Transportation Museum and its historic train rides. Located in Forest Park at Noblesville, the museum has artifacts from the steam, diesel, and electric periods of rail history and offers steam and diesel train excursions over thirty-eight miles of track, in some cases combining the ride with dinner. Special trains in August take about 20,000 people to the Indiana State Fair from Fishers Station.

Noblesville, the county seat, has maintained its historic flavor. The city was platted by William Conner and Josiah Polk in 1823. The Peru and Indianapolis Railroad—over whose tracks the historic trains run today—came through the city in 1851, the same year the town was incorporated. Some fifty-three buildings in downtown Noblesville have been placed on the National Register of Historic Places. They include the Hamilton County Courthouse, constructed 1877–79 and restored 1992–94. It is of the French Renaissance style and its two-story courtroom was the site of the 1925 murder trial of the Ku Klux Klan leader D. C. Stephenson.

The county is named after Alexander Hamilton, aide to Washington during the Revolutionary War and the first secretary of the treasury. It was organized in 1823.

"Hamilton County is so beautiful that any artist would be hard pressed to decide where to paint. I opted for the Conner Prairie Settlement with its easy access, attractive traditional landscaping, and interesting buildings and people. I chose a simple theme, the split rail fence. It has protruding posts that appeared random at first glance. Closer study revealed a practical and solid barrier— strong but still soulful with vines and small plants softening the edges. My childhood home had a rail fence in front—I guess it conveys stability to me. Conner Prairie staff allowed me to make numerous visits and I met many kind people as I painted. Many kids who had never seen plein air painting were very enthusiastic. I hope I played a small part in their future interest in art by answering questions and listening to stories about their own art."

ROBERT EBERLE
"Prairie Light"
Oil on canvas 22 x 28 inches

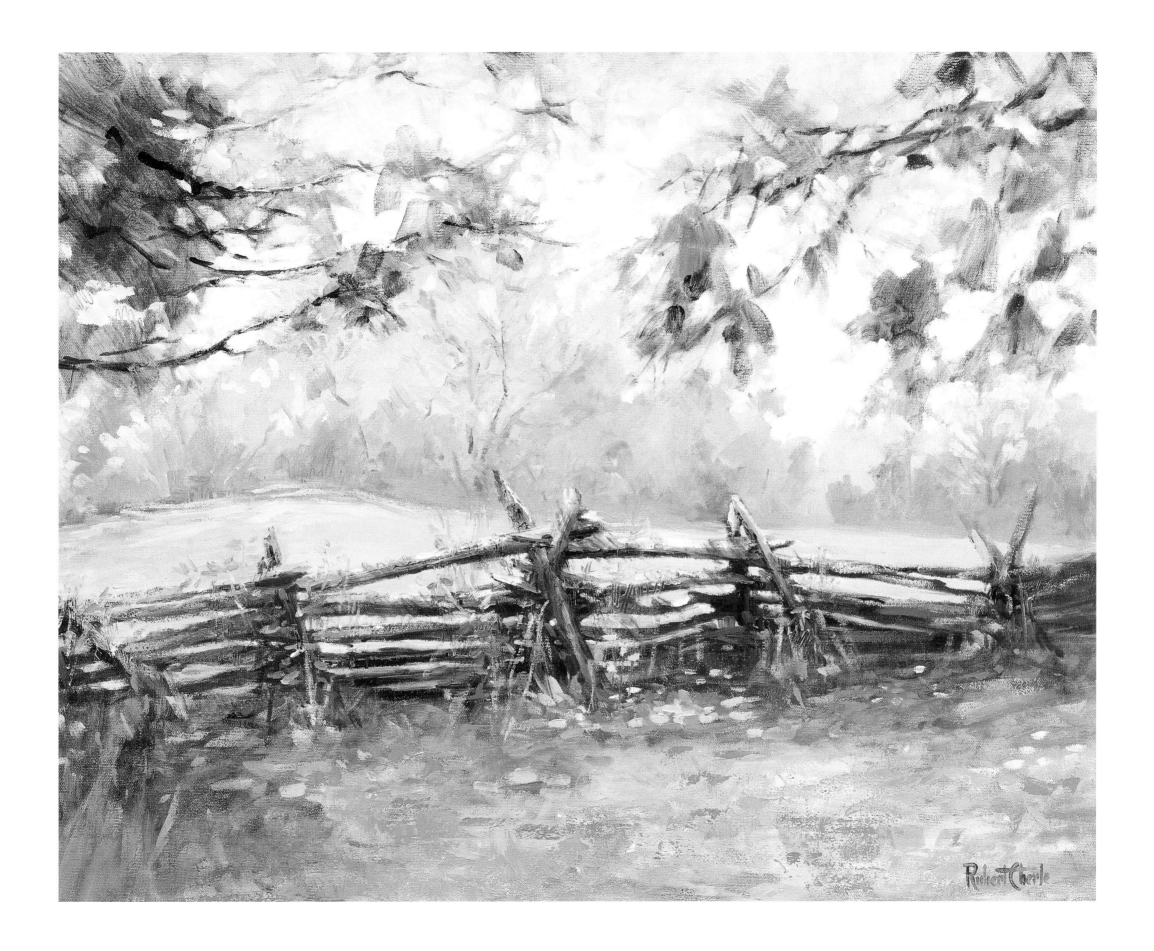

HANCOCK COUNTY

Hancock County is one of several counties in the middle of Indiana where the old and the new co-exist. Nowhere is the distinction more clearly evidenced than with Old National Road, U.S. 40, which goes through the mid part of the county, and newer Interstate 70, which crosses the county to the north. U.S. 40, in the tradition of its day, goes right through the heart of the county seat, Greenfield, while newer Interstate 70 bypasses the main part of the city.

Those aren't the only differences between yesterday and today. Much of Greenfield was built in the late nineteenth and early twentieth centuries. Downtown Greenfield has two historic districts—the Courthouse Square Historic District, centered around the Romanesque/Tudor Gothic Revival 1896 courthouse on the square, and the residential historic area, the major attraction being the 1850 house on Main Street where the Hoosier poet, James Whitcomb Riley, was born and grew to manhood. The Victorian homes, which are part of the residential historic area, were mostly built in the late 1800s when Greenfield and the county were part of the Indiana gas boom. Here, as elsewhere, the gas soon disappeared, ending the growth spurt that Greenfield and other cities experienced.

In contrast, especially in the western part of the county and in homes readily accessible to high speed Interstate 70, are found the newer houses of today's two-county population—people living in Hancock but working in Indianapolis in Marion County. Even the farms that remain in the county, now fewer than 700, have become major operations with rural businessmen utilizing the sophisticated machinery of today as opposed to the labor-intensive farm equipment of their fathers.

Greenfield, however, still remains the center of county activities. A major crafts festival occurs the first weekend of each October to commemorate the October 7, 1849, birthday of Riley. Hundreds of arts and crafts booths, a parade, and Riley Home programs highlight the weekend. The Entertainment on the Courthouse Plaza on Friday evenings in June and July is a popular pastime. In Riley Park, the Old Log Jail, built nearly 150 years ago, attracts visitors, and couples still marry at the chapel in the park, also about 150 years old.

It's the Riley home, though, which receives the most attention. Some of the poet's best-known works were based on his experiences there, including "little Orphant Annie," who worked in the Riley home, and "the old swimmin' hole," which is at Riley Park. The house was built by Riley's father who was, among other things, an accomplished carpenter. Next door is a museum of Riley memorabilia.

What is Hancock County today was first settled in the early 1800s. When Indiana became a state in 1816, Indians still inhabited the area. It was not until the Treaty of St. Mary's in 1818 that Indiana gained possession of these lands. Part of Madison County at the time, Hancock separated and organized in 1828.

The county is named after the first signer of the Declaration of Independence, John Hancock. He wrote his name boldly and in large letters, "so that King George would have no trouble seeing it." Even in recent times, when a person was asked to sign a document, "Put your John Hancock here" was part of the American lexicon.

"This, I was told, was the 'Ol' Swimmin' Hole' referred to in James Whitcomb Riley's poem. I made three trips to Hancock County before deciding on a scene. I missed Riley Park the first two times, until a friend drove me to the site. I was inspired by beautiful patterns of light and shadows in this morning scene."

DON RUSSELL
"Brandywine Creek at Riley Park"
Oil on linen 18 x 28 inches

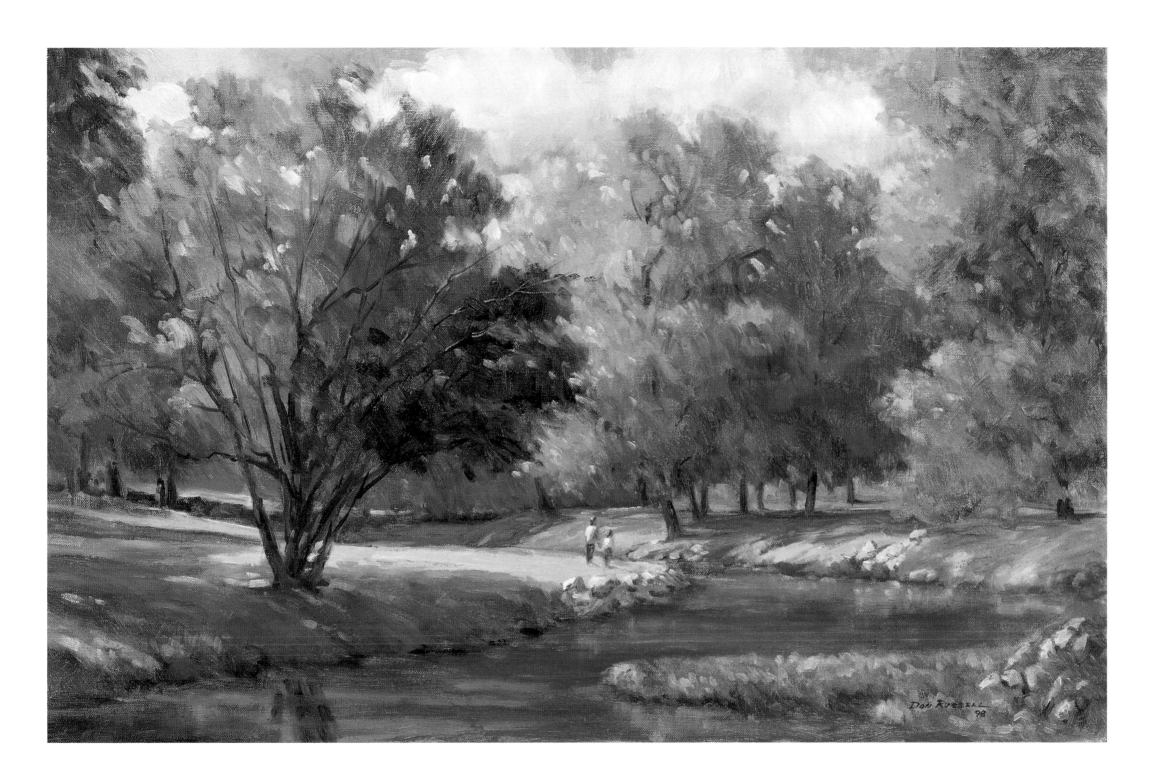

HARRISON COUNTY

If it's Indiana government history you want and you're in Harrison County, then you're in the right place.

When the Illinois Territory was separated from the Indiana Territory in 1809, the old Northwest Territory capital at Vincennes was isolated. The new Indiana capital had to be closer to the civilization of the day, so it was moved east in the direction of the Ohio River to Corydon. At the town square, a new two-story Federal-style limestone building which was to house the Harrison County courthouse was converted (in the planning stages) to make the building Indiana's capitol.

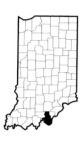

While it was under construction, forty-three delegates from Indiana's thirteen counties gathered in Corydon to write the state constitution. They shared space in the "courthouse on the hill," a log cabin built for Harrison County officials. (This building no longer exists; a private residence was built on the site in 1917.) Because it was summer and hot, and because their space was cramped, the delegates frequently met under the shade of a large tree nearby. The tree, part of which stands today encased in a sandstone memorial, is known as the "constitutional elm." On November 4, 1816, twenty-nine representatives and ten senators moved into the new capitol along with the lieutenant governor.

Across Walnut Street is the headquarters and home of Indiana's second territorial governor, William Hendricks. It's another two-story Federal-style house, which Hendricks built in 1817 and used as the governor's residence when he served from 1822 to 1825. The house remained in Judge William Porter's family after he purchased it in 1841 until the state bought it and opened the house to the public in 1979.

Other historic structures in Corydon include the first state office building (1817) where the state's treasury of silver was kept in strongboxes in a cellar and which today is a private residence; the Posey house (1817), now a museum where the son of the last territorial governor lived until his death in 1863; the Westfall house (1807), directly behind the constitutional elm and now a private residence; and the Branham Tavern (1800), a two-story log structure originally built by Governor William Henry Harrison.

Don't forget that Indiana's only Civil War battle was fought here when Confederate General John Hunt Morgan's raiders swept through southern Indiana and, after a struggle with the home guard, captured the town.

The early history of the area begins around 1790. Among the first white explorers was Squire Boone from Kentucky. He was one of those frontier entrepreneurs who had settled lands, built forts, helped bring in settlers, and still managed to have very few worldly goods when he and brother Daniel went looking for new lands in southern Indiana. Near Corydon, they found a series of caves, some hidden. Inside the caves are waterfalls and spectacular rock formations. Squire Boone's grave can be found nearby as well as the restored Boone grist mill, powered by water coming from the caves.

The old Corydon Railroad still travels through the southern Indiana hills. It uses a line built in 1883 but the train is from the twentieth century. Another county attraction, shared with Crawford, is the Harrison-Crawford State Forest with its 24,000 acres, offering picnicking, hiking, and water activities on the Blue and Ohio rivers.

William Henry Harrison, Revolutionary War soldier, territorial governor for twelve years, and Whig Party winner of the U.S. presidency in 1835, was the western hero for whom the county was named. After taking the president's oath, Harrison died one month later.

"I visited scenic Corydon on a beautiful, sunny day. I met Fred Griffin, local historian and 'walking history book.' He graciously showed me all around the historic town. Later he showed me on a map where his farm is located, along the Ohio River. His farm has been painted and photographed many times. Having lived in Harrison County all his life, Fred is known by everyone and has published several books on Corydon history. I chose to paint the first capitol because it is the premier landmark for the county, marking an important period in Indiana's history."

ROBERT EBERLE
"Indiana's First Capitol"
Oil on linen 20 x 24 inches

HENDRICKS COUNTY

There were only 385 people living in Avon in 1990. Seven years later, the population was 4,007—a ten-fold increase. While the rest of Hendricks County hasn't experienced quite that rate of growth, this county, sitting on the west side of Indianapolis, has absorbed part of the metropolitan expansion that dominated central Indiana in the late twentieth century.

Avon's case is exceptional. Talk about transportation access: It is located between Interstates 70 and 74, with U.S. 40 and 136 running east and west nearby, and U.S. 36 passing right through the town, also east and west; Indiana 267 goes through north and south; Interstate 465, which loops around India-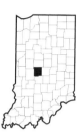napolis, is seven miles to the east; it is home to Conrail's Big Four switching station, providing rail transportation; and the town is just west of the Indianapolis International Airport. So when United Airlines put in its $800 million maintenance center and Federal Express expanded its package sorting hub with a $210 million addition at the airport, Avon and the rest of Hendricks County found large numbers of these 8,000 new job holders moving into their communities. Then, Qualitech Steel Corporation put its $500 million world headquarters and mill just up the road at Pittsboro in 1998. Farther southeast at Plainfield is the 700-acre Airwest Business Park.

Yet, of the county's 266,000 acres, around 180,000 are still devoted to agriculture at the dawn of the twenty-first century. The major crops are corn and soybeans.

Between 1992 and 1996, more than 3,000 single-family-housing building permits were issued in unincorporated parts of the county, continuing the late twentieth century trend toward living in the country and working in the city.

Of the counties to the west of Marion County and Indianapolis, Hendricks in the mid-1990s had the largest total work force, almost 45,000.

The county has more than transportation and industry. It has the national headquarters of Islamic organizations near Plainfield in a 124-acre Islamic Center of North America. Located about three miles south of Plainfield, the religious and educational center was constructed in 1982. The headquarters of the Western Yearly Meeting of the Religious Society of Friends (Quakers) is located in Plainfield. It was the Quakers who were among the early pioneers of Hendricks County in the mid-1800s.

Plainfield also has the county's largest park, the seventy-five-acre Hummel Park, operated by Guilford Township. The park, which is connected across White Lick Creek by a 300-foot wooden bridge, includes a paved track, picnic shelters and gazebos, nature trails, sports fields, and a community center. To the west, in the county seat of Danville, are Ellis Park, the county's oldest park with fifty acres of sports fields, clay tennis courts, swimming pool, basketball court, and playgrounds, and the fifty-three-acre Blanton Woods Nature Park, established for environmental education.

The longest drag strip in the world—4,400 feet—is part of the Indianapolis Raceway Park, operated by the National Hot Rod Association. It is located east of Brownsburg and also has a 0.686-mile oval and a fifteen-turn, two-and-a-half-mile road course. The U.S. Hot Rod Nationals have been held at the track since 1961 with an annual estimated crowd of 165,000 that watches some 1,000 racing teams compete for a purse now exceeding $2 million.

The county is named after William Hendricks, who came to Indiana from Pennsylvania in the early 1800s. Secretary to the state's constitutional convention in 1816, he was elected governor in 1822. He later served two terms in the U.S. Senate.

"This was my second drive through Hendricks County. I painted on a warm, sunny day in June, near a fence with cows watching my progress. One cow in particular, with many flies on her nose, was especially curious as to what I was doing. This pleasant sunny scene south of Pittsboro was very typical of the county."

DON RUSSELL
"Hendricks County Back Road"
Oil on linen 16 x 20 inches

HENRY COUNTY

Fact really is stranger than fiction. Consider Henry County. The gas boom of the late 1800s propelled it forward as it did several communities in east central Indiana. Automobile, kitchen cabinet, and piano manufacturing gave the county its reputation.

But these were outdone by a flower. It was 1901 when the Heller brothers, Myer and Herbert, entered their new rose in the International Rose Show in Kansas City. Their rose, the American Beauty, took the show by storm with its petals "the size of goose eggs." Rose growers descended on New Castle to buy plants and learn how to nurture and grow them. Prominent women were photographed holding American Beauty roses with the stems dragging behind them for ten feet or more— the longer the stems, the better. Not surprisingly, New Castle became known as "Rose City."

Like the gas boom, however, the "rose boom" wilted. Strains became more removed from the original; they were quite susceptible to disease and wouldn't grow in many climates. When a tornado hit New Castle in 1917, numerous greenhouses were demolished.

Only a few years later, New Castle was in the national news again with the disappearance of a young girl, Catherine Winters. Last seen on the busiest street in town in broad daylight, she simply vanished. One theory had gypsies stealing her. Next, her father, stepmother, and a former boarder were charged with murder, but the indictments were dropped because of insufficient evidence. The case, reported in newspapers nationally, held America's attention with numerous rewards offered for information. The mystery has never been solved.

In 1948, the nation's attention was once again riveted on Henry County. Ross Lockridge Jr.'s blockbuster novel, *Raintree County,* was published. "Raintree," of course, was Henry County. (The golden raintree, according to the Johnny Appleseed legend, grew from a single seed. Whoever found it would have all his dreams answered.) When the movie was produced, Hollywood, too, focused on the county. The climax occurred with the later suicide of the author.

Getting less national acclaim have been other Henry County accomplishments: the Maxwell automobile, one of five automobiles built in New Castle in the early 1900s by Maxwell-Briscoe Motor Co., now a division of DaimlerChrysler Corporation, the county's largest employer; the Hoosier Kitchen Cabinet Company which began the industrial development of New Castle in 1900; and the Krell French Piano factory, in New Castle for fifty years in the early 1900s.

The world's largest high school basketball arena is New Castle's Chrysler Fieldhouse, seating 9,385. Close by is the Indiana High School Basketball Hall of Fame Museum. Its exhibits take visitors through the state's high school basketball history. In the southwestern corner of the county is Knightstown where much of the motion picture *Hoosiers* was filmed, based on the Muncie Central–Milan championship basketball game, possibly the most famous in history.

In the eastern part of the county is a state historic site marking the birthplace of Wilbur Wright. Along with Orville, he managed actual flight in 1903 at Kitty Hawk, North Carolina. A replica of their first 1903 plane, said to be the only replica built to fly, is in the Wilbur Wright Birthplace Museum.

Henry County is home to numerous antique shops, especially along Old National Road. Some visitors come for the equestrian shows at Henry County Memorial Park in New Castle. Outdoor recreation is found at Summit Lake State Park, Westwood Park, and the Wilbur Wright Fish and Wildlife Area.

It's Patrick Henry—"Give me liberty or give me death!"—for whom the county is named. It was organized in 1821.

"Henry County was my childhood playground and is home to many scenes I hope to share with the world on canvas someday. J. Ottis Adams painted near Springport, a scene he called 'Prairie Dell.' He captured the feeling of the prairie, the springs, and creeks wonderfully. Maple sugar production has played a part in the state's history and remains a source of income and interest today. I personally love it and have watched it being produced, and I wanted to represent this part of Indiana."

LYLE DENNEY
"Rutherford's Maple Sugar Camp"
Oil on canvas 16 x 20 inches

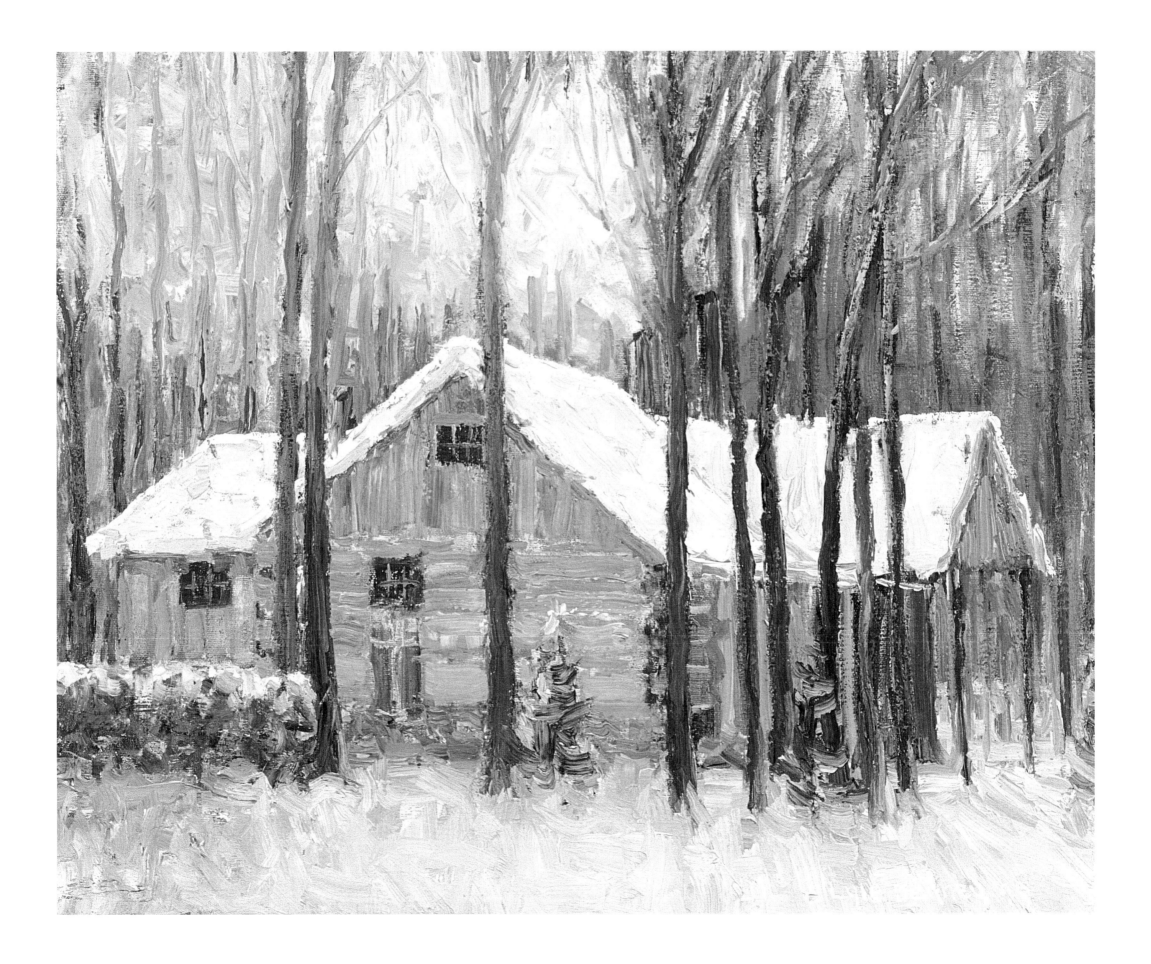

HOWARD COUNTY

It was one of the last counties in the state to be established, in 1844. If Howard needs any solace about that fact, it can find it in the reputation of its county seat, Kokomo, "the City of Firsts."

Inventor Elwood Haynes had much to do with this. While claims abound about the invention of the automobile, Kokomo sticks by its statement that Haynes, on July 4, 1894, drove "America's first car" along Pumpkinvine Pike east of the city, traveling at a rate of six to seven miles an hour. Haynes would later build automobiles in Kokomo until 1925.

Haynes, however, did more than invent and produce automobiles. His patents in metallurgy alone mark him as a major American scientist. His two most important inventions were stainless steel—although claimed, too, by others—and Stellite, an alloy still used today, even in satellite equipment. He also devised a vapor thermostat to regulate home heating systems.

Haynes's residence was given to the city in 1965 by the Haynes family and is now a museum. Haynes's antique automobiles, artifacts of his inventions and manufacturing, and the industrial history of central Indiana are included in the exhibits.

Other Kokomo firsts in the auto industry include the pneumatic rubber tire in 1894, aluminum casting in 1895, the carburetor in 1902, the push-button car radio in 1938, the signal-seeking car radio in 1947, and the all-transistor car radio in 1957.

Kokomo contests Worthington's claim to the largest sycamore tree ever to grow. Kokomo's tree, or rather the stump of the tree, rests in Highland Park where it was dragged from the banks of Wildcat Creek. It measures fifty-seven feet in circumference. Also in Highland Park is the "world's largest steer," Old Ben. At his death in 1910, he weighed 4,700 pounds, was sixteen feet, three inches in length, and stood six feet, six inches tall at the shoulder.

The Howard County Historical Museum is housed in the Seiberling mansion, built in 1891 by Monroe Seiberling, founder of Kokomo's Diamond Plate Glass Company. The mansion, considered to be a mixture of Romanesque Revival and Neo-Jacobean, features hand-carved woodwork, Moorish design brass hardware, and irregular roof contours.

Seiberling and others were attracted to Howard County by the supposedly unlimited natural gas. The first well was tapped October 6, 1886, at 920 feet—twenty feet below an earlier effort to find oil. The well—another "first" claim—was said to be the greatest in the world, producing gas at twelve million cubic feet a day. The Indiana gas boom was on and in only months Kokomo was transformed into an industrial center.

The only remaining gas boom industry today, dating back to 1888, is the Kokomo Opalescent Glass Company, manufacturers of designer glass for use in stained glass art. Some ninety glass factories were once located in Howard County. Now the glass industry is memorialized at the Greentown Glass Museum. The biggest Greentown plant, the Indiana Tumbler and Goblet Company, produced glass containers in a wide variety of colors including "holly amber" and "chocolate" until it was destroyed by fire in 1903.

Howard County, although one of the smaller counties in land size in central Indiana, has one of the larger populations at slightly more than 82,000. The automobile industry is the main employer.

Kokomo is said to be named for an Indian, but no positive proof has been found to confirm his existence. The county is named after T. A. Howard, an Indiana representative and district attorney.

"I found a great little nature preserve about five miles east of Kokomo on U.S. 35—the Wildcat Creek Reservoir. Many varieties of trees and marshy inlets make this a perfect spot for birds to rest during their long migrations. As I strolled the well-maintained trails, I saw where beaver had nibbled hardwood trees and much evidence of other wildlife. I spotted the scene I wanted to capture—maple and redbud trees, just beginning to glow in spring colors, leading to the sparkling blue lake. It was a sight I could not resist. I tried out my new half-box French easel and found it to be the perfect easel for a quick set-up—light and compact, it can be carried like a backpack. I set up and painted a small sketch, and later decided to make a larger piece."

ROBERT EBERLE
"Spring at Wildcat Reservoir"
Oil on linen 16 x 20 inches

HUNTINGTON COUNTY

The first white settlers to come into what is now Huntington County were mostly hunters and traders, attracted by the area's natural resources. The Indians who lived there, the Miami, had built their civilization on the same economic foundation—hunting and trading. For years, the land was big enough to accommodate everyone—Indians, French trappers, British traders, and the new American settlers. Ultimately, of course, it wasn't and the Miami were removed from their Indiana homeland to new settlements in the Kansas Territory.

During those years before white settlers took over the area, Chief Jean Baptiste Richardville of the Miami had one advantage. His mother controlled the so-called "long portage" between present-day Huntington and Fort Wayne. River transportation was the only practical commercial system in the 1700s and early 1800s. Portages were necessary in transporting people and commerce between rivers from the Great Lakes down to the Ohio and Mississippi.

These portages were eventually replaced by the expanding canal system. The Wabash and Erie Canal link between Fort Wayne and Huntington opened in 1835. It lasted for twenty years before the Erie Railroad came through, railroads by then replacing canals and rivers all across the state as the main form of transportation.

The forks of the Wabash, just west of Huntington where the Wabash and Little rivers come together, is the site of the Forks of the Wabash Historic Park, a museum and park recounting the story of the Miami and early European settlers. The Forks of the Wabash Pioneer Festival during the fourth full week in September at Hier's Park also builds on this Indian–white settler experience.

At the forks is the Federal-style chiefs' house built around 1834 on the property of Chief Richardville. The house was the permanent residence of Richardville's son-in-law, Chief Francis LaFontaine. Possibly the first frame house to be constructed in the county, it has been restored and is maintained as a museum.

Of course, for most Huntingtonians, water has an entirely different meaning 200 years after the days of the long portage. Recreational fishing and boating are the attractions today at the Salamonie and Huntington reservoirs. The Salamonie River State Forest and Lake in the western part of the county extend into Wabash County, where the dam on the river just before it joins the Wabash backs up the 2,855-acre lake during the summer months. In all, the state forest includes more than 13,000 acres with a beach, campground, bridle paths, and walking trails. Just southeast of Huntington are the Huntington Reservoir and Lake, located in the Little Turtle State Recreational Area on the Wabash River, the lake filling 870 acres. It has the only mountain bike trail on state property, a beach, model plane airport, and camping, archery, and hunting.

Huntington is the site of Huntington College, a liberal arts school chartered in 1897 as Central College. Its name was changed in 1917.

In 1988, the forty-fourth vice president of the United States, Dan Quayle, although born in Indianapolis, was elected while living in Huntington. He had served in the House and Senate. A vice-presidential museum, honoring all vice presidents, including five elected while living in Indiana, but mostly focusing on Quayle's career, is located in the historic former Christian Science Church.

Agri-business remains an important part of the county's economy with some 700 farms covering 188,000 acres. Soybeans, corn, and wheat are the major crops.

The county and county seat are named for Samuel Huntington, president of the Continental Congress and signer of the Declaration of Independence. The county was organized in 1834.

"Having grown up near a small lake with many creeks and ponds nearby, I have always found water to be a source of inspiration and mystery. I chose to paint the wetland area around Salamonie River east of Wabash. Rangers guided us to the marshy wildlife viewing areas, where we found many types of grasses and reeds, offset by branching trees, giving a panoramic view of the shallows. Ducks darted about, and an occasional heron made this an idyllic scene, typical of Indiana's environment."

ROBERT EBERLE
"Salamonie River Wetlands"
Oil on linen 20 x 24 inches

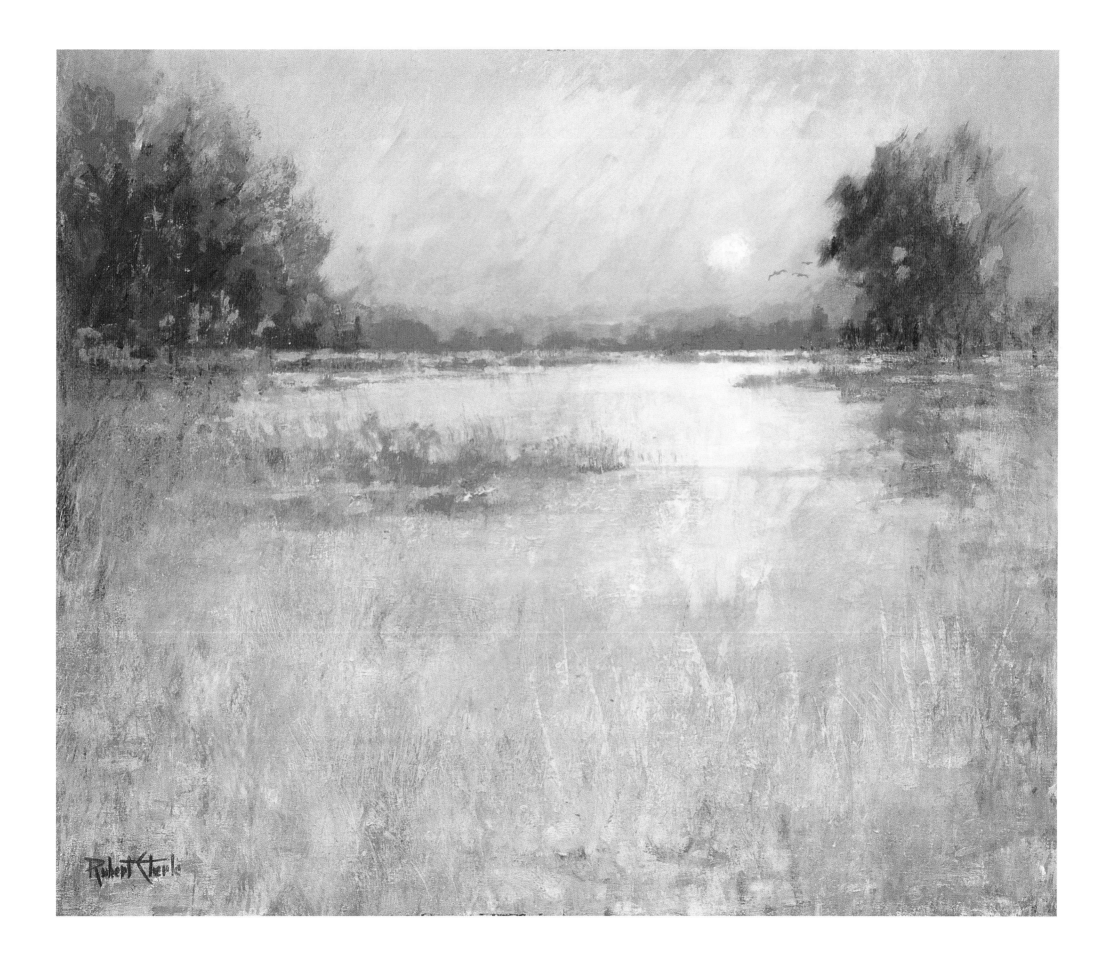

JACKSON COUNTY

A ten-year period in Jackson County, from 1866 to 1876, produced both good and bad news.

First, the bad news: The first train robbery in the nation's history occurred at Seymour on October 6, 1866. The Reno gang, at that time made up of brothers John and Simeon and another man, Franklin Sparks, boarded the Ohio and Mississippi Railroad train leaving Seymour and robbed the express car of $10,000. Over the next two years, the gang grew in size, possibly to as many as 200 men. A year after the first robbery, a second train was held up and eight months later, in their third train robbery, the Renos stole $96,000 from the Adams Express Company car about twelve miles south of Seymour.

With other robberies and numerous unsolved murders in the county, a group of citizens finally decided they had had enough and so they organized the Seymour Regulators. On July 20, 1868, the Regulators hijacked a train carrying three of the gang members to jail and hanged them. Four days later, they caught three other gang members and hanged them from the same tree. Five months later, they took four gang members, including Frank, William, and Simeon Reno, from the New Albany jail and hanged them. Thus the gang's power was broken.

Now, the good news: During this same period, three covered bridges were built in the county to span the east fork of the White River. All three exist today. One, at Medora in southwestern Jackson County, is the longest covered bridge in the world—three spans of 434 feet. Bypassed in 1970, it's a Burr arch truss, built in 1875. Upstream is the Shieldstown covered bridge, also bypassed in 1970. The bridge is 231 feet long and is a two-span Burr arch truss, built a year later in 1876. Just outside Seymour, in the northeastern part of the county, is the Bell's Ford bridge, 325 feet long. It is the only post truss covered bridge known to exist in the world—built when bridge construction was changing from wood to iron and using both materials. Part of the bridge fell into the river in an early 1999 storm but restoration was scheduled by year's end.

The Hoosier National Forest extends over much of the northwestern part of the county. Its 430,000 acres also go into Brown, Lawrence, and Monroe counties. Hunting, fishing, and camping are major attractions. South of Brownstown (the county seat) is Starve Hollow State Recreation Area, also with hunting, fishing, and camping plus boating, a nature center, and cultural arts. Muscatatuck National Wildlife Refuge's 7,724 acres just east of Interstate 65 is the larger of two such refuges in Indiana.

Arguably the most scenic of all—Jackson County claims the vistas are as spectacular as in any forest anywhere—is the Jackson-Washington State Forest, extending into Washington County to the south. Its Skyline Drive covers six miles over glacier-formed limestone outcroppings called knobs and it is on this drive that the vistas occur.

A World War II museum at former Freeman Field in Seymour recalls its pilot training days from 1942 to 1947 when the field was decommissioned. The field was named in honor of a Hoosier military pilot, Captain Richard Freeman, who was known for his mercy flights to troubled parts of the world in the late 1930s. Today, the field is used for agriculture and as an industrial park.

Jackson County, created in 1816, was named after the hero of the Battle of New Orleans in the War of 1812, Andrew Jackson.

"Jackson County has everything from flat wet fields along the Muscatatuck River to beautiful foothills as you near Brown County. I chose the Mann Farm in the rolling hills between these extremes because of the peaceful feeling of the landscape and cattle grazing in the late evening."

LYLE DENNEY
"October in Jackson County"
Oil on canvas 24 x 36 inches

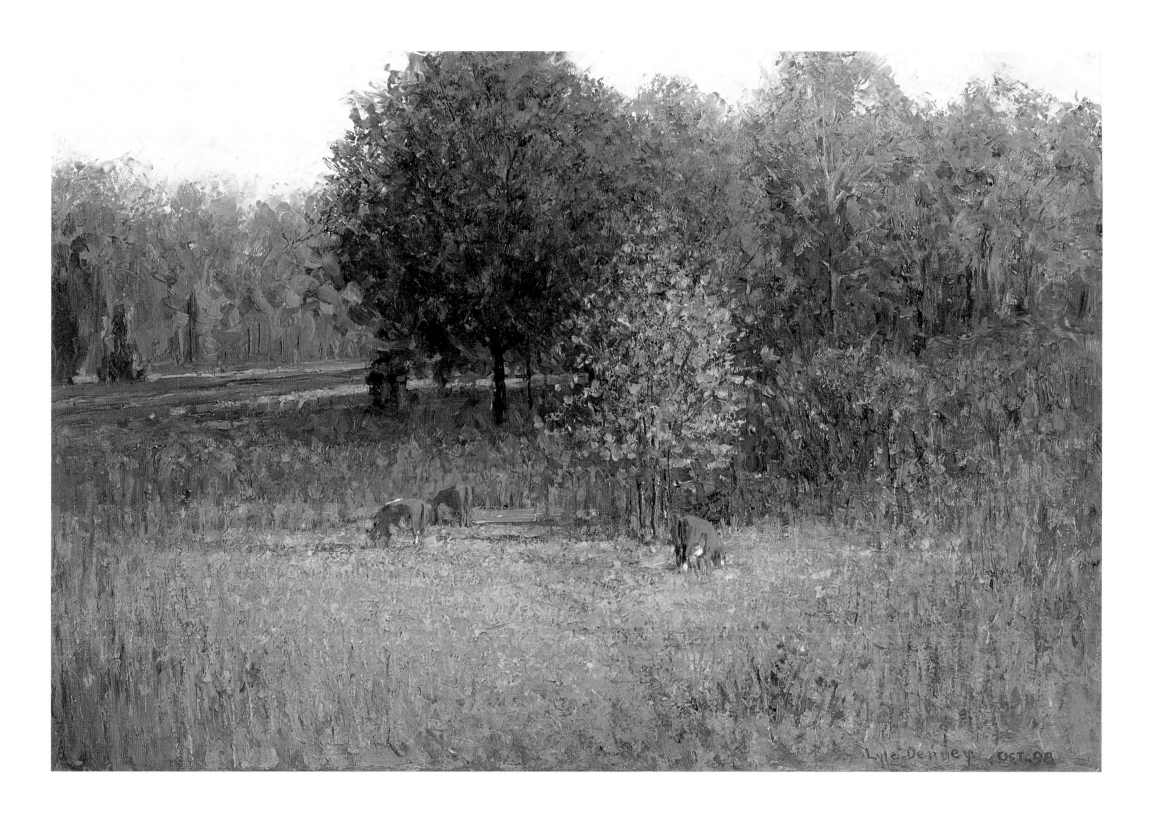

JASPER COUNTY

No one knows with certainty when the Potawatomi Indians came into what is today's Jasper County, but it is likely to have been in the 1700s. When the first known white explorer came through, however, *is* documented. That would be René-Robert Cavelier de La Salle, seeking the best route from the Great Lakes to the Gulf of Mexico. While looking for this route and at the same time laying French claim to possession of mid-America, he used the Kankakee River, which now forms the northern border of the county.

What the Indians and those early French explorers found along the Kankakee were swamplands, river islands, woods, and, to the south of the river, rolling prairie. Today, the northern part of the county has Christmas tree, asparagus, blueberry, and pumpkin farms. In season, there's a lot of activity as shoppers either select, cut, and buy their own or stop at one of the roadside stands. To the south are potato and mint farms interspersed with grain farms, pig operations, and cattle ranges. Farming and livestock continue to be the major occupations of the county. The Indians living in the area when the explorers came through were also farmers as well as hunters and fishermen. The French named them Pouutouatami, later Potawatomi, for "fire builders," given their habit of burning off their fields following each harvest.

Jasper remains a mostly rural county. Interstate 65 winds its way along the western side of the county, while U.S. 231 goes up the middle of the county and through the only city of size, Rensselaer, the county seat with about 5,000 residents. The city was originally platted as Newton, but its name was changed less than a year later to honor James C. Van Rensselaer. Joseph Yeoman built the first cabin in Jasper County in 1835, but four years later Van Rensselaer arrived with authority from the federal government to control much of the land in the area, including fields already cultivated by Yeoman. Van Rensselaer won out.

The smaller communities in the county—DeMotte, Remington, and Wheatfield—have antique shops, craft stores, auctions, and sidewalk sales. Fishing and hunting for pheasant, quail, rabbits, ducks, and deer are the major outdoor activities in season.

In the northeastern part of the county is the Jasper-Pulaski State Fish and Wildlife Area. Here, the sandhill cranes pause during their migrations to and from the south in late autumn and early spring.

Saint Joseph's College is located in Rensselaer. Originally founded in the late 1880s as a school for underprivileged and orphaned Indian children, it became a two-year and, eventually, a four-year college. The site of the Indian school is listed on the National Register of Historic Places.

Among the buildings in the Pioneer Village at the Jasper County Fairgrounds is the Parr post office, one of the smallest in the nation, measuring only nine by eleven feet. Even at that size, it was targeted and robbed by bandits (who later were captured by the FBI).

The county, organized in 1838, is named for a Sergeant Jasper, who was reputed to have been a master spy and scout for the Revolutionary War hero, General Francis Marion, the so-called "swamp fox" who plagued British forces in the southern colonies. Jasper is also supposed to have taken the American flag, which had been shot off its staff during a British attack at Fort Moultrie on Sullivan's Island in South Carolina, and nailed it back to the broken staff as a signal that the fort had not surrendered.

"I chose this rural setting in the midst of large farms east of Rensselaer. The shape of the creek in the distance and the colors of the scene were exciting. I parked along a dirt road and got well dusted by a passing combine and pickup trucks."

DON RUSSELL
"Iroquois Creek"
Oil on linen 18 x 24 inches

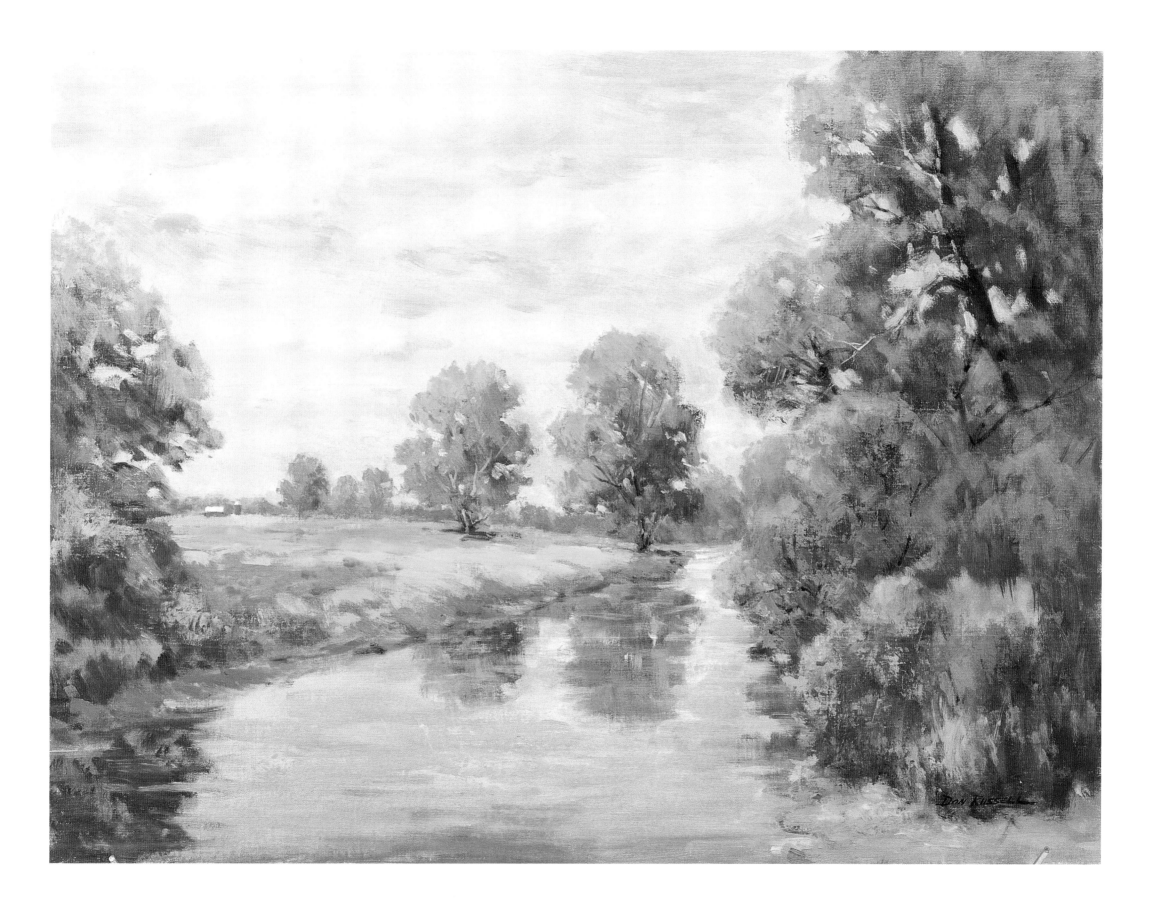

JAY COUNTY

All across eastern Indiana in the late 1880s, the story was the same: gas wells were sending up flames from underground reserves that might last forever. In many a small community, the trappings of city life sprang up overnight as entrepreneurs sought ways to utilize natural gas to build hoped-for industrial empires.

Portland, the Jay County seat, staked its claim to the first natural gas well in the state on a strike in 1886. The well was at the corner of Depot and North streets in Portland. Whether it was truly the first well or not, the outcome is not in question. Dozens of glass factories were soon in business throughout the county. Although only two remain today, they have almost 1,000 employees, making the glass industry still one of the county's major employers.

The history of the business, termed "America's oldest industry" by its enthusiasts, is visible in the Dunkirk Glass Museum, featuring more than 5,000 pieces of glass from 105 factories. Included in the museum are twenty-five leaded glass windows, twenty-five hanging glass lamps, and hundreds of hand-blown and hand-pressed glass creations.

Similar to other counties in northeastern Indiana, Jay's settlement was hastened in the early 1800s by water—the Salamonie River flows through the middle of the county, Limberlost Creek across the northeast, and the Wabash River to the far northeast—and by roads—the Godfrey Trace crossed the county mostly along today's Indiana 26 and Quaker Trace passed through northeastern Jay and the community of New Corydon on its way from Richmond to Fort Wayne. It was at New Corydon where the county's first white settlers, Peter and Mary Studebaker, came into the county and also where Jonathan Chapman—Johnny Appleseed—planted one of his orchards.

Another thoroughfare in the northern part of the county was the Balbec Pike, which today is somewhat the route of Indiana 18. Underground Railroad sites were located along this pike and the historical society which has restored one of them—the Jimmy and Rachel Sillivan cabin north of Pennville—is seeking official recognition for it from the federal government as a station under the National Underground Railroad Network to Freedom Act of 1998.

While Geneva and Rome City are places where Hoosier author Gene Stratton-Porter lived, the Loblolly Marsh along the Jay–Adams border was where she went to collect insects and butterflies. This marshland is how much of the northern part of the county looked before the Limberlost Swamp was drained. It abounds in geese, ducks, and wild game.

Portland hosts what it terms the world's largest gas engine and tractor show each summer. Attractions including a bluegrass festival and vintage bike show draw an estimated 100,000 people. The arts flourish year 'round under the Jay County Arts Council with civic theater, arts workshops and exhibits, string instruction, and arts performances.

Portland's entire central business district was placed on the National Register of Historic Places in 1996. Floral Hall, an octagonal barn at the Jay County Fairgrounds, is another historic building. Possibly the county's oldest building is the Goldsmith Chandler Federal-style brick house in Pennville, built between 1839 and 1841.

Jay County was formed in 1835 and Portland was incorporated in 1843. The county is named after John Jay who served in numerous assignments including governor of New York, secretary of state, and chief justice of the U.S. Supreme Court. One of his lesser-known responsibilities was a mission to Great Britain in 1794, which averted a second war with England.

"The underground railroad history associated with this cabin was my inspiration for this painting. The cabin, nestled in a shady grove of trees and surrounded by farm fields, made a simple but meaningful scene. This quiet homestead holds a hundred secrets of danger, fear, and bravery. Every county in Indiana has little jewels such as this, which hold their special place in history. I was fortunate to have found such a gem in Jay County."

DAN WOODSON
"Underground Railroad Cabin"
Oil on canvas 16 x 24 inches

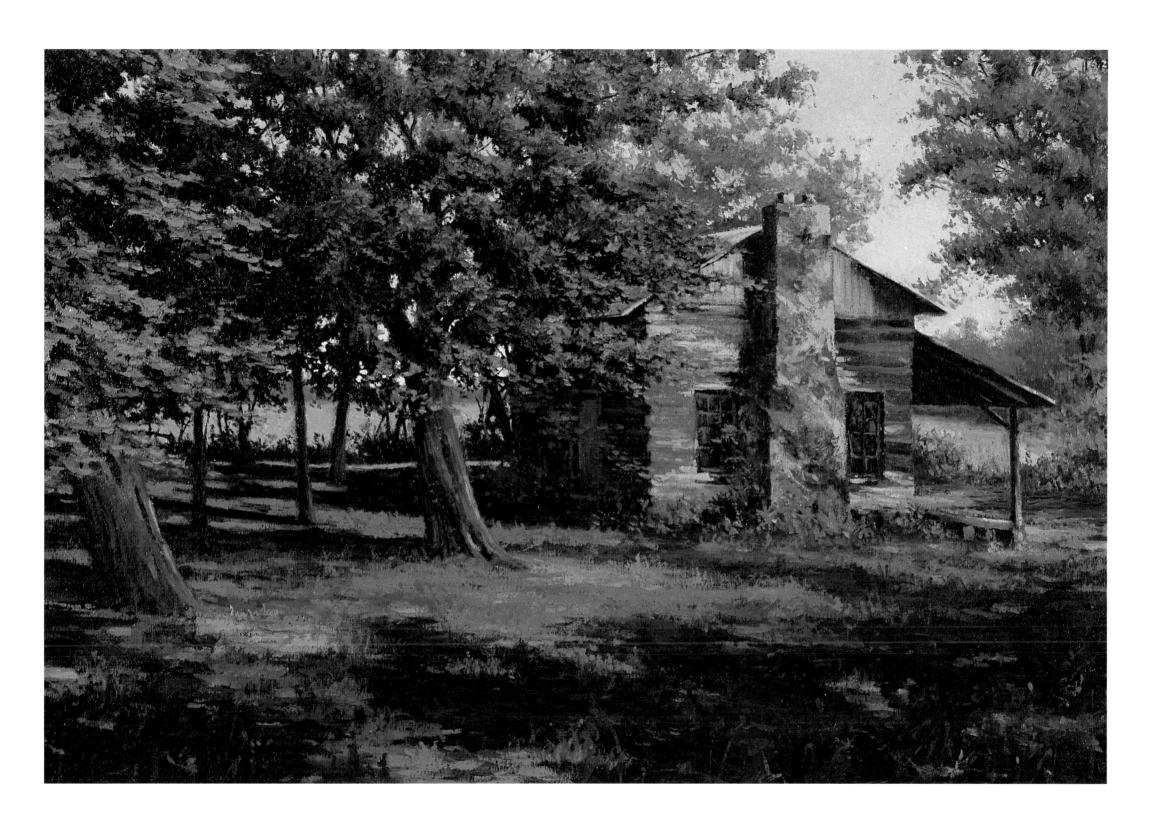

JEFFERSON COUNTY

Madison has quite a name to live up to: the nineteenth-century Williamsburg of the Midwest! However, many a visitor to Madison would agree with enthusiasts who find the town captivating.

Madison made a name for itself early on. Indians ceded the land in 1805 and settlers began arriving in 1808 to this gateway to the Indiana Territory nestled along the Ohio River in southern Indiana. By 1809, a town was established and named after James Madison, then president of the United States. It lost out to Corydon in the struggle to become the territorial capital, but when Indiana became a state in 1816, Madison was the state's largest city, albeit with a population numbering in the hundreds.

For the next forty years, it was a major entryway and export center for Indiana, capitalizing on water, road, and rail transportation. While Madison was not a ship-building town, it was, nevertheless, a leading shipping center on the Ohio River. The Michigan Road, built 1831–34, extended from Madison northward through Indiana to Michigan City and was the state's first important north–south overland route. The first railroad north to Indianapolis, the Madison and Indianapolis Railroad, was completed in 1847 and gave Madison access to the central farmlands and industries of Indiana.

As important as these business successes were, they are not what Madison supporters mean in comparing it to Williamsburg. That relationship rests on how the city has preserved its early architecture, retains its small town charm, and continues its long tradition of the arts.

No fewer than 133 Madison city blocks comprise Indiana's largest historic district, encompassing 1,500 structures. Probably best-known is the James F. D. Lanier Home, a state historic site. Set on a hill overlooking the river, the Greek Revival home was completed in 1844 by the banker who at least two times helped save the state from financial ruin. It is but one such building, however. The Shrewsbury-Windle House, designed by Francis Costigan, the Lanier Home architect, was created to rival the banker's mansion and is known particularly for its freestanding spiral staircase. The Jeremiah Sullivan House, constructed in 1818, is considered the town's first mansion, while architect Costigan's own home, built on a twenty-two-foot lot, uses a sliding front door and other innovative elements in the restricted space.

The small town charm comes from the intact business district just a few blocks from the riverside promenade. Up in the hills is a mixture of older buildings whose owners sought the high ground and more modern subdivisions and commercial structures.

The arts are an ongoing tradition with the Madison Chautauqua, a juried show of nearly 300 artists and craftspeople; Madison in Bloom, spring tours of public and private gardens; and the Nights Before Christmas Candlelight Tour of Homes tours of seasonal decorations in Madison's nineteenth-century mansions.

Just a few miles to the west along the river lies one of the state's most scenic parks, Clifty Falls; its 1,361 acres also include the Clifty Canyon Nature Preserve. Part of the abandoned Madison and Indianapolis railroad line runs through the park and that area is now a walking trail. Just a little farther to the west is Hanover, site of Hanover College, which traces its roots back to 1827. It is the state's oldest four-year private liberal arts college.

Jefferson County is named for President Thomas Jefferson, whose personal and active interest in the Lewis and Clark expedition made him a popular hero of the county's pioneers.

"Sunsets on the Ohio River are spectacular from the high bluffs of Clifty Falls State Park in Madison and from the grounds of Hanover College. The scene was breathtaking as rose and orange light shone on the trees. It brought to mind a painting done by T. C. Steele a hundred years ago, showing how little the area has changed since Steele's day. From the home of the president of Hanover College, I tried to capture the color and light of the sunset; the trees were bathed in a coral glow, and lavender shadows reflected on the misty blue water, which curved out of sight in the distance. Earlier in the day I spotted eight wild turkeys along the road on my way to Madison to participate in an IPAPA paint-out. After a day of painting tug boats and tour boats, I left for Hanover to paint the sunset, then returned to Clifty Inn for an enjoyable evening of conversation and fellowship with other members of IPAPA."

ROBERT EBERLE
"Ohio River from Hanover College"
Oil on linen 20 x 24 inches

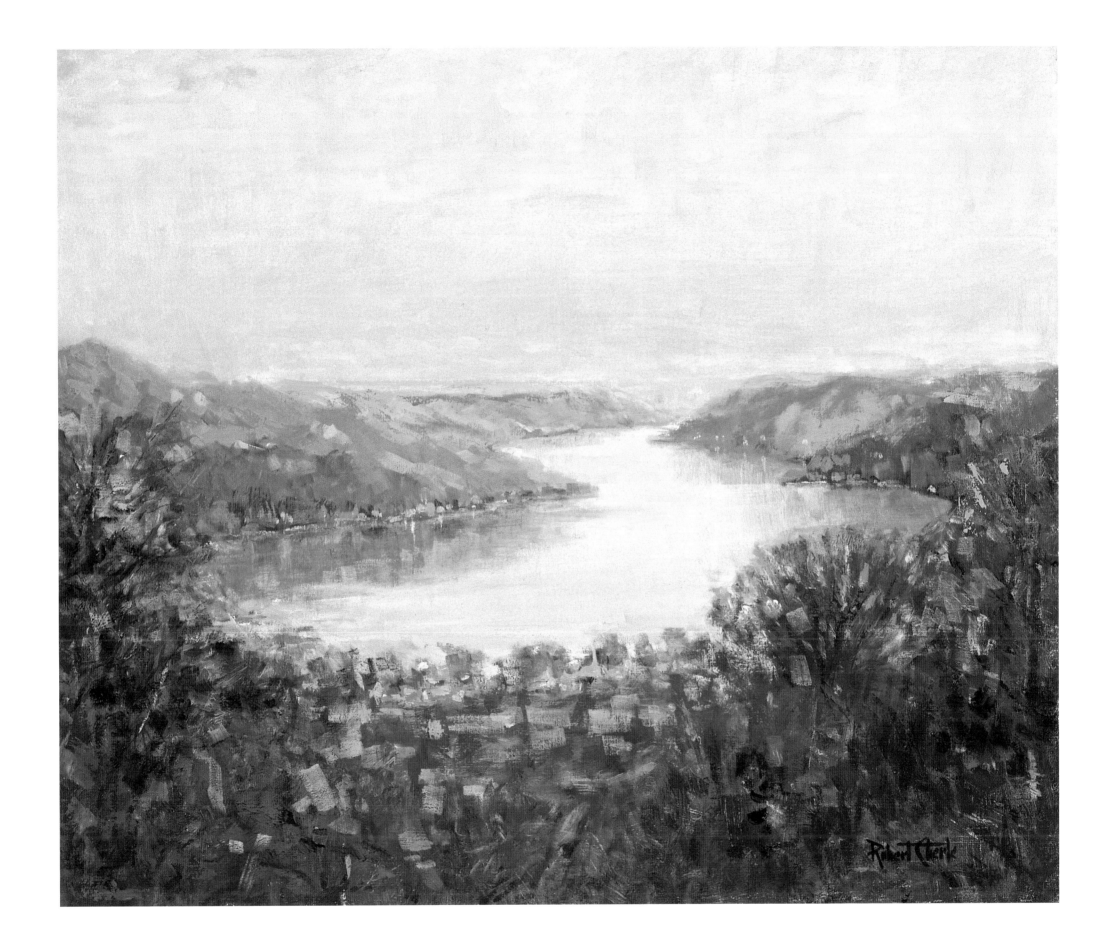

JENNINGS COUNTY

General John Hunt Morgan, the Southern raider, thought about it and decided to back off.

Sweeping through southern Indiana on a Confederate seek-and-destroy raid, he arrived at Vernon July 11, 1863, ready to destroy bridges on the Madison and Indianapolis Railroad. He called upon the Union troops and volunteers gathered at Vernon to surrender. Twice they refused. It may be that Morgan considered himself outnumbered, although estimates place his forces at several thousand and the defensive number at less than 1,000—perhaps as few as 400. In any case, Morgan thought better of attacking, gave up his efforts to take the town and destroy the bridges, and moved on.

It may be Indiana's most famous battle-that-never-happened.

Vernon has also repelled efforts to replace it as the county seat, in favor of moving the site to nearby and larger North Vernon, which has nearly 6,000 residents to Vernon's 400 or fewer. The issue wasn't settled until 1948 when an earlier decision to move the county seat was set aside by the courts.

Vernon is virtually surrounded by the Muscatatuck River, which winds through the middle of the county. The town is composed almost entirely of historic buildings, so much so that the entire community has been placed on the National Register of Historic Places. Among the buildings are the Jennings County courthouse, on which construction began in 1857; the North American House, probably the town's oldest building—1838—and once a stagecoach stop; and the Smith Vawter house, built in the 1830s by the son of the town's founder. What is supposedly the first elevated railroad trestle constructed west of the Allegheny Mountains is part of a curved incline railroad track at Vernon's outskirts.

Some 10,000 acres of Jennings County are public recreational lands. Almost 8,000 of them are in the Muscatatuck National Wildlife Refuge, shared with Jackson County. The refuge's marshes, lakes, springs, forests, and meadows provide a resting place and feeding areas for migrating birds. At Muscatatuck, a Native American word meaning "land of the winding waters," more than 280 bird species have been catalogued.

Two other nature areas are the Muscatatuck Park, once owned by the state with facilities developed by the Civilian Conservation Corps and the Works Progress Administration during the 1930s, and the Crosley Fish and Wildlife Area, at one time owned by Powell Crosley Jr., Cincinnati industrialist and sportsman. The state gave Muscatatuck Park to the county in 1968; today it includes bird watching, camping, fishing, picnicking, playgrounds, recreational fields, and a one-room schoolhouse that has been moved to the site. Also on the grounds are the ruins of the Old Vinegar Mill and the Red Brick Inn. The 4,000-acre Crosley Area, purchased by the state in 1958, offers fishing, hunting, archery, camping, and picnicking.

Two covered bridges remain in the county, and both are still in use. The James covered bridge over Graham Creek on Road 650 South was constructed in 1887. It's a Howe truss of 124 feet. Another Howe truss of the same length crosses Sand Creek at the north edge of Scipio. It was built in 1886 and was one of the first and longest spans to be built without a center support.

In eastern Jennings, Butlerville flourished for a time as a railroad town. The mother of Richard Nixon, former U.S. president, was born near the village, as was Jessamyn West, noted author of *The Friendly Persuasion,* among other books.

The county is named for the first Indiana state governor, Jonathan Jennings, and was organized in 1816.

"Jennings is a beautiful county with many tempting areas to paint. This is a view from the cemetery at Vernon, looking up the hill to the north. I loved the light on the house and the color in the trees."

DON RUSSELL
"From the Cemetery at Vernon"
Oil on linen 16 x 20 inches

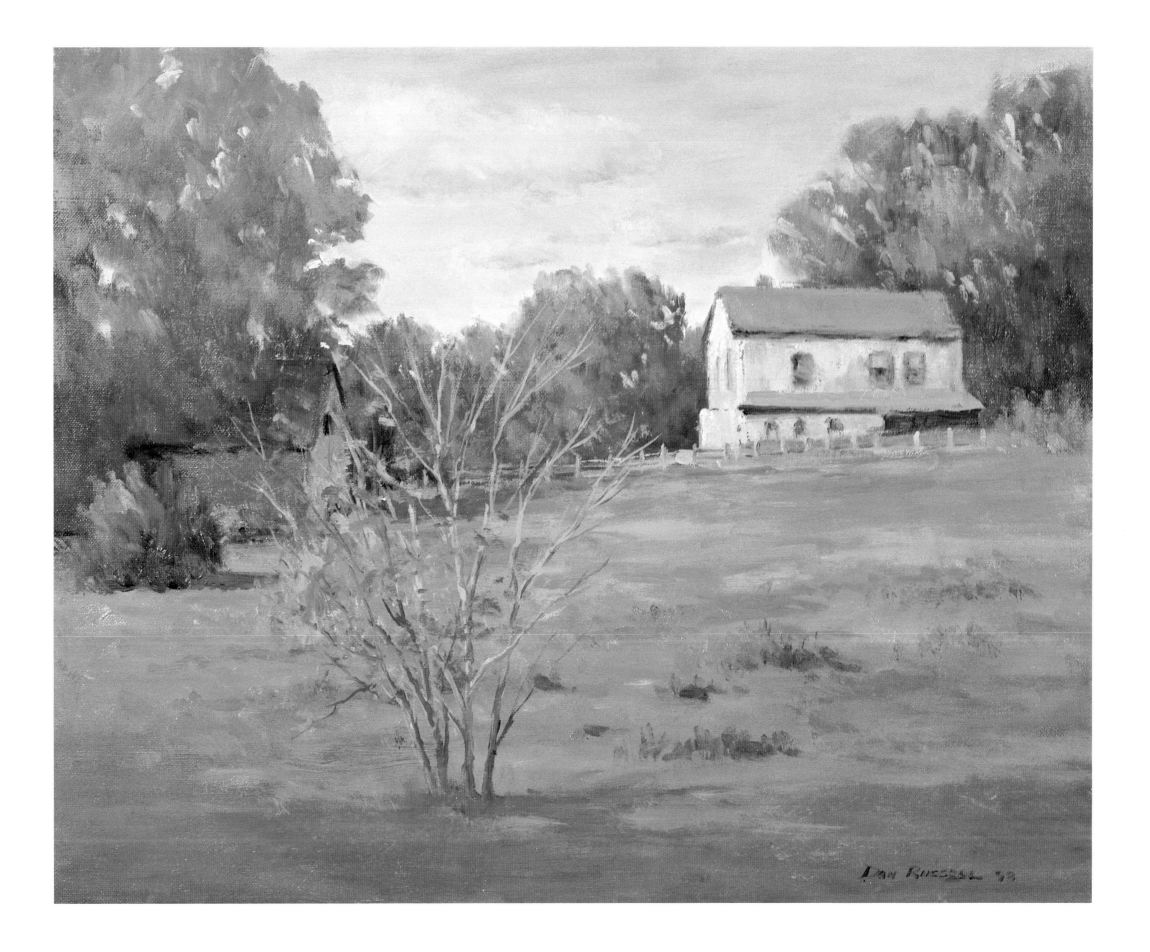

JOHNSON COUNTY

The arts thread their way from Johnson County's early days, through World War II, to today's concern about preserving the county's history.

One of the founders of The Society of Western Artists, J. Ottis Adams was born in 1851 in the small town of Amity in southeastern Johnson County. While a youth, he showed artistic promise, later studied at the South Kensington Art School in London, and, back in Indiana, founded the Western Artists, often called the Indiana Colony, in conjunction with T. C. Steele.

Half a century later, Italian soldiers of World War II who were prisoners of war at Camp Atterbury asked permission of the American military to build a chapel. In 1943, they constructed a small brick and stucco structure, painting religious frescoes on the walls and ceilings. Over time, the paintings deteriorated—the prisoners are said to have used dyes from plants and berries in the absence of war-shortage lead paint. These paintings have been restored by Hoosier painters, who attempted to preserve the colors the Italians used. Their Chapel in the Meadow can be seen today near the Stone Arch on the grounds of the Atterbury State Fish and Wildlife Area, only a few short miles from Adams's birthplace at Amity.

The U.S. military still owns the chapel grounds, which are surrounded by 1,000 acres given to the state in 1970 by the federal government. The nature preserve includes swimming, picnicking, indoor horseshoes, campgrounds, an amphitheater, and the Hoosier Horse Park, venue of the 1987 Pan American Games equestrian events.

Franklin, named for Benjamin Franklin, is the county seat. Founded in 1823, the town took on additional importance when the Madison and Indianapolis Railroad came through in 1846. Today, the northern part of the county is part of the Indianapolis metropolitan sprawl as Johnson County abuts Marion County to the south. Greenwood, just south of Marion County, has grown rapidly as part of that expansion, including the Greenwood Park Mall, one of Indiana's largest shopping malls.

Franklin is the site of Franklin College, chartered in 1834 and the first Indiana college to admit women (in 1841). Because of strong abolitionist feelings in the community, male students left campus to fight in the Civil War, forcing the college to close between 1864 and 1869. The college had a devastating fire in 1985 in Old Main, three adjoining buildings constructed between 1847 and 1888. The college immediately started reconstruction and moved back into the rebuilt buildings two years later.

In downtown Franklin stands the Johnson County Courthouse, the fourth in a series starting with a log cabin in 1824. The present structure, a National Register of Historic Places building, was constructed between 1879 and 1882. Nearby is the Johnson County Historical Museum, housed in the former Masonic Temple, dedicated in 1924. Beside the museum is a log cabin that was built in 1835 and moved to the site in 1974 from a nearby farm.

The county seat is also known for its Methodist Home for the Aged, which now serves a nondenominational need for the elderly, and the Indiana Masonic Home, opened in 1916 and today housing older Masons and family members. Sometimes called "a city within a city," it has its own hospital and other facilities needed for a self-sustained operation.

The county, more rural to the south and urban through the middle along U.S. 31 and Interstate 65, was founded in 1822 and is named for Indiana Supreme Court Judge John Johnson.

"This county offered so many possibilities; a beautiful county courthouse; the color and excitement of the flea market at Bargersville; the rolling landscape; the railroad tracks at Depot Park; the gazebo and stream at Province Park. . . . As the early morning sun rose behind the buildings of Franklin College, its beauty and history came alive. Journalism Hall, built in 1903, is a lovely three-story building with a round dome, much like Monticello in Virginia. It best conveyed the strength, heritage, and solid values of small-town liberal art colleges."

ROBERT EBERLE
"Journalism Hall at Franklin College"
Oil on linen 20 x 24 inches

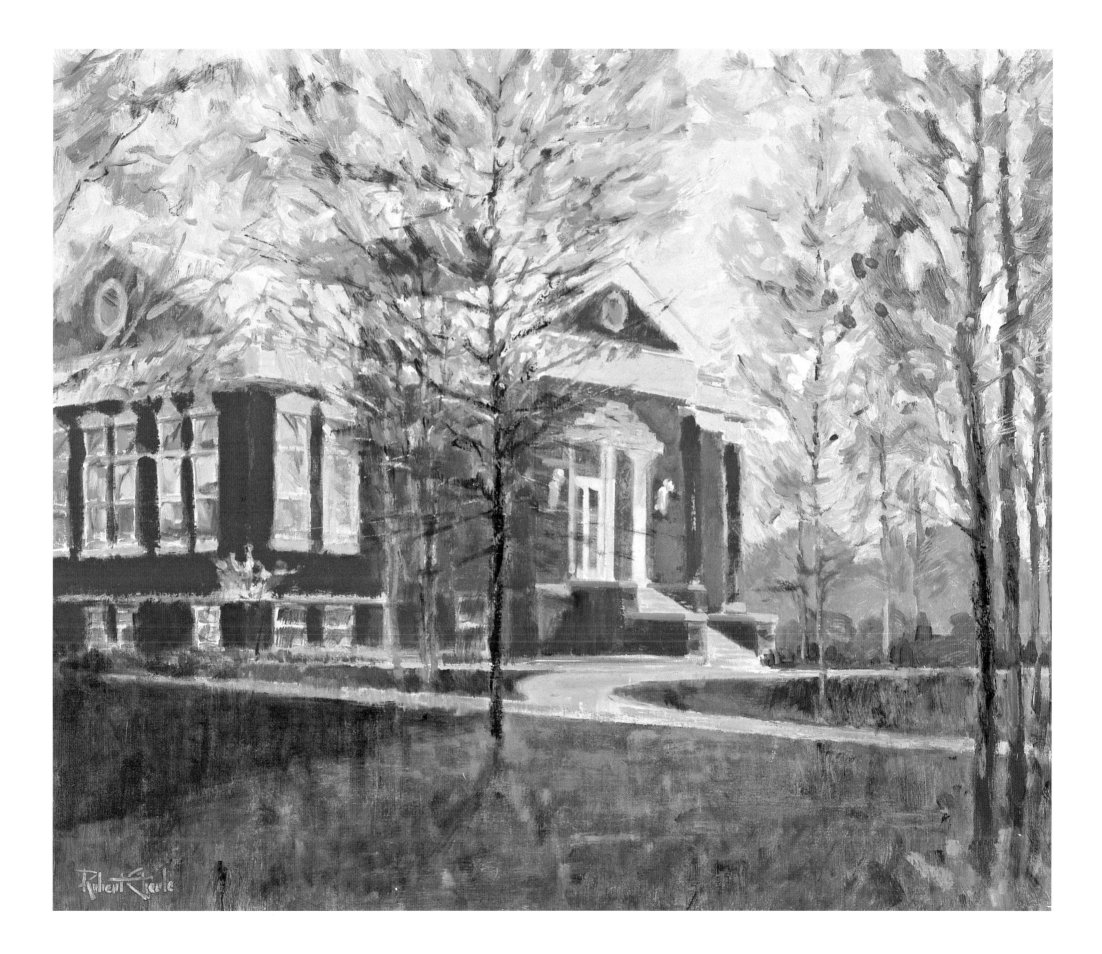

KNOX COUNTY

William Henry Harrison had his hands full. Governor of the Indiana Territory, he oversaw federal activities throughout the region, which in 1804 included the present states of Indiana, Illinois, Michigan, and Wisconsin, plus part of Minnesota. At least it no longer included Ohio, which had reached statehood.

Then came news of the Louisiana Purchase. The part south of 33 degrees north was to become the Territory of Orleans. Though the boundaries were vague, the rest of it—today's Missouri, Arkansas, Iowa, North and South Dakota, Nebraska, and Oklahoma, along with much of Kansas, Colorado, Wyoming, Montana, and the rest of Minnesota—were added to the territory that Harrison governed during 1804, all out of a two-story frame building in Vincennes.

In fact, Harrison probably did little governing of these new lands. The United States didn't even know what was there; Lewis and Clark would not complete their exploration through the lands obtained from France for another year. Harrison's time was likely taken up by more immediate problems, mostly with the Indians headed by Tecumseh and his brother, the Prophet. Nevertheless, at least theoretically, Harrison's command was enormous, stretching to the Rocky Mountains.

U.S. possession of the old Northwest Territory could also be said to have started at Vincennes. When France withdrew from the Midwest in the Treaty of Paris in 1763, Great Britain took charge of Vincennes and other outposts. The French in Vincennes were required to give allegiance to the British crown, which sent troops to occupy the town and fort on the Wabash River in 1777. With the Revolutionary War started, George Rogers Clark led American forces to take what was now called Fort Sackville at Vincennes from the British on July 14, 1778. They didn't fire a single shot that day. Lieutenant Governor Henry Hamilton, British commander at Detroit, immediately moved his men south and retook the fort December 17, although Clark was gone. Then, in one of the most daring campaigns of the revolution, Clark marched other troops 180 miles back to Vincennes through flooded riverlands and, in a surprise attack, recaptured the fort and Hamilton February 23, 1779, after a two-day siege. The British effort to control the area north of the Ohio River was at an end.

Visitors to Vincennes today can see historical buildings that were part of the western movement. The territorial capitol has been restored and was moved to its present site in 1949. Nearby is a replica of Elihu Stout's *Western Sun* newspaper office. Across the street from the capitol building is Grouseland, home of Harrison. It was on the lawn that he met Tecumseh in an attempt to resolve their disputes. They couldn't; the Battle of Tippecanoe followed in 1811, when the Prophet was killed. With Harrison leading the Army of the Northwest, Tecumseh's power—and the final British effort for influence—were crushed by Harrison two years later in the Battle of the Thames.

Other Vincennes sites include the Old Cathedral, built between 1826 and 1840; the cathedral's library with its priceless collection of rare books; the Old State Bank, perhaps the state's oldest surviving bank structure, built between 1836 and 1838; and the Knox County Courthouse, 1872–76. More recent tourist attractions include the Lincoln Memorial Bridge, where Abraham Lincoln and family crossed by flatboat over to Illinois from their Indiana home, and the George Rogers Clark National Historical Park, its memorial with seven murals depicting important periods in the life of the Revolutionary War hero.

Knox County is named for General Henry Knox, Revolutionary War hero and aide to Washington. He later served as secretary of war in Washington's administration.

"I found this pleasing composition downtown in Vincennes. The many old and historic buildings here that memorialize the rich Revolutionary War-era history of this area made my decision difficult. This wintry scene with the church in the distance represents a typical scene on a snowy day."

LYLE DENNEY
"Winter in Vincennes"
Oil on canvas 20 x 30 inches

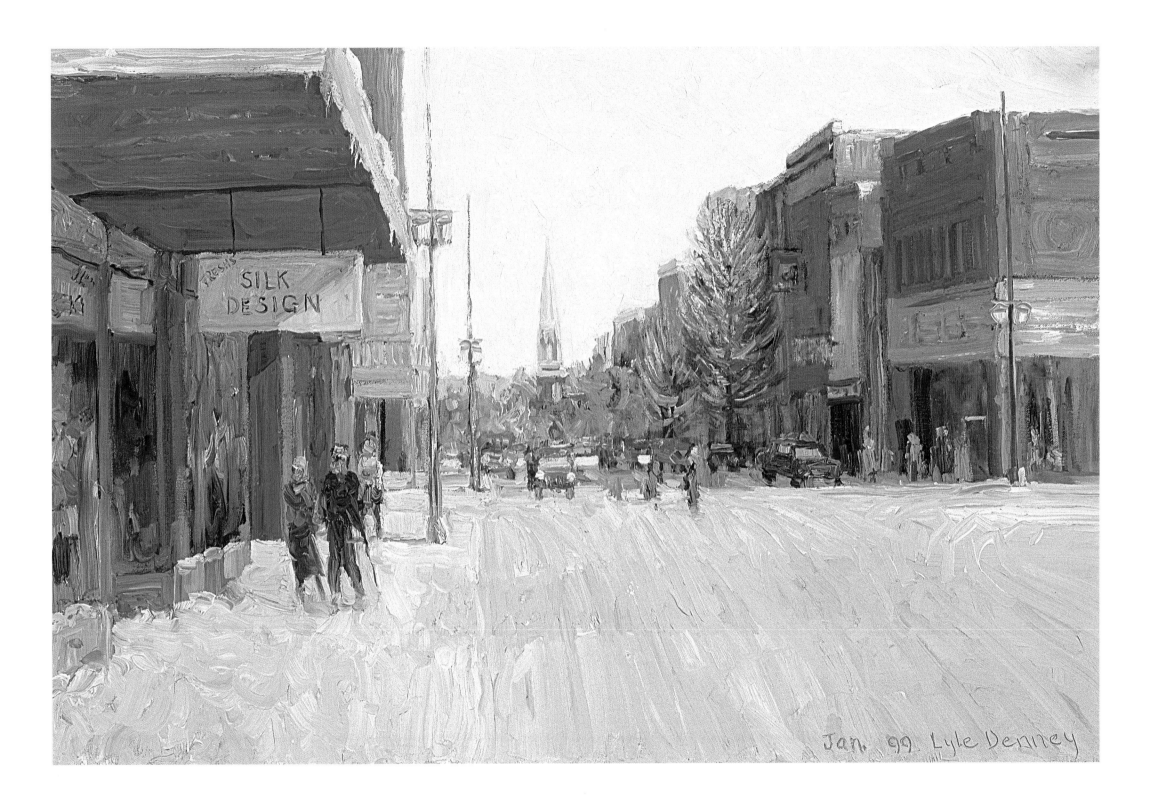

KOSCIUSKO COUNTY

The history of Kosciusko County during the twentieth century is America's history of the twentieth century.

It begins in the early 1900s with the last vestiges of the evangelistic revivals. At Winona Lake, former baseball player Billy Sunday was preaching at places like the Billy Sunday Tabernacle—wooden buildings with sawdust floors where thousands gathered to hear and perhaps "hit the sawdust trail" for the altar when the evangelist called for sinners to repent and be saved.

Winona was the chautauqua center of the Midwest during these early years. Sousa's band played. William Jennings Bryan orated. Will Rogers spun stories. And tens of thousands came for the event.

With the Roaring Twenties came the Spink Hotel and gambling casino on Lake Wawasee, where high rollers lounged away the hours in between trying to make, or maybe lose, their fortunes. The dance pavilion, Waco, welcomed the big bands.

As the years passed, Kosciusko remained mostly a rural county—millions of eggs are still shipped every year from Mentone—but industry made its mark. Early on, cement was manufactured, and ice was cut from the lakes during the winter months. The world's largest printer, R.R. Donnelley and Sons, now has a large unit in Warsaw. Three major orthopedic manufacturers are located in Warsaw and numerous smaller manufacturers are at work in the county's towns.

As Americans found increased leisure time in the latter half of the century, Kosciusko's lake communities flourished. The county has more than 100 lakes, including the biggest natural lake in Indiana, the Wawasee, covering nearly 3,000 acres. Eli Lilly, the Indianapolis pharmaceutical king, was the first Wawasee developer, building a sports club and summer lodge on the north shore. Other well-known lakes are Winona, Tippecanoe (the deepest lake in Indiana), Webster, Chapman, and the Barbee chain. Everything from cabins to small mansions appeared in the lake communities in the post-World War II years.

Today, Winona Lake, incorporated in 1913, has become a suburb of Warsaw, named after the capital of Poland. Located at Winona Lake is Grace College and Seminary. Its Rodeheaver Auditorium—named after Homer Rodeheaver, the famous hymn writer—is a center for musical and cultural activities.

Although Mentone native Lawrence D. Bell died in 1956, his career helped lead America into the late twentieth century. An aviation enthusiast, he founded the Bell Aircraft Corp. and his planes recorded at least twenty firsts, including shattering the sound barrier, flying two-and-a-half times the speed of sound, developing a jet-propelled fighter, and several helicopter firsts including making the first commercial helicopter. A Mentone museum houses artifacts and scale models from Bell's career.

Kosciusko may be the most unusual of all county names in Indiana. Those who know something about it are aware that it is named after General Tadeusz Kosciuszko of Poland—the "z" was dropped when the county was formed in 1835. He came to America as a thirty-year-old fortifications expert and served brilliantly during the Revolutionary War.

What fewer Americans know is the rest of the story. Returning to his homeland, he led the Polish Army in its struggle with the invading Russian Army, won battles against superior forces, was captured and imprisoned, but ultimately released. He came back to the United States in 1797—though never to Indiana—collected his United States pension, sold lands awarded to him, then took the money to buy slaves and free them. In the last year of his life—1817—he freed the peasants on his estates in Poland. A grateful Polish people buried his remains in a Krakow cathedral.

"My first trip to Kosciusko County was a rainout. On my second trip, after driving the county for two hours, I looked at my map and decided to look at Palestine Lake. When I drove into a boat launching area, I was excited by the bright white barn reflecting into the water and the pattern of algae."

DON RUSSELL
"Palestine Lake"
Oil on linen 20 x 24 inches

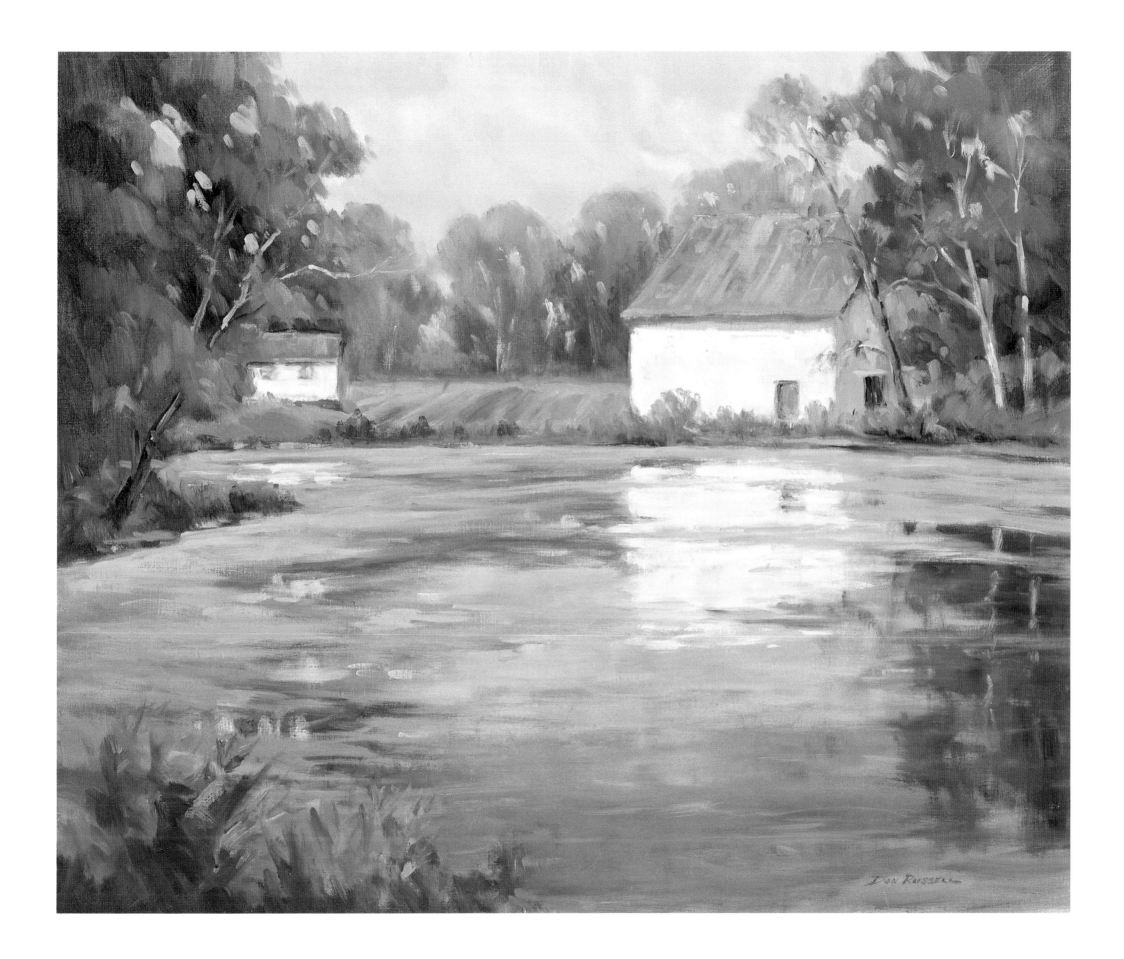

Don Russell

LAGRANGE COUNTY

There are flea markets and then there's Shipshewana.

Beginning each year in May and continuing through October, what is called the Midwest's largest outdoor flea market takes place in the heart of this Old Amish Order community. More than 1,000 vendors display just about every imaginable item each Tuesday and Wednesday. Year 'round, in a nearby building, antiques and other items are auctioned every Wednesday with up to eleven rings of auctioneers selling at one time. In another gallery of some 31,000 square feet, antiques are on sale, also year 'round. Then, on Fridays, there's an auction of livestock, horses, ponies, hay, and tack. The community itself has an additional 100 boutique shops.

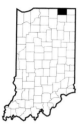

It's not hard to believe that every week thousands of people—perhaps as many as 100,000 a year—visit this small community in northwestern LaGrange County, set in the midst of the third largest Amish settlement in the United States.

The story of the Amish, the Mennonites, and the Hutterites is recounted at the Menno-Hof Visitors Center, located across Indiana 5 from the flea market and auction. The center's barn structure was built using rough-sawn oak beams fastened by knee braces and wooden pegs. Its exhibits tell of persecution in Europe and the eventual spreading of today's 750,000 members throughout fifty-seven countries.

The Topeka Livestock Auction is held especially for the sale of draft horses. Upwards of 10,000 prospective buyers show up for the spring and fall draft horse sales. Topeka, located in southeastern LaGrange, has also become a busy industrial and business town. Its businesses include the production of buggies for the Amish—a symbol of Amish separation from the modern world. A regular buggy costs about $3,000 while the more ornate ones go for about $6,500.

As in other northern Indiana counties, lakes, marshes, and knobs dot the LaGrange County landscape, formed by prehistoric glaciers. The Pigeon River Fish and Wildlife Area just east of Mongo in northeastern LaGrange is an 11,500-acre state facility for waterfowl protection. It is the largest fish and wildlife area in the state and has within its confines the Curtis Creek Trout Rearing Station. Nearby at Brighton is Greenfield Mills, with grist mills built here in 1846 and still in operation.

Olin Lake, 103 acres, and its nature preserve are connected to Oliver Lake, 371 acres, in the south-central part of the county. In all, there are sixty-four natural lakes in LaGrange County, many around the communities of Wolcottville, Stroh, and South Milford in the southeastern part of the county.

Howe is where the first white settlers came into the county and, for a time, was the county seat. It is the site of Howe Military Academy, begun in 1834 as a grammar school from a bequest given by John B. Howe, lawyer and schoolteacher. The 150-acre campus features the Chapel of St. James, built between 1901 and 1914 in the shape of a cross. The chapel has leaded glass windows and graves of Episcopal bishops in the basement, but the favorite story about the chapel is how a German student-artist exchanged his skills for his tuition by hand-carving the chapel's pews.

The town of LaGrange, located in the middle of the county, became the county seat in 1844. Its 1879 courthouse, constructed of limestone and red brick, has a 125-foot-high clock and bell tower that dominates the town's skyline. Brick streets still surround the courthouse.

LaGrange is named after the home of Lafayette, the French patriot who aided the Americans in the Revolutionary War.

"This area, southeast of Shipshewana, is very typical of LaGrange county, with its abundance of Amish homes, always neat and clean, large barns and houses, dirt roads, and familiar black buggies. The warmth of this country road emphasized the crisp white house against the warm, dark trees. The clothes waving in the warm breeze on Monday wash day added a familiar element to the scene. All this made for a very peaceful, inviting setting in one of my more interesting counties."

RONALD MACK
"Monday Morning"
Oil on canvas 20 x 24 inches

LAKE COUNTY

Even at the end of the twentieth century many Hoosiers didn't consider Lake County and "the Region" to be Indiana. It's probably equally true that many from the county didn't consider themselves to be real Hoosiers. But the Lake County of 2000 is a far different place than the Lake County of the early twentieth century. While very much a part of the Chicago metropolitan area, some of Lake County, especially its southernmost area, becomes more like much of the rest of the state with each passing year.

As Indiana developed through the latter part of the nineteenth century, Lake County, although established in 1836, was in many ways cut off from the rest of Indiana. The Kankakee River marshlands made overland travel difficult, if not impossible. In addition, the county's rivers, the Grand Calumet and the Little Calumet, flow east and west, not north and south and, by doing so, geographically define the Calumet Region.

The development of railroads to Chicago through the county in the late 1800s, followed by massive industrialization, served to tie the region more closely to the rest of the state. First, Standard Oil built a major refinery at today's Whiting. In 1901, Inland Steel Corporation constructed a large mill at East Chicago. Indiana Harbor, on the other side of the new Indiana Harbor Ship Canal, had booming industries. The giant of them all was U.S. Steel Corporation's biggest mill, built along the lake, and a new city—named Gary after the chairman of the board—to support the mill.

The years ahead were, for the most part, not easy ones for Lake County. Large numbers of immigrant workers came to work in the mills, and their living conditions were often deplorable. For years, the mills beat back all attempts at unionization but eventually capitulated. The Depression severely dampened the economy. With World War II came high employment again, along with thousands of blacks from the South and the flight of whites to the county's southern suburbs.

At the twentieth century's close, while industry remained important in the county, smaller businesses, shopping malls along U.S. 30 across the county, entertainment, and leisure activities defined Lake County life more and more. The meandering Kankakee River, which forms the southern boundary of the county, is noted for fishing. The 3,400-seat Radisson Star Plaza at Merrillville is one of the Midwest's biggest entertainment centers, attracting top-flight stars. Five casino boats line Lake Michigan's shores.

The county has proclaimed its wide ethnic diversity a strength. Ethnic fairs and festivals have expanded across the summer months—in July alone there are two Serb Fests in addition to an Italian Fest, a Greek Fest, and a Mexican Fest.

Lake County is, to some degree, two distinct regions. There is the heavily industrialized northern section of Whiting, East Chicago, and Gary extending down into Portage, Merrillville, and Crown Point; but while much of the lakefront is absorbed by heavy industry, not all of it is. It is referred to by Lake County residents as the "coast" and still offers spectacular settings of white dunes, water, and cool breezes. The southern part is more pastoral; only Cedar Lake and Lowell are towns of size there.

So far as is known, the county is named because it lies next to Lake Michigan.

"The Hammond Marina is home to the Empress Casino Boat and Hotel. The marina is busy with modern attractions, colorful boats, and newly painted docks. The vertical masts and pilings reflected into the water making this classic scene a visual treat against the large casino boat. This painting was fun to do, moving quickly from bare canvas to finished painting, and was well received by the public. Boaters turned around to see my work, and many people who stopped by told me they had never seen an artist working from life before. Some even offered to buy the finished painting. On this enjoyable sun-filled day my wife, Carol, sunbathed and swam in Lake Michigan while I painted."

ROBERT EBERLE
"Marina at Hammond"
Oil on linen 20 x 24 inches

LAPORTE COUNTY

The road was less than perfect. Protruding stumps were common. If it rained, the mud made it impassable. Still, in 1836, the Michigan Road, despite these obstacles, linked the state of Indiana from Madison in the south to its northern terminus at Michigan City.

Madison was clearly where the road should begin in the south, for it was one of the state's largest cities—a major river city, a key port for the Ohio water traffic, and a crossing point for people and products from Kentucky. Where the road should end in the north, however, was questionable. Michigan City received that honor and the town's founder, Isaac Elston, hoped it would become the county seat, too. (That didn't happen—LaPorte had been selected when the county was organized in 1832.)

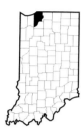

Michigan City's growth quickly outstripped that of the new county seat. In the late 1800s and early 1900s, millions of tons of sand were shipped from the Lake Michigan dunes to glass manufacturers in central Indiana and for use as landfill. The Michigan Central Railroad had its repair yards in the city until the company moved to Michigan. The major industry was the manufacture of railroad cars by Haskell-Barker, which later merged with the Pullman Company. (Pullman-Standard closed its plant in 1970.) Railroads criss-crossed the county by the late 1800s, contributing to the development and growth of both Michigan City and LaPorte as well as other smaller communities.

East of Michigan City in Hesston is the LaPorte County Historical Steam Society with its outdoor museum of steam engines, several of them reminders of the steam engine railroad days.

LaPorte's biggest manufacturing operation was Allis-Chalmers, which bought out a local company, Advance-Rumely, started in 1853. Both companies specialized in farm equipment. When Allis-Chalmers left in 1983, it ended a 130-year manufacturing history.

LaPorte's courthouse, built in 1892, and the surrounding business district have been designated as historic sites by the National Register of Historic Places.

A sign of the times may be that a strip mall now stands in LaPorte where the farm equipment factory was, while an outlet mall in Michigan City operates where Pullman-Standard once manufactured railroad cars. The former Kingsbury Ordnance Plant located in southeastern LaPorte County—producing shells during World War II and the Korean War—is now the site of an industrial park as well as the Kingsbury State Fish and Wildlife Area and Mixsawbah State Fish Hatchery.

In more recent years, tourism has become important for the county, one of three counties to border Lake Michigan to the north. (This happened when the Indiana–Michigan border was moved ten miles to the north, giving Indiana access to the lake in the northwest.) Visitors are drawn to the only operating lighthouse in Indiana at Michigan City, restored in 1971, as well as to a shipping and lake museum. Washington Park offers swimming, a fishing pier, picnic areas, and a panoramic view from an observation tower built atop a sand dune. On the county's southern border with Starke is the Kankakee State Fish and Wildlife Area.

Farming uses about 70 percent of the land today. Major crops are corn, oats, soybeans, and wheat. Orchards and some vineyards are found in the northern part of the county.

The county's name is taken from the French phrase *la porte*, meaning "the door." When French fur traders arrived in the late 1600s, a natural opening through the forest served as a gateway to the prairies beyond.

"I found the makings for a good composition from the roadway around Stone Lake, north of the city of LaPorte. I was intrigued by the patterns of clouds in the sky and the reflected light in the water. I thought I was painting on Pine Lake, just across the bridge, but luckily Marcia Morris recognized the scene and I gladly changed the title."

DON RUSSELL
"Stone Lake"
Oil on linen 16 x 20 inches

LAWRENCE COUNTY

The Empire State Building, Washington National Cathedral, Grand Central Station, Rockefeller Center, U.S. National Archives, Chicago Tribune Tower, The Waldorf-Astoria Hotel, Biltmore House, and Chicago's Museum of Science and Industry.

They're some of America's great historic buildings and all have one thing in common: They were built of Indiana limestone. Most of the stone came from Lawrence and Monroe counties in southern Indiana. At one point in the late 1800s, more than 100 stone quarries were in operation in these two counties. Even today, the limestone industry is the third largest employer in Lawrence County.

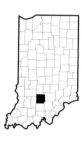 Nathan Hall, an Ohio stonecutter, built a small mill in Bedford in 1860 and began the first commercial quarrying of Indiana limestone. Public attention came in 1911 when construction started on the Bureau of Engraving and Printing building, the first Washington D.C. federal building to be built entirely of stone. A year later, thirty-nine stone mills in the area cut more than ten million cubic feet of limestone. In 1926 came the formation of the Indiana Limestone Company, a merger of twenty-four independent companies representing 90 percent of the area's stone industry. The nation became dramatically aware of the industry with the completion of the Empire State Building in New York City in 1930.

Lawrence County's walking tours of homes and cemeteries in Bedford and driving tours through the county feature the industry. One, the blue tour, takes the visitor to the quarry near the Hopkins Cemetery from which stone was mined for the Empire State Building. More limestone was sent recently for exterior repair of the seventy-year-old structure.

A county favorite is Spring Mill State Park, east of Mitchell in the southern part of the county. Its inn, built sixty years ago of limestone, has a 1976 addition expanding it to seventy-four rooms plus a conference center. The park is open year 'round and features a pioneer village, restored to look much as it did in 1831 when Hugh and Thomas Hamer acquired the property. A three-story grist mill, fed by water conveyed from a cave to the mill's water wheel, still grinds grain. On the grounds is Donaldson Cave, with its northern blind fish. George Donaldson bought a forest tract in 1865 and allowed no cutting of timber or hunting, so the state park today has a preserve of trees—the Donaldson Woods. Some of the trees are more than 300 years old.

Also on the grounds is the Virgil I. Grissom Memorial, a tribute to the Mitchell native, who was one of the original seven astronauts, second American flier in space, and one of three to die in an Apollo training mission fire at Cape Kennedy in 1967. Space artifacts are housed in the memorial, including the Gemini 3 capsule in which Grissom orbited the earth in the first manned Gemini flight. The capsule was later plucked from the seas by the USS *Intrepid* and thus became known as "the unsinkable Molly Brown."

A second Grissom memorial is located in Mitchell. It is a limestone replica of the Redstone rocket used to blast the astronauts into space during the Mercury program. The rocket stands on eight inscribed tablets. Nearby is a tree planted from a seed taken into space by Bedford astronaut Charlie Walker, a participant in shuttle flights.

The county is named for Captain James Lawrence, whose famous words as he lay mortally wounded in the War of 1812 sea battle with a British man-of-war—"Don't give up the ship!"—have become the Navy's most cherished rally. The county was established in 1819 with Bedford as the county seat.

"Nothing says Lawrence County like limestone. I want to thank George James, who works for Indiana Limestone, for his assistance in taking me to the quarry. I painted here twice on location. It was so peaceful and inspiring as the morning light came through the trees across the water."

LYLE DENNEY
"Autumn at Klondike Quarry"
Oil on canvas 24 x 36 inches

MADISON COUNTY

The county had seen booms before.

First, it was the canals. The Central Canal was to bring prosperity to the beginnings of Andersontown (later shortened to Anderson). But the Depression of the late 1830s ended this project almost before it started. Then it was natural gas. After all, in the late 1880s, Madison County sat in the midst of the greatest natural gas field in the United States. However, as everywhere in east central Indiana, the burning of gas night and day and the heavy industrial use of what appeared to be an unlimited supply depleted the wells. By the early 1900s, that boom, too, ended.

 Then came the automobile industry. This boom was different. It has now lasted for a century, through good and bad times. It could be said to have started at 12th and Meridian streets in Anderson in 1896 where the two Remy brothers, Frank and Perry, developed magnetos and dynamos for the fledgling automobile industry. Out of that beginning came Remy Electric. It became part of General Motors in 1918 along with Delco, a transplanted Ohio firm that produced the electric self-starter. Cars were built in Anderson, too—seventeen different types in the early part of the century, including the Lambert. While the auto builders didn't last long, the auto parts manufacturers did. General Motors, Delco Remy, and Guide Lamp brought thousands of jobs to Madison County.

Bad times came with the Depression, but during World War II all plants were focused on the war effort with full employment. In the early 1980s, with the American automobile industry in trouble, it was a different story—Anderson had one of the nation's largest percentages of unemployment. By century's end, stabilization seemed to have returned. The county had actually gained population by a 1997 estimate compared to the 1990 census, even though Anderson's population had declined by a few hundred during the same period.

Today, despite all the manufacturing activity, about 80 percent of the county is still devoted to agriculture. Anderson's downtown maintains its historic flavor with the restored Paramount Theater, the Carnegie Fine Arts Center, the Big Four Railroad Station museum and ballet, the West 8th Street and West Central Historic districts, and the Gruenewald Historic House. It has a modern flavor, too, with new buildings and a new name for Anderson University, the Madison County Government Center, the City Building, the Anderson Public Library, the Indian Trails Riverwalk, and improvements at Shadyside Park.

The history of the county goes back to the Hopewell-Mounds Builders—their earthworks can still be seen at Mounds State Park near Chesterfield. Later came the Delaware who, in 1818, agreed to sell their lands to the new state of Indiana. The first white settlers came into the area around present-day Pendleton, where the falls on Fall Creek promised a power source. It was near here that three white men were hanged after the 1824 murder of nine Miami and Seneca, thought to be the first execution of whites for killing Indians.

It was in Elwood, the city of his birth, in the northwestern part of the county, that Wendell L. Willkie accepted the Republican nomination for president in 1940 before a huge crowd.

The first seat of government for the new county, organized in 1823, was in Pendleton but was moved to Anderson in 1828.

The county is named for James Madison, fourth U.S. president and an author of the Federalist Papers.

"There are many beautiful places to paint in this county, like the Fall Creek area in Pendleton, but I chose Mounds Park because of the Indian history and the hills. I love to hike with a camera, and each time I visit this overlook of the White River I stop to soak it in. I met a lot of nice people here as they hiked along. I think they were as surprised to come upon an artist out painting in the woods as they were to hear Beethoven's Moonlight Sonata playing. This painting was a joy."

LYLE DENNEY
"April in the Mounds"
Oil on canvas 27 x 40 inches

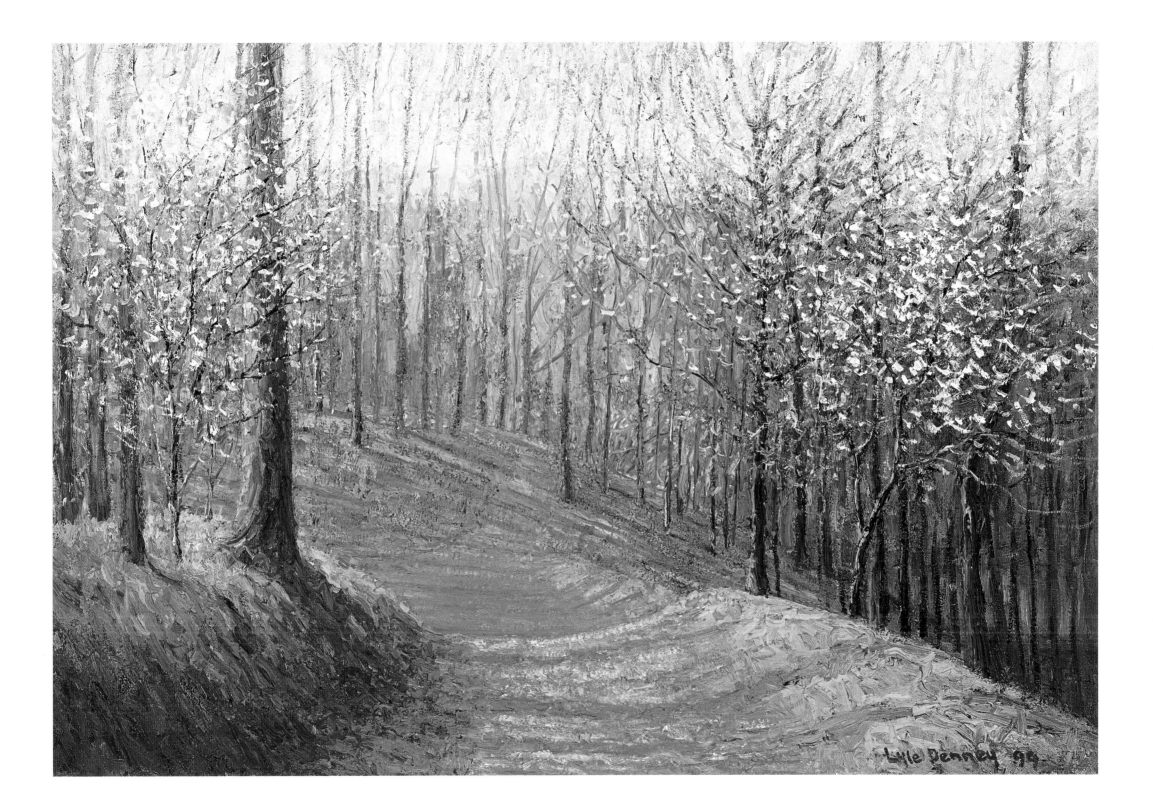

Lyle Denney '94

MARION COUNTY

Hoosiers need to be of a certain age to remember when Indianapolis was called "Naptown." In part, it was a friendly appellation, but it was also a social comment: Indianapolis was a place where you might fall asleep because not much was going on.

Indianapolis and Marion County—one and the same thing since a joint government termed Unigov was implemented in 1970—have long since shed their "big farm town" reputation. Now the twelfth-largest city in the nation, Indianapolis, which once only spread out, has gone skyward, too, with a true big-city skyline. The county, established in 1821, was named for the Revolutionary War hero, General Francis Marion.

Interstates 65 and 70, connecting the east with the west and the north with the south, are merely the latest fulfillment of the "Crossroads of America" designation. A century ago, the interurban converged in Indianapolis and tied together passenger traffic for the state on its electric rail lines. Indianapolis had the largest interurban station in the world—the Indianapolis Traction Station.

Railroads played their part in transforming a farmland state capital into a growing metropolis. The first union station in the nation was built here in 1853 (replaced by a larger terminal in 1888) to serve the city's commerce and passenger needs. For decades—through two world wars, through the Roaring Twenties, through the Depression—Union Station was perhaps the city's main landmark.

Indianapolis is probably known best for automobiles and for speed. Without question, the Indianapolis 500 has been the world's most famous race for years. Started in 1911, the race attracts drivers from all over the world and is Indiana's largest public event. Growing immediately in popularity was the NASCAR Brickyard 400, first held at the track in 1994.

The relationship between Indianapolis and automobiles has been more than racing around a closed track. Cities throughout central and northern Indiana produced cars in the early 1900s, but Indianapolis even more so. As many as seventy different automobiles were manufactured in the city, the most famous being the Duesenberg, the Stutz, and the Marmon. The automobile industry, along with Allison, which built fighter plane engines, and Curtiss-Wright, which manufactured propellers, was one of the key players in the industrialization of Indianapolis in the years following the Depression and during World War II.

For Hoosiers at the beginning of a new century and for whom "Naptown" means little or nothing, Indianapolis is understood to be an entertainment, cultural, business, and sports mecca. Its sports credentials were solidified in the early 1980s when the National Football League's Colts came to town and as governing bodies of amateur athletic groups established their headquarters here. By the end of the 1990s, Indianapolis reinforced its place in the sports world by securing the national headquarters of the governing body for collegiate sports, the National Collegiate Athletic Association, and by erecting a new fieldhouse for the National Basketball League's Indiana Pacers. The city is also home to the Indians, a Triple A baseball team.

The White River State Park, located in downtown Indianapolis, offers a world-class zoo, the Eiteljorg Museum of Native Americans and Western Art, and soon a new state museum whose construction began in the late 1990s.

Indianapolis has a long-standing musical tradition, rooted in the ragtime and jazz of the 1910s and 1920s, which continues today in clubs around town.

No, it isn't Naptown any more.

"Before deciding on this view, I spent the entire morning studying the area of White River Park. I found the Indianapolis skyline and the White River from the walk behind the zoo appealing on this July evening. I have painted 200 or so paintings in Marion County but have rarely chosen urban scenes. I thought this would be the best representation for this county."

DON RUSSELL
"Indianapolis from the Zoo"
Oil on canvas 18 x 24 inches

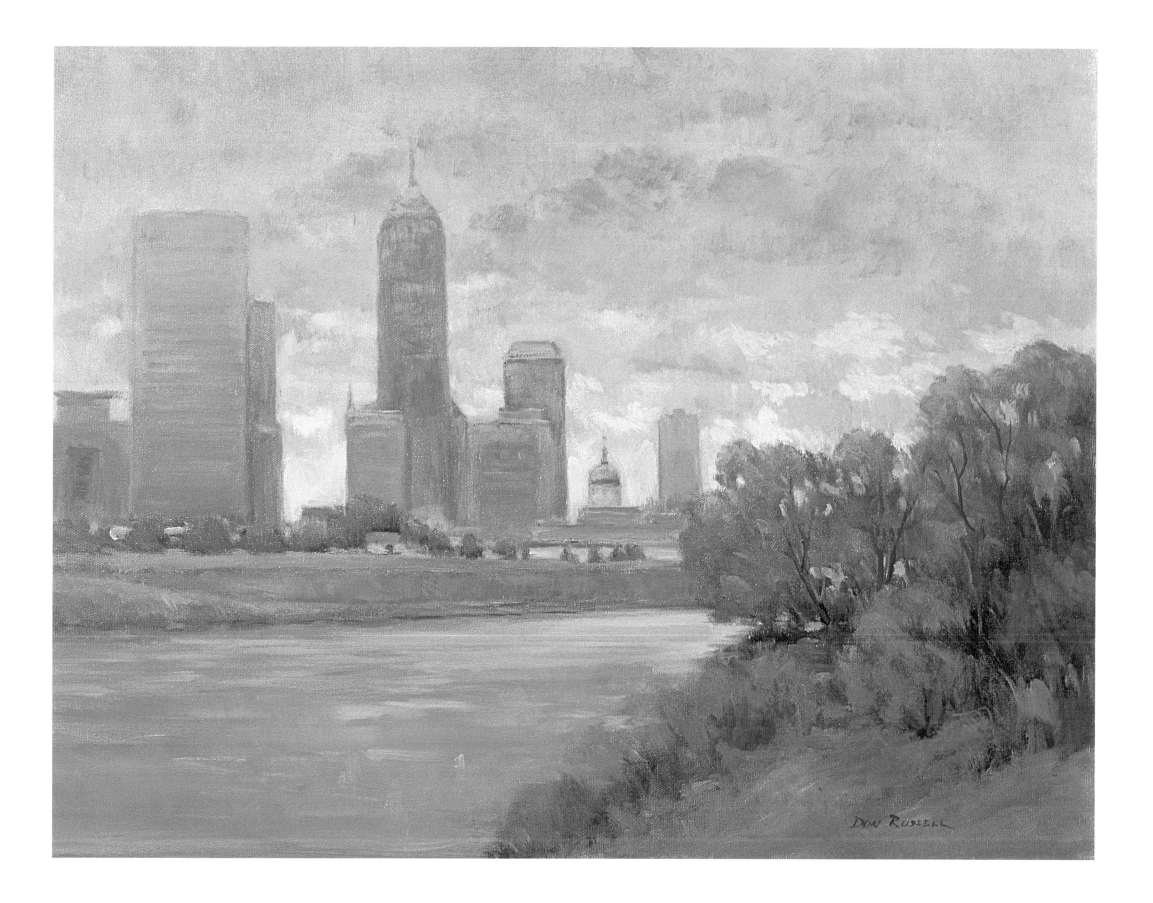

Don Russell

MARSHALL COUNTY

When James Blair, John Sering, and William Polke saw that Indiana might form a new county in the northern part of the state—and would need a county seat—they took the usual steps of land speculators of the day. They made certain they possessed land in the geographic center of the probable county and then they planned inducements. When Marshall County was formed by Indiana in 1835 and organized in 1836, here was their offer: Put the county seat at what was to become Plymouth and they would provide $1,000 in cash, sixty-three lots to be sold for county operating funds, a plat for a courthouse, another for a "market house," and a burying ground.

They won the bid.

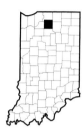

It was a likely spot because Michigan Road, running from Madison to the Michigan border, went right through the town site. The center of the village was the intersection of Michigan Road and the old LaPorte Trail. The city's growth was not all that rapid, however—fifteen years later its population stood at around 600.

Within two years of the county's organization, a tragedy that is commemorated even today occurred with the removal of the Potawatomi Indians to the West. Chief Menominee resisted until armed troops in late August 1838 force-marched nearly 900 tribe members to the Kansas Territory. Along the way, forty or more died, Menominee among them, in what has since been called the "Trail of Death." The chief is the subject of a monument, which stands where the march started near Twin Lakes, south of Plymouth.

The county is known outside Indiana as the site of the Culver Academies, which are located in the southeastern part of the county. The Culver Military Academy for boys was founded in 1894 on the shores of 1,800-acre Lake Maxinkuckee, the state's second-largest lake—Wawasee being the biggest. In 1971, the Culver Girls Academy was started. The Black Horse Troop, said to be the last cavalry unit in the nation, led the inaugural parades for President Reagan in 1981 and 1985 and continues to present summer parades on the grounds. The schools also offer summer camps on the 1,800-acre campus where, during the academic year, students board from more than thirty states and twenty other countries. They even have their own airport and aircraft for instructional use.

To the north, near Donaldson, is the Ancilla Domini Junior College, founded in 1937 on Lake Galbreath by the Poor Handmaidens of Jesus Christ.

Recreation, built around the county's lakes, is a major tourist attraction. The Blueberry Festival, an annual three-day event each Labor Day weekend, and the Culver Lakefest, with its fireworks show over Lake Maxinkuckee, are two summertime highlights. Bourbon celebrates with an antique tractor show each year. The county has six golf courses, including the United States Golf Academy and Swan Lake Golf Resort at Plymouth. Plymouth's Centennial and Magnetic parks are also popular recreational sites.

Plymouth's large industrial park is home to many small manufacturing companies. The county is also a rich farm area with major crops of corn, oats, and potatoes. Bremen is known for its mint fields.

The first county jail, built in 1838, had its entrance on the second floor. Prisoners were lowered through a trap door into the ground floor! The present courthouse in Plymouth was completed in 1872 and remodeled in 1914. It is of Georgian Revival design with a central clock tower. The county was named for U.S. chief justice John Marshall, who died the year the county was formed—in 1835.

"I've always wanted to paint a foggy morning painting, and this was my chance. I hadn't planned a painting like this for the project, but when you think about it, farms blanketed in fog are a typical sight in Indiana. As I sketched the buildings and trees and took some photos for reference along the roadside, I noticed how quiet the morning was. The fog dampened the sound and seemed to sweeten the smell of the grasses and weeds. Groomed gardens take a back seat to the flowering weeds in the country, which is my favorite place to be. Painting the Queen Anne's Lace was a joy."

DAN WOODSON
"Misty Morning"
Oil on canvas 20 x 36 inches

MARTIN COUNTY

The people of Martin County had trouble making up their minds. In the fifty-one years between the founding of the county in 1820 and the final move to Shoals in 1871, the county seat was moved nine times!

To be exact, it wasn't named Shoals when the seat of government was moved there—it was Shoals Station. Before that, it had several other names, including Memphis. When the post office dropped the word "Station" from the town's name in 1868, the citizens went along and officially changed the name in 1872. Well, actually, the county seat wasn't exactly in Shoals either. The courthouse is across the river in what used to be called West Shoals, but it was annexed near the turn of the century.

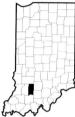

The first county seat was at Hindostan, southwest of Shoals. The community had thirty-three "heads of families" in the 1820 census, making it the largest town in the county. It attracted settlers because it was on the New Albany–Vincennes stagecoach line and the Hindostan Falls produced power for stone, grist, and saw mills. Shortly after its designation, illness decimated the small community, killing or driving off every resident. Today that site is the Hindostan State Fish and Wildlife Area.

Next the county seat went to Mt. Pleasant, a town on the other side of the White River, because it was now the biggest with thirty families. Seven more moves followed, though not, fortunately, due to the tragic circumstances of Hindostan.

Interestingly, the largest town in the county and its only incorporated city, Loogootee, was never the county seat. Perhaps it was not considered because it sits right on the border with Daviess County. When the Ohio and Mississippi Railroad came through the town shortly after it was platted in 1853, people living in Mt. Pleasant, just a stone's throw away, began moving to the larger town. It became a freight and livestock shipping center.

Much of Martin County is taken up by two large tracts of government-owned lands: the Hoosier National Forest, which spreads across seven southern Indiana counties including southeastern Martin, and the Crane Naval Weapons Support Center, covering almost all of the northern third of the county.

Crane is a nearly 63,000-acre facility for the manufacture, testing, and storage of ammunition. Today, about 3,500 civilian workers are employed. During its heyday in World War II when it supplied the Atlantic fleet with munitions, nearly 10,000 workers were at the facility. Its man-made 800-acre Lake Greenwood is open to the public for fishing and boating.

Gypsum turned out to be the biggest natural resource of the county during the second half of the twentieth century. One shaft near Shoals is the deepest gypsum mine in the nation.

The county's terrain is some of southern Indiana's most hilly and scenic with cliffs and bluffs, formed from the runoff of Ice Age glaciers. Perhaps the best example of the county's natural wonders is the Jug Rock, the product of centuries of erosion of a mountain. Located near Shoals, the bottle-like rock appears to be balancing a flat stone at its crown.

In only a very few of Indiana's ninety-two counties is there any argument about the county's namesake. In most cases, it's obvious—Boone, Decatur, Jefferson, and Washington, for example. In Martin County, it's less clear. The most apparent choices are three Kentuckians—a Major Martin (first name unknown), Major Thomas Martin, and John P. (or T.) Martin. The leading candidate is John P. (or T.) Martin—*if* he were John Martin, the Kentucky frontiersman and Indian fighter. But no one can be sure.

"This is a beautiful county with its rolling hills. I was excited by the colors of the farm field and the bank of the east fork of the White River, which runs through almost the entire county. It was late afternoon and the light was warm. I had hoped for more fall color in the trees, but it was still a little early in October when I painted here."

DON RUSSELL
"South Side of East Fork"
Oil on linen 18 x 24 inches

Don Russell '98

MIAMI COUNTY

They may not be the professionals of yesteryear, but sometimes it's hard to tell.

Each July during ten performances spread over an eight-day period, local school children, who have been practicing during the winter and spring months, star in the Circus City Festival. Some of them are descendants of the circus performers who called Peru their winter home before taking off each year to thrill worldwide audiences during the late 1800s and the early part of the twentieth century. No circuses are based in Peru any more—not since the 1940s, actually—but in 1960 Peru decided to restore its circus days once a year. About 250 young performers, from six to twenty-one years of age, do it all

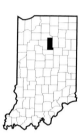

during the festival performances—flying trapeze, walking the high wire, motorcycling, balancing on the teeterboard, and, of course, clowning. For a while they used a tent, but since 1968 the show has taken place in the Circus City Center. The annual event, with arts and crafts, midway, rides, food, and games, ends with a Saturday circus parade.

It harks back to the days when America's top circuses wintered near Peru. The first was the Hagenbeck-Wallace Circus—Red Skelton was one of its clowns. Others included the Clyde Beatty Cole Brothers Circus and the legendary Buffalo Bill's Wild West Show. They are remembered at the Circus Hall of Fame and Museum, situated on the Wallace Circus Winter Quarters.

Music remembers Peru for a different reason: Cole Porter. The composer of some thirty Broadway musicals and songs, including *Begin the Beguine, Let's Fall in Love,* and *In the Still of the Night,* was born here in 1891. In Indianapolis, the new Indiana Historical Society building has a Cole Porter Room, commemorating the work of Porter and other Indiana musical greats. Though Porter spent much of his life in New York and California, he is buried in Peru.

Miami County's population dropped about 5,000 in a five-year period in the early 1990s, but is projected to grow slowly to around 33,000 (up 1,300) in the early 2000s.

The county is primarily agricultural, but even so, it took a serious population and economic hit when Grissom Air Force Base was decommissioned in the 1990s. Since then, part of the base has been converted into the Grissom Air Museum with an indoor display of bombs, missiles, flight trainers, uniforms, photos, engines, and other military memorabilia. Outside are historic aircraft, including the B-17 Flying Fortress, the B-58 nuclear bomber, the B-47 Stratojet, the A-10 Warthog, and the EC-135 command post aircraft from Desert Storm. The Blue Angels, an aerial performing group, are usually part of a weekend air show in June.

Three rivers flow through the county—the Eel, the Wabash, and the Mississinewa. It's the Mississinewa that is dammed to prevent flooding downstream and to provide recreation. When the reservoir is filled during the flood season, it covers more than 12,000 acres. Fishing and boating bring an estimated 500,000 people to the area annually.

Miami County is named for the Miami nation and its leaders, one of the best known being Chief Godfroy. He became a wealthy landowner and operator of trading posts, selling furs to traders and representatives of eastern merchants. He is buried in the Godfroy Cemetery, not far from the "Seven Pillars of the Mississinewa"—sixty-foot limestone bluffs cut away over the centuries by the river.

The county was organized in 1834 but its boundaries were not settled until 1840. Peru is the county seat, developing as an important trading center on the Wabash and Erie Canal in the early 1800s.

"On my first trip to Miami County it was cloudy, but this scene appealed to me. I made a second trip three days later and painted when the weather was improved. The Wabash River bridge across from the old train station and the buildings across the river made a great view with the variety of shapes and reflections in the water. I think it's a keeper!"

DON RUSSELL
"Wabash River at Peru"
Oil on canvas 14 x 18 inches

DON RUSSELL

MONROE COUNTY

The people at the Monroe County Convention and Visitors Bureau in Bloomington are smiling. Just look at the accolades that have come their way recently: *The 50 Healthiest Places to Live and Retire in the United States* ranks Bloomington twelfth. *Money*'s great places to retire ranks Bloomington sixth in the nation, while Rand McNally's rating of best places for retirees lists Monroe/Brown counties at number eight. *Psychology Today* puts Bloomington at number seven out of twenty-five of the least stressful cities in America. *The Campus as a Work of Art* declares Indiana University–Bloomington one of the five most beautiful campuses in the nation. *Vegetarian Times* says it's one of the eight most desirable places in the nation; *Bicycling* ranks it seventh in places to bike; and *Golf Digest* figures it to be sixth out of the seventy-two best counties for a golfing retirement.

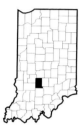

No wonder Bloomington's population stands at 61,500 and the county at 111,000.

Those numbers don't include the hundreds of thousands who pour into Bloomington for Indiana University events or the other hundreds of thousands who make Lake Monroe, Lake Lemon, Griffy Lake, and the Hoosier National Forest their recreational destinations.

Lake Monroe, lying south of Bloomington, is Indiana's largest man-made lake— 10,750 acres created by damming Salt Creek in 1963. It's partially surrounded by the northern half of the Hoosier National Forest's nearly 78,000 acres. Skiing, swimming, boating, and fishing are big activities. The 1,650-acre Lake Lemon is northeast of Bloomington; its surroundings are ridges and ravines. Boating and fishing are popular there as they are at Griffy Lake, a 1,200-acre nature preserve originally designed as a water supply for the city.

Downtown Bloomington is centered around the 1902 courthouse with its stained glass window and copper weathervane that sits atop the building's dome. The downtown business district has withstood the onslaught of shopping malls and offers some 175 stores, galleries, and restaurants. In all, the county has more than 250 restaurants and, partly because of the large number of international students attending IU, has a wide range of ethnic specialties.

Much of the focus, of course, is on Indiana University's main campus with its 33,000 students. Since it is located in Indiana, basketball plays a prominent role as the Hoosiers compete in the Big Ten athletic conference.

But there's much more at IU than basketball. Founded in 1820, it is the oldest state university west of the Alleghenies. IU is known internationally for its music school where more than 1,000 musical events take place annually. Its opera performances constitute one of the longest-running programs in the Western Hemisphere. The Lilly Library contains more than 350,000 books including a Gutenberg Bible. The Indiana Memorial Union building, which includes a 200-room hotel, is the world's largest student union.

The campus is also home to Thomas Hart Benton murals, created for the Indiana exhibit at the 1933 World's Fair in Chicago. They are each twelve feet high and once extended 230 feet around the Indiana State Hall. Today, forty-one of them are in three campus buildings, telling the story of the state from its inception to modern times.

Of interest near the campus is the Wylie House Museum, the home of Indiana University's first president, Andrew Wylie. Built in 1835, it is one of the city's oldest structures and its rooms and grounds have been restored to depict the home of a university administrator in the 1840s.

The county is named for James Monroe, fifth U.S. president and the author of the Monroe Doctrine, warning European nations not to meddle in Western Hemisphere affairs.

"As I drove all over the county I kept hoping the sun would emerge. But the clouds were getting heavier, so I painted an overcast scene. Two painters stopped to talk and look at my painting, but they turned out to be house painters. We compared the cost of our brushes and they liked the smaller brushes I was using, because they would be good 'trim' brushes!"

DON RUSSELL
"Overcast day—Lake Lemon"
Oil on linen 18 x 24 inches

MONTGOMERY COUNTY

Books and publishing might be the best words to describe Montgomery County. After all, Crawfordsville, the county seat, has been called "the Athens of Indiana."

The book for which Crawfordsville is known is *Ben-Hur,* written by General Lew Wallace. It was published in 1880 while he was governor of the New Mexico Territory, but Wallace said, "the greater part of my work was done at home, my favorite writing place, beneath an old beech tree near my house." Both the house and the tree are gone, but Wallace's Study, built in 1896, is today a museum housing Wallace memorabilia, including not only his writings but also his paintings, violins he both made and played, and some of his inventions.

Publishing has continued into the twentieth century in Montgomery County. R.R. Donnelley and Sons has had a publishing plant in Crawfordsville since 1921. It is the largest employer in the county with more than 2,000 workers who perform pre-press, printing, and binding of trade, religious, children's, and book club books. Joining this firm in the city is the distribution center for Golden Books Publishing, printer of books for children. While its work force is less than 300, it distributes more than 200 million Golden Books annually from its Crawfordsville center.

One of the nation's few remaining all-men colleges was founded in Crawfordsville in 1832. The school went through several name changes and educational missions before emerging in 1839 as Wabash College. Today, with an enrollment of around 850, its students come from more than thirty states and twenty-five other nations. Its graduates rank sixteenth out of 1,500 similar colleges for completing graduate education and receiving doctoral degrees. It is also one of the most richly endowed, having the twentieth-largest endowment per student of all American schools. The college has an open library for Crawfordsville residents and invites them to cultural activities on campus.

Historic buildings play a prominent role in Crawfordsville and around the county. Ten buildings at Wabash College are rated historically outstanding by the Historic Landmark Foundation of Indiana. The Old Jail Museum was the first of seven revolving jails built in the nation—and the last to be operative. The sixteen cells, constructed in a pie-shaped fashion on two tiers, would only open to a single door as they were revolved by the jailer who used a hand-operated mechanism.

The center of historic homes is the Elston Grove Historic District with houses built between the 1830s and the 1960s. Isaac Elston built his home in 1835 in a wooded grove that was at that time east of Crawfordsville. Today, the house serves as the residence of the Wabash College president. The Lane Place is the city's major showplace. Built by Henry Lane, one of the founders of the Republican Party and a strong supporter of Abraham Lincoln, it was used as a focal point for his many political activities. Restored by the historical society, its furnishings date from the Colonial Period to the Empire and Victorian eras.

Shades State Park in the southwestern part of the county has one of the largest stands of virgin timber in Indiana on its 3,076 acres. Lookouts, deep ravines, and dense woods make up much of the park, especially the Pine Hills Nature Preserve.

Montgomery County, organized in 1822, was named for Major General Richard Montgomery, who died in the Battle of Montreal during the Revolutionary War. Crawfordsville was named for Colonel William Crawford, frontiersman, who served under both General Anthony Wayne and Governor William Henry Harrison.

"Driving south on 231 toward a spot I planned to paint, Carol and I saw a small bridge over Sugar Creek and stopped to check it out. It was 9:30 in the morning and the air was cool, the mist was rising off the creek, and the sun was just rising over the trees. It was an awesome scene we knew wouldn't last long. I set up my easel and painted the scene as I saw it. This was one of those landscapes that almost paints itself. Everything was just right; from the autumn reflections to the misty, distant light and the deep shadows along the creek's edge."

ROBERT EBERLE
"Misty Morning over Sugar Creek"
Oil on linen 16 x 20 inches

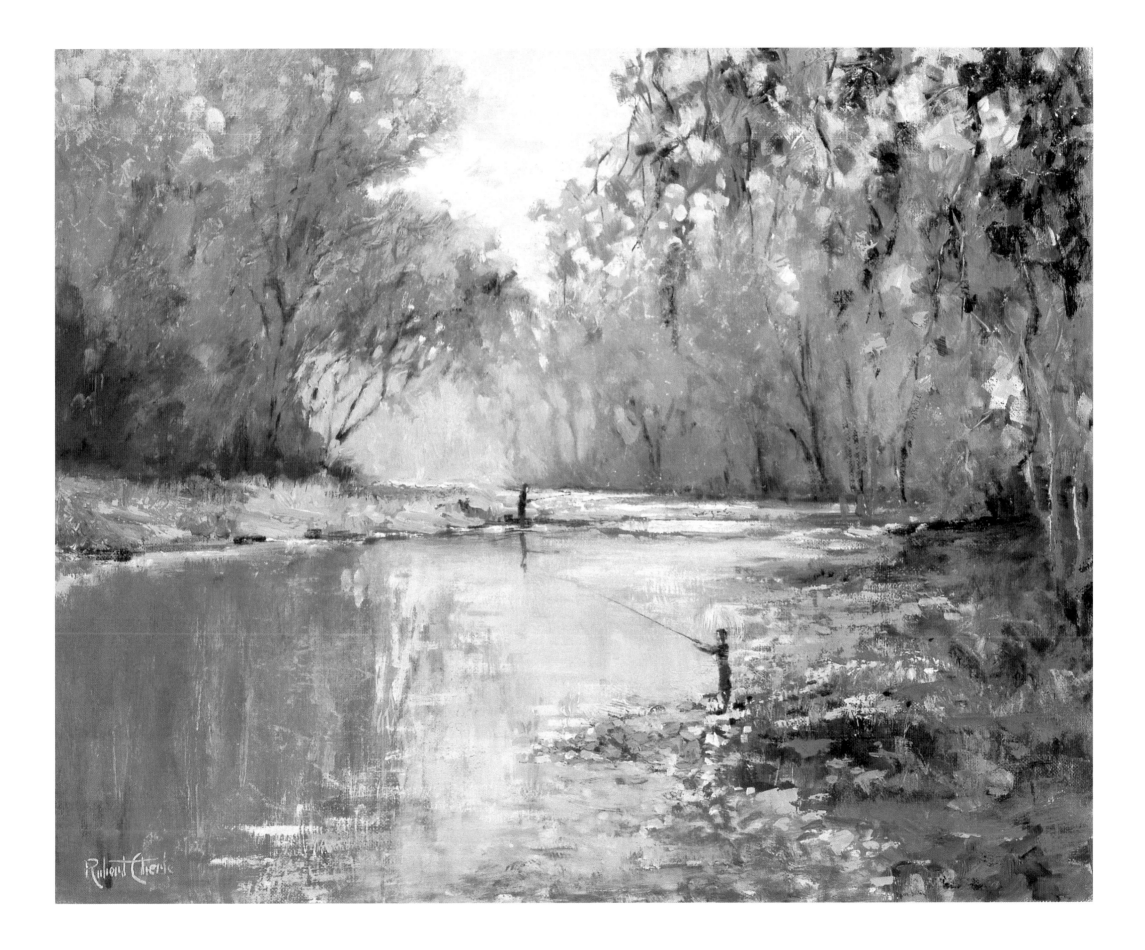

MORGAN COUNTY

Martinsville hoped to become part of the Indiana gas boom in the 1880s, but a gas drill hit water instead. Not just any water, however—an artesian spring began to flow. Over the next few years, more artesian water was found and its curative powers were widely heralded. Soon restorative sanitariums where the ailing could "take the waters" were a major business in the city. Like the natural gas wells, the sanitariums' days were numbered. By the early part of the twentieth century, both gas and artesian curative waters were mostly history, although the Homelawn Sanitarium in Martinsville continued into the early 1970s.

Before and since, the main occupation in Morgan County has been farming, located primarily in the flatlands of the north. The southern part of the county tends to be more hilly, where a prehistoric glacier ended. On the southern border of the county, shared with Monroe County, is the Morgan-Monroe State Forest. Its 23,680 acres make it Indiana's second largest state forest, the Clark State Forest being the biggest by 300 acres. Its activities include boating, fishing, camping, hiking, hunting, and picnicking.

Another woods of note in the county is Bradford Woods, now used by the Riley Children's Hospital for recreation. The Bradford family purchased the woods over a period of several years. The last survivor of the family, John, who was a close friend of the Hoosier poet James Whitcomb Riley, gave the land to Indiana University's trustees for the benefit of the hospital and its programs for children.

The west fork of the White River runs from the northeast to the southwest corner of the county and was to have been part of the early 1800s canal through the county. Because the river was already a major route of transportation, the canal was to transfer to the White River at Port Royal so that traffic would flow south on the river. At the last minute, the transfer site was not included in the canal's bidding specifications and Morgan County's canal opportunities ended.

Today, Morgan County's location between Marion County to the north and Monroe County to the south has made it in part a residential community for workers employed in Indianapolis and Bloomington. It was the second fastest growing county in terms of population until the late 1990s, when it slipped to seventh place. Two Indiana governors called Morgan County home—Emmett Branch and Paul V. McNutt. McNutt was governor (1933–37) during the difficult years of the Depression and solidified power in the governor's office during those years as he jockeyed for a higher federal position. Later, he became high commissioner to the Philippines.

Another county resident achieved his own notoriety in the 1930s. John Dillinger was a boy when his family moved to a farm near Mooresville, just south of the Marion County line. A Mooresville stickup started his life of crime, which eventually ended in his shooting death outside the Biograph Theater in Chicago. The Dillinger Historical Museum, however, ended up in Brown County at Nashville.

The effective date for organization of the county was in 1822, with Martinsville declared the county seat. The county is named for General Daniel Morgan, a Revolutionary War hero, who was also elected to Congress. Martinsville takes its name from John Martin, a member of the committee appointed by the Indiana legislature to determine the location of the county seat.

"The temperature was close to 90 degrees on this hot, humid day. A farmer drove by on his tractor and gave me a puzzled look. I waved, but he didn't wave back. Maybe they see too many artists in this area!"

DON RUSSELL
"Morning on Centennial Road"
Oil on linen 16 x 20 inches

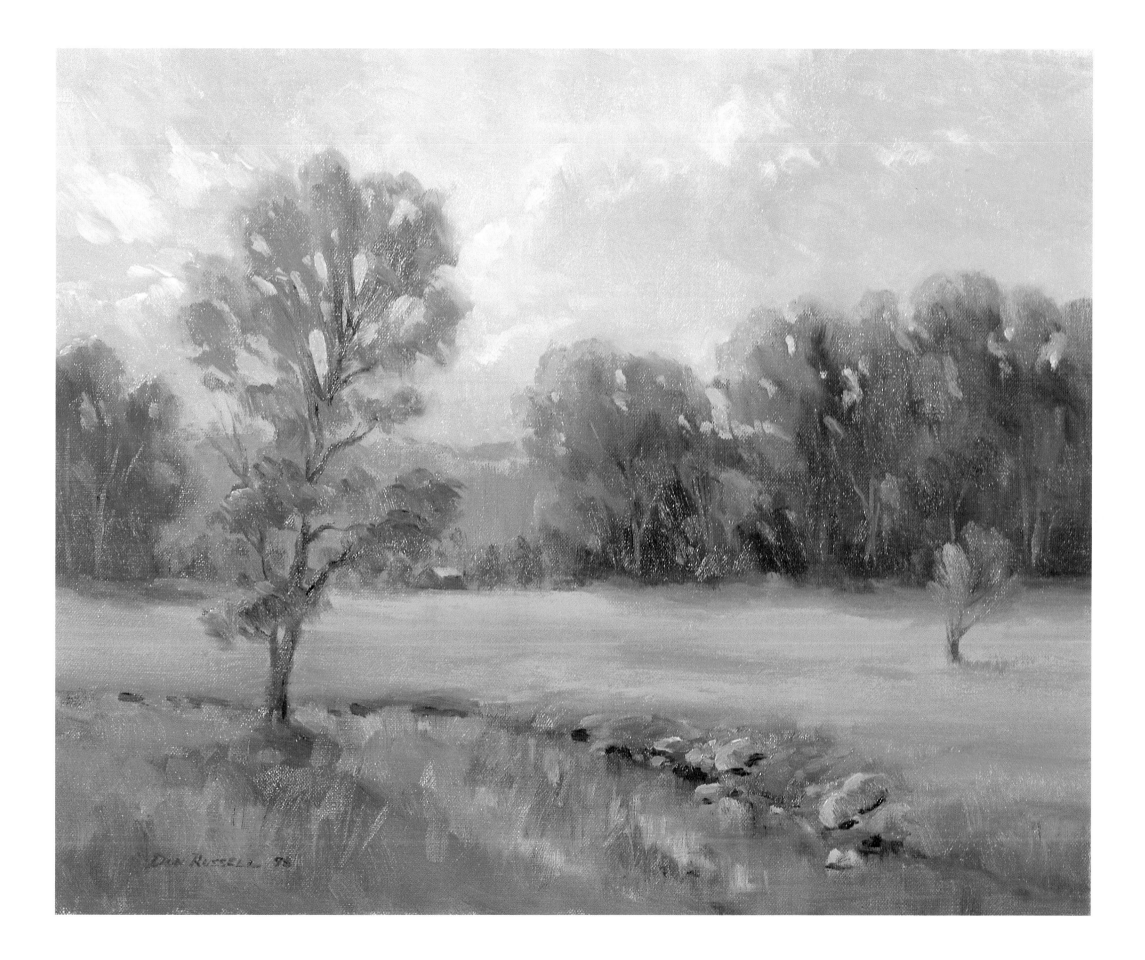

NEWTON COUNTY

Newton County may be unique among Indiana counties in having been organized as a county twice.

When northern Indiana was first divided up by the state in the early 1830s, Newton was one of fourteen new counties. However, one thing led to another: Lake County was separately organized in 1837, taking all of Newton north of the Kankakee River, then Porter County was subtracted, and finally what was left of Newton was added to Jasper County when it was reorganized.

Not that Newton County was all that attractive at the time. Much of its former northern part was the Kankakee Swamp. Bordering on the swamp was Beaver Lake and its own swamp, covering perhaps as much as 36,000 acres. While its beaver and other game were sought-after targets of trappers and hunters, the land for settlers was largely inhospitable. Add to that the outlaws who lived in and around Beaver Lake, frequently hiding out on one of its many islands. Accounts abounded of horse thievery, counterfeiting, and other undesirable acts that were tolerated by the few people living in the area because they were for the most part left alone by the outlaws. Finally, after a number of incidents and posse chases, the locals decided they had had enough. Organized vigilantes drove the outlaws out, probably heading west.

About the same time, efforts were underway to drain the swamps and Beaver Lake. The swamps hindered travel north into Lake County and toward Chicago while the lake, extremely shallow, covered promising farmland. These drainage efforts took years—actually continuing into the twentieth century.

Meanwhile, other attempts were made to reorganize a new Newton County. Politics, petitions, court cases, and injunctions followed before a final Indiana Supreme Court decision in 1859 allowed formation of the county to take place. So, some twenty years after the first time, Newton County was again on the Indiana map.

Interestingly, part of the county has been made into a lake again—the Willow Slough State Fish and Wildlife Area in the western part of the county lies along the Illinois border. The nearly 10,000-acre state project includes the 1,500-acre man-made J. C. Murphy Lake. To its north along the Kankakee River, and shared with Lake County, is the 3,000-acre LaSalle State Fish and Wildlife Area, named for the French explorer who may have been the first white man to come down the river.

An unexplained geological formation is found just east of Kentland. Called both "the Kentland Crater" and "the Kentland Dome," rock formations rise from the earth vertically rather than horizontally. The solid rocks are perhaps 1,500 feet higher than the surrounding area. Theories include a long-ago meteor strike, an earthquake, or a subterranean gas explosion that forced their eruption from the ground. This area is now the Newton County Stone Quarry.

Kentland is the county seat, named for Alexander Kent who platted the town in 1860. The Hoosier playwright and author George Ade was born in Kentland as was the 1920s governor, Warren McCray. McCray remains a paradox. He championed women's right to vote, systematized the state's highways, improved the state teachers' pension fund, and supported more enlightened state mental institutions. At the same time, he is the only governor to be convicted of a felony while in office—using the mails to defraud. He resigned and was sent to federal prison for ten years. Later he was given a full pardon by President Herbert Hoover.

Newton County was named for Sergeant John Newton, a soldier who served with General Francis Marion during the Revolutionary War.

"I felt the rich heritage of Indiana's farmers as I drove along Highway 4. Mile after mile of unobstructed views across vast farm fields provided a panorama of changing colors and shapes in the sky. At dusk the sheared lands yielded an unfettered view of a majestic sunset and cloud formations. Agriculture is the economic base of Newton County and the farms are huge with giant silos and vast fields. I wanted to capture this vastness in a painting."

ROBERT EBERLE
"Golden Moments"
Oil on linen 20 x 24 inches

NOBLE COUNTY

As the twentieth century neared its end, the woman who was arguably Noble County's most famous resident was brought home to be buried near the cabin she had built on Sylvan Lake at Rome City.

Gene Stratton-Porter, author of fifteen books that sold millions of copies, lived in her two-story cabin, Wildflower Woods, on the south shore of the lake from 1914 to 1919. Earlier, she lived in Geneva in Adams County where she wrote her most famous book, *Girl of the Limberlost.* After her years on Sylvan Lake, Hollywood beckoned and she moved to California, where her books were being made into motion pictures. She was killed in a Los Angeles auto–street car accident in 1924 and buried there.

Seventy-five years later, with the dedication of a new visitors center for the Stratton-Porter cabin at Rome City and the desire of her grandson to have her body returned to the state, legal barriers were cleared for the bodies of the author and her daughter, Jeanette Meehan, to be returned to Indiana.

Rome City and Sylvan Lake had not changed greatly from a half-century before when Stratton-Porter arrived in 1914. Sylvan Lake had been developed in the 1870s as a resort with hotels, a dance hall, and other amusement and recreational attractions. Life was quieter where Stratton-Porter lived on the south shore. The author/photographer would venture out in the wooded and swampy lands gathering material for her naturalist-centered novels.

Sylvan is but one of numerous lakes in the county, the others the result of prehistoric glacier patterns. Typifying these glacier-formed lakes is Chain O'Lakes State Park in the southern part of the county. The 2,678-acre park has perhaps the oddest shape of any state park—only one mile wide but four miles long. Within the park are eleven lakes—eight of them connected—with seven miles of shoreline.

Albion is the county seat, situated near the center of the county, and one of the county's several small towns.

The largest city, Kendallville, is located in the northeastern part of the county. In modern times, Kendallville has developed its East Industrial Park, which includes such well-known firms as Dow Corning and The Budd Company, producers of sheet and molded compound plastics. The city's major employer is Favorite Brands, makers of confectionery products. Other manufactured items include iron castings, fuel injection lines, suspensions and axles, appliance controls, and springs.

The city, named for the postmaster general of the United States, Amos Kendall, has its own lake, the 117-acre Bixler Lake, surrounded by 320 acres of municipal parklands.

Transportation has played an important role in Kendallville's development. An early plank road connected it to Fort Wayne to the south along the present route of state road Indiana 3. Railroads came through including the New York Central, the old Grand Rapids and Indiana Railroad—later absorbed by the Pennsylvania—as well as the interurban line earlier in the twentieth century. Today, U.S. 6 is the major east–west highway through the city while U.S. 33 goes through the western side of the county, coming north from Fort Wayne.

The other city in the county, Ligonier, was laid out in 1835 by a native of Ligonier, Pennsylvania—hence, its name. The railroad's arrival in the 1850s helped the city grow through shipping of grain from nearby farms.

Noble County, organized by the state in 1836, was named for James Noble, the first U.S. senator from Indiana.

"The wide, inviting front porch overlooking Sylvan Lake, the gardens, and long wisteria arbor at Gene Stratton-Porter's log home near Rome City would make anyone feel creative. A short afternoon rain caught me off guard. I peeled my compact plastic emergency poncho open, tearing holes in it until it was useless, just as the brief shower stopped. I threw the poncho away. Three impressive and inquisitive high school students from the area, working on an assignment on Stratton-Porter, talked with me about my painting. They also asked for my autograph, and that was a first for me."

DAN WOODSON
"Gene Stratton-Porter Home at Rome City"
Oil on canvas 20 x 26 inches

OHIO COUNTY

Four facts are certain about Ohio County. Another is in dispute.

First, it is the smallest county in Indiana. Its total land area is but eighty-seven square miles, with a population of about 5,000. Tucked into southeastern Indiana, it's bordered on the east by the Ohio River, on the north by Laughery Creek and Dearborn County, on the west by Ripley County, and on the south by Switzerland County.

Second, the county is named for the river. The history of the county has always been tied to the river, called Great River by the Iroquois. In earlier days, flatboat traffic down the river was the major

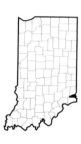

form of transportation. By the mid-1800s, the steamboat had replaced the flatboats in getting produce to market and people headed west; Rising Sun was one of the prominent stops, as boats plied the river. When the railroads came to Indiana, none was built closer than ten miles from the county's border, thus bypassing Ohio County and leaving it to remain largely the same for decades. The only town in the county, Rising Sun, was cut off by the river on one side and high hills on the other so that overland traffic was almost nonexistent. The significant recent change on the river has been the Grand Victoria Riverboat, part of the Grand Victoria Hyatt Hotel development in Rising Sun.

Third, while no one knows for sure just who the first white man was to see the area, the first settlers are known: they were the John Fulton family that settled at the future site of Rising Sun in 1798. By 1814, Rising Sun had been platted and other settlers were arriving, almost all of them by river.

Fourth, while it might not be a fact, strictly speaking, no one is likely to dispute that the countryside of Ohio County is among Indiana's most beautiful. The Laughery Creek Valley, with its ridges, rock outcroppings, and wooded areas, along with the vistas of the Ohio River from high ground in the county, offers some of the state's most picturesque views.

What is open to argument is why the county seat is called Rising Sun. The commonly held opinion is that the Fultons, when they saw the sun coming up over the Kentucky hills, were struck by the sight of it. Or was it the sun coming up over the river itself? Or did it have to do with some Iroquois name? We will never know for sure.

In the early 1900s, Rising Sun had a few industries, including the Whitlock Furniture factory. Today, no manufacturing exists and the county relies on the farming of tobacco and other crops and tourism. The Hyatt casino and resort have certainly had an impact. Some population increase has come from the greater Cincinnati metropolitan area with urbanites seeking rural communities in which to build new houses or restore older homes. The town's riverfront is still used as a park and resting place for watching the water. The park has a playground and gazebo and is a stopping point for the open-air trolley rides that tour Rising Sun during the summer months. Numerous boat docks and launching facilities line the river.

The courthouse, built in 1845 in Rising Sun, is the oldest one in continuous use in Indiana. Its architecture is Greek Revival.

Probably the best-known home in the county is the Speakman house, built in 1846 near present-day Indiana 56, close to the Dearborn County border. It was a stagecoach stop and is believed to have been an Underground Railroad station for slaves fleeing north.

"In this, Indiana's smallest county, I was drawn to paint the distant hills beyond the river and dark foliage at the riverbank, coupled with the now familiar sight of a riverboat. My wife, Dottie, and I talked with many local people about the casino boats now common on the river. Most had high hopes that these new attractions will offer new economic vitality for the riverfront areas of Indiana."

RONALD MACK
"Riverbank"
Oil on linen 16 x 20 inches

ORANGE COUNTY

When North Carolina Quakers moved into what was to become Orange County in the early 1800s, they brought with them a fond recollection of that state's governor, Samuel Ashe, and the memory of his recently deceased young son, Paoli Ashe. The son had been named for the Corsican freedom fighter, Pasquale Paoli. So when it came time to give the new county seat a name, Paoli it was. In 1987, a visiting Corsican couple brought a bronze bust of Pasquale Paoli, which has been placed in the office of the Paoli Chamber of Commerce.

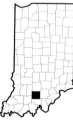

The county, named for Orange County in North Carolina, the home of many of those first settlers, was organized in 1816, the same year that Indiana became a state. The Piankeshaw Indians ceded the land to the United States by treaty.

The oldest county town, however, is Orleans, founded in 1815 and named in honor of Andrew Jackson's victory over the British at New Orleans in the War of 1812. Orleans, by official proclamation of Governor Edgar Whitcomb in 1970, is the "dogwood capital of Indiana." When Eddie Wheeler planted a dogwood tree in his yard as a gift to his wife, Elizabeth, she dreamed of state road Indiana 37 lined with red and white dogwood trees. Residents transplanted seven miles of dogwoods from the woods to the highway by 1966. Today, an April Dogwood Festival is celebrated.

French Lick and West Baden are two towns nestled in the hills of scenic southern Indiana that have attracted national attention. The story of West Baden Springs Hotel reads like a sprawling work of fiction covering three centuries and the lives of hundreds with a plot including ups and downs, a nation in turmoil, economic depression and wars, and millions of dollars. Owners came and went. It burned to the ground as the twentieth century approached, and the owner, Lee Sinclair from Salem, Indiana, rebuilt an even more magnificent structure within two years. At the end of the 1900s, a partial restoration to the once-abandoned "eighth wonder of the world" had been completed, but almost all of its rooms remained untouched. Preservationist officials were still looking for a buyer to finish the multi-million dollar restoration at the close of the twentieth century.

The French Lick Springs Resort Hotel, a mile and a half from West Baden, was for years the unofficial summer home of the Democratic Party. It was at the 1931 National Governors' Conference where Franklin D. Roosevelt picked up substantial support, ultimately leading to his election as U.S. president in 1932. The resort offers all manner of sports plus musical performances and major conferences. Now owned by Boykin Hospitality, it is undergoing a $20 million restoration, spread over ten years. (French settlers' livestock in the 1600s seemed to benefit from licking the mineral deposits found in the springs; thus the name French Lick, so dubbed by newly arrived Americans.)

Much of Orange County is part of the Hoosier National Forest, which spreads over seven counties in southern Indiana. The French Lick, West Baden and Southern Railroad, part of the Indiana Railway Museum in French Lick, runs a two-hour train ride that goes through twenty miles of the forest. It also passes through the 2,200-foot Burton Tunnel. Since the train cannot turn around, it must first go backward and then forward on its return trip to French Lick.

Two miles south of Paoli is the Pioneer Mothers' Memorial Forest, eighty acres of virgin timber surrounding an ancient village site believed to have been built a thousand years ago. Another recreational favorite is the Patoka Reservoir with boating, fishing, and hiking.

"West Baden Springs Hotel, now being restored to its original beauty, is an Indiana treasure. I chose to paint a scene from the grounds to represent Orange County. The Hygeia Building caught my eye because of its low, horizontal lines. Its warm hue in the spring sun contrasted against the huge vertical evergreens. The rusty early spring color beyond the pines with warm shadows added to the composition. The hotel is slowly returning to its original magnificence. Everyone should see this unique Indiana landmark."

RONALD MACK
"Hygeia"
Oil on linen 16 x 20 inches

OWEN COUNTY

For more than 180 years, Owen County has been one of Indiana's least populated counties: no urban areas, only two incorporated towns, and mostly rolling farmland along with broken land and ravines. That's changing.

It's a somewhat common Indiana story. First, the flatboats plied the west fork of the White River, which runs southwest through the county from Gosport down to Greene County, bringing commerce and expansion to river towns such as Freedom which was, for a while, a stopping point. Then came the railroads. If a community had only boat traffic, it soon saw its population and business dwindle. From 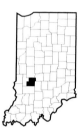 the middle of the 1800s through the early part of the twentieth century, the railroad towns prospered. But they, too, went into decline as goods and people were increasingly moved by highways. Other cities grew, such as nearby Terre Haute and Bloomington and a little farther to the east, Indianapolis.

Now the population shift has started to come full circle. Just as the early settlers left their Southern homes in search of more land, a different life-style, and a better future for their children, so today's urbanites are moving from the cities, looking for good land values, a slower-paced way of living, and perhaps realization of their dreams of an America that seems to be slipping away in the busyness and compactness of big-city life. With Interstate 70 just a few miles north of the Putnam County border, U.S. 231 and Indiana 67 traversing the county north to south, and Indiana 46 crossing the county from Bloomington to the east and Terre Haute to the west, Owen County sits in the middle of what could become a population corridor between Indianapolis and Terre Haute.

The county was settled mostly by arrivals from the Carolinas, Virginia, and Kentucky. Later migrations from Ohio brought German settlers, mostly to the southwestern part of the county. Hardwood timber, streams and springs, and farmland attracted and sustained a mostly agricultural population with some coal and limestone mining.

The county's only two incorporated towns are Spencer, the county seat, and Gosport. The town of Gosport is the only one in Indiana located directly on the 10 O'clock Line, a boundary line created when a sword placed in the ground cast its shadow at 10 A.M. Legend has it that this was declared in a treaty between Indians and white settlers in 1809, opening much of southern Indiana for settlers. Another legend has the county referred to as "sweet Owen" because its late election results provided the margin for a Congressional victory.

The county also has Indiana's oldest state park, McCormick's Creek, located just east of Spencer and founded in 1916. One feature of the park is a deep, mile-long canyon that offers a rugged climb for hikers. Along the county's northern border with Putnam County is Leiber State Recreational Area and Cataract Falls. Its upper falls are the second highest waterfall in Indiana. The recreational area is the result of a giant flood control program and Cagles Mill Dam. The falls, while on Mill Creek, are named for the small community of Cataract, now a hamlet but once the site of grist and saw mills.

The county was established in 1819 and is named for Colonel Abraham Owen, who fell in the 1811 Battle of Tippecanoe, fighting with William Henry Harrison against the Indian forces of Tecumseh and the Prophet. Spencer is named after a fellow Kentuckian who fought and died in the same battle, Captain Spier Spencer.

"The water level at Cataract Falls in May of 1998 was very high from recent deluges of rain. The teeming water at the lower falls was impressive. The Painting Indiana project had just begun and I was eager to get started, but my broken wrist still had metal pins and rods holding the break in place. In pain and frustration, I decided to start from sketches, photos, and memory, and return to paint on-site later. Applying paint to my brush with my left hand, I transferred it to my broken right hand and applied the paint to the canvas. It took a while, but I did it, and this is one painting I will hate to part with."

DAN WOODSON
"Lower Falls at the Cataracts"
Oil on canvas 20 x 30 inches

PARKE COUNTY

When Parke County declares itself to be "the capital of covered bridge country," no one seriously disputes its claim. After all, of Indiana's ninety-three remaining covered bridges, Parke County has thirty-two.

What do these vestiges of the nineteenth and early twentieth centuries mean to the county? Some measure is indicated by the estimated two million people who annually visit western Indiana in mid-October for the Parke County Covered Bridge Festival. Overnight lodgings are at such a premium that residents of Rockville—the center of the festival—open their homes to guests for the ten-day event.

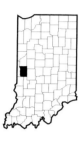

The entire county gets into the October festival with guests "eating their way around the square"—downtown around the 1879 courthouse—and branching out to historic Bridgton and its mill, crafts at Rosedale, Tangier's buried roast beef, Bloomingdale's Quaker community, Mansfield Village's antiques, and, of course, covered bridge tours.

Building these bridges was no easy task. Timber for most of the bridges—planks, sides, roofs—was usually cut from poplar trees on the spot. Oak was generally hauled in by horse-drawn wagons for fashioning the trusses, uprights, and arches. The process would take from six months to a year. Contrary to a somewhat common belief, the purpose of the covered bridges was not to protect passengers passing through; they were to keep the wood in the bridge from rotting.

The major nemeses of the bridges, though, were vandals, fires, and floods. In one flood, waters were so high that rescuers went through, not under, the Mecca covered bridge in their motorboats. Some bridges had to be replaced several times over the years.

A re-creation of early life in the county can be found at the still-growing Billie Creek Village, where nearly forty different structures, including three covered bridges, have been moved from around the county. Its Civil War re-enactment is one of the Midwest's biggest. A modern inn is part of the non-profit living-history museum.

Along with covered bridges, mills have played their role in the county's history. With abundant, fertile land and transportation provided first by the Wabash and Erie Canal and then by the railroads, the milling and grain industries for decades shipped their surplus to distant points.

Parke County was at one time coal-mining country. Several of its smaller communities prospered as company towns. Life was somewhat on the rough side. Rosedale, for example, supposedly had twelve working mines in the vicinity and, in town, eleven saloons. In the first fifty years of the twentieth century, an estimated thirteen million tons of coal were shipped out of Parke County. But the coal eventually played out and, with the coal gone, most of the towns slipped back to hamlet size.

Parke County has three state-operated outdoor attractions: Turkey Run State Park in the north, Raccoon Lake State Recreational Area in the east, and Shades State Park, shared with Montgomery County, in the northeast. The cliffs of Turkey Run were formed some 300 to 600 million years ago, shaped by glacier action into their present sandstone deposits. The exact origin of the "Shades of Death"—later shortened to Shades—is not known, but probably came in part from the deep shadows cast by the thick forests of the present park. The Raccoon facility is part of the Cecil M. Harden Lake and reservoir management system.

The county, established in 1821, is named for Benjamin Parke, the first territorial delegate to the Congress. Rockville is the county seat.

"On a still and peaceful morning at the Mansfield Roller Mill, the grass was still wet and cool with dew. It conjured images of decades past and of how some things have remained the same. I saw the makings of a beautiful painting. On the other side of the mill was a different story. Anne and I had arrived on the weekend of an annual motorcycle gathering—hundreds of beautiful Harleys, choppers and the like. We saw leather and bandannas and considered backing out slowly, but realizing that a fat, gray-haired artist posed no threat, we stayed. The bikers were friendly and respectful and added an interesting element to our day."

DAN WOODSON
"Mansfield Roller Mill"
Oil on canvas 24 x 36 inches

PERRY COUNTY

The Ohio River is a boundary for thirteen Indiana counties including Perry and has played an important historic role in their development and economy.

It is along the Ohio that the first white settlers came into today's Perry County in the early 1800s. The Ohio provided the major form of transportation throughout much of the nineteenth century for the county. The railroad, on the other hand, didn't reach Cannelton on the river until 1888, in part due to the hilly terrain.

Packet boats, along with paddle wheelers carrying both cargo and passengers, worked the Ohio on their routes from Louisville on down the Mississippi to New Orleans. Troy, Tell City, Cannelton, and Rome were ports of call. The Abraham Lincoln family frequented Troy, then the center of commerce for the area. Robert Fulton's first steamboat, the New Orleans, took on coal at Tell City in 1811. His younger brother, Abraham, moved to Tell City to manage Robert's 1,000 acres of what they hoped would be a mining business; but he was killed in an accident and is buried in Troy Cemetery near Fulton Hill.

Industries came and went for Perry towns along the river. In 1954, Cannelton lost its Cannelton Cotton Mill, the town's major business since the 1850s. The Cannel Coal Company had a long and often unsuccessful run in mining throughout the 1800s but through its promotional activities did entice other companies to town at mid-century including paper mills, cotton mills, a foundry, and a glassmaker. The county's major employers today are in iron castings, electric motors, and crushed stone and ready-mix concrete.

River accidents are part of the county's history. Revolutionary War hero Marquis de Lafayette was wrecked on a stormy night in 1825 on the Ohio near Cannelton when his steamer, the *Mechanic,* struck an object and quickly sank. He and his crew escaped, to be rescued at the Indiana shore the next morning. A steamer carrying Union soldiers on their way home from the Civil War in 1865 ran aground near the hamlet of Magnet. The boiler exploded, killing ten soldiers. All are buried in a mass grave near the Ohio, still tended today by a Perry County family.

Perry County residents suffered as did other river communities when the Ohio flooded, especially in the late winter 1937 flood that destroyed two-thirds of Cannelton. One of the river construction efforts culminated in 1962 in a high lift fork and dam system built by the Corps of Engineers. It created a 114-mile "lake" in the Ohio from Cannelton back upriver to Louisville that has become a major water sports area.

Almost two-thirds of Perry County is part of the Hoosier National Forest, which extends north through seven counties. Of the forest's 194,000 acres, 60,000 are in Perry County. The forest offers camping, hunting, fishing, water sports, swimming, horseback riding, and picnicking in addition to wildlife watching.

The first county seat was at Troy, but that town found itself on the county's western border when Spencer County was created. Rome was the county seat for most of the first half of the nineteenth century. The third county seat was Cannelton, with Tell City becoming the fourth in 1994. It has nearly half of the county's population and was named after the legendary Swiss hero, William Tell, by the original Swiss settlers.

Perry was created in 1814, two years before Indiana became a state. It was named in honor of Oliver Hazard Perry, who defeated and captured a British fleet on Lake Erie during the War of 1812.

"I've hunted and camped in Perry County for several years—it is beautiful rolling country sweeping down into the Ohio River Valley. I found a gorgeous place with a long vista east of Derby. The fields were not yet plowed and the wild mustard was in bloom, clover and other wildflowers were growing, and I just had to try to put it on canvas."

LYLE DENNEY
"Spring in the Ohio River Valley"
Oil on canvas 20 x 28 inches

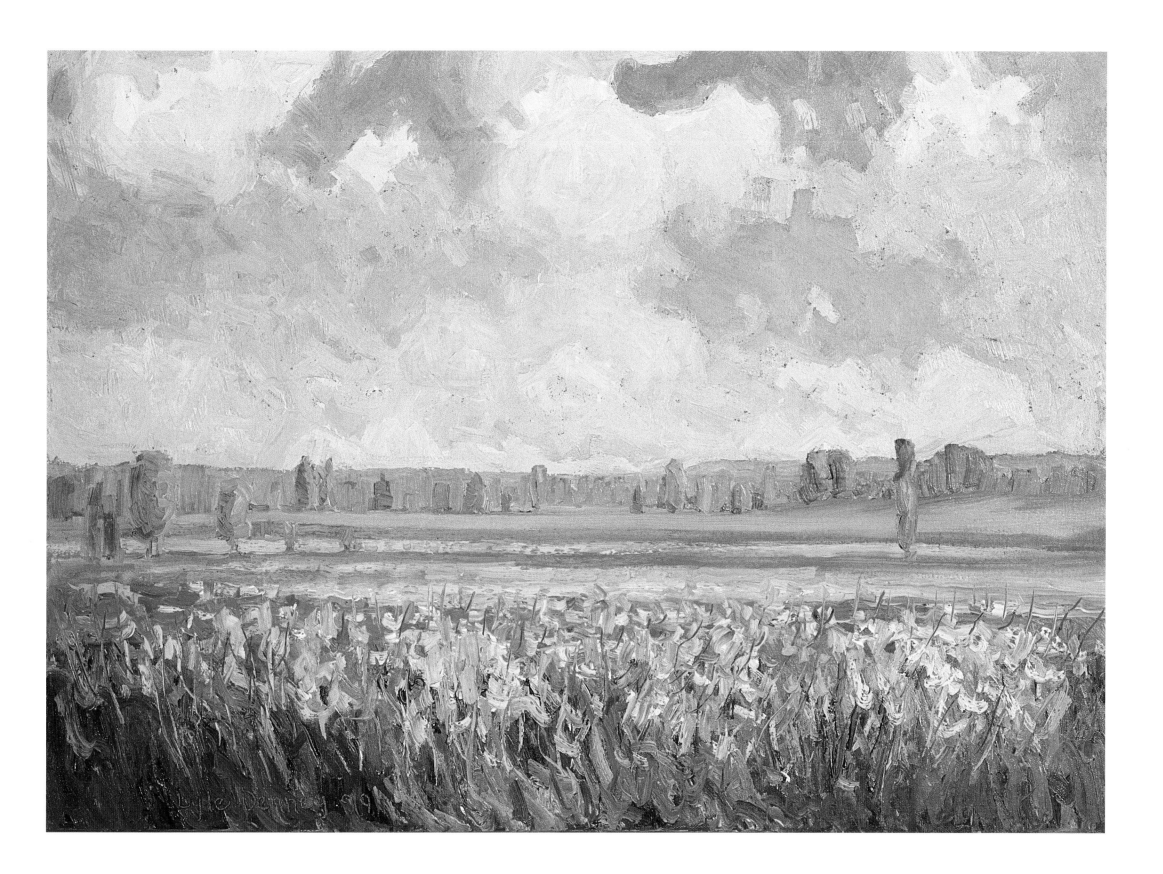

PIKE COUNTY

After the final boundaries of Pike County were worked out in 1826, life more or less drifted along for county residents. Petersburg, along the north border, was made the county seat. (The folks at White Oak Springs Fort, the first settlement in 1807 built to provide protection along the Buffalo Trace, might have sought the honor but apparently were not interested.) Winslow and Otwell developed as small towns while Spurgeon, though even smaller, became the only other incorporated town along with Winslow and Petersburg.

Rolling farmlands and wooded hillsides dominated the countryside. One activity of note as the county was developing occurred when the up-and-coming Illinois politician, Abraham Lincoln, came back to Indiana where he had lived his early years to deliver an address in 1850.

Then, in 1860, coal was discovered and Pike County has been coal mining country ever since. The first mine, "Old Ben"—now Kindill #1—located south of Coe in southwestern Pike County, is still being worked today. Pike County claims it is the oldest mine in continuous operation in the nation. Two major electrical power plants are located along the White River, just north of Petersburg, utilizing local coal. Shaft and strip mines also ship coal, with production in the millions of tons annually. While the number of employees has decreased with advanced technology, mining still remains the largest single industrial employer in the county.

One aftereffect of strip mining has been the development of the Sugar Ridge State Fish and Wildlife Area in the southern part of the county. The Indiana Department of Natural Resources has reclaimed more than 7,000 acres with fishing and hunting the major activities in and around Sugar Ridge's more than one hundred lakes.

Another outdoor recreational site is the Pike County State Forest near the center of the county. It covers 2,914 acres and offers hunting, fishing, hiking, and horse trails. The 200-acre Prides Creek Park including a ninety-acre lake is located in the northern part of the county, with fishing, tennis, basketball courts, and campsites. In all, the county has more than 7,000 acres of water combined with a twenty-mile wetland section along the Patoka River where more than 200 bird species have been identified.

Rivers and water projects have been an important part of Pike County's history. The Patoka River flows through the center of the county whose northern boundary is formed by the White River and its east branch. In the mid-1800s, the Wabash and Erie Canal came through the county. Remnants of earthen dikes that contained the canal waters and also served as tow paths for the mules pulling the boats still exist where the canal crossed the Patoka River. The canal never met its builders' dreams, however, in part because of the transportation impact of the railroads.

A three-story brick courthouse, the fourth in the county's history, is located in the county seat, Petersburg. Even today, Petersburg is the only town in the county with a population of more than 1,000: there were 2,535 in the last census out of the county's 12,631 inhabitants. The county was the first created after Indiana gained statehood in 1816.

The county is named for Zebulon Pike, discoverer of Pike's Peak, who earlier in 1806 found what he believed to be the headwaters of the Mississippi River in present-day Minnesota. He also found British trappers on American land, part of the recent Louisiana Purchase. Trouble with the British along the frontier was one reason for the soon-to-be-fought War of 1812. A brigadier general, Pike died in that war, killed in the American attack on York, now Toronto.

"After driving many back roads on our second visit to this county, we came to a deeply wooded area. The sun shone through on the curve at the bottom of the hill and the winding road sparkled like a diamond. I backed up the car and unloaded quickly to capture this mood. It was probably the most pleasant place I've ever painted. There was not a sound, not even a chirping bird. A four-wheeler passed by in the morning and that was it for the rest of the day."

RONALD MACK
"Country Serenity"
Oil on linen 16 x 20 inches

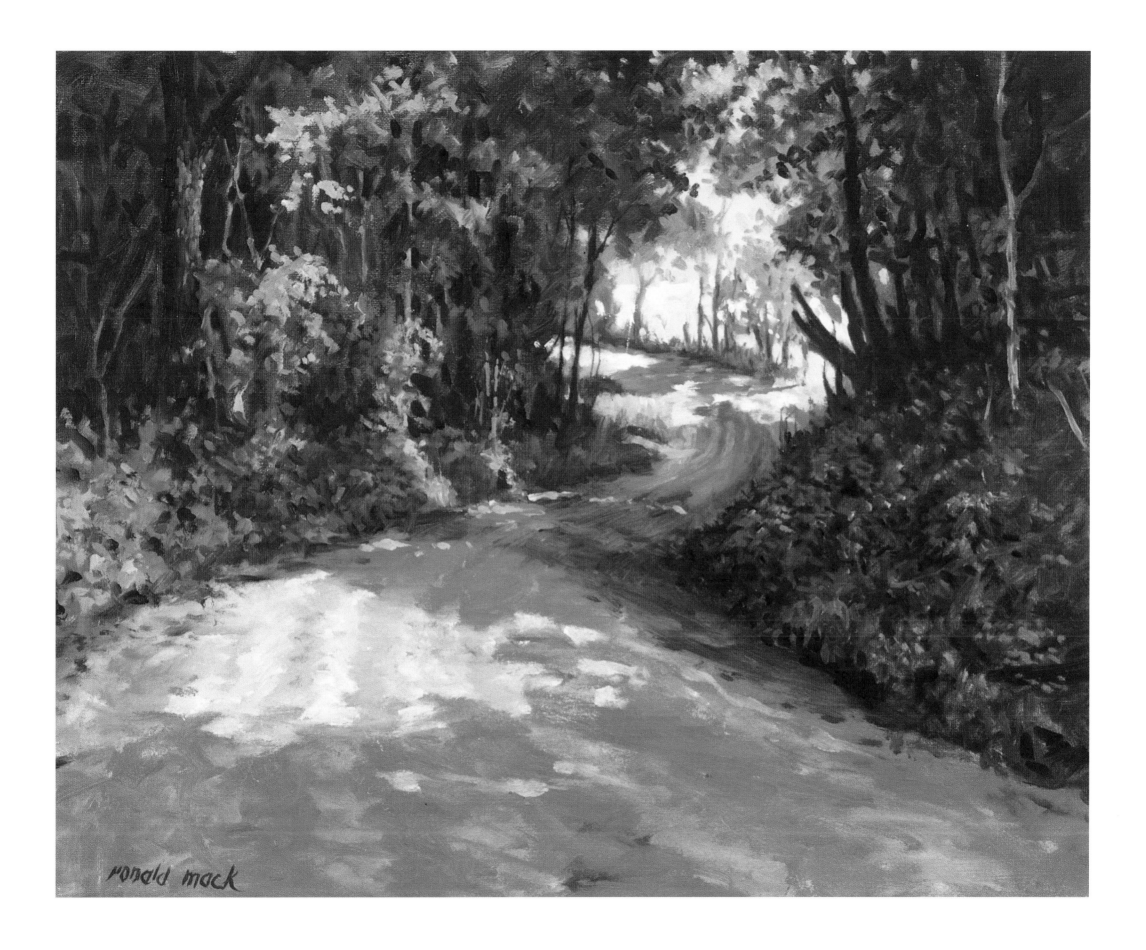

PORTER COUNTY

For hundreds of thousands of swimmers, sun-worshippers, runners, picnickers, and others taking it easy, the Indiana Dunes offer miles of peaceful recreation and relaxation. Most visitors leave it at that: a picturesque Lake Michigan setting to be enjoyed.

For the U.S. National Park Service, it's more. The administrators in charge of the Indiana Dunes National Lakeshore extending along the northern border of Porter County remind visitors that the Dunes offer an ever-changing understanding of nature. Lake Michigan, the Dunes, and Porter County were shaped millions of years ago when the great Wisconsin glacier—massive sheets of ice—extended as far south as central Indiana, crushing everything under it. Receding some 16,000 years ago, rocks and sand were among the deposits it left behind at what became the Dunes.

While Lake Michigan doesn't have this force, the shoreline is still altered year by year—it's the "younger" part of nature. Move back from the shore, the Park Service teaches, to see nature as it was. Away from the water and shore is land that has changed less and is therefore much like what the glacier left behind.

The Park Service is not alone in maintaining this unique Hoosier landscape. Indiana Dunes State Park is a three-mile-long, 2,182-acre area of beach, drifting sand hills, and wooded lands, just north of Chesterton. The Calumet Trail is adjacent to the park, a nine-mile biking, jogging, and walking path also open for cross-country skiing during winter. These recreational areas are joined by thirty county and city parks and trails, one of them the twelve-foot-wide Prairie Duneland Trail that extends from Portage to Chesterton.

Porter County land, along today's U.S. 12, was a primary route for long-ago travelers journeying from Wayne (today's Detroit) to Fort Dearborn (today's Chicago). Another trail, coming across from Fort Wayne to Dearborn, the so-called Sauk Trace, is today's U.S. 30. The county is also traversed east to west by U.S. 6, Interstate 94, and the Indiana Toll Road, as well as Indiana 2 and 8. Indiana 49 is the main north–south road.

Porter County's population boom profited from the industrial expansion of Indiana's northwest corridor during the last part of the twentieth century, including the Burns International Harbor and the industries that have grown up around it, such as Bethlehem and Midwest Steel, Cargill, and Union Carbide. As workers fled the Chicago-area industrial cities, Porter County cities including Portage, Chesterton, and Valparaiso saw rapidly rising populations. By the end of the twentieth century, Porter had the ninth-largest population of Indiana's ninety-two counties.

It was a very different story 180 years ago when the first white trappers, mostly French-Canadians, came into the territory. The first settler in 1822, Joseph Bailly, built a trading post and had started construction of his main house when he died in 1835. His descendants continued to build at the homestead, which ultimately became part of the Indiana Dunes National Parkland along with the nearby Chellberg Farm, maintained as an early twentieth century working farm. The Bailly Cemetery is also part of this historic complex.

The county, formed in 1836, is named after Commodore David Porter who, while in command of the *Essex* during the War of 1812, captured seven British ships in the Atlantic. Later, he was blockaded in the harbor at Valparaiso, Chile, and captured. Following the war, President Andrew Jackson appointed Porter ambassador to Turkey, where he served for twelve years.

Valparaiso, the county seat, is home to Valparaiso University with its 140-foot campanile next to the Chapel of the Resurrection, the world's largest collegiate chapel with seating for 3,000, and its Brauer Museum of Art.

"We drove through most of the county, but nothing appealed to me more than the dunes. This was a totally different type of painting for me. The Indiana Dunes on Lake Michigan, with its sand and many different types of vegetation, made a very interesting place to paint. It was cool on this early morning and there were no people there so it was very quiet."

RONALD MACK
"Life Amidst the Dunes"
Oil on linen 16 x 20 inches

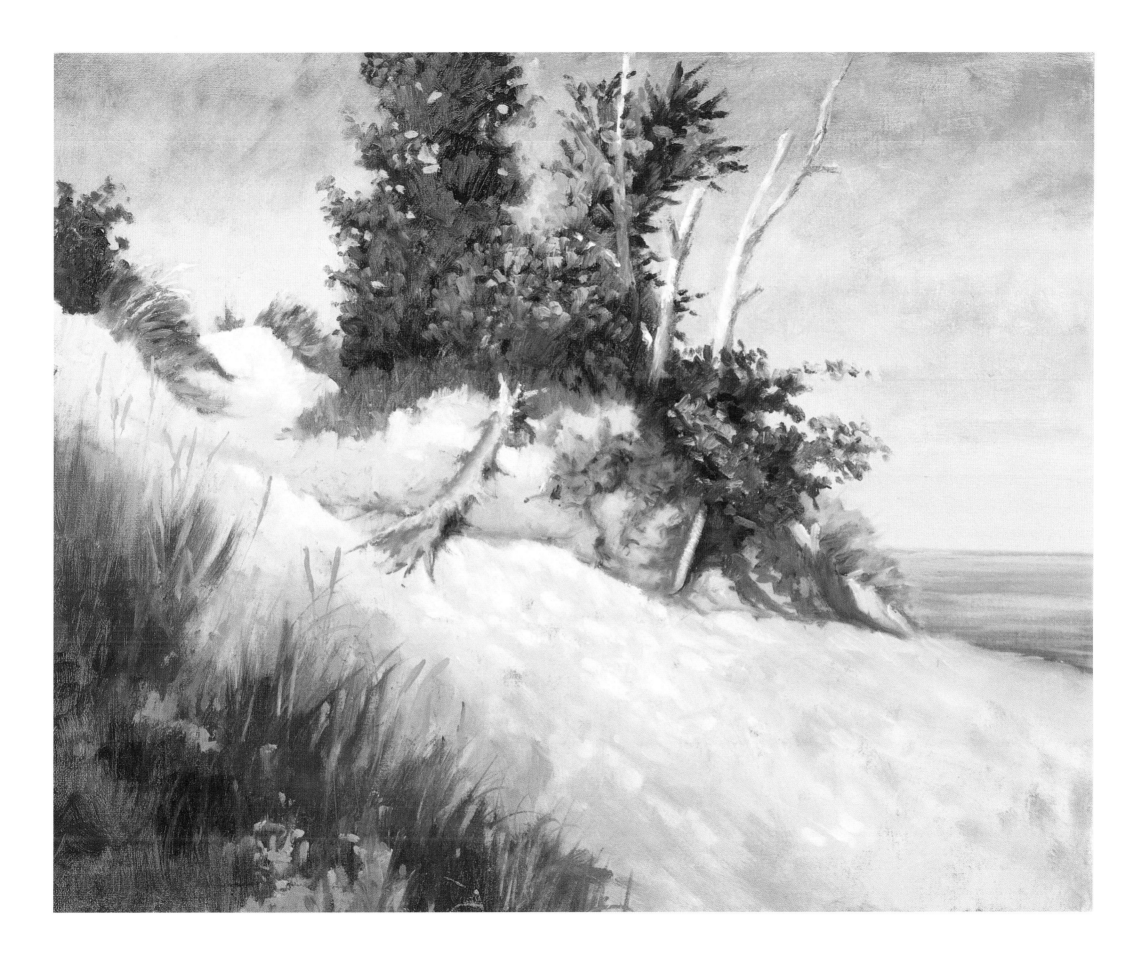

POSEY COUNTY

Both men had a vision. In the short term, their dreams didn't fully materialize, but in the longer term, much of what they advocated became part of the American way of life.

George Rapp moved his group of followers in 1814 by flatboat from Pennsylvania down the Ohio and then up the Wabash River to an almost uninhabited stretch of land he called Harmonie. They had earlier fled Germany for the United States to escape religious persecution. At Harmonie, they awaited the Second Coming of Christ, which they thought would occur during their lifetime. On their 20,000 acres, they built a prosperous, self-contained town that demonstrated the values of a planned commu-nity and successful farming on the Indiana frontier. Communal living included equality even in death—the Harmonist Cemetery has no grave markers to distinguish one citizen from another. By 1824, with celibacy reducing their numbers, they returned to Pennsylvania.

The buyer of their community was Robert Owen, whose experiment in building a model social order lasted only two years. During that brief time, he attracted some of the most enlightened figures in the country to what he called New Harmony. Among his social experiments were free education, equal education for boys and girls, child labor restrictions, and women's rights. Owen closed his utopian effort in 1826, but his children stayed behind to play important roles in American public life, including Richard Owen, the first president of Purdue University, and Robert Dale Owen, who, while in Congress, introduced the bill to establish the Smithsonian Institute.

Historic New Harmony exists today, administered by the University of Southern Indiana and Indiana State Museum and Historic Sites. It blends the buildings of the 1800s with the Atheneum, a late-twentieth-century structure that houses the visitors' and conference center.

The county was formed the same year Rapp came, in 1814. An early fort was built at Blackford, just north of present-day Mount Vernon. It became the first county seat but that was moved to a more central location on land donated by the Rappites at Springfield. The final move occurred in 1825, when the seat was moved to Mount Vernon, then developing as an important Ohio River town.

Mount Vernon was originally McFaddin's Bluff, named for Andrew McFaddin, who settled in the area around 1806. The town was platted in 1816 and named after George Washington's home in Virginia. Its location on the Ohio made it a prominent shipping port that, for a time, rivaled upriver Evansville. During its early years, grain mills and a steam-powered lumber mill were operative. Mount Vernon's growth was aided by the building of a plank road from New Harmony to the town as well as the arrival of the railroad in 1871. Until these transportation routes were developed, the river had been the only means to ship goods and receive supplies.

The Hovey Lake State Fish and Wildlife Area is located in the southwestern corner of the county, northwest of where the Ohio and Wabash rivers meet, the lowest land level in the state. The area's cypress trees are believed to be the northernmost stands in the nation.

Agriculture remains the main commercial activity, although the discovery of petroleum deposits in the 1930s brought workers and more businesses to the county. In addition to the oil, deposits of coal and minerals have also been found.

The county is named for Thomas Posey, who became governor of the Indiana Territory in 1813. It was formed from parts of Gibson and Warrick counties. The present county courthouse was built in 1876.

"This was my first visit to New Harmony. The history of this area is fascinating. The 'Rappite' houses of New Harmony were good subjects, especially with the fall colors. The warm green color of this house blended harmoniously with the trees and other surroundings."

DON RUSSELL
"The Poet's House—New Harmony"
Oil on linen 18 x 24 inches

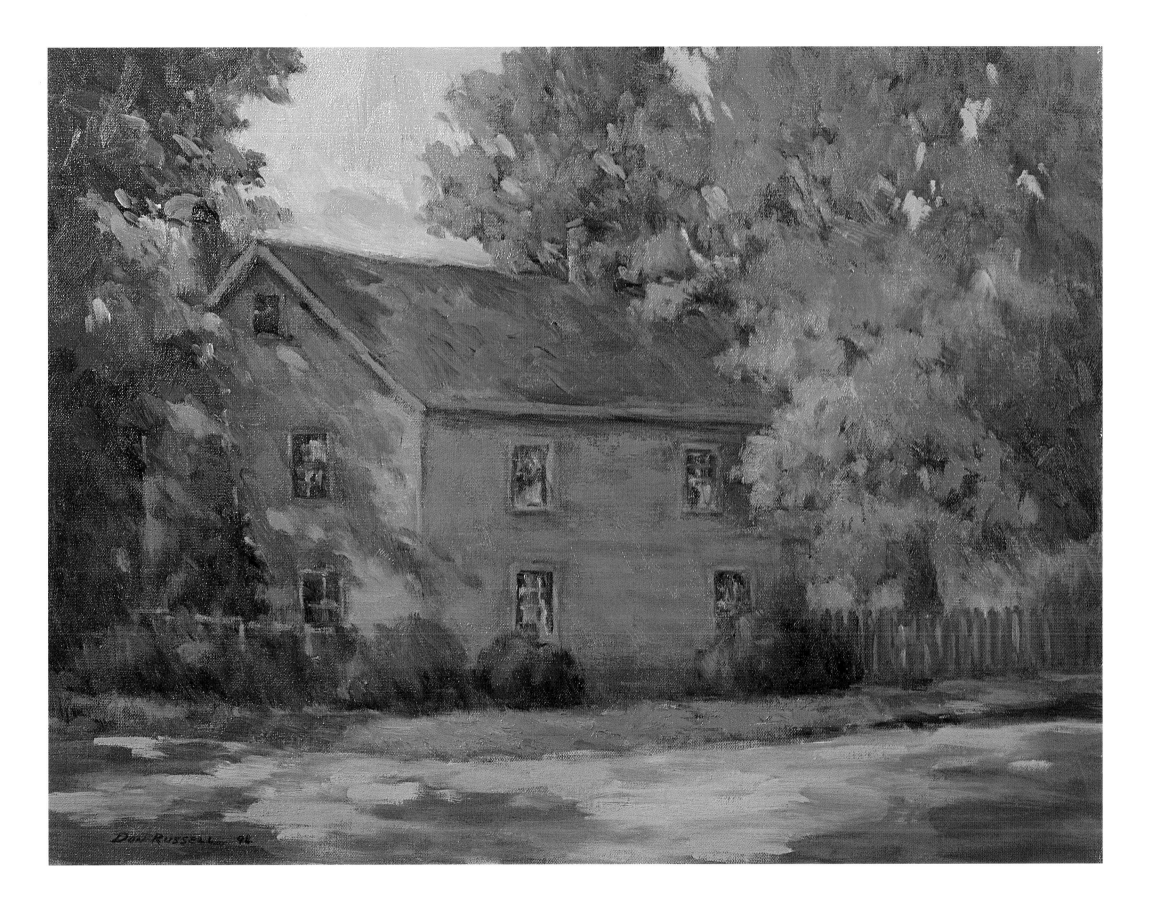

PULASKI COUNTY

The early history of Pulaski County was typical of northern Indiana. French trappers as they plied their fur trade encountered the Miami and Potawatomi Indians. Several wars later, settlers from the new United States began to move into the area, eventually forcing out the Indians. Slowly swamps were drained, lands were cleared, commerce began to move up and down the rivers, and finally the call for organized government reached the new state legislature.

In the case of Pulaski County, the Indians ceded land to the United States in an 1832 treaty and settlers were in evidence by 1835, mostly along the Tippecanoe River. Pulaski became the eighty-seventh Indiana county, created in 1835 and organized in 1839 with Winamac—originally Winnemack—as the county seat. The county was created out of White and Cass counties.

Although the Indians were forced out, their presence remains in county place names. Winamac is named for a Potawatomi chief whose encampment is believed to have been on the banks of the river where the county seat is located. Others include the Tippecanoe River and Indian Creek.

Winamac was selected as the county seat in 1839 according to the practice of the day. Five commissioners from other counties gathered and made the decision. They met in the cabin of John Pearson, who just happened to become the town's leading business leader, operating a general store, tavern, and saw mill. In due course, he was the clerk, recorder, and auditor. Winamac was also the site of a government land office from 1839 to 1857.

As in other Indiana counties, the wood frame courthouse—in older counties the first courthouse was built of logs—has been replaced, first by a brick one in 1862 and then by one of Bedford limestone in 1894 at a cost of $50,000.

A pedestrian bridge built across the Tippecanoe River at Winamac in 1923 is still in use. The Soldiers and Sailors Memorial Bridge, 200 feet in length, ends at a city park on the east bank and near an artesian well drilled in the 1880s, also still in use, on the west bank.

Pulaski County is mostly flat agricultural country with the exception of land along the Tippecanoe and in what has become the Tippecanoe River State Park and the Winamac State Fish and Wildlife Area. This land had been cleared for farming and grazing until the Depression of the 1930s. The National Park Service bought more than 7,000 mostly sandy acres and put Works Progress Administration men to the task of building park facilities and trails, and converting the land back to its natural state. Their product was given to Indiana in 1959 and divided into two areas: 2,761 acres east of U.S. 35 became the state park and, west of the highway, 4,592 acres became the fish and wildlife area. The Tippecanoe River flows along the east side of the state park, mostly made up of wooded areas, fields, and marshes with a sand hill nature preserve at the northern end of the property. Across the highway in the fish and wildlife area, birding, nature studies, and hunting are the main activities.

The county is named for Casmir Pulaski, a Polish Revolutionary War hero who led the colonial cavalries at the siege of Savannah, where he died in action. The county name is pronounced something like "puh-la-SKY" ('a' as in cat) although you will also hear it pronounced "puh-la-SKI." While no one is certain of the reason, it is believed the pronunciation came from an early settler who migrated into the area from Pulaski, New York, a small town that is pronounced in the same way.

"I really wanted to capture the history and charm of the Tippecanoe River. Upon our arrival at the Tippecanoe River State Park, we found a beautiful scene but decided to keep exploring. Paying no attention to some warning signs, something about mosquitoes, we cut through a thick wooded area in search of a 'wilder' piece of river. Thick got thicker as we stumbled through fallen limbs in the shoulder-high weeds, with big black and yellow spiders mixed in for color and fear. Ankle-deep mud greeted us about the time we lost our direction. An eternity later, we stumbled out, sweaty, muddy, and exhausted. Checking the time, we found our horrendous trip had lasted only twenty minutes. I painted that first beautiful scene."

DAN WOODSON
"Still Water"
Oil on canvas 20 x 30 inches

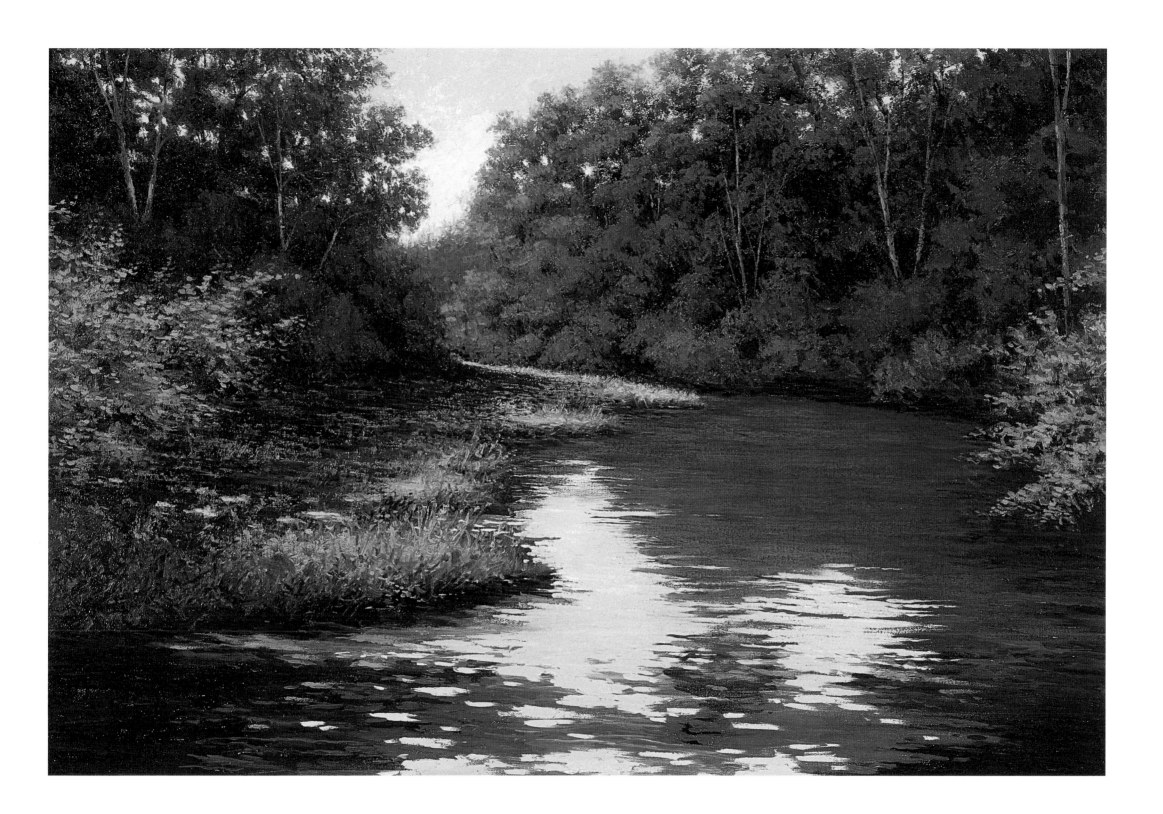

PUTNAM COUNTY

Separated by half a century, two men found career beginnings only a few blocks apart in Greencastle. After building their far-flung companies, they closed out their lives forty miles to the east in Indianapolis. Their influence, however, went beyond their careers, leading to two of the nation's most significant enterprises.

Eli Lilly opened a drugstore in downtown Greencastle, married, and, when the Civil War came, left to serve in the Union army. Following the war, he built his worldwide pharmaceutical empire in Indianapolis. Lilly became one of America's leading philanthropists and his Lilly Foundation at the end of the twentieth century was one of the world's largest in assets.

A few blocks away, in downtown Greencastle, and fifty years later, in DePauw University's East College building, student Eugene C. Pulliam with other young men interested in newspaper careers in 1909 founded Sigma Delta Chi, an organization dedicated to professionalism in journalism. Pulliam later made Indianapolis his headquarters for Central Newspapers, Inc., including his flagship newspapers, *The Indianapolis Star* and *The Indianapolis News*. Sigma Delta Chi, now called the Society of Professional Journalists, is the world's largest professional association of journalists.

Greencastle has been the center of Putnam County since the county was organized in 1822. Ephraim Dukes deeded part of his land to be used as the county seat in 1823. Tradition has it that the city was named Greencastle because Dukes originally came from Greencastle, Pennsylvania. Because of its selection as the county seat and with the building of the railroad, Greencastle's population had grown to 2,589 only one year later. Nearly two centuries later, it has been named an all-American city and is on a list of the one hundred best small towns in America.

Greencastle is the home of DePauw University, founded by the Methodists as Indiana Asbury College in 1837. It admitted women in 1867 and was rescued from financial ruin by New Albany financier Washington C. DePauw in the 1880s. The school then was renamed after him in 1884. DePauw's historic East College underwent extensive restoration in the late 1970s and its third floor Meharry Hall was saved in the process, including its old chapel pews, balconies, and hand-carved woodwork.

Putnam County covered bridge enthusiasts like to note that all nine of its bridges are situated on curving roads that gracefully lead onto each bridge and across the river, in seven cases over Big Walnut Creek. The longest remaining bridge, the Dick Huffman, lies in southwestern Putnam between U.S. 40 and Interstate 70. Built in 1880, it is 265 feet in length and uses two spans over the Big Walnut Creek.

In Greencastle, the first courthouse was a frame structure, built in 1827. A one-story brick followed in 1832, a two-story brick in 1848, and the present Greek Revivalist structure in 1904. On the courthouse lawn is a V-1 "buzz bomb," developed by the Germans in a desperate attempt to conquer Great Britain during World War II. The bomb memorial, mounted on a limestone "V" for victory, is dedicated to county military service personnel killed during the war.

Leiber State Recreational Area is in southern Putnam, bordering Owen County. The Putnamville Correctional Facility, also in southern Putnam, lies along U.S. 40.

Some dispute exists about the county's naming. Most sources say it was named for Israel Putnam, a frontier fighter and general in the Continental Army. Others believe it was named after Rufus Putnam, who also served in the Revolutionary Army, later laid out the fortifications at West Point, and in the 1880s formed the Ohio Company of Associates to buy and settle western lands.

"With forty-two covered bridges in a fifty-mile area, Putnam and surrounding counties in western Indiana are home to the largest concentration of covered bridges in the world. The autumn Covered Bridge Festival was a perfect subject and, as I drove the county, I found many worthy scenes. I chose Oakalla Bridge over the Big Walnut River, erected in 1898. I loved the contrast of the red bridge against the green background. When I rounded the bend the light was just perfect for painting. I set up and painted quickly before the shadows changed and it became too dark to distinguish the sky from the river."

ROBERT EBERLE
"Oakalla Bridge"
Oil on linen 16 x 20 inches

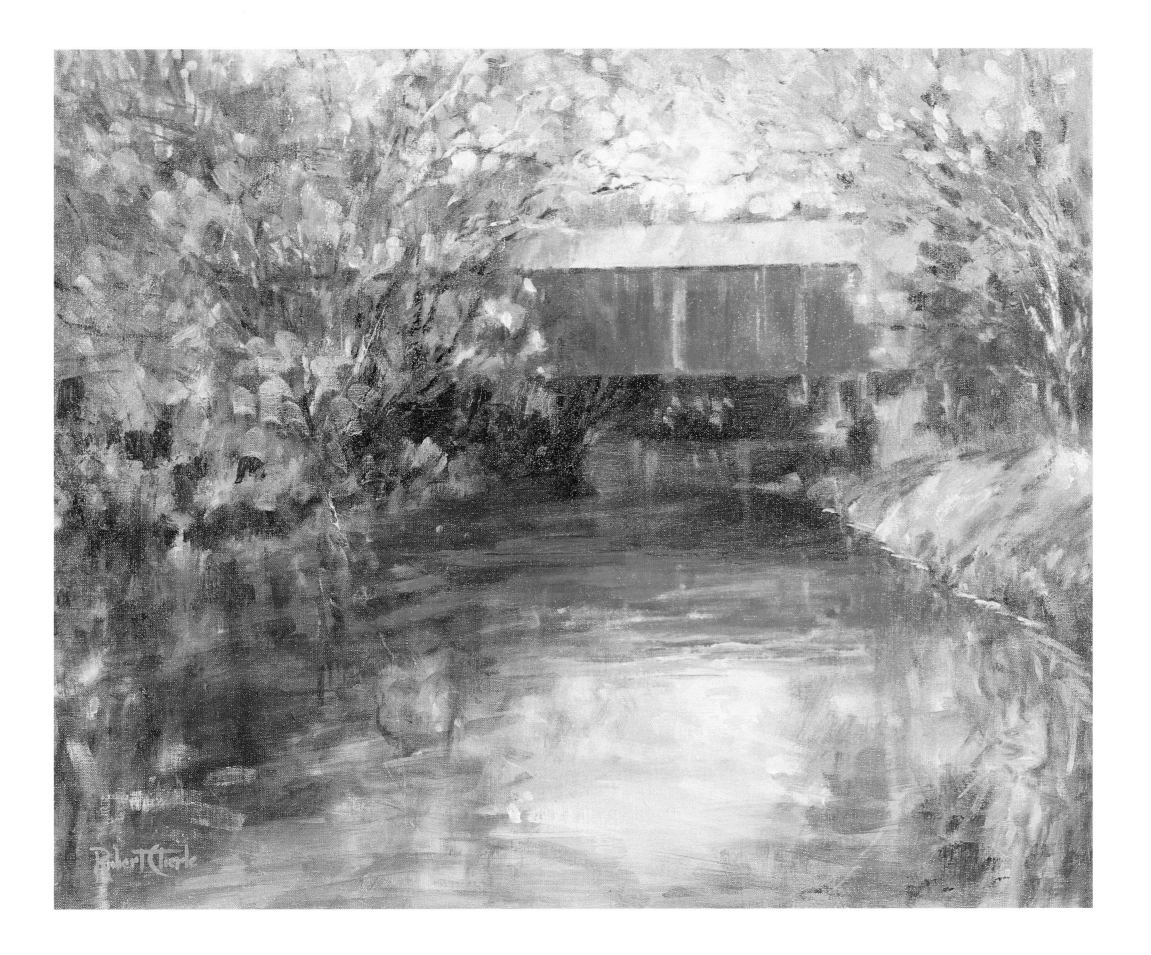

RANDOLPH COUNTY

If someone were to say Randolph County isn't what it used to be, that person would be right—as far as land area is concerned. Following the Indian treaties leading up to its organization as Indiana's twelfth county in 1818, Randolph had as its northernmost border the state of Michigan! Over time, area after area was subtracted and new counties were formed. But then again, Randolph itself was created by taking off the top of Wayne County.

Quakers coming from North Carolina settled the Randolph County area first in 1814. They brought their beliefs of equality with them and, within a few years, three predominantly African-American settlements existed here. A school for freed slaves, the Union Literary Institute in southeastern Randolph County, was perhaps the first such school in the nation. While primarily for African-Americans, it would accept any child "who wanted to learn." Part of one building still stands today.

Randolph was one of the eastern Indiana counties that benefited from the gas boom of the 1880s. The major industry today in county seat Winchester is Anchor Glass, which has existed under one name or another for more than a hundred years. The plant manufactures glass containers for foods and beverages and its products are shipped worldwide.

The county courthouse, the third to be built on the town square, is nearly 125 years old. The first floor has a twenty-four-foot mural created by local artist Roy Barnes. The mural depicts events in the county's history and important personages, including two governors, military figures, film director Robert Wise, and Wendell M. Stanley, winner of the Nobel Prize in chemistry. One of the governors, James P. Goodrich, 1917–21, was a major state grain elevator owner. On the lawn is the oldest Civil War memorial in the state and the second tallest at sixty-seven feet—the Soldiers and Sailors Monument in Indianapolis is the tallest and the second oldest. The figures on the memorial were sculpted by Lorado Taft, whose other work includes Gettysburg battleground figures.

Just west of Winchester is the Winchester Speedway, the second oldest racetrack in the state—the Indianapolis 500 track being the oldest by five years. The speedway is reputed to be the fastest half-mile track in the nation. Tarlton Kenworthy of Randolph County wasn't in a race but he became Indiana's first traffic fatality in 1907. Hurrying to the scene of a train wreck, he swerved his car to miss a dog at a jog in the road near Ridgeville, so the story goes, and his auto hit a pole.

Its customers throughout the world know Wick's Pies of Winchester. Its sugar cream pie has been patented—perhaps the only patented pie in the world. Wick's Pies ships about 12,000 pies per day, even internationally.

Union City—it's in both Indiana and Ohio and, so, in two time zones—is the home of the Union City Body Company, another 100-year-old business. It produced the auto bodies for Elwood Haynes's first gasoline-powered car and later built specialty bodies for many of Indiana's automobiles. Following numerous changes of products, today it is a world leader in manufacturing forward drive vans.

The origin of the name for both the county and the county seat is not certain. Winchester may be named for the city in North Carolina from the area where early settlers came; the same may be true for the county, a reference to Randolph County in North Carolina. Perhaps Winchester was named for a leader in the War of 1812, James Winchester.

"Farmland is in western Randolph County, and I really like the feel and looks of this small Indiana town. There are more scenes waiting to be painted in this beautifully restored city. This elevator isn't used for farm produce anymore, of course, but instead houses a business. Still, it fits in with the look of this typical small town."

LYLE DENNEY
"The Crossing in Farmland"
Oil on canvas 12 x 16 inches

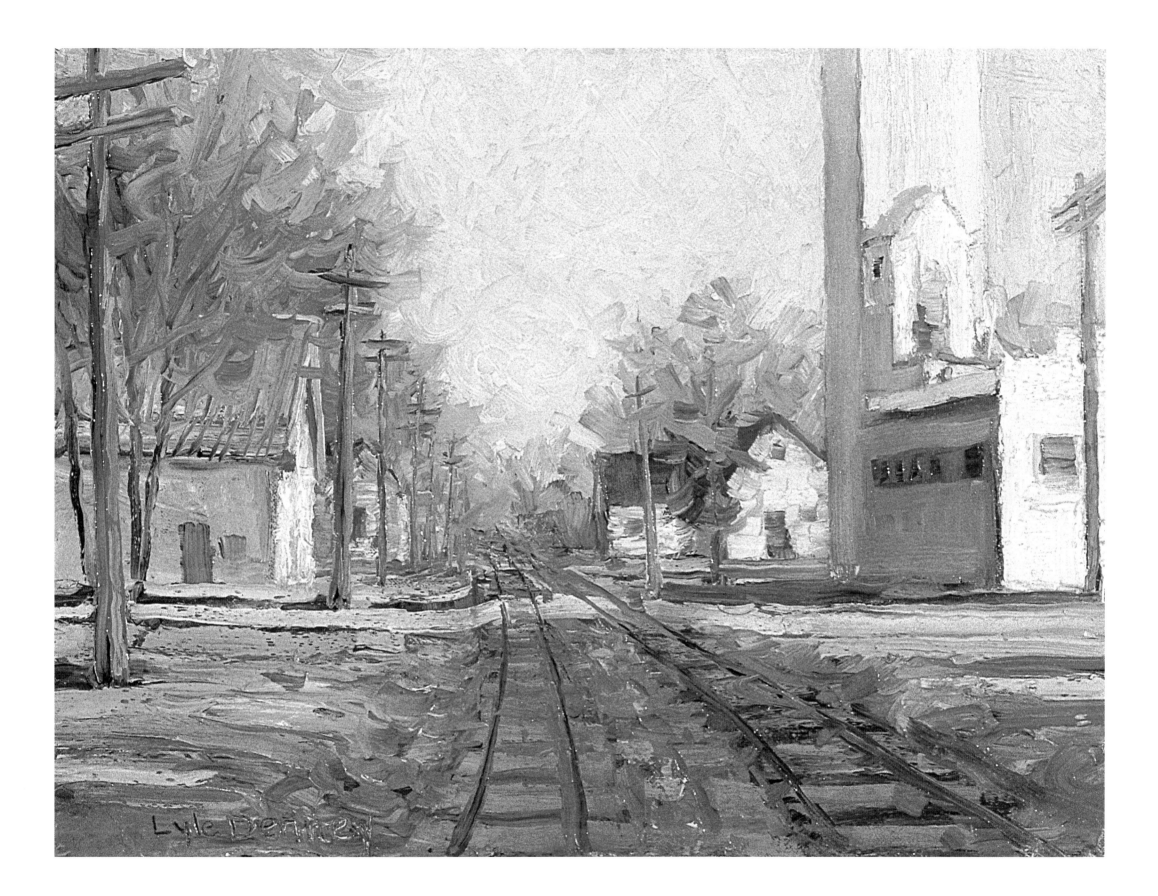
Lyle Drenkew

RIPLEY COUNTY

When Southern cavalry leader John Hunt Morgan and his raiders swept through southern Indiana during July 1863, they briefly occupied Versailles, the Ripley County seat. Lore has it they robbed the county courthouse where an astute clerk had already taken much of the county's money and hidden it in the ground. Forced to open the courthouse vault, he turned over to the raiders what money was left.

As the story goes, the raiders noted a number of purses. When Morgan asked whose purses they were, the clerk, thinking fast, replied that "several widow ladies" placed them there for safekeeping. "I never robbed a widow yet," the Southern commander is supposed to have responded and moved on.

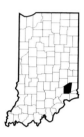

(This gallant action, if true, didn't help Morgan when, less than two weeks later, he was captured in Ohio after most of his command had either been killed or captured.)

The courthouse, under construction at the time of the raid, still serves as the center of government and justice for the county. Tradition has it that Morgan took the weapons of the Ripley defenders and smashed them against the newly constructed walls of the courthouse. Remodeled several times, a clock tower was added to the courthouse in 1932 as a memorial gift. In 1972, further remodeling made the third floor usable for offices and storage.

The county's first court met at Marion—now New Marion—in 1818 to select a county seat two years after organization of the county. The decision was made when John DePaul offered one hundred acres at present-day Versailles. The honor of naming the county seat was given to DePaul, who selected Versailles, the French city and home of DePaul's ancestors.

Ripley's major attraction is Versailles State Park, one mile east of the county seat on U.S. 50. It is the second largest state park in Indiana at 5,905 acres. The entrance to the park passes near one of the county's two remaining covered bridges over Laughery Creek. Restored in 1993, the bridge is in use today. Laughery Creek is backed up by a dam just north of the bridge to create the 230-acre Versailles Lake in the park. The county's second covered bridge over Otter Creek was bypassed in 1996. The state park is the southern terminus of the Hoosier Hills Bicycle Route, which runs twenty-seven miles north to Batesville. There it connects to the Whitewater Valley Route that ends sixty-six miles later on the Earlham College campus in Richmond.

Northeast of Versailles is Milan, a town of fewer than 2,000 and home of one of the most publicized high school basketball teams in history. In 1954 Bobby Plump sank a final shot in the state basketball finals to defeat the big city Muncie Central Bearcats, 32–30. The story of that game was later retold in the Hollywood motion picture *Hoosiers.* Another small Ripley town, Friendship, located in the southeastern part of the county, is host to the National Muzzle Loading Rifle Association shoots. Nearly 70,000 enthusiasts arrive in the spring and the autumn at the community of about a hundred people.

Hillenbrand Industries, Inc. is the county's largest employer at Batesville, with about 1,800 workers at Hill-Rom Company, manufacturers of hospital furniture, and 1,300 at the Batesville Casket Company. Batesville became the dominant city in this county when the railroad came through in the 1850s.

The county is named for Eleazer W. Ripley, who fought in the War of 1812 and later settled in Louisiana, where he was elected to the U.S. House of Representatives.

"Rural letter carrier Carol Swinney gave me directions to many beautiful places in rugged Ripley County. When I arrived at my chosen spot on March 13th, six to eight inches of new snow had fallen, blanketing everything in white. I painted on the 14th and the most incredible thing happened—the temperature rose to 50 degrees, the sun stayed out the whole day, and there wasn't a cloud in the sky! I painted along Friendship Road in comfort on a perfect winter day. The snow melted by day's end, but not before I got it on canvas!"

LYLE DENNEY
"Winterset in Laughery River Valley"
Oil on canvas 26 x 39 inches

RUSH COUNTY

In the late nineteenth century, if you wanted a covered bridge built in Rush County, there was only one place to go. You went to the farm of Archibald Kennedy, who, along with his sons, doubled as a carpenter and bridge builder. Even today, six of their bridges still stand in the county—that is, if you count the Homer bridge which floated downstream in the 1892 flood and is now used as a barn on private property in southwest Rush County. Four of the other five were constructed between 1877 and 1888, while the fifth, Norris Ford over Big Flat Rock River, was built in 1916 by son E. L. Kennedy and *his* sons. The longest of the bridges—indeed, the longest two-span covered bridge in Indiana—is Moscow, which also spans the Big Flat Rock, and is nearly 334 feet in length.

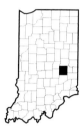

Historians know the county best as the last representative of one longtime presidential political practice. In a bygone day, candidates for the presidency generally ran their campaigns from their hometowns. In 1940, Rushville's adopted son, Wendell L. Willkie, won the Republican nomination and ran his national campaign from his rented home on Harrison Street. Although Willkie was born in Elwood and accepted his nomination there, he had married Edith Wilk in 1918 and used her mother's home for his race for the presidency, preferring this small-town setting over his more recent residence in New York. Willkie lost to Franklin D. Roosevelt, winning only ten states, one of them Indiana. Roosevelt appointed him as an "envoy to the world." Out of his trips, he wrote *One World,* which became a best-seller. He was a candidate again briefly in 1944. Willkie died later that year and is buried in Rushville's East Hill Cemetery.

The Treaty of St. Mary's opened Rush County to settlement in 1818. Dr. William Laughlin was one of the first white settlers in 1821 and it was he who provided the lots for the county seat at Rushville. A tablet honoring him stands on the courthouse lawn. Early in the county's history, one of its residents, Samuel Bigger, was elected governor in 1840. Quakers from North Carolina came to the county early, too. One of their communities was at Carthage, where Henry Henley donated funds to establish a free library, completed in 1902.

The present Rush County Historical Society Museum is located in the home of another favorite son, John K. Gowdy, who served as consul general to Paris during the administration of President William McKinley. The Victorian home was given to the historical society by Gowdy heirs in 1940.

Rushville is noted for its early twentieth century homes—more than 50 percent of its homes were built prior to 1939, with Georgian, Victorian, and Italianate architecture prominent along the city's main streets.

The courthouse, built from 1896 to 1898, is made of Bedford limestone and is the third in the county's history. It is listed on the National Register of Historic Places.

Agriculture has always been the base of Rush County's economy. Corn and soybeans, along with hogs, have been its most important commodities. Pioneer Hybrid, one of the largest seed companies in the world, has a facility here that employs more than 1,200 seasonal workers.

When William Laughlin gave some of his lots to establish present-day Rushville as the county seat, he asked that the county be named for his teacher, Dr. Benjamin Rush, a signer of the Declaration of Independence and perhaps the best-known physician in America during the Revolutionary War period.

"On an earlier foray to locate painting spots, I drove into Rushville and admired the beautiful old homes and stately courthouse. As one of my first opportunities to paint en plein air for the Painting Indiana project, I was tempted to paint a city scene, but I wanted to paint a landscape. As I drove out of town on Highway 3 toward Milroy I found this scene of the Little Flat Rock River. Remnants of snow lay on the ground with leaves like jewels shining through. The trees raised their limbs to the sky, looking grateful for the beautiful day and lovely view they were part of."

ROBERT EBERLE
"Along the Little Flat Rock River"
Oil on linen 16 x 18 inches

ST. JOSEPH COUNTY

If football fans were asked to select one university team that epitomizes collegiate football, there's a strong argument to be made that the choice would be the Fighting Irish of Notre Dame.

Through the decades, the Fighting Irish seemed always to be in the thick of the race for a national championship. The big game of the year would often be played at Notre Dame Stadium in South Bend. As football fans know, the founder of this dynasty was Knute Rockne, who served as head coach from 1918 until his death in an airplane crash in 1931. Over the years, the "subway alumni"—fans who never attended the university but vigorously supported its teams—cheered as Rockne's teams won 105 games against but twelve losses and five ties, including five undefeated seasons. While more recent teams have sometimes fallen upon hard times, the aura of Notre Dame football continues.

If the argument requires buttressing, consider the placement of the College Football Hall of Fame—in South Bend. The 1995 state-of-the-art attraction depicts the history of the game, its athletes and coaches, and the great games of the past.

The university—far more than just a national football power—is a commanding presence in the South Bend/Mishawaka communities. Father Theodore Hesburgh, who became president in 1952, moved Notre Dame forward as an academic institution and his service on important national commissions brought even more attention to the school.

Automobile enthusiasts would know South Bend for another reason: the Studebaker. Wagon manufacturers Henry and Clement Studebaker opened a small wagon repair shop in the mid-nineteenth century and started producing wagons for the Union army during the Civil War. With the arrival of the horseless carriage, the Studebakers began building automobile bodies and then complete automobiles. Up against the Detroit Big Three, Studebaker car sales eventually dropped and the company closed.

Other major historic industrial firms include the Bendix Corporation, which made electric starters and later brakes for automobiles; the Oliver Chilled Plow Works, where James Oliver invented a way to harden iron plows; and the Singer Sewing Machine Company.

Depressions, labor unrest, and changing markets have led to an up-and-down economy in South Bend. Recently, the city has had a rebirth with the development of convention and tourism facilities downtown—focused on the Century Center convention complex—as well as banking and other customer services. Mishawaka has become a major shopping center for the Michiana area—the northern tier of Indiana counties and those of Michigan just across the border. Among other South Bend attractions, in addition to Notre Dame and the Football Hall of Fame, are the Potawatomi Zoo, the Oliver Mansion/Northern Indiana Center for History, the Stanley Coveleski Regional Baseball Stadium, the East Race Waterway, the South Bend Museum of Art, and performances at the Morris Performing Arts Center.

In southwestern St. Joseph County is Potato Creek State Park, a 3,940-acre facility centered around Worster Lake with swimming, fishing, skiing, camping, cabins, hiking and bicycle trails, horseback riders' campgrounds, and a nature preserve.

Early trappers included Alexis Coquillard, considered the founder of South Bend, who established his trading post in the early 1820s near the bend in the river. Edward Sorin was the early settler, sent by the Holy Cross Order, who founded the mission and school in 1842 that was to become Notre Dame. The mission was for the Potawatomi; the school was to be for religious and secular education. The county is named after Jesus' father, Joseph, and was established in 1830.

"I often ask local residents to suggest sites when I am unfamiliar with a county. When many suggest the same place, I check it out. In South Bend, the suggestion was Notre Dame. Walking through the campus was like stepping into another world; a comfortable place where you speak low in reverence, a sacred place steeped with tradition. I found the golden dome unique and inspiring and painted it twice, choosing the second one as the county painting. I know if I painted it a thousand times I would never do it justice. I don't regret the attempt—I was humbled by the experience."

DAN WOODSON
"Golden Dome"
Oil on canvas 20 x 24 inches

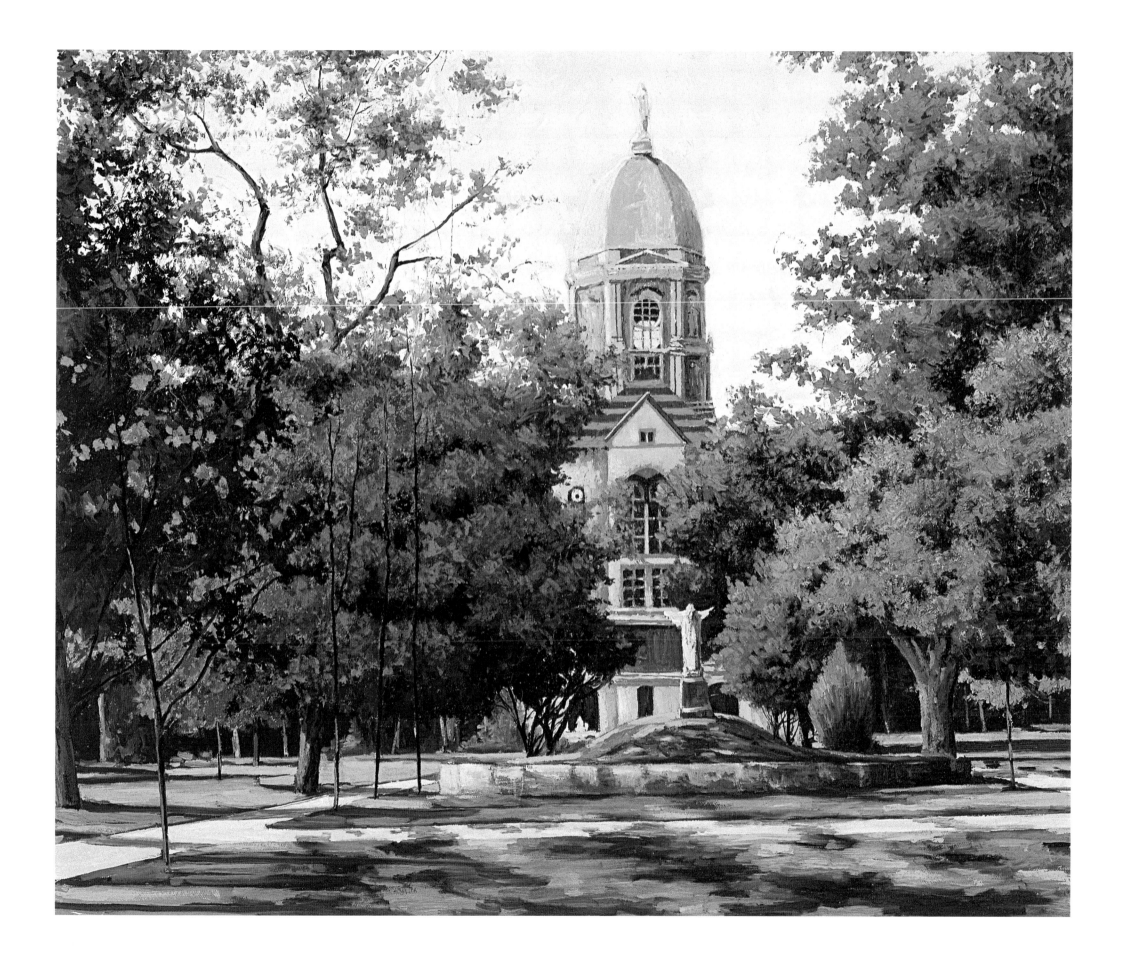

SCOTT COUNTY

The war party of Shawnees came deep into southern Indiana. Their raid on September 3, 1812, was probably a part of the War of 1812 in which they often allied themselves with the British against what they considered to be the encroaching Americans. For whatever reason, they fell upon the frontier cabin settlement at Pigeon Roost in present-day Scott County. When they departed, more than twenty of the settlers were dead, including men, women, and children. All were buried in a common grave.

Today, Pigeon Roost—so named because it is said that the flight of pigeons blocked the sun with their sheer numbers—is a state historic site, commemorating one of the last major tribal war party attacks against white settlers in Indiana. A forty-four-foot-tall obelisk marks the scene of the raid and recounts its details.

At that time, Scott County had not yet been organized. That came eight years later when parts of five existing counties were unified to form Scott, resulting in one of the state's smaller counties.

Some fifty years later, another group of marauders swept through when Confederate General John Hunt Morgan's troops invaded the county. They rode through Leota and Vienna and spent the night at Lexington. The troops forced local citizens to furnish them with meals; the next morning they were gone, headed toward North Vernon.

Five years after that, on May 22, 1868, the infamous Reno gang pulled their second train robbery on a line between Scottsburg and Austin—the first robbery was at Seymour in Jackson County. This time they hit the jackpot, escaping with $96,000 in gold and government bonds. Local legend has it the gold was buried near Austin. Over the decades, many a hole has been dug, but, so far, no gold has been found.

Scottsburg has been the county seat since the mid-1870s. Earlier, Lexington, in southeastern Scott County, held the honor. As happened frequently in Indiana counties, citizens asked that the seat be more centrally located to equalize travel time for county residents.

Scottsburg today lies on Interstate 65 and U.S. 31, the major routes between Louisville and Indianapolis. Its courthouse was completed in 1874 with its most recent remodeling in 1997. A courthouse lawn monument honors the career of Lexington's William H. English. He was the Democratic candidate for vice president in 1880 and earlier had served four terms in the Congress.

Leota, in western Scott County, is located at an old crossroads. The Buffalo Trace linked the Ohio River to the Miami lands in today's central Indiana, while the Vincennes Trace ran from Cincinnati to Fort Vincennes. The community also has Indiana's newest covered bridge, which spans Coonie Creek.

At Scottsburg's William H. Graham Park, one of the last remaining interurban cars has been placed on its original tracks. The Scottsburg railroad station has also been restored, as has the Austin station.

Hardy Lake State Recreational Area is in northern Scott County, with a 714-acre lake, boat ramps, and camping. It also has a rehabilitation center for wounded wildlife (not open to the public).

A family-owned canning factory is located in Austin near the northern county boundary. Joseph F. Morgan started the firm just at the close of the nineteenth century and it has been a major county employer through four generations.

The county is named for the Kentucky governor General Charles Scott. A veteran of the Revolutionary War, he served in the Virginia state legislature and then moved to Kentucky, where he was a noted frontier fighter before becoming governor in 1808. Kentucky troops were sent to help Hoosiers during the War of 1812, which added to Scott's popularity.

"Sometimes you know it when you see it. That's what happened in Scott County, a beautiful rolling country with a multitude of wonderful subjects to paint. Earlier in the year our friend Tom Vance had taken us on a tour of his favorite scenes. On this trip, after a long scouting day with my faithful friend and navigator, Anne, we took a gravel road south of Leota and I spotted it—a ditch! And this ditch knew how to dress. A backdrop of warm blue sky, purple hills trimmed at the bottom with autumn colors, and trees of various sizes and hues, surrounded by vast golden soybean fields, made it so enjoyable to paint."

DAN WOODSON
"Golden Fields"
Oil on canvas 24 x 36 inches

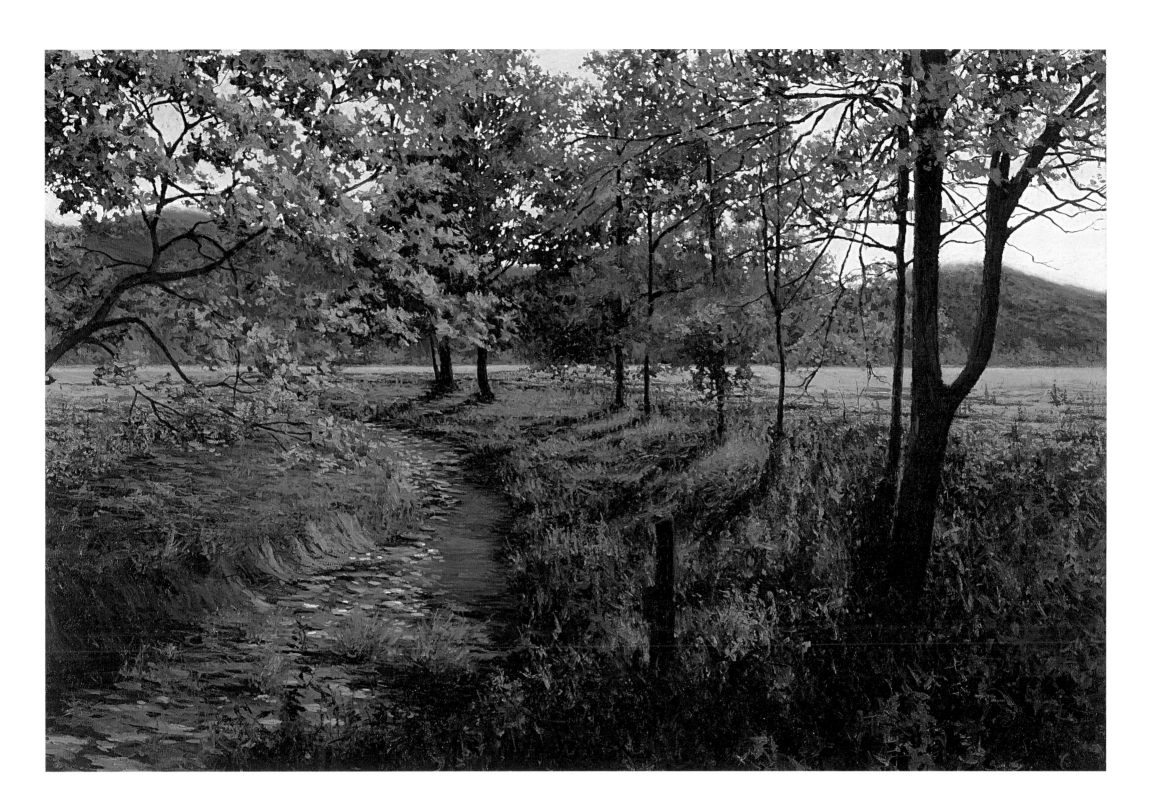

SHELBY COUNTY

It was an experiment. Historians know the so-called railroad started July 4, 1834, but no one today is positive just how long it lasted. Terms usually used are "short-lived" and "brief." It may have been the first railroad west of the Alleghenies; it was certainly Indiana's first railroad. The horse-drawn railroad cars ran over a mile and a quarter wooden track from Shelbyville to Lewis Park. Judge William Peasley was the entrepreneur behind this experiment.

Later, railroads as we know them came through, linking the Shelby county seat to Indianapolis and other Indiana towns. These railroads were important for shipping Shelbyville's major manufacturing product in the early twentieth century: furniture. As Southern furniture makers developed, however, furniture factories in Shelbyville closed. Today, the main county employer manufactures fiberglass. Other manufacturing includes oil seals and rings, automotive plastic parts and glass, paper and plastic packaging, sheet metal parts, silk screen printing, and aluminum transmission housing.

The Junction Railroad Depot at Morristown in northeastern Shelby County is still standing. The depot served the Junction Railroad, running between Shelbyville and Knightstown in the mid-nineteenth century.

Interstate 74 from Indianapolis to Cincinnati goes through the county, northwest to southeast, and passes just north of Shelbyville while Interstate 65 traverses the southwestern corner of the county. Other major highways include Indiana 9, running north to south, and Indiana 44, running east to west through the middle of the county.

Shelby County, located southeast of Marion County, is one of the central Indiana counties benefiting from Indianapolis's growth late in the twentieth century. The county's estimated population in 1996 was 5,000 more than in 1970. Shelbyville's population during the same time increased by more than 1,000.

While it's slipping from the list of books read by young people, at one time just about everyone (in Indiana at least), was familiar with *The Bears of Blue River.* Its author, Charles Major, was a Shelbyville native. The Blue River flows through Shelby County, running roughly through its middle, north to south. Major's other well-known novel at the time, late in the nineteenth century, was *When Knighthood Was in Flower.*

John Hendricks was one of the founders of Shelbyville, which was established in 1822 and incorporated in 1850. His son, Thomas A. Hendricks, became Grover Cleveland's vice president in the 1884 election. Thomas Hendricks died in office, having served nine months. Hendricks was the second of five Indiana vice presidents, the others being Schuyler Colfax, who served under Ulysses S. Grant, Charles Fairbanks under Theodore Roosevelt, Thomas R. Marshall under Woodrow Wilson, and Dan Quayle under George Bush.

The county courthouse was built in 1936 and, unlike in most Indiana counties, is not on the county seat's central square. It is located on the site of a previous (1870s) courthouse. The square, as part of a recent downtown refurbishing effort, includes the Joseph Memorial Fountain, named for Julius Joseph, who made a donation for the fountain, and a bronze statue depicting *The Bears of Blue River*'s hero, Balsar Brent, holding his two pet bear cubs.

Two historic districts are located in Shelbyville, the Commercial Historic District and the West Side Historic District.

The county, formed in 1821, is named after Kentucky's first governor, Isaac Shelby. Consistent with other Kentuckians for whom Indiana counties are named, he was a frontier fighter as well as a politician.

"I've traveled to Shelby County to fish and hike since I was a child, inspired by reading The Bears of Blue River *by Charles Majors. There are five scenic rivers in this dear old county, all of them worthy of a painting. But when I found this spot in town, I knew this was the scene to preserve. I painted there twice and the many people I met there were as polite and thoughtful as I could hope to find anywhere."*

LYLE DENNEY
"Springtime in Shelbyville"
Oil on canvas 24 x 36 inches

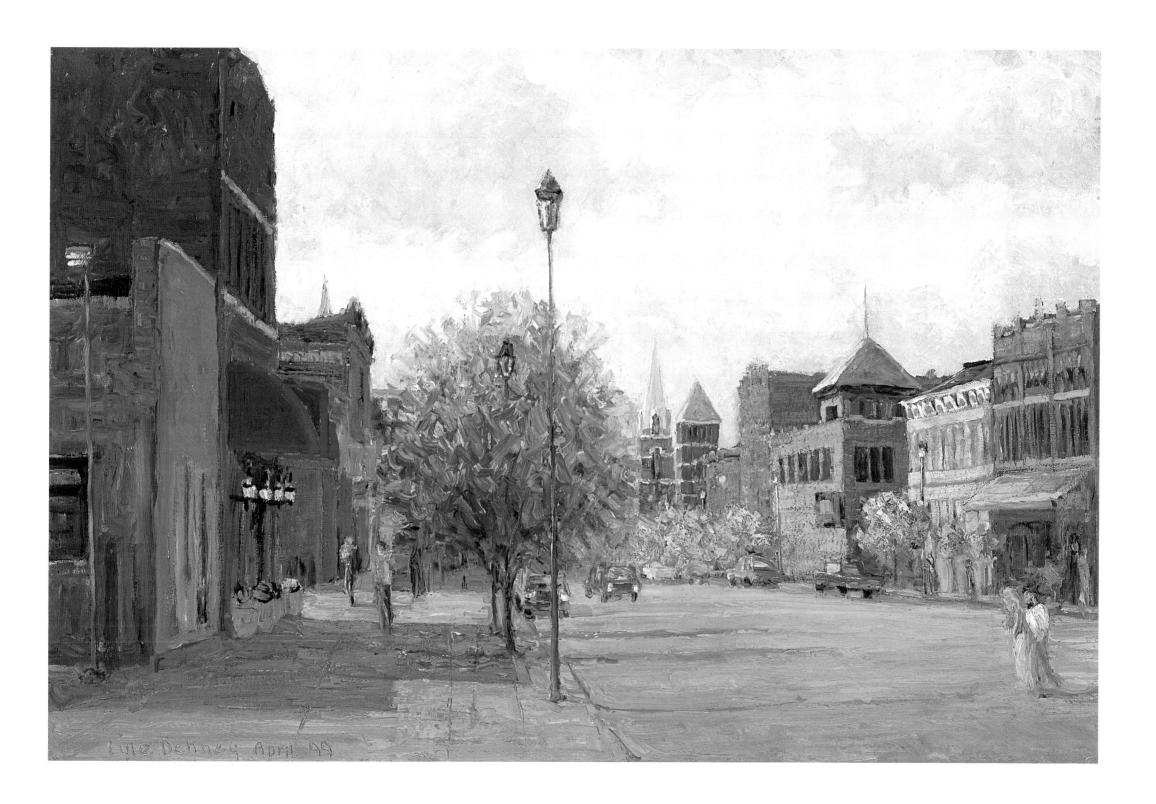

Lyle Denney April 99

SPENCER COUNTY

It's a certainty that Abraham Lincoln's formative years in Spencer County had a significant influence on his life. "There I grew up," Lincoln was quoted as saying.

The future U.S. president was seven years old when his father, Thomas, moved the family from Kentucky into southern Indiana in 1816, the year Indiana became a state. Getting to their 160 acres from Troy, where they crossed the Ohio River, was a rugged frontier challenge; Lincoln later said he "never passed through a harder experience" than he did going from Thompson's Ferry to the homesite. With standard self-sufficiency, the Lincolns grew or made nearly everything they consumed. Then, in

1818, young Abraham's mother, Nancy Hanks Lincoln, died. In the years that followed, Abraham got whatever schooling he could—"by littles" was the way he put it—including reading his first law book. He also got plenty of work as a rail-splitter, both on his own farm and working for others.

One of the significant events in Abraham's life occurred in 1828, when he was nineteen. A family friend and founder of the nearby town of Gentryville, James Gentry, asked Lincoln to accompany his son on a flatboat loaded with goods down the Ohio and Mississippi rivers to New Orleans. Lincoln saw the western United States river country and, perhaps most importantly, he also saw slavery firsthand. Today, a marker near Rockport, the county seat, commemorates where their trip originated.

After fourteen hard years in Indiana, the Lincoln family migrated to Illinois. Lincoln returned to Spencer County only once, in 1844 while campaigning for Henry Clay. It was on this trip that he visited his mother's grave.

Lincoln's Indiana years are recalled at the Lincoln Boyhood National Memorial in Lincoln City as well as at the Lincoln Pioneer Village and Museum in Rockport. The national memorial includes a visitors center, the Lincoln log cabin memorial, Nancy Hanks Lincoln's grave, and a historical farm, which is a working pioneer homestead with cabin, outbuildings, split rail fences, animals, gardens, and field crops. The Lincoln Boyhood National Memorial is administered by the National Park Service. The Rockport Lincoln Pioneer Village and Museum includes replicas of cabins from the Lincoln era, built by the Works Progress Administration in the 1930s, and other artifacts from the area's past.

Across the road from the Lincoln Boyhood National Memorial is Lincoln State Park, a 1,700-acre recreational area, much of it constructed during the Depression by the Civilian Conservation Corps. The park was the site of the Noah Gordon Mill where, according to Lincoln lore, young Abraham would sit reading while his horse went round and round, grinding corn. Nearby is the Little Pigeon Primitive Baptist Church. Abraham's sister, Sarah, who died in childbirth, is buried there, along with her stillborn child.

Just a few miles to the east of Lincoln City is Santa Claus, Indiana. Not much happened for a hundred years after the town was named until Evansville industrialist Louis J. Koch began construction in 1946 of what is believed to be the world's first theme park, Santa Claus Land, now Holiday World and Splashin' Safari. Just to the west of Lincoln City is Gentryville and the restored home of Colonel William Jones, a friend of the Lincoln family where Lincoln stayed during his 1844 trip to Spencer County.

Spencer County is named after a hero of the 1811 Battle of Tippecanoe, Spier Spencer, who died during the fight.

"After visiting the Lincoln State Park, I went to see the Lincoln Boyhood National Memorial. I drove across the railroad tracks and there it was, a pleasing scene of beautiful trees and a wonderful vista across farm fields."

DON RUSSELL
"Lincoln City"
Oil on canvas 16 x 20 inches

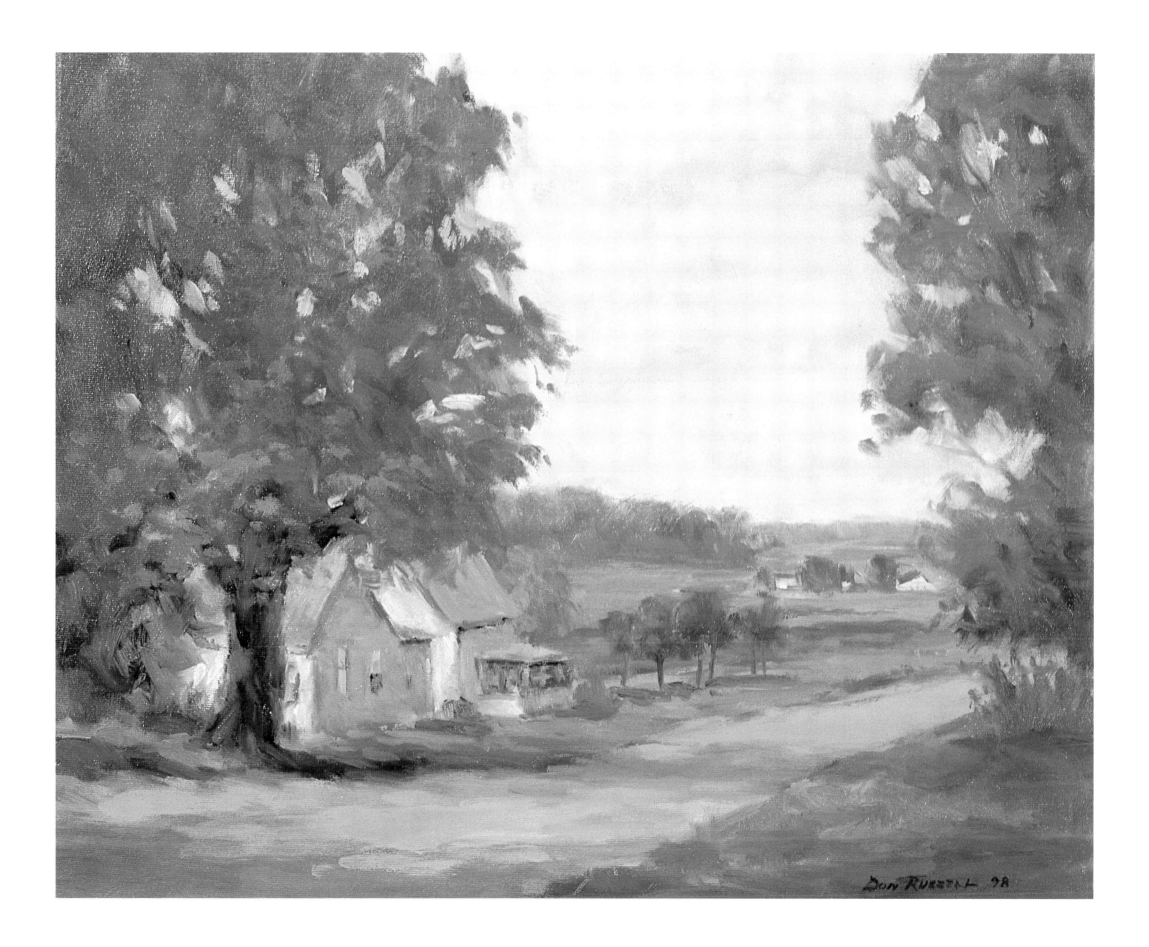

STARKE COUNTY

One story has it that Starke County, organized in 1850, might have included an area north of the Kankakee River. Apparently, it was going to be too expensive to put a bridge across the Kankakee River to link the two sides, so the river became the northwestern boundary of Starke. What was north of the river became part of LaPorte County.

Much of northern Starke County was under water in the Kankakee valley, or as it was in those days, the Kankakee swamp. In some places, the river expanded to more than a mile wide and more than five miles long, creating a body of water known as English Lake. Both the swamp and the lake are gone now through drainage efforts, but the town of English Lake remains.

Due to the impassable swamps and marshes, surveyors trying to map section lines in the 1830s had a nearly impossible task. Families living on higher ground used boats to get into town because paths were under water. It was not for another half-century that drainage systems reclaimed much of the land where, according to one account, "the waters were waist-deep the year around." Even then, drainage efforts were often obstructed by persons living on the ridges who made a living out of wild game and fish in the swampy lands. Most of the area is fertile farmland today, with open ditches and underground tile lines. Quality peppermint grows in the muck and other county soils. Corn, wheat, oats, rye, hay, soybeans, Christmas trees, blueberries, strawberries, and vegetables are other common crops.

As with most Indiana counties, railroads played an important role in Starke's development. They included—all of them mid- to late nineteenth century—the New York, Chicago and St. Louis; the Indiana, Illinois and Iowa; the Chicago and Erie; the Pittsburgh, Ft. Wayne and Chicago; the Chicago, Indianapolis and Louisville; and the Richmond and Muncie.

As Bass Lake in south central Starke was developed, it became a favorite for trainloads of vacationers from Chicago, especially in the 1920s. It is Indiana's fourth-largest natural lake and Bass Lake State Beach offers swimming, waterskiing, camping, picnicking, and playground equipment. Koontz Lake, in northeastern Starke, attracts its own summer visitors. A devastating tornado dumped debris in the lake in the 1960s, but that has since been cleared. The state also maintains the Kankakee State Fish and Wildlife Area—4,095 acres along the river in northwestern Starke County.

The county seat's courthouse in Knox is its third. The first was a small frame building that was replaced first in 1863 and then a second time in 1898. The present 138-foot three-story structure is topped with a clock tower.

Starke's best-known native son was Henry F. Schricker, who moved from North Judson to Knox to become publisher of *The Starke County Democrat* and was later elected a two-time governor of Indiana, in 1940–44 and again in 1948–52. Schricker's Knox home on Main Street now houses the Starke County Historical Society Museum.

Among the items in the museum are clothing and furniture belonging to Che Mah, who moved from China to the United States in 1881 while traveling with circuses and retired in Knox in 1900. He was reputed to be the smallest man in the world, measuring twenty-eight inches in height.

The county was named after the Revolutionary War hero, General John Stark, who played a role in the American victory at Saratoga. Somehow, an "e" was added to the county name. The county seat, Knox, is also named for a Revolutionary War hero, Major General Henry Knox.

"Round Lake Church was a bright spot in a world of green. Early in the day the setting appealed to me, but the morning light was blocked by trees, making the church appear cold with no shadows. We returned late in the afternoon to find the church glowing with the sun's orange light, surrounded by a warm hue of green. Lifelong member Ray Short showed us inside and told us about its long history. He also told us about how mint, used to flavor chewing gum and toothpaste, is grown in the county, adding that residents like to say that Starke County is in 'mint' condition!"

RONALD MACK
"Round Lake Church"
Oil on linen 16 x 20 inches

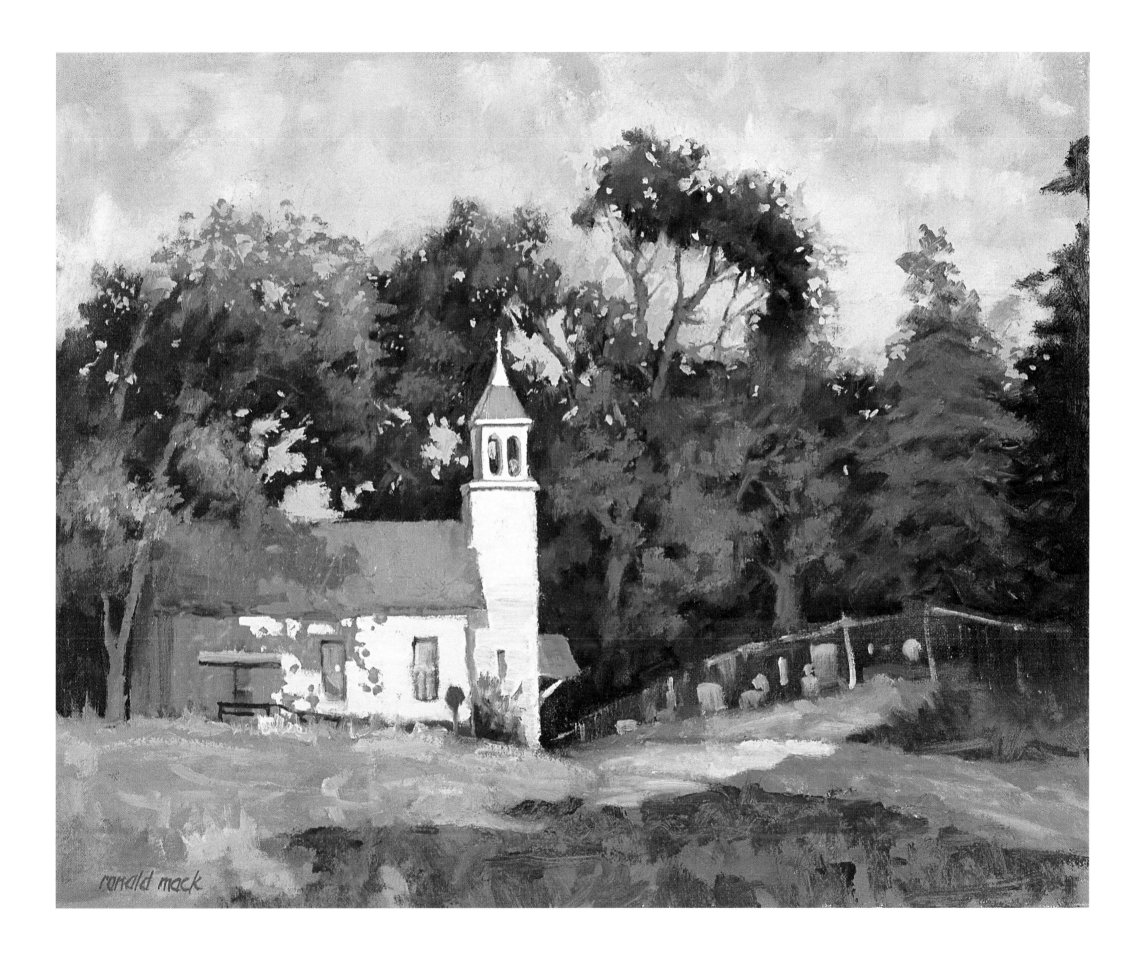
ronald mack

STEUBEN COUNTY

It's true. Steuben County doesn't have 101 lakes, as advertised. Actually, the number is closer to 115!

They are all left over from the last glacier to cover Indiana, the so-called Wisconsin Glacier, a sometimes mile-thick ice sheet that began melting perhaps 15,000 years ago. As the ice receded, sunken blocks broke away, creating today's "kettle hole" lakes. These and the larger bodies of water that formed were gouged out of the earth by this force of nature, leaving Steuben County, located in Indiana's uppermost northeastern corner bordering on Michigan and Ohio, with more lakes than any other county in the state.

Pokagon State Park and Lake James, north of county seat Angola and close to the Michigan border, is Steuben's best-known lake and recreational area. Its 1,203 acres were established as a state park in 1925 and include the 142-room Potawatomi Inn. Recreational activities are fishing, waterskiing, boating, camping, hiking, tennis, horseback riding, and a nature center and cultural programs. In winter months, ice fishing, sledding, ice-skating, cross-country skiing, and tobogganing are favorites.

The county was once prime hunting ground for the Potawatomi and Miami. Even today, flint spearheads and arrowheads can be found in the fields. The state park is named after the last chief of the Potawatomi nation, Simon Pokagon. His father, Leopold Pokagon, ceded a million acres to the United States.

Orland in northwestern Steuben is believed to be the oldest town in the county. Settlers from Vermont arrived in the mid-1830s, but the town was not incorporated until 1915. It was first called the Vermont Settlement. Its present name, according to local lore, was randomly selected from a hymnbook. Another county name change occurred when Brockville seemed too close to the spelling of Brookville in southern Indiana. The present name, Fremont, was selected to honor John C. Fremont, the western explorer. Other changes include Enterprize to Hamilton, Wiselberg to Salem Center, and Millersburg to North Benton and eventually to Hudson.

The eastern influence on the county is evident in the county seat's name. It is named for Angola, New York, home of early settlers. Now it is located at the intersection of east–west U.S. 20 and north–south U.S. 27. Interstate 69 loops around Angola to the west, going through the county on a north–south route. Angola was incorporated as a city in 1906. Because of its proximity to Pokagon State Park and area lakes, its population increases substantially in the summer. The county courthouse was completed in 1868, built to resemble Boston's Faneuil Hall. The county's focal point is the Soldiers Monument, located in the center of Angola to honor those from Steuben County who served during the Civil War. Topped by Columbia extending her arm with a peace wreath, tablets at the bottom of the monument list the 1,278 men who fought and the 280 who died.

Steuben County was an active route in the Underground Railroad. Two major trails included a western route up through Orland to Michigan and a second along the present Penn Central railroad line through Angola north to Fremont and into Michigan.

Steuben is named for Baron Frederick von Steuben, who became a general in the American Revolutionary Army in 1777. He trained troops for Washington at Valley Forge and fought with the American forces in the climactic battle at Yorktown. He was granted American citizenship following the war and died at his farm in New York in 1794. The county was originally part of LaGrange County but was separated in 1835 and organized in 1837.

"I intended to paint a snow scene in Steuben County. Waiting for the right snow at the right time didn't materialize. Being a working man, weekends are the only time I could travel to my counties. Four trips to Steuben County proved it is indeed the land of lakes. On Hamilton Lake, I found a quiet area with vegetation framing a lovely view across the water. The rows of multicolored cottages and boats made a lovely composition of a typical scene in this lake-filled county."

DAN WOODSON
"Hamilton Lake"
Oil on canvas 16.5 x 24 inches

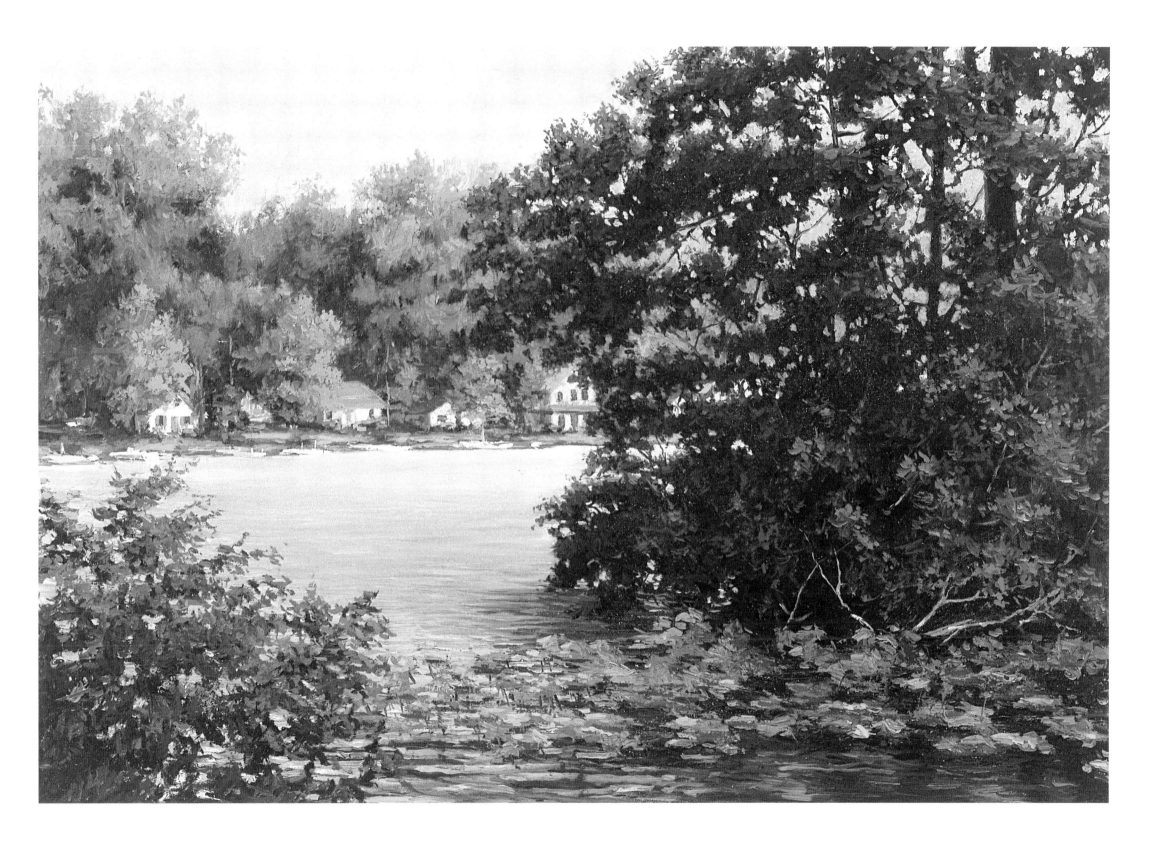

SULLIVAN COUNTY

During the summer weeks in the early twentieth century, they came by the thousands to the park area at Merom Bluff overlooking the Wabash River. This chautauqua—part educational, part political, part religious, and certainly social—drew some of America's best-known speakers of the day, among them William Jennings Bryan, Eugene V. Debs, Billy Sunday, Carrie Nation, and Jeanette Rankin, first woman to serve in the U.S. Congress. In addition to the speakers, musical numbers and recitations were other forms of entertainment.

Families would load up food and supplies in wagons to spend several days on the bluff. Old-timers remember it as a big family reunion, because many who were there from all over the county were, in fact, related. Finally, several weeks later, it would end. Much like the county fairs of a few years later, the Sullivan County residents would disperse, looking forward to the next year. By 1936, with automobiles and other entertainment, the heyday of the chautauqua was over, although Merom has a present-day chautauqua the first full weekend of each June.

On top of the 200-foot bluff is the town of Merom, once a busy river port and still a good location for a grand view of the Wabash River. Like other towns along Indiana's rivers, when the railroad bypassed it—stopping instead at nearby Merom Station—its days as an important community were numbered. It was even the county seat until that was moved to the more centrally located Sullivan in 1842.

Sullivan was the name given the new county seat when its former name, Benton, was found to be already in use by another Indiana town. The first settlers came into the county in the early 1800s; the railroad reached the new county seat in 1854. Growth occurred late in the nineteenth century with the discovery of coal, mostly in eastern Sullivan County. It is estimated that at one time as many as 450 mines were operational in Sullivan, Greene, and Knox counties.

Coal mining is still a major occupation but the shafts have disappeared, replaced by strip mining. Today, it is difficult to recognize what was once level farmland with the hills and strip pits covering large areas of eastern Sullivan County. What is reputed to be the second largest coal shovel in operation, the so-called "Big Shovel," scoops up tons of coal in one swipe in Jefferson Township in one of the remaining strip mining operations. Lakes formed from the strip pits, now used for fishing, vary in size from five to more than 200 acres.

Lake Sullivan, located at the northeastern edge of Sullivan, has 461 acres, used for swimming, fishing, boating, and camping. Sullivan County shares Shakamak State Park on its eastern border with Greene County in addition to the Greene-Sullivan State Forest, also on its eastern border in the southern part of the county. The Minnehalia State Fish and Wildlife Area, the second largest in the state with 11,400 acres, is just east of the county seat.

Carlisle, located in southern Sullivan County, was probably named for Carlisle, Pennsylvania, home of early settlers. It appears to have been laid out by French surveyors since lots were organized in the early 1800s on forty-five-degree angles, paralleling the Wabash River, as contrasted with the north–south, east–west lines used by British and American surveyors. James Ledgerwood was the first settler, having been given a tract of land in reward for his Revolutionary War services and because he negotiated a treaty with local tribes shortly after he arrived in 1803.

The county is named for Daniel Sullivan, a Revolutionary War hero, and was organized in 1816.

"Every county has special people like Marie Monroe and Bill Tennis of Sullivan. When Anne and I met with them to get historical information, they treated us as if they had known us for years. Mrs. Monroe gave us all the information we needed and her friend Mr. Tennis provided a tour of the county's treasures. Had it not been for our new friends, we would never have found Merom Bluff. The spectacular view of the Wabash and beyond to Illinois was made even more fascinating with the history supplied by our special tour guide."

DAN WOODSON
"Merom Bluff"
Oil on canvas 24 x 36 inches

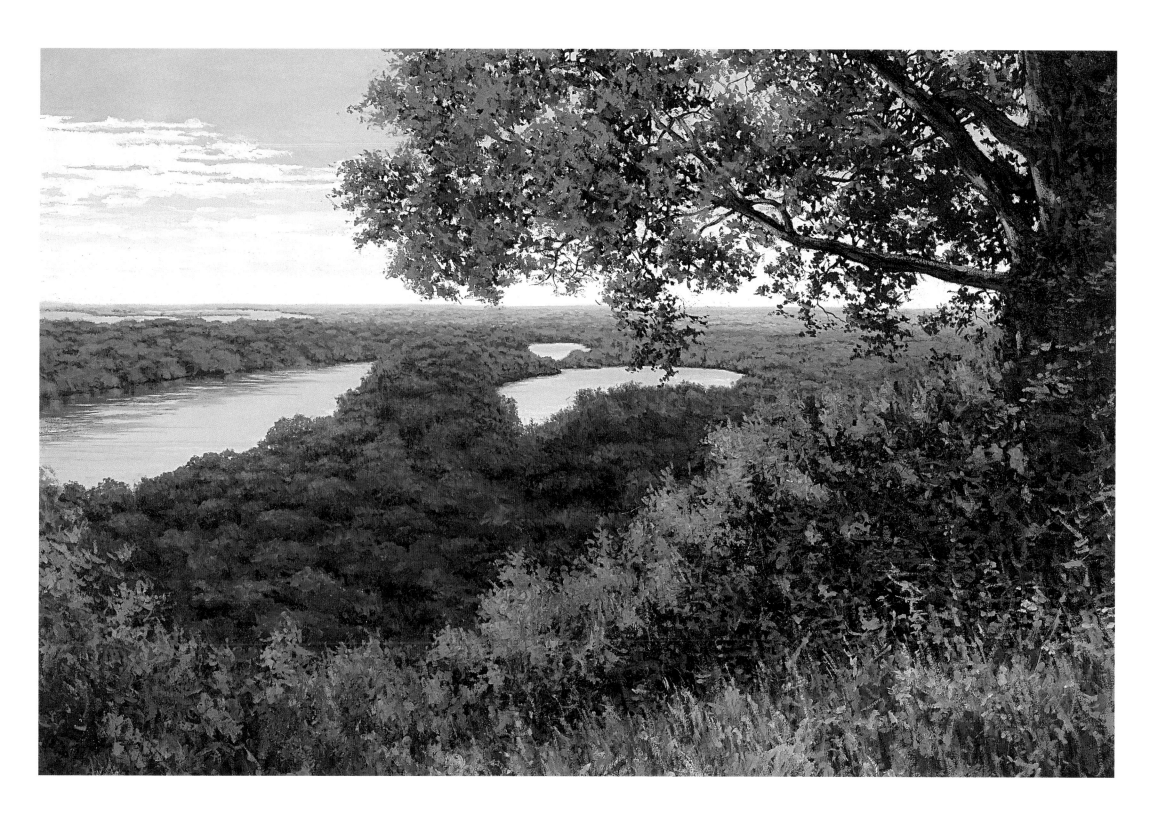

SWITZERLAND COUNTY

John James Dufour was fourteen years old when he left Vevey, Switzerland, in 1798 for the United States and, ultimately, the Ohio River. His goal was to carry on a family tradition of "wine dressing" in this new country. Soon other relatives—brothers, sisters, and children—followed. An early 1800s spring frost took their grape crop in their first attempt at a commercial vineyard. (Thomas Jefferson and others had established earlier vineyards along the East Coast, but they were meant to produce only family wines.) The Dufours moved to lands upriver and settled on 3,700 acres along today's Indian Creek. They called it "New Switzerland."

Their first wines, probably in 1807, were of limited quantity but good quality. They enlarged the vineyards every spring along the hillsides of the Ohio. The vintage of 1808 yielded 800 gallons and the next year about 1,200 gallons, according to a county history written by Perret Dufour in 1925, who said their Cape grape was judged "superior to that of the Claret of Bordeaux" and their Madeira grape produced a white or yellow wine. At its peak, their wine production exceeded 12,000 gallons annually.

Over time, they became important citizens in what was to become Switzerland County, established in 1814 by taking parts of Jefferson and Dearborn counties. Other Swiss settlers attracted to the area were also industrious, raising corn, wheat, potatoes, hemp, and flax. Swiss women made straw hats, which were marketed in Cincinnati and to the river trade south into Mississippi.

The county seat, which the Dufours laid out—spelled Vevay but pronounced *vee-vee*—still has fine homes built by the well-to-do on Market Street, above the floodplain and overlooking the old town. They present an array of architectural styles from Greek Revival to Queen Anne, along with smaller and simpler cottages on the side streets. One mansion is the home of Ulysses P. Schenck, who made a fortune selling hay. Built in 1846, its freestanding cherry spiral staircase was designed by noted architect Francis Costigan.

A more modest house is located on Main Street, the birthplace of Edward and George Eggleston. Edward became famous for his novel, *The Hoosier Schoolmaster*, published in 1871. George was also a well-known author and newspaper editor. Another Switzerland county native, Elwood Mead, is from the upriver community of Patriot. He was the chief engineer in the construction of the Hoover Dam and its lake, Lake Mead, is named in his honor.

Two Vevay public buildings of note are the Hoosier Theater, constructed in 1837, where theatrical and musical performances are still presented, and the Switzerland County Historical Museum, located in the former Presbyterian Church, built in 1860. One of its features is a piano believed to be the first brought into Indiana.

The courthouse is Classic Greek Revival in architectural style and was built in 1864. The county has kept it in its original form, both inside and out. A six-sided privy is on the courthouse grounds along with a jail built in 1853 and a gazebo.

The Markland Locks and Dam have widened the river near Vevay. Constructed between 1956 and 1963, two parallel locks are located on the Kentucky side of the river. The dam creates a nearly 100-mile-long lake, one of a series along the river.

A new addition to the river heritage will be a floating riverboat casino, to be docked seven miles upriver from Vevay at Florence. The hotel and entertainment complex is expected to open in the fall of 2000.

"I chose this winding road that leads far into the splendid hill country of Tapp Ridge. The dark trees framed the scene with a natural border around the protruding hill that occupied center stage. All this green pushed me to produce subtle values of the same color, and then change the value by adding cool grays. Beautiful country! The day before, I had painted an early morning scene with horses. The next day we came across this setting and I was inspired to paint again, letting the committee decide which one to use."

RONALD MACK
"Hill Country"
Oil on canvas 20 x 30 inches

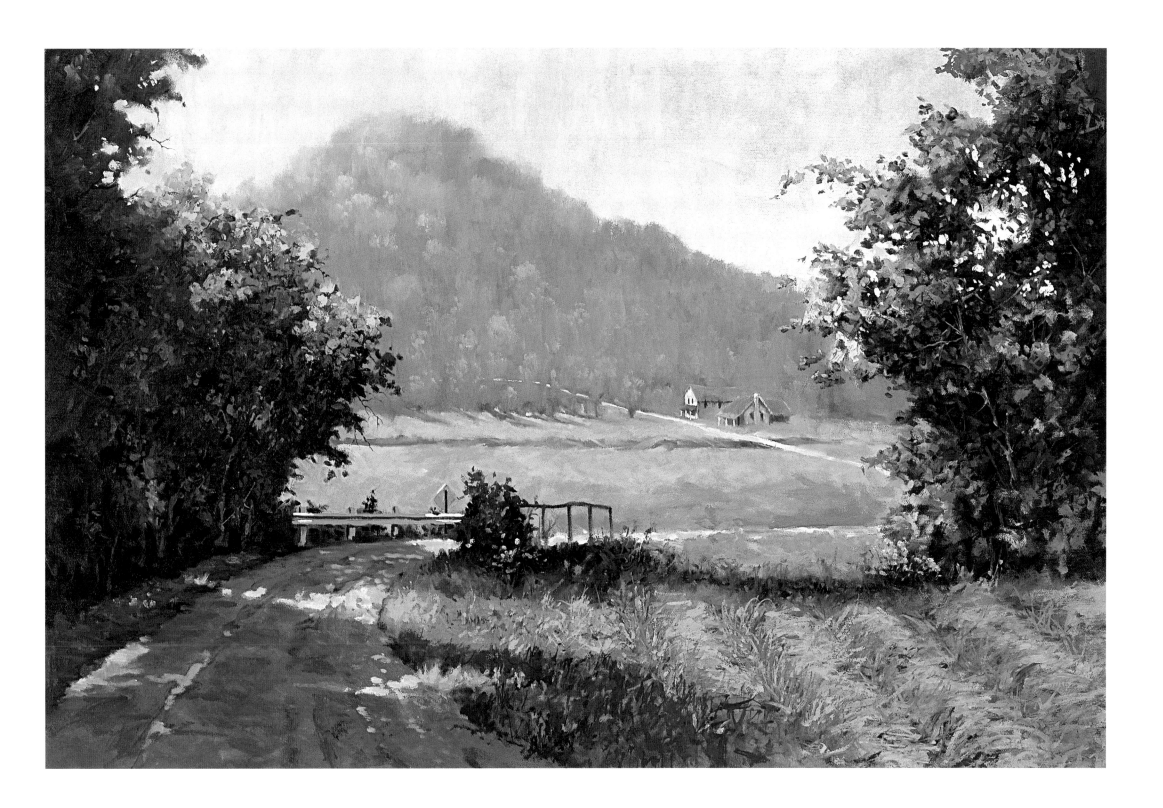

TIPPECANOE COUNTY

William Digby figured there was money to be made by establishing a town as far north on the Wabash River as the new steamboats would be able to travel upstream. So he went to the Christmas Eve land sale at Crawfordsville and bought the area on the river he believed would be the uppermost point for boats. He platted the land in May 1825 and named it for the Marquis de Lafayette, the French hero of the Revolutionary War.

Whether he had it exactly right about the boats is difficult to say today, but he was certainly correct about his new town, Lafayette. It soon became the supply center for settlers moving into the territory.

Tippecanoe County was formed in 1826 and Lafayette became the county seat. The river provided excellent transportation with the city wharf just a block from the courthouse square. Transportation took another step when the Wabash and Erie Canal arrived in the 1840s, even though its use was relatively brief. A more important arrival was the railroad built into the city during the 1850s.

A reminder of those railroad days remains in the restored Big Four Depot. Built in 1902, the depot was given to the city by its rail owners in 1983. It was moved to its present downtown site to become part of the Riehle Plaza and continues its transportation function as the city's terminal for Amtrak, intercity buses, and the Greater Lafayette Public Transportation Corporation.

Across the Wabash River in West Lafayette is Purdue University, founded in 1869 by John Purdue, whose gravesite is in front of the campus's oldest building, University Hall. It was at Purdue that Amelia Earhart, while a faculty member, prepared her plane for her around-the-world flight. Purdue is also known as the home of astronauts, twenty-two of its alumni having been chosen for the nation's space program, including Neil Armstrong, the first man to step on the moon. The university's Elliott Hall of Music, seating 6,027, is the largest theater of any educational institution in the nation.

Just north of Lafayette at Battle Ground is the Tippecanoe Battlefield Memorial. The ninety-six-acre park marks the site where an American army, under the command of General William Henry Harrison, clashed with a confederation of tribes led by Tecumseh's brother, the Prophet, November 7, 1811. In a bloody battle, Harrison's forces prevailed. He then proceeded to burn the confederation's headquarters at Prophetstown, which he hoped would destroy the last vestige of Tecumseh's power; it didn't.

Later, Harrison mounted his successful campaign to become U.S. president with a Whig Party rally at that battle scene and use of the political slogan "Tippecanoe and Tyler, too!" (John Tyler was Harrison's vice presidential running mate who became president when Harrison died one month after assuming office.)

As the twentieth century ended, Indiana was purchasing property to construct Prophetstown State Park near the town of Battle Ground. The Wabash Heritage Trail was also being developed, starting at the Tippecanoe Battlefield and following the Wabash River into Lafayette, crossing the river and continuing south of West Lafayette.

A blockhouse built near where the French established Fort Ouiatenon in 1717 is one of the earliest settlements in present-day Indiana and site of the county's annual Feast of the Hunters' Moon. The Fowler House in Lafayette, built in 1851, is the location of the Tippecanoe County Historical Museum.

The Tippecanoe County Courthouse, constructed in the 1880s, is the county's third seat of government. It underwent a $15 million renovation in the mid-1990s.

"The residence of the commandant of the Grand Army of the Republic, who oversaw the Indiana Veterans' Home, is a three-story antebellum-style home. It was built in 1899 by James Alexander, a leading architect who designed many of Lafayette's finest homes. It was restored in 1977. The Indiana Veterans' Home was established after the Civil War to house Indiana's soldiers on land donated by the people of Tippecanoe County. Light illuminated the house from the south, creating long shadows from the tall, graceful trees, causing the stately columns to glow. I set up my easel and painted the scene quickly before the light was lost."

ROBERT EBERLE
"The Commandant's House"
Oil on linen 16 x 20 inches

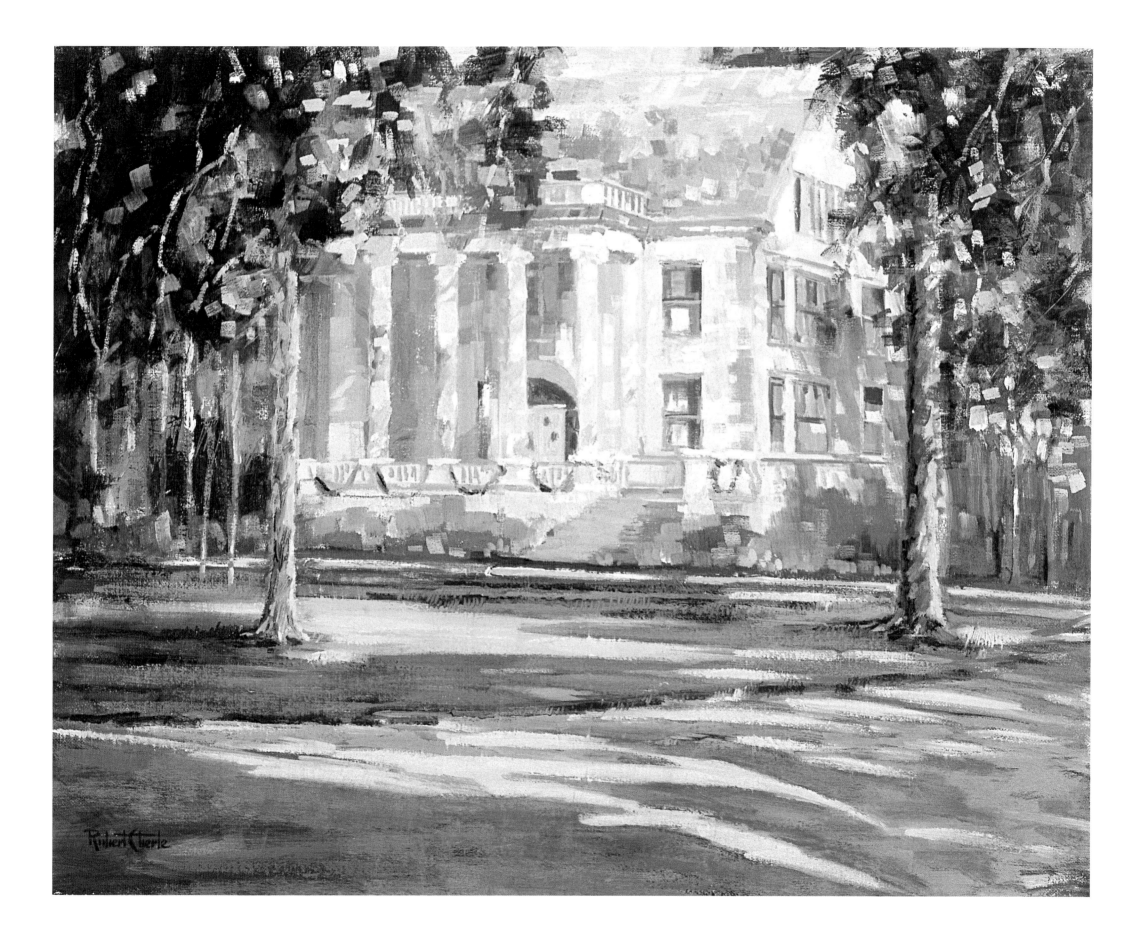

TIPTON COUNTY

It was inevitable that an Indiana county would be named for John Tipton, justice of the peace, sheriff, Battle of Tippecanoe veteran, surveyor, state commissioner, Indian agent, land entrepreneur, militia general, state legislator, and U.S. senator. Perhaps the only surprise was that it took so long, Tipton County not being organized until 1844.

Tipton's family moved to southern Indiana from Tennessee in 1807. He served with General William Henry Harrison at the Battle of Tippecanoe in 1811. He negotiated treaties with tribal nations, including the Treaty of Paradise Spring in 1826 at present-day Wabash that ceded most of the

northwestern part of the state to Indiana. He helped establish and set boundaries for Bartholomew County. As a surveyor, among other assignments, he established the Indiana–Illinois state boundary at the northernmost juncture. He was in charge of the militia that took 900 Potawatomi on a forced march to Kansas, a march in which at least forty died. He ended his long public career in the U.S. Senate.

Tipton County is on a low plateau that divides the watersheds of the Wabash and White rivers. In the Treaty of St. Mary's in 1818, the Miami nation gave up all land between the Wabash River to the north and what is now Tipton County to the south.

With the county established in 1844, Samuel King and his wife, Delila, donated a hundred acres for establishment of a county seat. Although the county was named in Tipton's honor upon its formation, the county seat was originally called Canton. As occurred with some frequency in naming towns, when postal service was established, it was discovered the state already had a Canton in southern Indiana and so the county seat was given the same name as the county.

The early settlers, coming from nearby counties, found mostly swampy land. Following extensive drainage, the rich, organic soil became highly sought after for farming. The area also had hardwood trees, many of which were simply cut down to clear property, but later saw mills operated throughout the county.

The railroad, a north–south line, arrived in Tipton only a few years after its founding in 1852. An east–west railroad was built in 1875. Indiana 28 passes through Tipton, east to west, while U.S. 31, going north–south, is five miles to the west.

Nine seed companies operate in Tipton County, including the largest of them, Pioneer Hi-Bred International, Inc., with headquarters for the company's eastern division located here. Contract growers annually provide the plant with 16,000 acres of seed corn, 40,000 acres of soybeans, and 2,000 acres of wheat. More than three million units of seed pass through the plant each year. Pioneer also operates a corn and wheat research facility in Windfall.

The county's population declined by 800 over a fifteen-year period (1980–95). Slightly more than one-fourth of the county's population resides in the county seat. Over half of Tipton's work force commutes out of county for employment, mostly to Kokomo.

Tipton Park, just south of downtown, has thirty acres of picnicking and playground areas including a city swimming pool.

Tipton's first courthouse was constructed in 1845, one year after the county was organized. The structure burned in 1857 and county offices met in churches and an annex until a new courthouse was built in 1860. That was replaced by the present courthouse, built in 1894. Its clock tower is 206 feet from cornerstone to flagpole. The clock's mechanism is four by eight feet and weighs about 3,000 pounds.

"This scene, painted in southeast Tipton County, could be anywhere in this area of flat, fertile farmland. In five trips and three previous paintings, I still didn't feel I had really captured the essence of the county. This view of spring plowing with the farm beyond personifies the area best. The bright sun made the spring colors seem even brighter and the cloud shadows moving across the land offered an interesting contrast to a common scene."

RONALD MACK
"Let's Call It a Day"
Oil on canvas 20 x 30 inches

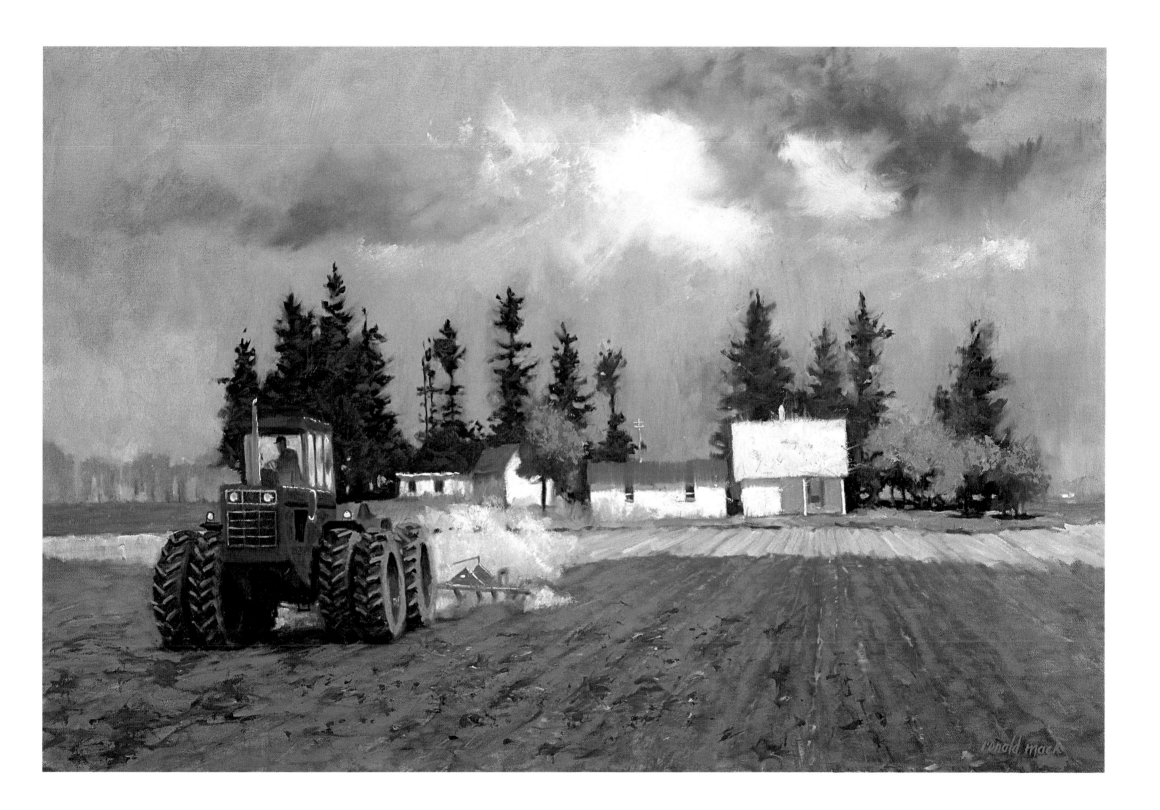

UNION COUNTY

It's the only county in Indiana whose name is based on an ideal. Most counties are named for early heroes of the Revolutionary War period, the Battle of Tippecanoe, the War of 1812, frontiersmen, or for Native Americans or something in their history. In this case, the name selected was Union, because the county was pieced together from parts of Fayette, Franklin, and Wayne counties.

Organized in 1821, it is one of the state's smaller counties and borders the Ohio state line. The Whitewater Memorial State Park, the Brookville Lake, and the Quakertown State Recreational Area make up much of the southwestern part of the county, with the east fork of the Whitewater River flowing south into Franklin County and the Mounds State Recreational Area.

In 1949, four counties—Fayette, Franklin, Union, and Wayne—acquired the initial acreage for a state park, to be established as a living memorial to the men and women who served in World War II. Whitewater Memorial State Park, all of which is in Union County southwest of Liberty, has 1,710 acres; 200 of its acres are in Whitewater Lake, which runs through the park. The Hornbeam Nature Preserve is on the western lake shore. Hornbeam and hop hornbeam trees grow there and in the spring the forest is covered with a carpet of wildflowers.

Brookville Lake, which is located in both Union and Franklin counties, lies to the south and is another 12,000 acres of land and 5,200 acres of water. The lake, backed up by the Brookville Dam in Franklin County, is sixteen miles in length with an average depth of thirty feet. Boating, fishing, swimming, hiking, picnicking, and nature study are favorite activities of park guests. Brookville Lake alone has nine boat-launching ramps.

The small, centrally located town of Liberty, platted in 1822 and named the county seat the following year, has Greek Revival, Italianate, and Gothic-style homes. The county's third courthouse is located on Liberty's courthouse square. Built in 1890, the limestone building has a four-faced clock atop its tower. In the southeast corner of the courthouse grounds is the Templeton cabin, considered the oldest log building in the county, constructed in 1807 on the east bank of the Whitewater River in Harmony Township. It was placed at its present location in 1980. The Union County Historical Society has restored the cabin with furniture from the nineteenth century on the first floor and a collection of artifacts from frontier life on the second.

The historical society has also acquired the Liberty Depot from the Chessie System. It, too, has been restored and now serves as the Union County Museum, home to memorabilia of the county's history. Built in 1886, the depot at one time serviced up to sixteen trains daily on their way to Cincinnati or Indianapolis. Other property of the historical society includes the old Liberty Water Works property and the First Missionary Baptist Church.

In Dunlapsville in southwestern Union on the east bank of the Whitewater, an original schoolhouse has been purchased by the Treaty Line Museum and is now part of the Pioneer Village. Artifacts of early pioneer family life are housed in the schoolhouse. The village also includes items from a grist mill and a general store moved from nearby Quakertown when the Army Corps of Engineers created the Brookville Lake flood control project. Five cabins have been reconstructed. The village has pioneer re-enactments during the summer months.

Farming is the primary industry of the county, home to about 7,000 residents.

"With great expectations and excitement, I headed out on a Saturday morning in April of 1998 for Union County to find a subject for my very first Painting Indiana painting. I didn't want to leave anything unnoticed. At the end of the day I had driven more than 350 miles and had not chosen a site. I went back the next day . . . same thing. I thought this would be the easy and fun part. I did decide on my subject the next weekend and it turned out great, but I still had seventeen counties to go. I had no idea then that I would log more than 21,000 miles by May of '99."

DAN WOODSON
"Backwater"
Oil on canvas 20 x 30 inches

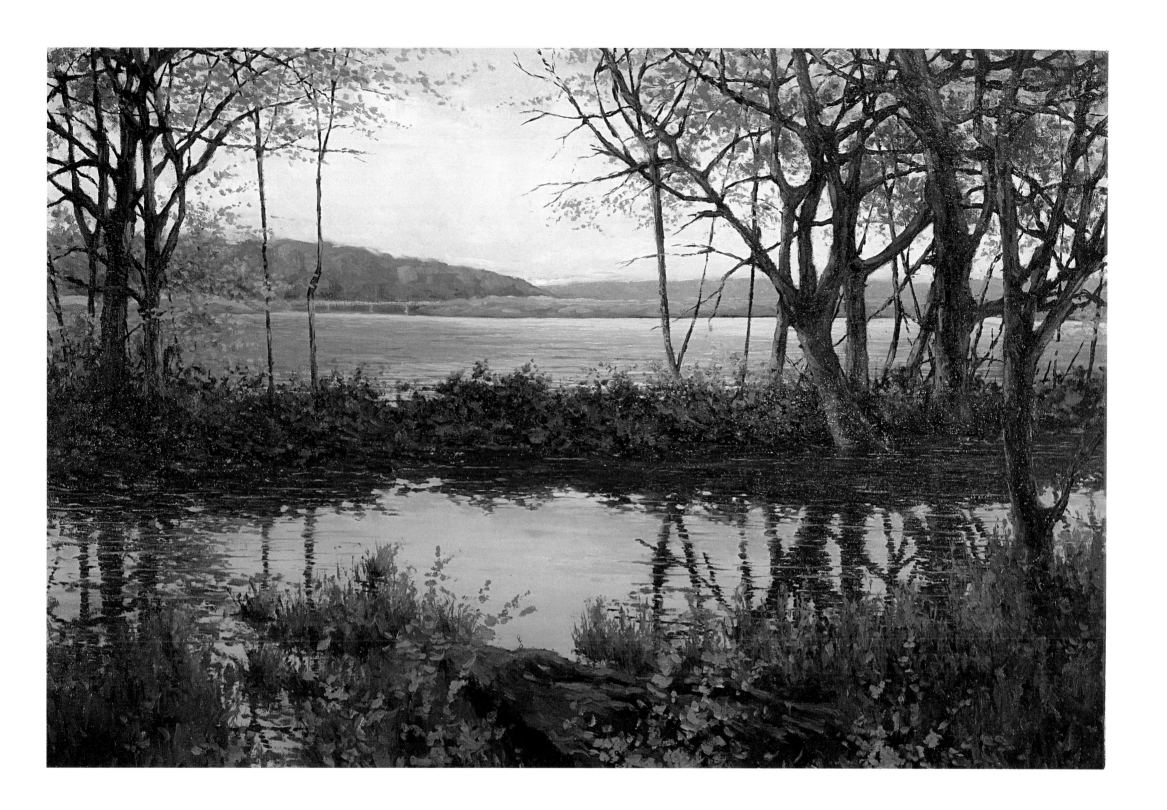

VANDERBURGH COUNTY

In the 1800s, land speculators at Indiana towns on the Ohio River vied to have their sites become the most prominent cities on the river. For numerous reasons, these communities either faded away, retained their small town atmosphere that may have served them well, or, as in the case of Evansville, the dream came true.

Not that it has been easy. Evansville did not grow rapidly in its early days. It has gone through depressions, floods, and other calamities. For instance, a cholera epidemic in 1832 devastated the community. The floods of 1913 and 1937 caused extensive damage. Today, however, it is the fourth-largest city in Indiana and is firmly anchored as the urban hub for southwestern Indiana, southeastern Illinois, and northwestern Kentucky. One million people live in the thirty-six counties that make up the Evansville marketing area.

The county was created in 1818 and—because of its river location, coal, and woodlands for timber—seemed on the verge of growing and prospering. A few years later, canals were very promising—first the Central Canal from Fort Wayne and later the Wabash and Erie Canal. As happened at so many other Indiana towns, the railroad delivered on the promise made by the canal. By 1900, more than 300 manufacturing firms were located in Vanderburgh County, including iron, steel, woodworking, furniture, automobile, and refrigerator companies.

World War II brought even more acceleration to the Evansville economy with the shipyards building military landing craft and Republic Aviation turning out P47 Thunderbolt airplanes. Employment quickly rose from about 21,000 to more than 64,000.

Today's urbanization is evident in the cultural activities available, such as the city's philharmonic orchestra, ballet, civic theater, and a recently renovated stadium. Recreational opportunities include city parks, Mesker Zoo, Wesselman Woods Nature Preserve, the county's Burdette Park, and the Howell Wetlands Education Center. Water recreation with marinas and boat-launching facilities on the river have increased. A forty-two-mile Pigeon Creek/Greenway Passage was under construction at century's end for walking and biking.

One measure of community development and the passage of time has been the number of Evansville city blocks and buildings designated as historic districts and places. Perhaps the best-known building is the Old Vanderburgh County Courthouse, which has dominated the Evansville skyline since its construction in 1890. Another landmark is the mansion of John Augustus Reitz, a French Second Empire-style mansion constructed in 1871.

The county's third courthouse, not used for government since 1969, is now managed by the Old Courthouse Preservation Society. It is used by community groups as a historical museum and art gallery and has rented space to some county offices. Memorials to the veterans of both world wars are on the courthouse lawn.

The area's history is also recounted at the Evansville Museum of Arts and Science along the river, the 1885 Willard Library, and the Angel Mounds State Historic Site.

Two universities serve the area: the University of Evansville and the University of Southern Indiana.

The county is named for William Henry Vanderburgh, Revolutionary War soldier and later a judge of the Indiana Territory Supreme Court. Evansville is named after Robert M. Evans who, with his friend Hugh McGary, had a clearing declared the county seat of what was then Warrick County. The city was incorporated in 1819.

"As I looked northwest on the walkway along the Ohio River, the distant buildings with their gray shapes made a nice composition. The tree line added to the perspective and the people enjoying the area brought it to life. I painted mid-morning on an overcast day with not too much bright sunlight."

RONALD MACK
"Riverside Walkway"
Oil on linen 16 x 20 inches

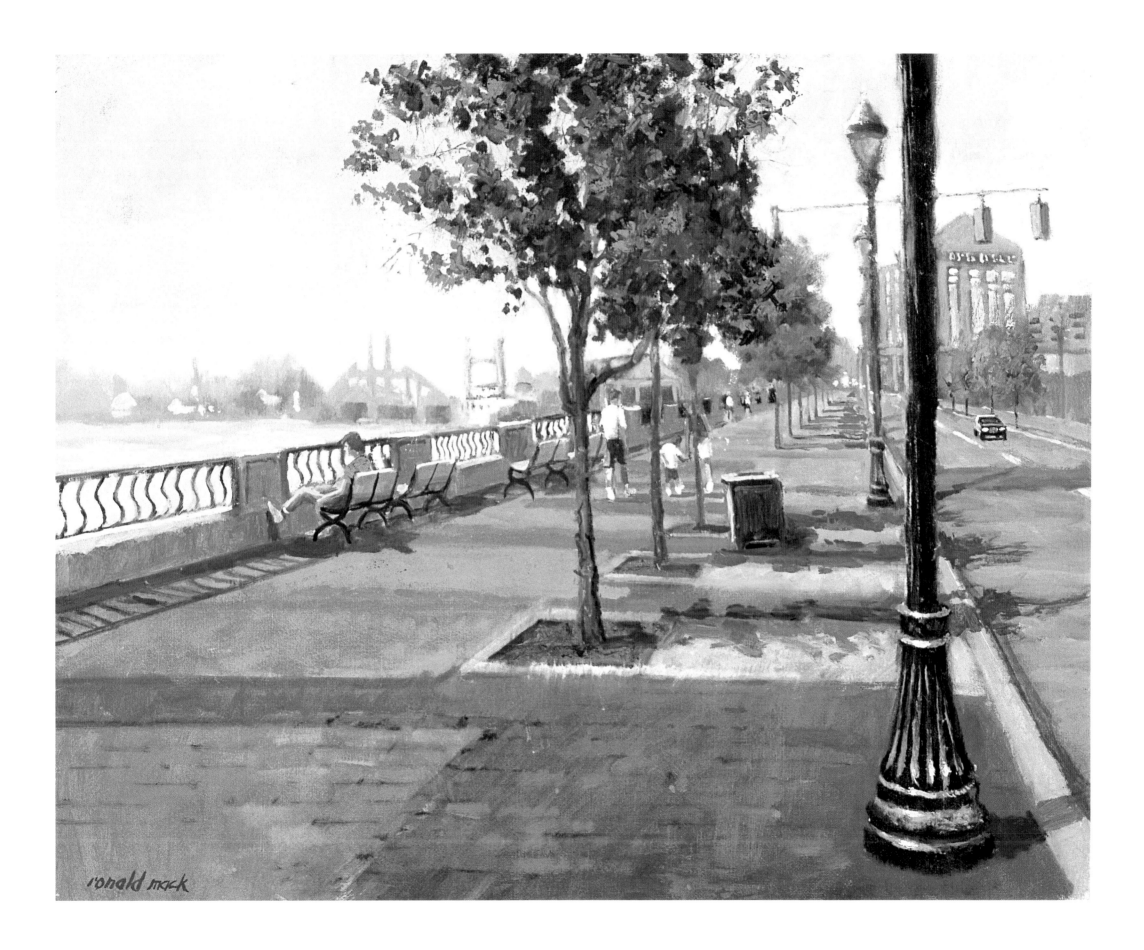

ronald mack

VERMILLION COUNTY

The fighting was intense as the Americans tried to take the small island of Ie Shima from the Japanese in the closing months of World War II. The U.S. forces held the beach and a few hundred yards more, but that was about it. Cautiously, small groups moved inland. As the machine gun fire started again, four uniformed men dove into a ditch. When the gunfire stopped, for some inexplicable reason, one man raised his head. That's when the Japanese sniper shot him.

Ernie Pyle was dead. He would have been forty-five in four months.

Word came down the line on the island that Pyle, the most famous war correspondent of all time, had been killed. The fighting seemed too fierce to go into the area to retrieve his body, but a chaplain and four volunteers went anyway. Two days later, Pyle was buried on the island along with other slain Americans. Then, in 1949, he was reburied at Punchbowl Memorial Cemetery in the Hawaiian Islands.

Pyle, who was born in a farmhouse near Dana in Vermillion County, was remembered fondly by his fellow Hoosiers over the decades, but no serious efforts were made to save the Pyle birthplace until the early 1970s. The farmhouse had been built and was still owned by the Elder family in 1851 with the Pyles living there briefly at the time of Ernie's birth, August 3, 1900. It was the widow of a great-grandson of the builder who suggested relocating the house to Dana. The state took over operation of the historic site in 1976.

Today, two World War II–style Quonset huts next to the house serve as a visitors center with scenes and memorabilia about Pyle's career. The house itself has more Pyle material in the basement while the first and second floors have been refurbished to represent a home at the turn of the twentieth century.

The county, organized in 1824, has one of Indiana's more unusual shapes. It is about thirty-five miles long and only seven miles at its widest point. It is against the Illinois border on the west with the Wabash River forming its eastern boundary. It is rural country with hills, farmlands, and small communities.

Vermillion has three covered bridges remaining, one of which is still in use—the 180-foot Burr arch Newport bridge over the Little Vermillion River on County Road 50 North. All three Vermillion bridges were built by J. J. Daniels in the 1870s and 1880s. A second covered bridge, Possom Bottom, has been moved to the Ernie Pyle rest park, east of Dana on state road Indiana 36. The third, Eugene, over the Big Vermillion River near the town of Eugene, was bypassed in 1973.

At the end of the twentieth century, the old Vermillion County Jail, built in 1896, and the sheriff's quarters, built in 1868, in Newport, the county seat, were being restored and transformed into a county museum. They are located at the site of the only legal hanging to take place in the county, in 1879.

Newport is also the site of the annual Antique Auto Hill Climb. Newport Hill, whose base is at the county square, rises 140 feet almost straight up, or so it seems. On the first weekend in October, pre–World War II and selected discontinued makes of autos compete for the fastest time to the crest of the hill. The climb originated in 1909 as a testing ground for the new horseless carriages.

The county is named after the Vermillion River, which flows through the middle of the county to join the Wabash River.

"The composition was set in place. The day was overcast and the endless shades of gray gave a beautiful contrast to the powdery snow sprinkled over the ground. The footpath was parallel to the creek, suggesting a beautiful 'S' curve. The fallen tree across the creek provided a moment to look, and then move on into the distant hills and trees to wonder what might be in the faraway structure."

RONALD MACK
"Coal Branch Creek"
Oil on linen 20 x 24 inches

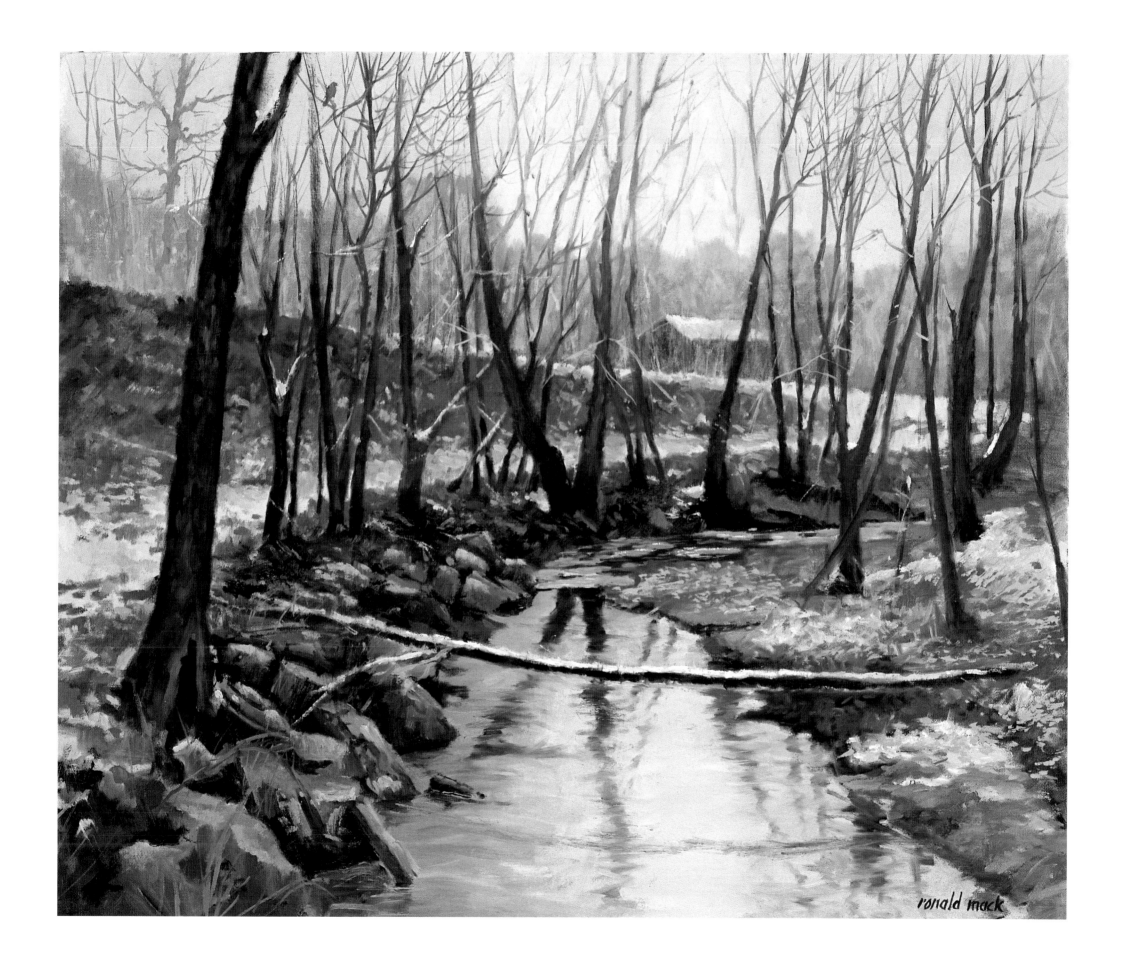

VIGO COUNTY

It was a difficult time for new labor unions. With Eugene V. Debs as its president, the American Railway Union had won after a strike for higher wages in 1894 against the Great Northern Railroad. When employees of the Pullman Car Company struck a few months later in Chicago, they asked for Debs's assistance in stalling Pullman cars and he agreed. Federal troops were sent, a court injunction followed, and soon Debs was in jail.

He grew up in Terre Haute, county seat of Vigo County. He left school at age fourteen and was soon involved in the growing labor movement. First, he tried politics, even serving in the Indiana General Assembly, but Debs became increasingly disenchanted with capitalism. Converting to socialism, he was that party's candidate for president five times, gaining most of his votes while again jailed by the government in 1920 for criticism of the 1918 Espionage Act.

Debs's North Eighth Street house is now a National Historic Home in the historic section of the near downtown. Over time, he became recognized as a humanitarian and writer, but in the turn-of-the-century days of labor unrest, less complimentary words were used to describe him.

Like the labor unions, Vigo County has had its difficult times. Terre Haute, French for "high ground," was founded in 1816 and became the county seat in 1818. Located on the Wabash River, it grew, especially when the National Road came through and later the railroad. However, city progress seemed variable. Businesses would come and businesses would go. The discovery of coal brightened the picture but the new city of Gary became the steel capital. Into the twentieth century, Terre Haute frequently suffered from high unemployment and loss of population. A reputation for gambling and crime didn't help.

Today, the economic situation has improved. A dozen Wabash Valley plastics companies employ about 4,000 workers and Terre Haute is among the top four Indiana cities in plastics production. Bemis is the largest printed polyethylene plant in the world. Applied Extrusion Technologies, Inc. operates the world's largest polypropylene films location. Ivy Hill Packaging is the country's largest producer of folding cartons for the software industry. Digital Audio Disc Corporation came to town in 1984 as Sony's only American plant for compact discs. Clabber Girl Baking Powder and Columbia Records are longtime city industries.

The 800 buildings of the Farrington Grove Historical Residential District are listed on the National Register of Historic Places. The Vigo County Historical Museum is part of this district. Near downtown is the E. Bleemel building, site of one of western Indiana's earliest existing breweries. Along the river is the home of Paul Dresser, who wrote Indiana's official song, *On the Banks of the Wabash, Far Away,* and Theodore Dreiser, the novelist who, unlike his brother, did not Americanize his name. The Fowler Park Pioneer Village, south of Terre Haute, holds an annual festival at its log cabins and shops.

Terre Haute has four higher education institutions: Indiana State University; Rose Hulman Institute of Technology; Saint Mary-of-the-Woods College, the nation's oldest Catholic liberal arts college for women; and Ivy Tech State College, which has a branch south of the city.

The courthouse was completed in 1888. On its northeast corner is the Soldiers and Sailors Monument at the spot where Union Army enlistments were made. A Vietnam Memorial is on the southwest corner, while a World War II jet fighter has been placed on the southeast corner.

The county is named after a naturalized American citizen, Francis Vigo, who aided George Rogers Clark against the British in the Revolutionary War.

"The stately courthouse in Terre Haute is a familiar sight in Vigo County. I was impressed by its size and complexity. I wanted to study the light and its effect on the building. I got up early before the sun was up and watched as the light and shadows changed. As the sun rose there was a brief time when the structure was half in the sun and half in shadow. The warm, sunlit courthouse against the cool sky color was well worth the wait."

RONALD MACK
"Vigo County Courthouse"
Oil on canvas 24 x 30 inches

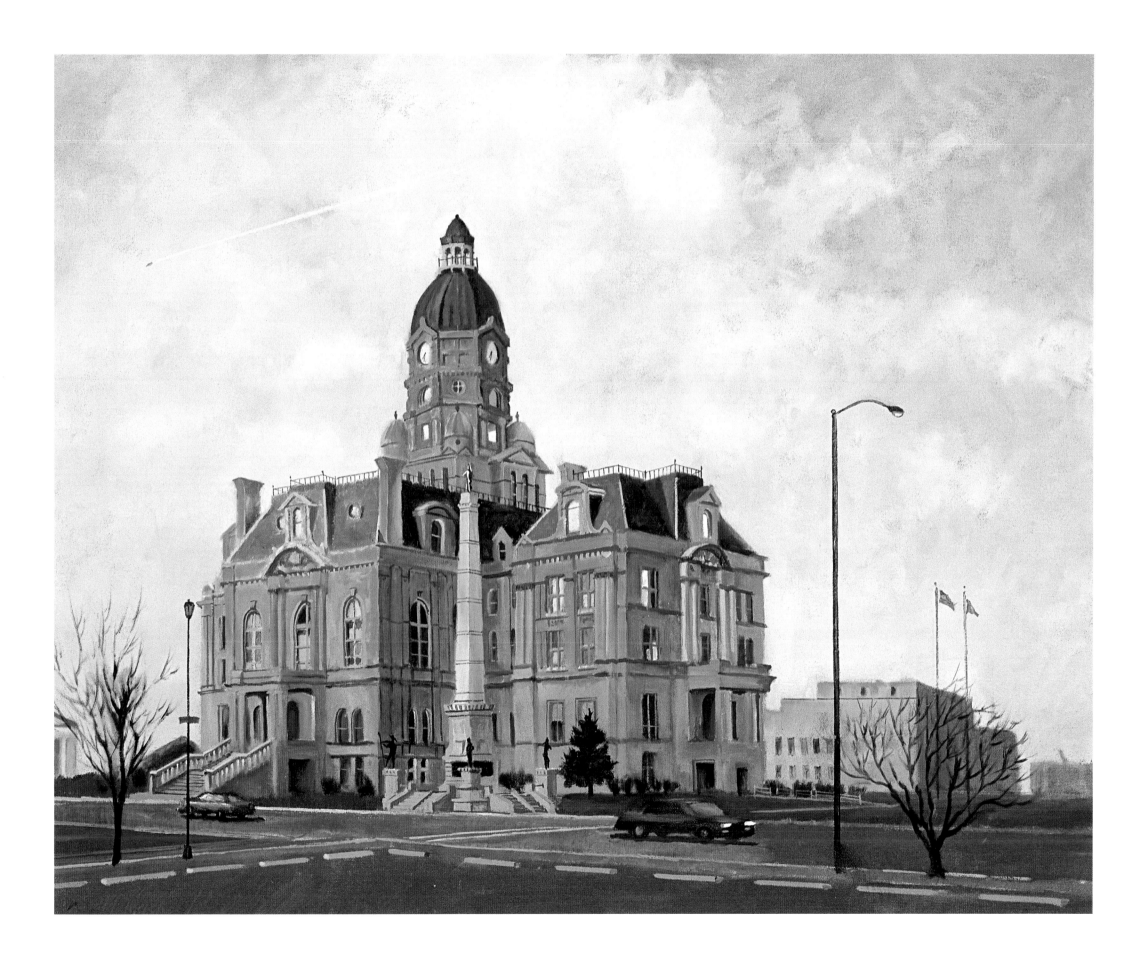

WABASH COUNTY

It was a late March evening in 1880 when the lights came on. Four powerful carbon arc lamps, mounted on top of the courthouse set high on a hill in downtown Wabash, sent beams of light that could be seen for blocks, lighting up what there was of the town. In so doing, Wabash became the first electrically lighted city in the world. One of those first lights has been preserved and placed in the courthouse foyer. A historical marker at the courthouse commemorates the event.

Both the city and the county are named for the Wabash River, one of four rivers which passes through the county and contributed to its settlement by Indians and later by white settlers attracted

to its farmland. The Wabash goes through the county, east to west, while the Mississinewa and Salamonie rivers both have been dammed by the Corps of Engineers to create two large reservoirs in the southern part of the county. The two reservoirs and their adjacent land areas each contain more than 16,000 acres. The Eel River crosses the northwestern corner of the county.

White settlement of present-day Wabash County came after Colonel John Tipton had negotiated the Treaty of Paradise Spring at today's Wabash in 1826. This treaty with the Miami and Potawatomi nations opened land in northern Indiana and southern Michigan. Frances Slocum, a young white girl who was kidnapped in Pennsylvania by the Miami Indians and who adopted tribal ways and an Indian husband, remained in nearby Miami County until her death in 1847. She was reburied in Wabash County after the Frances Slocum Cemetery was moved there because of the Mississinewa Dam construction.

Wabash County was established in 1833 but not organized until 1835. The Wabash and Erie Canal reached Wabash County in the mid-1830s and spurred economic growth. As happened all up and down the canal, it soon fell into disuse with the advent of the railroads. Remnants of canal locks still exist in the county, the most accessible being the Kerr Lock near Lagro, east of the county seat. The first railroad through Wabash County was built in 1856, roughly following the route of the canal. In fact, in the city of Wabash the canal was filled in and the railroad tracks were built over it.

Honeywell, manufacturers of heating equipment early in the twentieth century and later of thermostats, was for years the best-known county employer until it relocated. The Honeywell Memorial Community Center complex is the cultural center for the county with a wide range of conferences and programs. The Honeywell home in Wabash, now owned by Indiana University, houses French artifacts, collected by Eugenia Honeywell.

As in other Hoosier towns, early automobiles were built in Wabash, including the Champion, the Rettig, and the Service Motor Truck. The General Tire Company purchased the motor truck company's plant in the 1930s. The DeWitt automobile was built in North Manchester.

North Manchester is the second major town in Wabash County. It is the home of Manchester College, founded in 1860 as Roanoke Classical Seminary and relocated in 1889. It was the first American college to establish a peace studies curricular program. Andrew Cordier, assistant secretary general of the United Nations, and Paul Flory, winner of the Nobel Award in chemistry in 1974, are two of its graduates.

Thomas R. Marshall, born in Wabash, became Woodrow Wilson's vice president in the 1912 and 1916 elections. The family of author Gene Stratton-Porter lived south of Lagro and their farm is where she spent her childhood. Members of the family are buried in a nearby church cemetery.

"The first time I saw this street scene as we drove into Wabash, I was excited to paint it but the lighting was just not right. Dottie and I spent the day driving through the county and saw several tempting landscapes, but I kept going back to this scene. The old buildings with interesting rooflines reminded me of the movie **Oliver** *with its old English architecture. The steep hill and the evening light creating long shadows across the street added a certain mystery."*

RONALD MACK
"Wabash Street"
Oil on canvas 24 x 36 inches

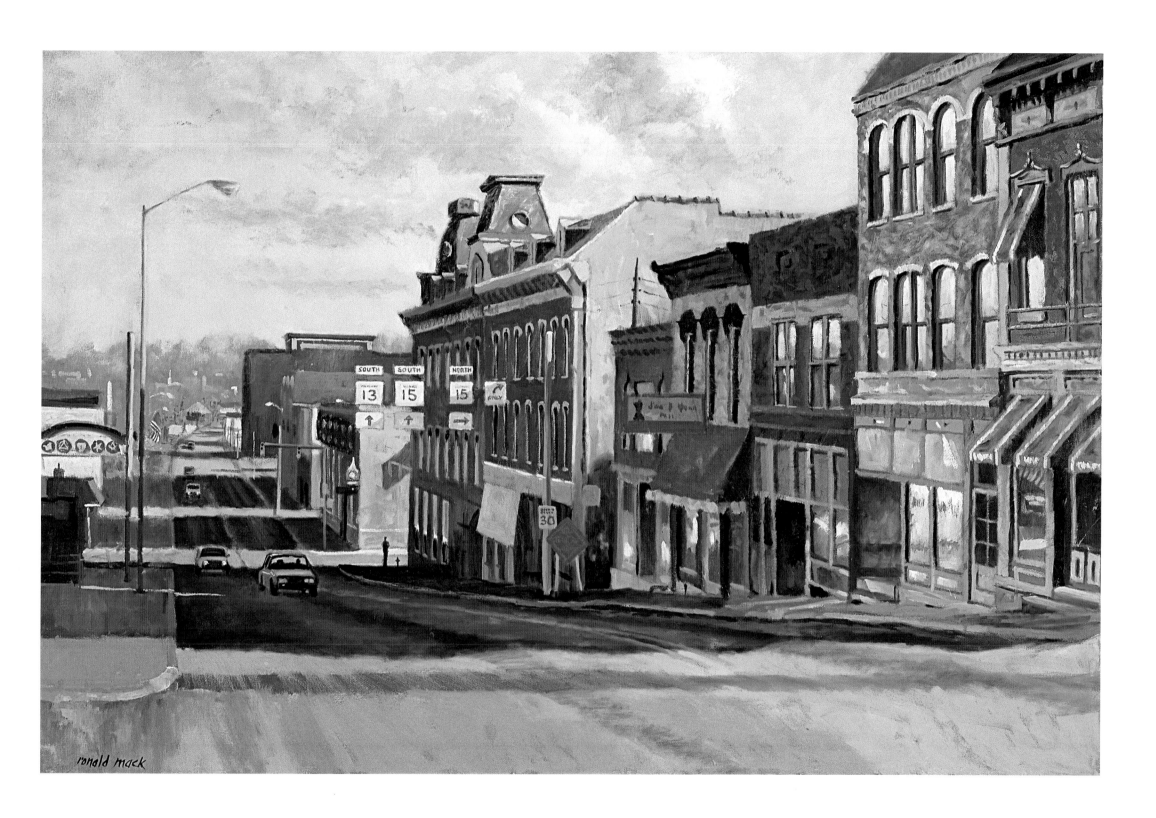

WARREN COUNTY

Williamsport Falls is known as Indiana's highest free-flowing waterfall. A loud roar can be heard in the downtown area after a heavy rainfall when the Fall Creek banks are full and cascading water falls about ninety feet into a sandstone gorge below. A gazebo has been erected high on the side of the Fall Creek Gorge opposite the falls where a panoramic view is visible. At certain times, when it has not rained for a while, visitors may be disappointed to find just a trickle of water going over the falls. Even then, however, the unusual rock formation, developed over the years by the flowing water, is of interest.

While the falls need a rainfall to be at their best, the opposite is true for the Fall Creek Gorge Potholes, northwest of Kramer. Water from melting glaciers running over sandstone began the creation of this small gorge, a steep-walled canyon. The potholes are almost circular openings in the sandstone bed of the canyon, more visible when the water is low. The area was purchased by the state at the end of the twentieth century to preserve its rock formations, creek beds, and rare plant species.

The Paul Dresser Bridge crosses the Wabash from Williamsport over into Attica in Fountain County. The stone piers of an earlier bridge are still in the water to the north. Dresser enjoyed the supposedly restorative powers of the mud baths at the Mudlavia Spa and Mud Bath Resort at Kramer. The belief is that he drew his inspiration for the official Indiana song, *On the Banks of the Wabash, Far Away,* while traveling to the resort in 1897. Today the resort is in ruins but water from the mineral springs is still commercially bottled and shipped.

The Wabash forms the entire eastern boundary of the county which lies against the Illinois border on its west. Williamsport is also the county seat. William Harrison had the town platted in the late 1820s and it was first known as William's Port.

The courthouse, the county's fifth, was built in 1908. Nearby is the Warren County Historical Society Museum. A number of buildings more than a hundred years old are in Williamsport, including the Tower House, an Italianate villa constructed in 1854. Other buildings include an 1840s shingled house along the riverfront; the Old High Inn, a Federal-style sandstone, built in 1851 with three front stairways; and the 1890 Presbyterian Church, used until the 1960s, which has its original stained glass windows and is being historically restored.

In the northeastern part of the county is the Mound Cemetery, north of Chatterton, believed to have been developed prehistorically by the Mound Builders. To the east is the 432-foot-long High Bridge, which spans Little Pine Creek sixty-five feet below.

Upriver from Williamsport lies the town of Independence, where it is believed that Zachariah Cicott, a French-Canadian fur trader, was the first white settler to come into the county. Later, he was in William Henry Harrison's army as a guide at the Battle of Tippecanoe. He is buried in Independence Cemetery.

The county is named for Joseph Warren, who was a commander at Breed's Hill in the opening days of the Revolutionary War. Wounded in action at the battle, he later died from the wounds. The county was formed in 1827. It covers 368 square miles and has a population of slightly less than 9,000.

"The people at Independence were very friendly and interested in the painting activity. One person wanted to commission a painting of his house and pond, but I told him I would be too busy with the Painting Indiana project."

DON RUSSELL
"Wabash River at Independence"
Oil on linen 16 x 20 inches

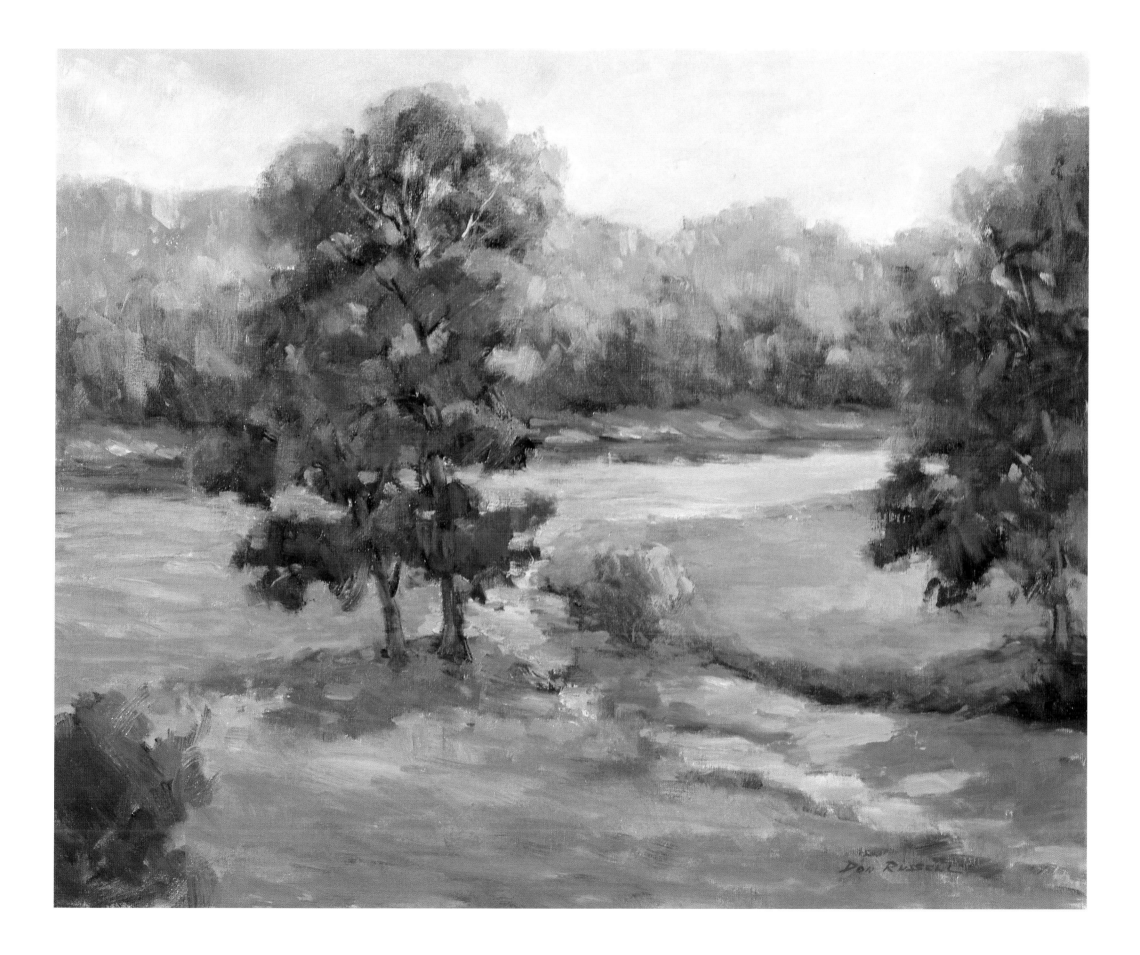

WARRICK COUNTY

The raid is said to have lasted only four hours. The invaders were properly called a guerrilla band rather than an army. On July 18, 1862, this group of Southern sympathizers from Kentucky crossed the Ohio River at Newburgh and briefly captured the city—the "first town north of the Mason-Dixon line to be captured by the Confederate forces during the War Between the States," according to a historical marker.

Only a few hours later, having confiscated supplies and ammunition, they retreated back across the river. They got away just before armed county residents and two boatloads of militia from Evansville arrived. During the seizure of Newburgh, not a shot had been fired.

John Sprinkle is credited with being the first white settler in today's Warrick County in 1803. This settlement, then called Sprinklesburg, became Newburgh in 1837. Newburgh profited as a river port in its early years, but when the railroads bypassed the town in the mid-1800s, Evansville, eight miles to the west, soon surpassed it as an important river city.

Today, the town is a prominent destination for tourists with its riverfront and older buildings and shops. Among them are the Cumberland Presbyterian Church, started in 1851 and, since 1965, the Newburgh Town Hall; the Newburgh-Ohio Township Public Library, built in 1897 with a Carnegie-financed northeast wing added later; and a number of homes built in the mid-1800s, including the oldest Newburgh brick house, built in 1839 by Henry Weiss.

On the river are the Newburgh Locks and Dam with the locks along the Indiana side. The upper river pool maintained above the dam extends upstream for about fifty-five miles to the Cannelton Locks and Dam. The gate section of the dam is more than 1,150 feet long with each gate 110 feet long and thirty-two feet high.

Boonville is the county seat and the county's largest town. Its progress was stimulated by the arrival of the railroad in the 1870s. It is named for Ratliff Boon, a cousin of Daniel Boone. He served in the territorial legislature, Indiana's General Assembly, the U.S. Congress, and as the state's lieutenant governor.

When the Lincoln family lived in southwestern Indiana, young Abraham is said to have walked from his family's farm into Boonville to borrow books from his lawyer friend, John A. Brackenridge. Lincoln lore has it he also would go to the courthouse when he could to watch his friend during trials.

The Warrick County Museum is on the second floor of the Ella Williams School building, which served as an elementary school until 1976. Renovated in 1986, its museum rooms include collections on war and peace, fine arts, stitchery of early fashions and home items, a Victorian parlor and nursery, an old-time kitchen, and a schoolroom.

Scales Lake Park, operated by the Warrick County Department of Parks and Recreation, is located northeast of Boonville as a family campground. The sixty-six-acre lake provides swimming and fishing while the park area offers camping, horseback and bicycle riding, hiking, picnicking, cabins, a playground, and a petting zoo.

Coal mining has long been an economic staple for the county. Its major manufacturer is the Aluminum Company of America, which constructed its Warrick Works in 1958.

Warrick County is named for Captain Jacob Warrick, who died in the Battle of Tippecanoe on November 7, 1811. The county was first organized in 1813 but its final boundaries were not determined until 1852 as new counties were created in southwestern Indiana.

"As I was driving through Warrick County on a beautiful, clear Indiana fall day, I felt I could see forever. The hay bales in the field created an idyllic scene of Indiana, and I knew I had to paint it. I have always loved Monet's paintings of grain stacks, and I wanted to try a painting using hay bales reflecting shimmering pastel light. The random pattern of light and shadow, tossed on the golden plain, begged to be captured on canvas. I liked the rounded shapes of the hills, trees, and hay rolls, lying heavily in the fields against a gorgeous sky. Warrick offered many lovely views of unspoiled Indiana. An artist could spend a lifetime there painting fields, hills, and trees."

ROBERT EBERLE
"Indiana Gold"
Oil on linen 14 x 20 inches

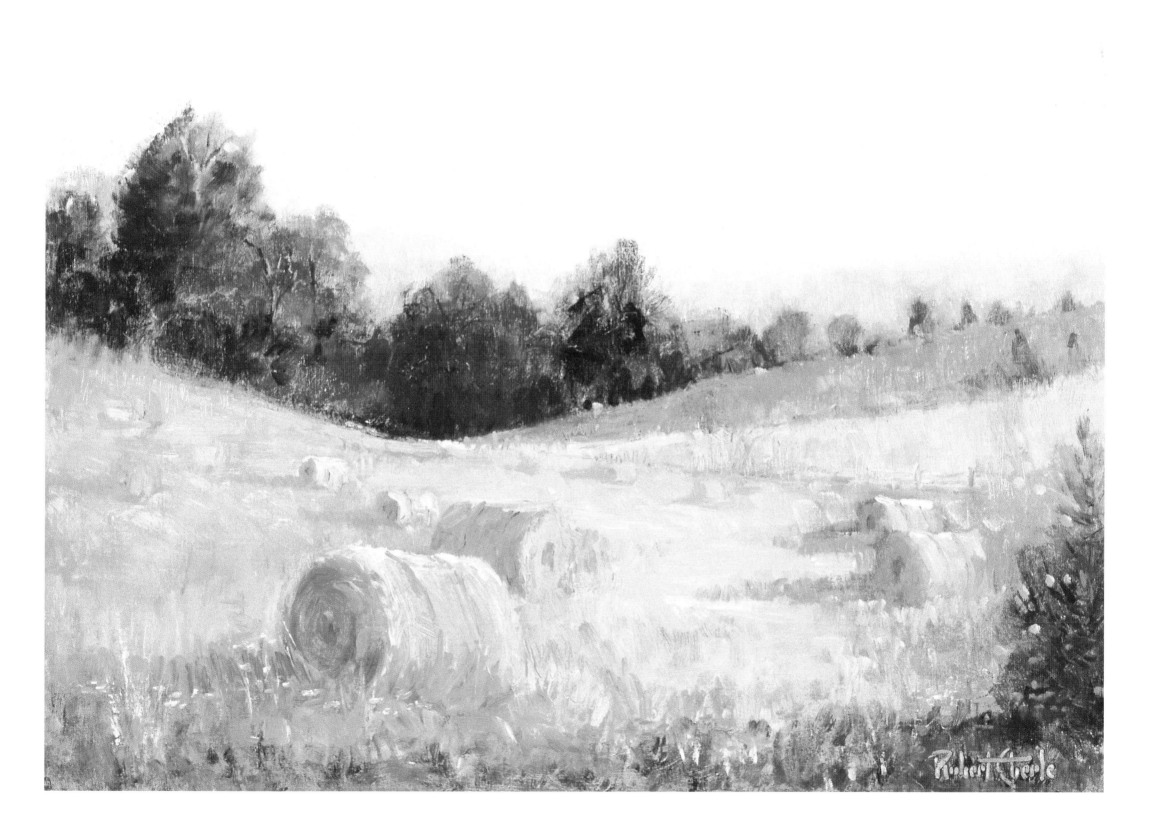

Robert Eberle

WASHINGTON COUNTY

When the commissioners met at the cabin of William Lindley to decide where to place the county seat for new Washington County, they looked at various sites before settling on land along the Blue River near the center of the county. Then came the question of what to call the soon-to-be-town. Local lore has it that, because Mary Lindley had been such a gracious hostess and served excellent meals to the commissioners, they responded to her suggestion. Salem it would be in honor of Salem, North Carolina, from whence the Quaker Lindley family had moved in 1809.

The county was formed in December 1813 from parts of Harrison and Clark counties. The Quakers from North Carolina were the largest group of settlers in the Salem area. As the new county seat, Salem was doing well until a cholera epidemic hit in 1833. Because of fear the disease would strike again, businesses closed and for several years, few newcomers arrived.

Dr. Charles Hay was a physician who stayed through the epidemic. He tended to victims while losing a son and a brother-in-law. Five years later, another son, John Hay, was born. The family moved to Illinois when John was a young boy. There, John worked for his uncle, who had a law practice in the same building as Abraham Lincoln. When Lincoln became U.S. president, Hay went to the nation's capital as Lincoln's private secretary. Later he became a well-known author and diplomat as well as secretary of state in the administrations of William McKinley and Theodore Roosevelt.

A focal point in Salem today is the house where Hay was born, the Stevens Memorial Museum, and the Pioneer Village, all of which make up the John Hay Center. The small brick house where Hay was born had earlier been the Salem Grammar School, founded by John I. Morrison. Morrison went on to become an Indiana University professor, a member of the 1850 state constitutional convention, and state treasurer. The Stevens Museum was constructed in 1970 as a memorial to the community's earlier settlers. It was built of native brick from other local historic buildings. Additions were made in 1984 and 1995. It features old-time dentist and law offices as well as local historic relics. The Pioneer Village, reconstructed to be an 1840s village, includes a log cabin, a warming house, a general store, a jail, a blacksmith shop, a carpentry house, a church, a schoolhouse, and a loom house.

George Brock was the first settler to live in the Salem vicinity, arriving in 1808. Others, including his son and sons-in-law from Virginia, had settled for a time in Kentucky but came across the river, joining him in and around present-day Salem.

The county's first courthouse was built in 1814 along with the first jail, constructed by Marston Clark, cousin of George Rogers Clark. The present courthouse was built in 1888.

Salem was briefly captured by Confederate General John Hunt Morgan in July of 1863 in his raid across southern Indiana. In town for less than a day, Morgan's raiders took what they could, burned the railroad depot, and moved on toward Ohio.

Salem's town fathers had earlier noted that the town needed a railroad for progress, so they worked out an arrangement with New Albany businessmen to construct the thirty-mile New Albany and Salem Railroad. The first passenger train arrived in 1847 and by 1854 the track ran to Lake Michigan. Later it became the Monon and in 1971 merged with the Louisville and Nashville Railroad.

The county is named in honor of George Washington, commander of the Continental Army and first president of the United States.

"There is no question why I chose this subject. It was in the morning when I saw the hot yellows and reds of this house against the cool, dark trees in the background, and it immediately caught my attention. It made such a wonderful composition. I later discovered that this was the birthplace of John Milton Hay, who was secretary to Abraham Lincoln. Mr. Hay was also a noted author, statesman, and diplomat."

RONALD MACK
"Back Porch"
Oil on canvas 16 x 20 inches

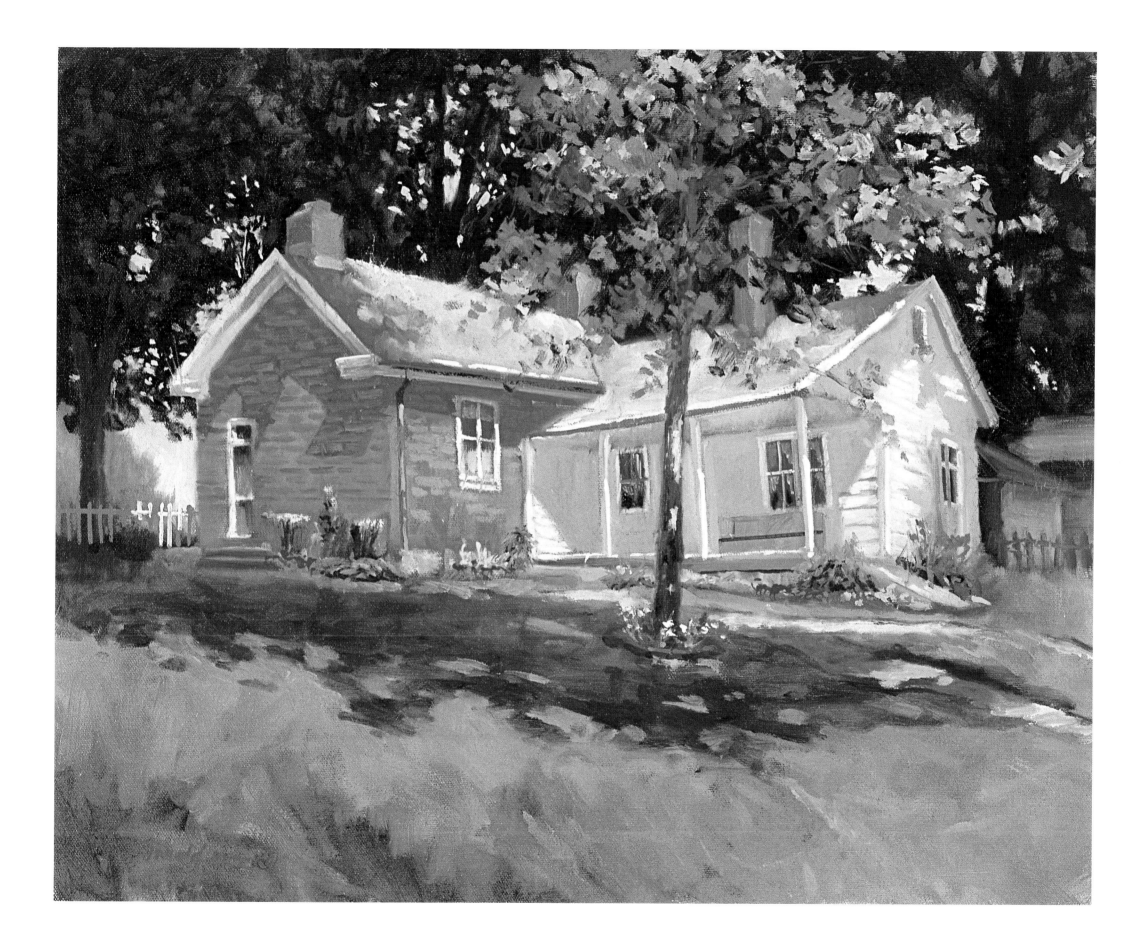

WAYNE COUNTY

While Indiana was building canals in the 1830s, the federal government was building the National Road from Cumberland, Maryland to Vandalia, Illinois. Indiana's canal system never quite lived up to its promise and, indeed, within thirty years, was no longer in use. The National Road almost suffered the same fate.

The National Road came into Indiana at Richmond in 1829. By 1834, it had been completed across the state. "Completed" is a relative term—not a macadamized, smooth road as we know today, but rather a rough clearing through dense forest. "Impassable, hardly jackassable," one critic noted. Still, over the next thirty years, an estimated 90,000 settlers came into Indiana each year using the road with Richmond as their town of entry.

Then the National Road fell victim, too, to the railroads. Trains provided faster transportation, especially important for perishable goods. In many places, the road became merely a dirt track used locally. It was saved by yet another mode of transportation—the automobile. By the 1920s, the National Road had been renamed U.S. 40 and was a major east–west route through the Midwest. By the 1960s, Interstate 70, usually running within a few miles of U.S. 40, had, in turn, become the more important long distance highway.

Much of the history of Richmond, the county seat, and Wayne County has been tied to the road and its migration patterns. Quakers from North Carolina—the first of them being David Hoover in 1805—were early white settlers in these Whitewater River lands.

Other Wayne County towns developed along the National Road—Centerville, Pennville, East Germantown, Cambridge City, Mt. Auburn, and Dublin. Near Cambridge City is the Huddleston Farmhouse Inn Museum, where John and Susannah Huddleston provided meals and shelter for travelers and feed for their horses. To the north of Richmond, Quaker Levi Coffin established his Underground Railroad station at his home at Newport, today's Fountain City. An estimated 2,000 escaping slaves passed through the Coffin house in a twenty-year period.

All along the road are historic houses from the National Road days. Federal-style architecture dominates the Richmond Historic District and Centerville. Greek Revival is prominent in Cambridge City and also in Richmond. Queen Anne architecture can be seen along East Main Street in Richmond.

While Richmond joined other Indiana cities in producing automobiles during the early twentieth century, it is the only place in which car production also started up in 1939. Powell Crosley Jr. of Cincinnati built a small car, the Crosley, at his Richmond plant. The two-cylinder car was ten feet long and had a four-gallon fuel tank. Crosley made his cars again after World War II but soon suspended production. At neighboring Hagerstown, automotive innovator Ralph Teetor invented cruise control in 1945.

Richmond is the home of Earlham College, a Quaker liberal arts college. Its Joseph Moore Museum of Natural History has the first complete mastodon skeleton in the nation, found in a field in Preble County, Ohio in 1895.

The Wayne County Historical Museum in Richmond occupies a former Quaker meetinghouse and on its grounds has a pioneer general store, an 1823 log cabin, a loom house, and blacksmith, cobbler, and apothecary shops.

Wayne County is named for General Anthony Wayne, known especially for his victory in the Battle of Fallen Timbers near Toledo in 1794.

"I walked a great deal one day in Richmond, an interesting old city with a very unique courthouse and early Indiana architecture. I wanted to paint something from an era past, as it stands today. The area of town I painted is part of the oldest section of Richmond. The well-tended houses were built with artistic character and have a real charm."

LYLE DENNEY
"A Street in Richmond"
Oil on canvas 18 x 27 inches

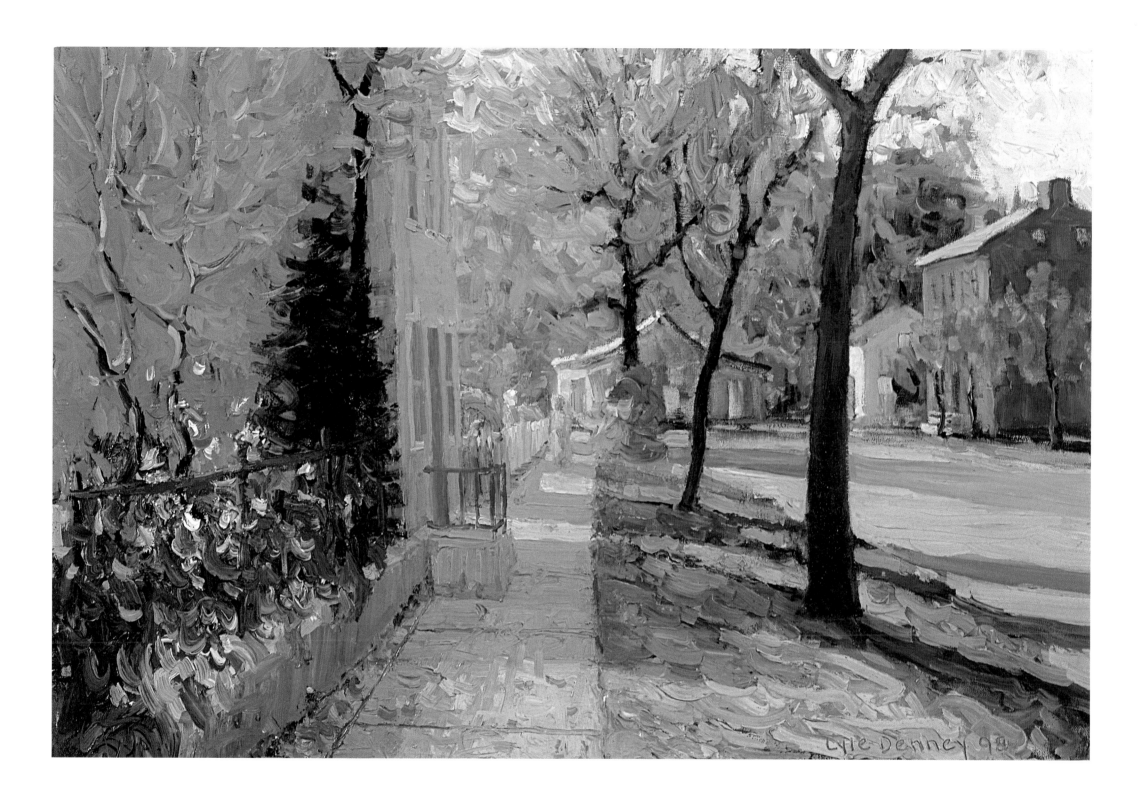

WELLS COUNTY

Nestled in between the Wabash River to the south and County Road 100 to the north is the 1,104-acre Ouabache State Park, modernized since its days as a state forest and game preserve to become both a quiet respite and a recreational playground. Ouabache—the Native American word commonly pronounced "Wabash" but locally sometimes pronounced "o-BOT-che"—has been a state park since 1983.

In the 1930s it was the Wells County State Forest and Game Preserve and had deteriorated to an eroded and timberless land. Then the Civilian Conservation Corps and the Works Progress Administra-tion went to work. Their programs of land management, reforestation, nursery plantings, and buildings and shelter construction helped bring the area closer to its natural state.

As a game preserve, the emphasis was on raising pheasants, quail, raccoons, and rabbits. In the 1950s, it was one of the largest producers of pheasant and quail chicks in the nation. Today, an Olympic-sized swimming pool, modern campgrounds, picnic areas, boating, fishing, tennis and basketball courts, playing fields, and a trail system make the park a retreat from the busyness of modern times.

Another favorite is the asphalt trail, which is accessible at the park entrance gatehouse and connects with the Rivergreenway Trail that follows the Wabash River to Bluffton. The ten-foot-wide path is five miles in length and is used by walkers and bikers. In addition to the Wabash, the Salamonie River crosses the southwestern corner of the county.

The county seat, Bluffton, was named in 1838 because it stands on a bluff at a bend in the Wabash River. It was selected in a three-to-two vote by commissioners over Murray, now a small community to the northwest. Its first settlers were Abraham Studebaker and family members from Darke County, Ohio. Earlier, Dr. Joseph Knox established the first settlement in what was to become Wells County at Murray, which at that time was called New Lancaster. Bluffton was not chartered until 1851.

The county's first courthouse, a log cabin, was completed by 1840. It was replaced by a brick building in 1843, but the court condemned it in 1888. The present courthouse, a four-story building with a 140-foot tower, was constructed in 1891. The Wells County Museum in Bluffton is located in the Victorian home built in the early 1880s by Alvin Stewart. It was sold to John Studebaker in 1892 and he lived there until his death in 1912. From the late 1920s until 1974, it was a funeral home. In 1974 the Wells County Historical Society purchased the house for use as a museum.

The population estimate in 1996 was 26,651 for the county, an increase of 2.7 percent over the 1990 census. Estimated population of the county seat was 9,500. Ossian was the second largest town in the county with a 1996 population of 3,000.

While agriculture utilizes most of the county's acreage, major manufacturing includes electric motors, fiberglass, automotive parts, rubber products, and snack foods, food processing, and distribution. The largest employer, however, is in the medical field: the Caylor-Nickel Medical Center and the Wells Community Hospital.

Wells is named for Captain William Wells, who was captured by the Miami when he was fourteen and fought with them in the 1790s. Later, he became a scout for General Anthony Wayne and died in the Fort Dearborn (Chicago) massacre in 1812. The county was created in 1835 from parts of Allen, Delaware, and Randolph counties and organized in 1837.

"Wells County is farm country and that's what the painting had to represent. How do you do an interesting painting of something you see so often that you take it for granted? All I had to do was find the right elements . . . easier said than done. I traveled for hours up and down country roads considering grain elevators, farmhouses, barns, and farm equipment. A farm field can be very interesting when you have the right trees, the right buildings and silos, the right sky, and the right time of year. I did struggle with this painting. I painted it over and over until everyone who saw it said 'Don't touch it, it's great.' Now I agree."

DAN WOODSON
"Finished Harvest"
Oil on canvas 16 x 30 inches

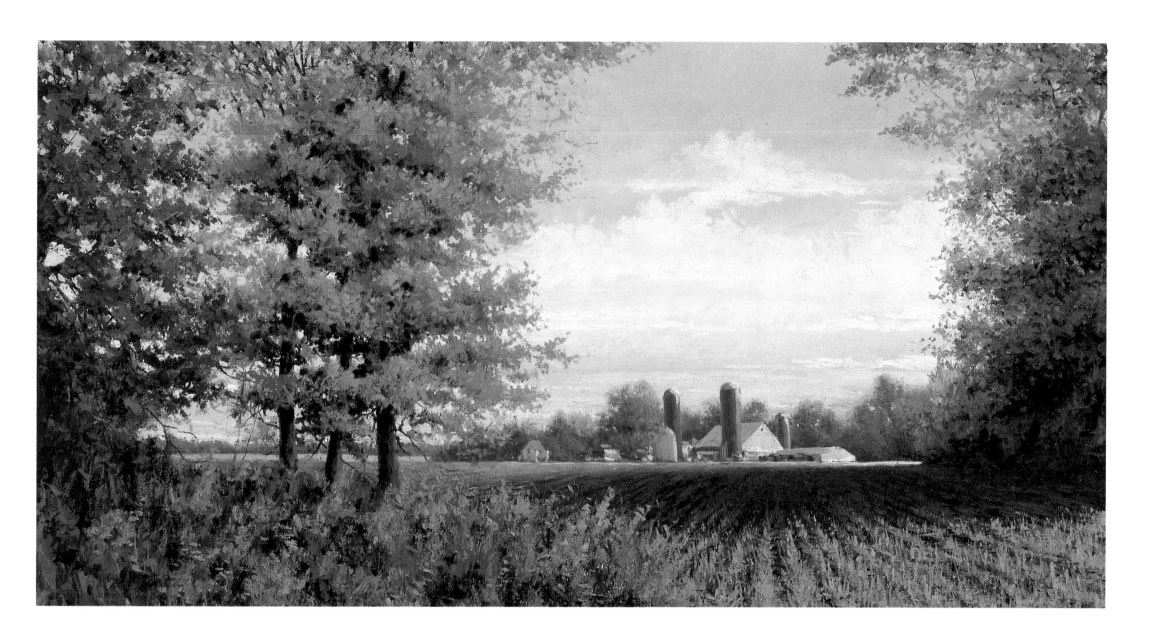

WHITE COUNTY

Two transformative events occurred in White County in the twentieth century, one created by man and the second by nature.

In the early 1920s, Norway Dam was completed on the Tippecanoe River, creating Lake Shafer north of Monticello, the county seat. In the mid-1920s, Oakdale Dam, south of Monticello, created Lake Freeman, which is shared with Carroll County. The dams were built by the predecessor of today's Northern Indiana Public Service Company to provide hydroelectric power. The two lakes, each with about 1,400 acres of water and fifty miles of shoreline, established Monticello and White County as a major summer resort area.

A longtime Lake Shafer feature has been the paddlewheel-driven Shafer Queen, which takes daily trips around the lake. With Indiana Beach on Lake Shafer, a privately owned resort with water park, amusement rides, and entertainment in addition to the usual water activities, the area has become one of northern Indiana's biggest tourist attractions. An estimated 700,000 people visit the area annually.

The second event occurred April 3, 1974, when a tornado swept through Monticello. It destroyed homes, schools, and much of the downtown, including the three-story Bedford limestone courthouse with its clock tower that had been built in the mid-1890s. Damage was estimated at more than $100 million. Over the years, Monticello has rebuilt. A modern government building now serves the county where the courthouse once stood. New homes and schools have replaced structures devastated by the tornado. One reminder of that day is the bell from the courthouse tower, which has been placed under a protective arch on the courthouse square.

The first settlers came into the Monticello area in 1829. In 1834, the state legislature created the new county out of part of Carroll County. Later Benton, Jasper, Newton, and Pulaski counties were created out of White County. The county reached its present size in 1840. Monticello was platted in 1835 and by 1849 the first dam had been built across the Tippecanoe to harness its power for a grist mill. A saw mill, a woolen mill, and a furniture factory followed.

As elsewhere in Indiana, the arrival of railroads made a significant difference. The Louisville, New Albany, and Chicago line was the first to come into the county. Monticello had its rail station when the Logansport, Peoria, and Burlington railroad came through.

The White County Historical Society occupied the former Carnegie Library building, when a new library building opened in 1992. Previously, a museum was located in the courthouse. It includes a clothing collection dating back to the 1850s, farming implements used over the past century, a 1918 schoolroom, Indian artifacts, a Hoosier kitchen, and White County records and memorabilia.

Perhaps the best-known historic landmark is located in western White County at Wolcott, the home of the town's founder, Anson Wolcott, a successful New York lawyer, businessman, and later a land speculator. He platted the town in 1861 and built his mansion during the 1860s, completing it after the Civil War. The house was given to Princeton Township by an Anson grandson in 1956.

Farming remains the major commercial activity in the county. Corn, oats, soybeans, and wheat are the main crops.

The county is named after Colonel Isaac White, who died in the Battle of Tippecanoe. The county seat is named after the Virginia home of Thomas Jefferson.

"We intended to find a subject for White County at Indiana Beach in Monticello. Mrs. Davis, the owner, helped us immensely in our search, allowing us into the park and even arranging for us to ride the riverboat so we could find a workable view. But I just couldn't find a scene that would capture all the excitement and entertainment of the popular water park and inspire me at the same time. On a spring trip through the county, I happened to find a snow-covered wooded area along the highway. Pleased and excited, I saw a painting in it at first sight. Sometimes these old quiet areas speak to me loudly and my imagination creates its history."

DAN WOODSON
"Late Snow in White County"
Oil on canvas 16 x 24 inches

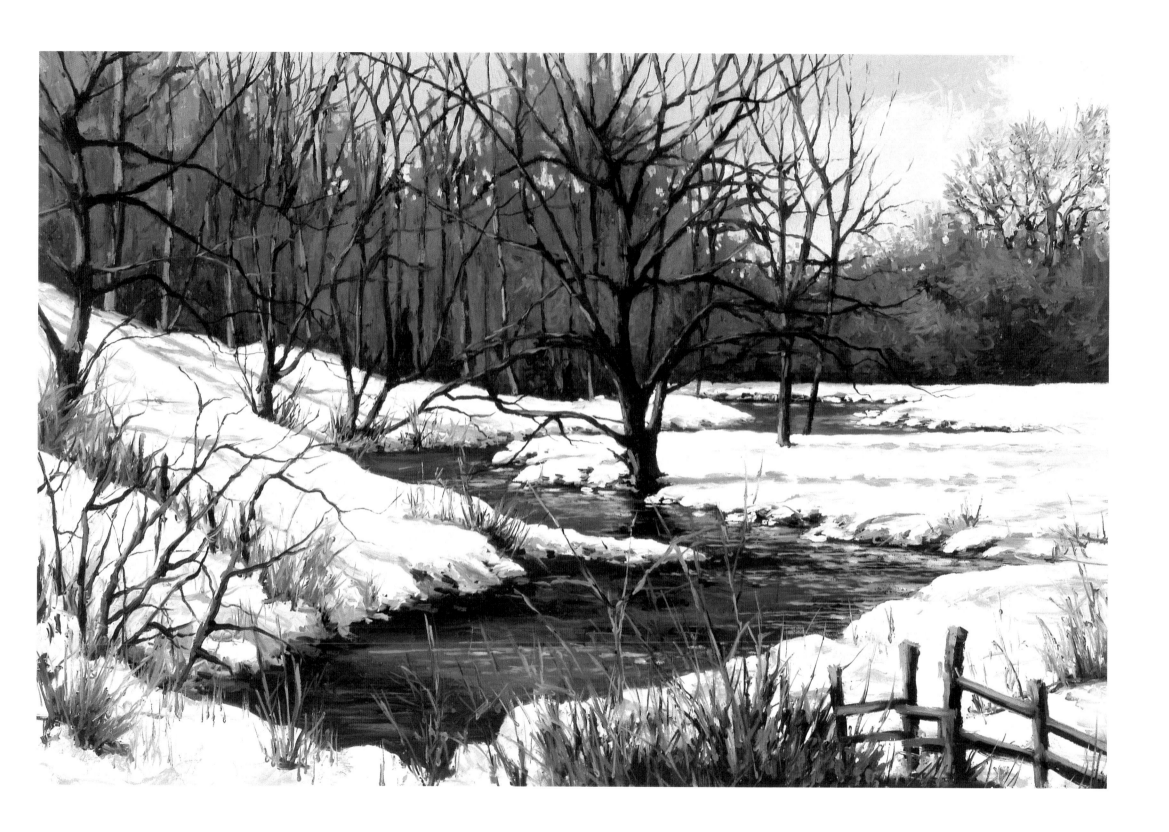

WHITLEY COUNTY

It's fitting that the final essay in a book of paintings from all ninety-two of Indiana's counties is about a county that has sixteen paintings depicting its history hanging in its courthouse. That county is Whitley and the courthouse is in Columbia City. The oil paintings, each nine inches by nine inches on canvas, have been individually framed and gathered in a composite frame that includes, in its center, a hand-lettered county map.

The county's early history is centered around the Indians of the area. Long before the white man came, the Potawatomi and Miami occupied the land, fishing and warring with other tribes. The great chieftain of the Miami, Little Turtle, was born about 1752 at the Miami village on the north bank of the Eel River, five miles east of present-day Columbia City. Today, a modern "village" of mobile homes is located along the Old Trail leading from Columbia City. A marker notes the birth and career of Little Turtle. His military victories over the white man included a massacre of U.S. troops in 1770; again a marker mounted on stone in a small clearing along De LaBalme Road tells of this event. Little Turtle later became an advocate for peace with the whites and died in Fort Wayne in 1812.

Long before the Indians, what is now Whitley County was buried beneath a thick sheet of ice. When the glacier receded, Whitley County had lakes, rivers, wetlands, flatlands, hills, and valleys. The deposits left were rich in drift soils, which, when drained, made excellent farmland. The county has twenty-eight lakes, ranging in size from Larwill's nine acres to Blue Lake's 239 acres. The combined acreage of the Tri-Lakes—Cedar, Round, and Shriner—is 395 acres. Eel River runs northeast to southwest through the county. The Collamer Dam, built in the mid-1800s to provide power for a milling company, is located in southwestern Whitley County. The site today is the Tapawingo Park.

Agriculture is a major enterprise in the county; however, manufacturing is also prominent. Major industrial production is in plastic automotive parts, machine parts, wire, and aluminum manifold castings.

Thomas R. Marshall, born in North Manchester, moved to Columbia City in 1875 to practice law. He was elected Indiana governor and then became Woodrow Wilson's vice president from 1913 to 1921. His Columbia City home on West Jefferson Street became the Whitley County Historical Museum, which has Marshall's belongings and records as well as other historic artifacts. Another Indiana governor, Ralph Gates, who served from 1945 to 1949, was also from Whitley County.

Columbia City was the birthplace of Lloyd C. Douglas, who became a well-known Lutheran minister but was even more widely known as an author. Two of his best-known works are *Magnificent Obsession* and *The Robe,* both of which later became major Hollywood motion pictures.

Whitley County was created in 1834 but depended upon Huntington County for judicial purposes until it was made an independent county in 1838. It is named for Colonel William Whitley, a Kentucky militiaman who was killed in the Battle of the Thames in the War of 1812.

The county seat was originally called Columbia until the post office notified officials that Indiana already had a town of that name. Columbia became Whitley and the southwestern county town of Whitley became South Whitley. Finally, in 1853, citizens voted to change the name again, this time to Columbia City.

The present courthouse is the third in the county's history, constructed in 1890. Earlier courthouses were built in 1841 and 1850.

"I had traveled to Whitley County several times and already had finished a painting, but I made one more trip to look for other scenes. Driving west on Highway 30, I glanced to my left and there it was—a beautiful old farm, nestled behind a creek in the trees. The Walter and Olive Schuman farm is well preserved and cared for with many quiet clues to the past. This scene would be a good subject in any season. I met Walter and Olive, and told them about the Painting Indiana project. I painted there two evenings with the sounds of an awakening spring around me. I love nature, wild and untouched, but I love more the places in nature that the hands of caring people have made for themselves. With an artistic touch, the changes are born out of human need, and no place says that like a farm."

LYLE DENNEY
"The Schuman Farm"
Oil on canvas 17 x 24 inches

Lyle Denney '91

Lyle Denney The underlying theme to Lyle Denney's life is passion. It can be found in his music through his mastery of the piano and five-string banjo, in his fondness for exploring nature while hiking, hunting, and fishing, and especially in his painting of the Hoosier landscape.

His introduction to oil painting came when he was a child. His uncle, W. Roy Denney, was a painter of the Kentucky landscape, and this exposure early in life set his future as an artist in motion. He received guidance and training during his high school years from his art teacher, William Zigler, who recognized and further developed his talent.

Lyle's impressionistic style is the result of years of painting the landscapes of his Indiana home. The works of the Hoosier Group artists T. C. Steele and J. Ottis Adams, American painter George Inness, and the French Impressionists Monet and Pissarro have greatly influenced his direction. Contemporary Hoosier artists, such as C. W. Mundy and the late Frederik Grue, also played a part in the development of his style and use of color.

The hallmarks of Lyle's work are the simple, small town settings he finds in Indiana and his use of color on canvas. For several years, he limited himself to the use of the three primary colors in his paintings, learning to mix and harmonize the tones of a complete scene. He currently uses as many as seven colors, mixed partly on the palette and partly on the canvas, and applied with broad and expressive brushwork.

He has had solo shows in Louisiana, where he made his home for a time as a young man. In Indiana, he has regularly received awards in the regional and state art shows in which he participates. One of his paintings won the People's Choice Award for Best of Show at the 1996 Hoosier Salon competition. Paintings for other juried exhibitions, including the annual Richmond Art Museum show and the Minnetrista Cultural Center's annual competition in Muncie, have been awarded for their artistic merit.

Lyle considers his talent God-given and painting from nature his call in life. He most enjoys painting the relationship of man to natural environments, "not just to paint the raw virgin forest made of God, but to paint the human touch."

His love of nature has been incorporated into all aspects of his life. He spends much of his free time outdoors, and his occupation as a mail carrier in the Muncie area also allows him to be outside.

He has found inspiration in books by Indiana authors such as Charles Majors and novelist and naturalist Gene Stratton-Porter. Reading these works as a child influenced his thinking on the natural world and its wonder. His admiration for Stratton-Porter and her Geneva home in the huge swampy area of northeast Indiana (then known as the Limberlost) was translated into one of his paintings for the Painting Indiana project.

Lyle's participation in this project marks a significant milestone in his creative growth. "Painting Indiana has been an experience that transcends words and description—all that I've done in art in my lifetime to the beginning of this project and all of the study I've made of the works of the great artists of the past could not teach me what I've learned while painting on location in eighteen counties this year. I am a changed person—I have found the thing I want to do in life . . . to be there, on location, painting people and landscapes with light and atmosphere, looking at life and finding its simplicity."

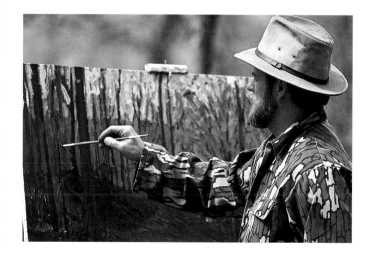

Robert Eberle

The images that Robert Eberle creates are markers along a lifelong artistic path. From the detailed work of his early years, he has grown in ability and understanding, and is now able to present not only the surface of a scene, but also the soul.

His gift has always been with him. Robert's ability, surfacing in junior high school, led him to Herron School of Art, through a career in commercial art, then to the Indianapolis Art Center and the Scottsdale Artists' School. His studies under Rosemary Lawton Thomas, C. W. Mundy, and others of great talent gave him invaluable technical skills and set him on an endless path of self-discovery.

Robert feels that creativity is an outgrowth of the experience of living, and art is apparent in every aspect of his life. The home he designed and helped to build—solar heated and partially underground—harmonizes with the earth around it, freely taking its warmth. Stained glass lampshades and panels adorn the interior as another expressive outlet. His studio is a creative environment all its own, brimming with great paintings and ideas.

Robert considers himself a perpetual student of growth, adaptation, and change. Through his painting, he has progressed to an understanding of the "poetry" of an image, manifesting itself through color, texture, application of paint, and interpretation. His impressionistic style captures fleeting moments in time, allowing the viewer to respond to the mood and the environment of that moment in a personal way. He admits the pursuit is sometimes frustrating: "There is so much that I envision; if only I had the skill to paint it all! But this frustration can be beneficial because it keeps me striving, hoping that the perfect scene, painted perfectly, is just over the next hill."

Robert joined the Painting Indiana project understanding its demands as well as its potential. He put aside other plans to take on the rigorous, time-consuming, and costly project, and considers the experience worthwhile. "No artist could spend a year traveling the state painting en plein air and solving the many problems that occur on site without learning much about light and shadows, equipment, techniques, and approaches. It has been a tremendous way to become more disciplined and focused. It has also allowed me to meet other artists and art mavens, to get public exposure, and at the same time, bring attention to this great state I live in."

Taking many roads less traveled, he has seen Indiana's beauty and has found a deeper appreciation for its history. His travels over the last year with his wife, Carol, have inspired a sense of pride and awe. He hopes that the project will convey this pride, showing not only what is happening around the state historically, environmentally, and economically, but also the diverse beauty with which Indiana is blessed. Through his paintings, it is easy to see his pride, concern, and love for the environment, and his exceptional talent.

Robert Eberle's work for Painting Indiana is a bright spot on his artistic path. He and Carol look forward to future travel in Europe, seeing for themselves the museums and painting the classical scenes on site. Added to a year's exposure to wonderful possibilities in Indiana, he will never run out of subject matter. Most of all, he will continue growing. "An artist never stops learning. That is what art is about: being a student, looking at things as if it were for the first time, with no preconceptions; being curious, seeing beauty in the way light affects things; learning how color and value evoke a mood; and seeing how a simple arrangement of objects can convey restful contemplation."

An active member of the art community, Robert is both student and mentor. Through his affiliations with the Hoosier Salon, Indiana Artists' Club, Indiana Heritage Arts, Inc. and the Indiana Plein Air Painters Association, he interacts with many local artists. Galleries displaying his distinctive work include Sigman's Fine Art, the Alliance at the Indianapolis Museum of Art, and Honeysuckle Gallery in Nashville. His numerous awards and honors are proof of his ability to convey his passion for the world around him on canvas.

This passion is expressed in his message: "Stop, take a deep breath, and look around this world we occupy. Sometimes it's chaotic, sometimes it's strange, and sometimes it is unbelievably beautiful. But always, like this artist, it is changing and growing."

Ronald Mack The painstaking discipline of a draftsman and the intuitive eye of an artist are at the heart of Ronald Mack's paintings. From his wonderfully detailed still lifes to his colorful and insightful response to the Indiana landscape, the union of the two disciplines is beautifully apparent.

Ronald has been a lifelong resident of southside Indianapolis. Inspired by the artistic ability of his older brother and championed by his father, Ronald's creativity was fostered early in his life. He majored in art in high school and attended classes at Herron School of Art. His studies at Purdue University Extension in architectural engineering prepared him for a thirty-eight-year career as a draftsman and design coordinator in engineering for Eli Lilly and Company in Indianapolis. From his work in drafting, he acquired the precise technical skills of interpreting what he saw and rendering them faithfully. Now ingrained and automatic, these skills serve him in the fine arts.

Several years into his chosen profession, the desire to develop his painting abilities surfaced. Studying with Rosemary Brown Beck, Foster Caddell, Margaret Kessler, C. W. Mundy, and other powerful instructors, Ronald has spent the last twenty-five years developing his talent in painting. He experimented with many media, found that he prefers oil painting, and now works in it exclusively. His efforts have produced brilliant and effective use of color and light in the traditional landscapes that he paints, both en plein air and in the studio/gallery at his home.

He is fascinated with color and its movement through his paintings. The use of complementary colors to emphasize or mute tonal qualities allows him to fill his scenes from nature with light and air. Increased sensitivity to the edges of objects creates more depth and draws the viewer's eye toward the center of interest. The results of his careful study are obvious—his landscape paintings, disciplined and contemplative, sing.

The still life paintings of Ronald Mack, for which he is also well-known, employ the same skills of precision and interpretation. His mastery of composition, understanding of light, and sensitivity to detail have produced many rich and wonderful studies. The lessons of color, reflections, and texture are equally alive in both his still lifes and his outdoor scenes.

The quality of his work has been confirmed by his many merit, purchase, and acquisition awards at the Hoosier Salon, Swope Gallery, Annual Wabash Valley Exhibition, Indiana Artists' Club, Indiana State Fair, Indiana Heritage Arts, Inc. and the Southside Art League. He has also been very successful in the sale of his works through the Hoosier Salon, the Center for Creative Arts and the Mack Gallery in Indianapolis, the Brown County Gallery and Museum in Nashville, and the Southside Art League in Greenwood. His membership in many art groups offers him constant communication with artists as well as art patrons. He teaches art classes at the Southside Art League, allowing him to pass along the learning that he has accumulated through his own training.

Ronald considers his participation in the Painting Indiana project a worthwhile challenge. Traveling the state with his wife of twenty-seven years, Dottie, he has explored many parts of the state that the native of Indianapolis might never have seen otherwise. His desire for perfection compelled him to travel to some of his counties numerous times to search for a subject or repaint a scene in a different light or season. His commitment is apparent in the nineteen paintings completed for the project. The pleasing views of Indiana are as diverse and colorful as Indiana itself.

Through his involvement, he has learned to spend more time developing his paintings, studying scenes for their compositional value, and even knowing when to start over. Rising to challenges and pressures has allowed Ronald to recognize the importance of his contribution to the project and to embrace the value of his own work.

With his work for Painting Indiana completed, Ronald's life will still be full. His never-ending artistic pursuits will undoubtedly provide him the excitement, adventure, and recognition upon which all artists thrive. Ronald will continue to grow, as all good artists do, with the simple goal of getting a good painting now and then.

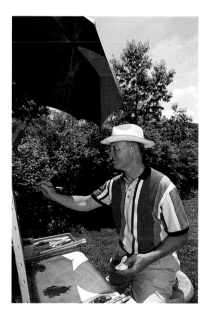

Don Russell

The landscape paintings of Don Russell—quiet, thoughtful, with a special light—are very much like Don Russell, the man. He is a prolific artist, regularly painting six days a week during his summers in Zionsville, Indiana. He slows the pace a bit in the winter in Florida, painting only eight to ten pieces. Florida, he says, just isn't as inspiring.

For twenty-six years, Donald E. Russell, M.D., worked as an orthopedic surgeon with Orthopaedics Indianapolis, performing surgeries at Methodist Hospital. Born in West Virginia, he graduated from the University of Pennsylvania, began his specialty training at Indiana University in 1964, and has been a Hoosier ever since.

In 1968, while in his residency at Indiana University, he visited the Indianapolis Museum of Art, then housed in the John Herron building. Inspired by the work of Jay Conaway, he decided that he would like to paint. He purchased art supplies at Harold Buck's store and was invited to take art lessons that Mr. Buck was offering. On call at the hospital on long shifts, he declined and set out to try on his own. After six months of experimenting alone, he knew the lessons would be beneficial. Accepting that it might take twenty years to reach real excellence, Don began what would be an extensive, lifelong education.

He studied with Indianapolis artist Adelee Wendell; then, after seeing the work of George Cherepov in a book, he went to Vermont to meet him and subsequently studied with him for over fifteen years. He received more training from Don Stone, the well-known New England watercolorist, and Bill Ashby, a teacher of portraiture and seascapes. The resulting friendship with Ashby led to annual painting trips to Monhegan Island in Maine for twelve years.

Of all his mentors, Don considers Cherepov the most influential. It was under his tutelage that he learned to see. If questioned about a color or value, Cherepov would answer "You can look," forcing his student to study the subject and find the solution himself. Through this teaching, Don became proficient at mixing color and interpreting the effects of light and atmosphere, skills he would implement throughout his artistic journey.

Don's work has progressed from the bright colors of his years with Cherepov to a more subdued color scheme. Being open to change has allowed him to continue growing. Consequently, he sometimes substitutes a different shade of one of his usual colors, or even limits himself to a palette of as few as five colors instead of the eight to ten with which he regularly paints. His willingness to alter his normal routine keeps his work fresh and ever changing.

Art has been a constant theme and a mainstay throughout his adult life. Expressing and reproducing light, capturing the mood of the day, and interpreting the dynamics of a chosen landscape allow him to become intertwined with the environment as he paints. His lifelong interest in theology, which nearly led him to study at the University of Chicago Divinity School before he began medical school, adds a spiritual element to his scenes. Plein air painting is his way of responding to all the finely tuned and delicately balanced elements of the natural world.

Don's travels throughout the United States have taken him east to Maine, New Hampshire, Vermont, and Connecticut; south to North Carolina and Florida; and to the western states of Wyoming, Colorado, Arizona, and New Mexico. In each new environment, he studied and painted the diversity of terrain and atmosphere. His first love, however, is the Hoosier landscape. In the nineteen paintings that he produced for Painting Indiana, he has captured the quiet and exquisite beauty that he found during his travels throughout the state.

Although his work has won numerous awards including Outstanding Oil and Best Landscape in Hoosier Salon competitions, his motives for painting remain personal. Painting is his opportunity for free expression and emotion, a satisfying and important part of his life. His goal is merely to continue to grow, change, and paint.

Donald E. Russell

Dan Woodson

Dan Woodson There has always been a great landscape painter in Dan Woodson, waiting to emerge.

By the time Dan was twenty-two, he had married, started a family, and served in the army during Vietnam. He found employment at a Muncie sign shop and that began his creative pursuit. C. J. Grice, one of the best sign artists in Indiana, became Dan's mentor. Through years of study and practice, he mastered the craft to a level that few achieve. In 1982 he designed an in-house sign facility for Marsh Supermarkets, and he has managed the department since that time. His artistic ability in design and construction of special displays and sign systems has earned a national award.

Throughout the years of raising and providing for his three children, his real desire was to be an "artist," beyond the skill he had achieved through his career in the sign business. Occasionally he would haul out his paint and brushes and try to copy paintings he admired. Works by Norman Rockwell, Monet, and T. C. Steele were studied, attempted, and then, in frustration, his paints were again put away.

Dan is color-blind, and that makes his journey more astounding and nearly unbelievable. He tells a story about trying to copy a Rockwell painting all night, only to have his son question him in the morning about the green dog. It was one of many obstacles he would overcome.

In 1993 Dan committed himself to landscape painting. Practicing after work, he studied the paintings of other artists, worked to understand their methods, and painted scene after scene in oil. He progressed quickly, drawing on the skills and discipline he had acquired through years as a sign artist.

Dan's formidable talent has made up for his lack of formal training and allowed him to develop, at his own pace, a truly original style. His color-blindness has become an asset that allows him to interpret minute tonal differences in landscape scenes that others, influenced by color, might overlook. Dan's overwhelming desire to paint has turned his weaknesses into strengths.

He often paints with a group of friends equally committed to landscape painting. Sharing techniques and learning to communicate his ideas were important factors in his growth as an artist. From this experience was born the concept of a more organized group of plein air painters. This was the stimulus for the formation of the Indiana Plein Air Painters Association, which he co-founded with fellow painting enthusiast Anne Carter.

Dan's love of painting is a reflection of his life. "I would paint even if I never won an award or sold a painting. The process of trying to do better, knowing I will never reach the level I want to achieve but always working toward perfection, gives me deep satisfaction. Success is not what you gain as a result, but knowing in your heart that you did your best, regardless of the results." Although he is successful in selling his work and competing for awards, they are merely means for him to continue painting.

The Painting Indiana project has been an adventure full of discovery, frustration, and personal growth. He saw hundreds of beautiful possibilities through his travels and choosing a single all-encompassing scene to represent a county was a constant concern. Knowing his choice would never please everyone, he chose scenes that inspired him.

Thriving under the pressure of the project, his full potential as an artist has emerged, and Dan now has more discipline, more depth as an artist, and more commitment to his creative path. He hopes that this path will lead to places like Williamsburg, Washington, Gettysburg, and Wyoming, where he can interpret the beauty and history of the world beyond Indiana. The Hoosier landscape, however, will always be the heart of his inspiration.

"Indiana is full of all those little quiet places, winding creeks, fields, small towns—and all these places are important. My appreciation for the Indiana landscape is almost overwhelming. . . . As I finished my last county painting, I wished I could go back and do them all again. I know now that Indiana has a lifetime of wonderful subjects I want to continue to paint. The time constraints and frustrations, mixed with the pleasant times, painting successes, and all the friends I have made along the way, were well worth the commitment I made to Painting Indiana."

Contributors

Because the author has been writing a weekly column about traveling through Indiana, he had firsthand knowledge on which to base many of this book's essays. However, he could not be everywhere or know everything. So, many Hoosiers were asked to provide information for the essays and later to check them for accuracy. What follows is our best effort to acknowledge and thank those county historians, members of chambers of commerce, convention center and visitors bureau staffs, and other helpful citizens who provided much of the data and descriptions for these essays and then read them to assure they were as accurate as possible. Almost certainly, some names have inadvertently been omitted. For the good work of all these contributors, the author is deeply thankful.

Contributors are listed alphabetically along with the cities and towns from which they reported.

Donna Adams, Tell City; Nancy Allredge, Greenfield; Tristan Ariens, Brookville; Linda Arnold, Warsaw; Stanley Barkley, Bloomfield; Linda Bell, LaPorte; Virginia S. Bennett, Veedersburg; Shirley Biehl, New Castle; Courtney Blankenship, Bloomington; Martha Bowers, Salem; Mark Brochin, Washington; Angie Bruns, Shipshewana; Blake L. Burns, Scottsburg; Nancy L. Burns, Mt. Vernon; Marcella Carter, Liberty; S. Castelo, Hartford City; Marilyn Chamberlain, Scottsburg; Alycia Church, Petersburg; Lois Clark, Brookville; Samuel M. Cline, Martinsville; Linda Clute, Greencastle; Willard Cockerham, Vincennes; Julie Cole, Franklin; Barbara Cottingham, West Lafayette.

Ray Dearing, Lebanon; Michael S. Dellinger, Shelbyville; Ray Dickerson, Liberty; Janet Dold, Monticello; Mary Ann Dorrell, Rising Sun; Melodie Dotlich, Danville; Lou Downs, Columbia City; Don Dunaway, Brookville; Nancy Eckerle, Jasper; Willadene Egner, Columbia City; Ann Farnsley, Vevay; Judy Flanigan, Connersville; Fenella Flinn, Nashville; Trula Frank, Wabash; Jerry Gerrard, Warsaw; Thelma Glaspie, Oxford; Harold Gossman, Jeffersonville; Robert B. Greene, Loogootee.

Mary Lee Hagan, Terre Haute; Ellen Harper, Vincennes; Brooke Harris, Rushville; Vevah L. Harris, Santa Claus; Carter Harrison, Jeffersonville; Janet Hartsuff, Angola; Gladys Harvey, Wabash; Patricia Hatcher, Columbia City; Claud Hayes, Vincennes; Paulette Hayes, Connersville; Brooke Harris, Rushville;

Eric Heidenreich, Princeton; Bob Hollis, Scottsburg; Judy Howenstine, Decatur; Jackie Hughes, Elkhart; Leanna Hughes, Newburg; Shirley W. James, Evansville; Tammy J. Johns, Rising Sun; Rhonda Jones of Indiana Tourism, Lafayette; Shar Joyce, South Bend; Imogene Keller, Corydon; Stacey Kellogg, Michigan City; Betty Kemple, Paoli; Sharon Kenny, Crawfordsville; Yvonne Knight, Jeffersonville; Susan M. Knochel, Kentland; Maxine Kruse, Bedford; Charlene Kruzick, Winamac; Patricia Lawson, Marion; Gena Lewis, Frankfort; Linda Lytle, Madison.

Lori Markle, Worthington; Mary Jo Martinek, South Bend; Joyce Mattingly, Muncie; Melanie Maxwell, Columbus; Douglas Mayer, Warsaw; Dan McCain, Delphi; September McConnell, Columbia City; Chris McHenry, Lawrenceburg; Diann C. McIntosh, Newport; Alice McKenna, Fort Wayne; Jennifer McNealy, Greensburg; Sally J. McWilliams, Madison; Rose Meldrum, Huntington; Joyce Miller, Peru; Marie Monroe, Sullivan; Micki Morahn, Carbon; Leigh and Marcia Morris, LaPorte; Sharon Morris, Leavenworth; Barb Mulholland, Kendallville; Ann C. Mulligan, Vevay; Edith Murphy, Scottsburg.

Sally Newkirk, New Albany; Jack B. Nicholson, Anderson; Karen Niverson, Fairmount; Lila O'Connell, Warsaw; Allen Dale Olson, Seymour; Patty Overpeck, Rockville; Karla Perkins, Greencastle; June Potter, Winchester; Catherine Powell, Peru; Tricia Priest, Madison; Arthur Redinger, Liberty; Jim Revalee, Connersville; Rosalie Richardson, Greenfield; Linda Rippy, Plymouth; Brock Rittenhouse, Bluffton; Dee and Terry Roderick, Williamsport; Theda Salmon, Knox; Nancy Sartain, Richmond; Phyllis Schoonover, Plymouth; Fern Eddy Schultz, LaPorte; Lisa Seegert, Kokomo; Michael B. Seitz, Logansport; Marilyn Shaul, South Bend; Martha Shea, Brookville; Melba Shilling, Knox; Ray Short, North Judson; Richard Simons, Marion; Pat Sitz, Rensselaer; Chris Smith, Winamac; John Martin Smith, Auburn; Melissa Spry, Vernon; Michael Steward, Worthington.

Vicki Tague, Portland; Kathleen Talenco, Chesterton; Bill Tennis, Sullivan; Lisa Terry-Bowsher, Logansport; Melinda Thompson, Versailles; Diane Timm, Tipton; Tom and Nina Vance, Leota; David G. Vanderstel, Indianapolis; Amy Vaughan, Fishers; Suzanne Vertesch, Danville; Brian and Julie Waldo, Bedford; Mary T. Walker, Richmond; Denise Weltzin, Brazil; Shirley Willard, Rochester; Bruce Woods, Crown Point; Paula Woods, Lafayette; Ron Woodward, Wabash; Vivian Zollinger, Gosport.

ANNE BRYAN CARTER is a Muncie-area native and has served as project coordinator for the Painting Indiana project. She, with Dan Woodson, co-founded the Indiana Plein Air Painters Association early in 1998, and originated the Painting Indiana project shortly after. Her story of the project clearly shows its heart and the excellence that each artist, writer, and volunteer has achieved throughout its course.

A graduate of Ball State University, she has worked in the sign industry for over twenty years, operating her own business in Muncie for thirteen years. She is currently project manager for the Marsh Supermarkets sign and display department. As a student of plein air oil painting, her work for Painting Indiana has been a joyous and life-changing experience, championed all the way through by her family and friends. Her wish to foster Indiana artists through IPAPA and to celebrate Indiana's landscapes has reached a satisfying union in the completion of this project.

EARL L. CONN is a Muncie-based writer and educator. He started in his Marion, Indiana, hometown as a sports reporter for the old *Marion Chronicle* while still in high school. The world was in the depths of World War II and any warm body would do. He didn't have time to learn to type and today still uses two fingers at his computer. Over the years he has written hundreds of freelance articles, founded and edited a denominational publication, written advertising copy, researched and written book chapters, served as a military writer in both the U.S. Navy and U.S. Air Force, worked for two Indiana newspapers, and reported for a news service. Along the way, he has taught for 44 years, first in high schools and then at Ball State University, where he eventually became the founding dean of its new College of Communication, Information, and Media.

Editor: Miki Bird

Book and Jacket Designer: Sharon L. Sklar

Typeface: Adobe Caslon / Sabon with Bickham Script

Compositor: Sharon L. Sklar

Book and Jacket Printer: Four Colour Imports